PAINTING THE CENTURY

101 PORTRAIT MASTERPIECES 1900–2000

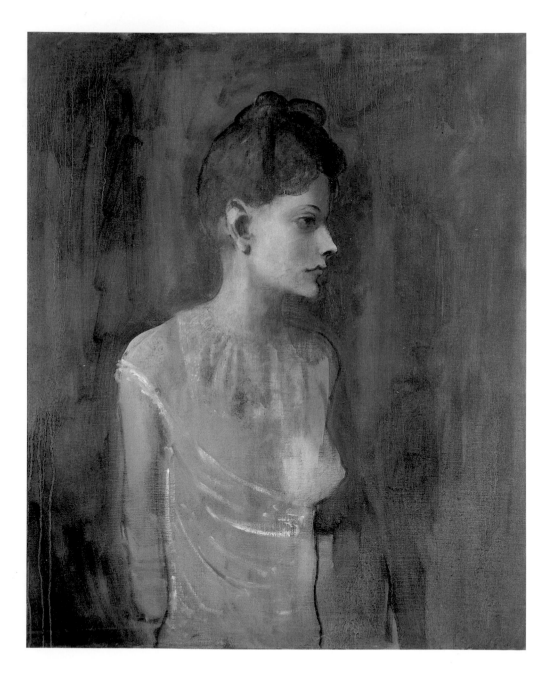

Pablo Picasso
Woman in a Chemise, 1905

PAINTING THE CENTURY

101 PORTRAIT MASTERPIECES 1900–2000

Robin Gibson

Introduction by Norbert Lynton

NATIONAL PORTRAIT GALLERY

PROVIDENT
FINANCIAL

PROVIDENT FINANCIAL is delighted to support the National Portrait Gallery's exhibition *Painting the Century*, which gives a fascinating insight into the art, and cultural and historical events of the last hundred years.

Founded in 1880, Provident Financial has grown into one of the most successful companies in the UK. Our patronage of the arts began in 1970, a time when corporate support of the arts was not commonplace. We began purchasing pictures from up-and-coming artists in Yorkshire, many of whom have since established successful careers. Our own collection now holds more than 400 works by artists including Henry Moore, David Hockney and Barbara Hepworth.

We believe that the arts are an essential ingredient of a balanced and flourishing society. Through the use of art, young people can build their creative skills and their confidence; and Provident Financial is committed to the use of art as a force for positive change within communities and is pleased to have developed a number of educational initiatives with the National Portrait Gallery to accompany this exhibition. These include working with inner-city schools from London, Liverpool and Bradford, and also enabling a number of school groups nationwide and students attending the practical art workshops to have free entry to the exhibition. In particular, we hope that this outreach programme will inspire GCSE pupils to draw on the exhibition in a creative and inter-disciplinary way.

We wish this historically important exhibition every success.

JOHN VAN KUFFELER
Chairman, Provident Financial plc

Foreword

The idea of this exhibition, *Painting the Century*, goes back to a discussion held long ago as to what the National Portrait Gallery should do to celebrate the millennium. Robin Gibson, the Gallery's chief curator, came up with the suggestion, which has remained intact, that we ought to stage an exhibition consisting of one portrait to represent each year of the century. Very importantly, he suggested that it should consist not only of British portraits, – the normal subject of exhibitions at the National Portrait Gallery – but of major portraits from all over the world. As such, it is one of the largest and most ambitious exhibitions ever held at the Gallery.

The discipline of selecting one portrait to represent each year of the century has been a considerable intellectual as well as logistical challenge. What should be the appropriate balance between conventional art practice and the avant-garde? What should be the balance between the importance of the sitter and of the artist? How far can an exhibition based on only a hundred portraits tell the story of portraiture in the twentieth century?

All aspects of the organisation of the exhibition, including the selection of appropriate pictures, the negotiations surrounding their loan and the writing of all the catalogue entries, have been the responsibility of Robin Gibson, who has been able to draw on his long experience and immense knowledge of the subject. In preparing the exhibition, he has been assisted by many people, but in particular by Professor Norbert Lynton who was for many years a Trustee of the Gallery, and who readily agreed to contribute the invaluable introductory essay. Our thanks must inevitably go to our lenders, both public and private, who responded sympathetically to our requests for loans. In addition, we are particularly grateful to Provident Financial for their exceptionally generous support for the exhibition.

CHARLES SAUMAREZ SMITH
Director, National Portrait Gallery

Preface
Robin Gibson

CATALOGUE NOTE

Date of work
The running graphic dates at the top of the page are used to denote the order of the works in the chronological sequence. They are sometimes not the same as the actual date of execution which is always given next to the title of the work.

Title
In order to assist the 'user-friendliness' of the book, titles of paintings have been given in English rather than adhering to the usual academic practice of giving them in the original language.

References
These are highly selective and may either refer to information or quotations given in the text or, where no page references are given, simply to further or related information about the artist.

Painting the Century is the book that accompanies a millennial, or more accurately centennial, exhibition of portraits from the twentieth century. My intention was to select a wide variety of significant paintings, one dated to each year of the century, so that they would form a chronological overview of some of the many important developments, both historical and artistic, that took place during the century. The original inspiration for the idea came from Richard Morphet's exhibition *Art in One Year: 1935,* which he organised at the Tate Gallery in 1977. Based on the simple but radical concept of showing everything from the Tate's collection that had been painted in 1935, the exhibition was a stimulating reminder of the wealth of widely differing modes of expression that co-exist at any given point in time. In comparison with landscapes, abstracts or still lifes, portraits are essentially a historically based art form. It seemed to me that by making a careful selection of portraits that were related in time (rather than the usual exhibition criteria of artist, style or theme), one might create a similarly unexpected view of a very exciting, if much longer period in history.

Since the selection of portraits had to be made on the basis of what was available for loan to an exhibition, *Painting the Century* could never be an anthology of the greatest portraits painted during the twentieth century. I hope, however, that the exhibition includes some of these, and that all of them are not only significant but interesting and enjoyable. Regarding the crucial matter of date, I had not fully anticipated the problem of replacing first choices for inclusion in the exhibition with substitute portraits of the same date, nor the problem of portraits whose dating was found during the course of research for the catalogue to be in doubt! The relatively few departures from the strict chronology that I had planned are due to these factors and I have indicated in the text where there are major discrepancies.

For reasons of space, my many acknowledgements have had to be accommodated at the end of the book. I am however especially indebted to Jennifer Cozens, who acted as part-time research assistant and compiled the Chronology, and to Norbert Lynton, not only for his authoritative essay, but also for allowing himself to be implicated in the concept of the exhibition and for much extremely useful discussion and advice.

Portraits from a Pluralist Century
Norbert Lynton

> To understand other people is a task which does not come to an end.
> IRIS MURDOCH[1]

> I mean, the real Bonnie and Clyde sure didn't look like Faye and Warren.
> Who wants the truth?
> ANDY WARHOL[2]

Everyone says the twentieth century had to be a bad time for portraiture. Long before it began, the inventors of photography had announced that 'from today painting is dead'. About that time, too, Ingres, a fine painter ('of limited intelligence', said Delacroix), maintained that easel painting was finished; mural painting alone would now be a painter's proper task. Robin Gibson has referred to 'the widely held view that portraiture was a dead duck that had been laid to rest at about the same time as Sargent in 1925.'[3] Add to this the widely held notion that radical modernists were intent on abandoning all likeness in order to make art abstract, utterly inhuman and unrelated to the appearance of anything in the world, and surely the art of portraiture was doomed.[4]

It wasn't merely art's problem. How could portraits flourish when we had such radical doubts about ourselves? Losing faith in a personal God, made in our image, we lost faith also in ourselves, made in His. Evolution, psychology, the recognition of mass society as the powerful if hasty motivator of our communal actions – all conspired to make us doubt any lasting significance for ourselves. Identity, always a question, in the nineteenth century became a crisis. 'A poet . . . has no existence,' wrote Keats, and 'Here lies one whose name was writ in water.' In the twentieth century we learned that identity is a function of image and is to be had in the shops. What the shops offer changes with the seasons, so images too must change. Where are stability and confidence? Not in the teachings of economics or medicine, not in nationalism or ethnic roots, not in employment or other relationships, not in the benignity of sunshine, rain or food. Earth itself seems to be querying our tenancy.

The century began with the call to be either superman or mass-man. As international disasters succeeded each other, faith in our leaders diminished and the media took them down from their *ex-officio* pedestals. We look for stars, not heroes. Andy Warhol got it right: let us all be famous for fifteen minutes. But monuments, statues? A plinth in Trafalgar Square, we were told quite recently, was calling for a monumental image . . . and after much debate it is now dedicated to serving as a display spot for a succession of monuments reminding us of nothing in particular, especially of no one in

particular. A lucky escape from something worse, no doubt, but also confirmation that setting up statues is not something we do with panache any more. Compare the presence of Bomber Harris, on the Strand, with that of Nelson on his column; compare Churchill's statue in Parliament Square with that of Abraham Lincoln close by. Yet statues are still, routinely, called for and still happen.

As so often, the opposite is also true. We have witnessed the emergence of a sense of community, of purposeful cooperation, for which there is no good historical precedent. Indeed, we live by it all the time, and complain loudly when it falters. It was signalled in Turgenev's *Fathers and Sons* (1862) and Chernyshevsky's novel *What Is To Be Done? – Tales about New People* (1863). In this, Vera Pavlovna is the New Woman; Kirsanov, her husband's friend and then her second husband, is the New Man. They live for truth, equality, progress. Their vision is one of smiling humanity, in cities like vast Crystal Palaces, 'nothing but glass and wrought iron'. Levin, in *Anna Karenina* (1877), is a New Man, a progressive who is also a hands-on farmer, a realist as well as an idealist; all the more touching, therefore, that when young Kitty is in labour with their first child, Tolstoy has Levin, desperate to help, rush to her bed with the family icon. Lenin, that eager student of *What Is To Be Done?*, re-created himself as a New Man, dedicated to serving the New Society. Jules Romains, in Paris, preached Unanism in his poems of 1908 and it was what many wanted to hear: modern society as a close tribe, each member dependent on every other member every minute of the day, and benignly so. The danger, as G. K. Chesterton pointed out, is that we come to take it all for granted: now we get on the Victoria Line tube at Green Park and fail to rejoice in the fact that Oxford Circus does turn out to be the next stop going north. If H. G. Wells, Aldous Huxley and others envisaged nightmare scenarios in which mankind turns itself into robotic slaves, many others saw a glowing future in this interdependence as the reasonable alternative to survival of the fittest. No century has been more searching and more generous in its portrayal of human sensibility and motivation in social studies, novels, films and dramas, and in its pictorial portraits.

A case is made for the fifteenth to the seventeenth centuries as being the great age of portraiture. The Renaissance is associated with a rise in human self-confidence. For portraiture it was a new beginning. Individuals of many sorts and conditions wanted to be represented 'from the life', yet in a range of styles from the detailed, transparent naturalism of Jan van Eyck, Piero della Francesca and Holbein to the poetic atmospheres of Leonardo, Titian, Rubens, Velázquez and Van Dyck, with Rembrandt thrown in to meet the demands both of realism and of imaginative transformation. A whole armoury of portrait types and forms was developed, from miniatures to full figures at more than life size, from official or domestic settings to symbolic backgrounds. A growing diversity of sitters commissioned portraits or were chosen to sit, from emperors and dukes to popes, abbots and scholars, artists

and craftsmen, as well as minor gentry and merchants, not to mention fine ladies and also their simpler sisters as pictured by de Hoogh and Vermeer. Whatever department we focus on, those were also centuries of bold patronage and vivid creative responses.[5] The Romans had made elaborate use of portraits in their civic and imperial roles, as their sculpture shows, learning their art from the Greeks and the Etruscans, but these were often monumental in form and function, calling for idealization above lifelikeness. Had more of their paintings survived, we would understand better how they used and valued domestic portraiture and perhaps have an even higher regard for their achievement. The new Romans of Renaissance Italy not only made full use of what they knew of the past but also, for all their obeisance to the ancients, had the drive and the talent to develop their inheritance and to disseminate it. Their combined achievement outshines that of the ancients by far, not least in the art of painting and its close ally, drawing.

How should nineteenth-century portraiture be rated, from Goya to Rodin, with Géricault, Ingres, Delacroix, Degas, Toulouse-Lautrec, Van Gogh and Cézanne on the way, not to mention Runge, Eakins, Whistler, Munch and Sargent? The taste for portraits of many sorts and occasions spread widely, as well as the emergence of what is now aptly called 'statue mania', whereby the human image, dressed and undressed, could be set up almost anywhere as an admonishing likeness or symbol for the betterment of passers-by. The century produced art of unprecedented banality, but also brilliant as well as testing works and a widening range of types and styles, not only over the decades but even if we take any one of them. We are told that today is the age of pluralism – but try, say, the 1880s, including its photographs.

Pluralism has been the blessing, and some would say the curse, of art since the Romantic age dethroned authorities and put a premium on human diversity, on originality of expression and on a radical questioning of art's bases. In many respects we are still within Romanticism. But modern painters, who often seem to have lost interest in representational truth, have in fact extended traditional concepts of portraiture whilst also introducing new ones, finding new styles and techniques along with new sorts of content. This essay is intended not only to support and if possible enhance the message of the 101 portraits in this exhibition, but also to suggest that portraiture is one of the modern age's most surprising achievements.

It is likely, too, that the twentieth century has produced some of the worst art ever, including some of the worst portraits. Once the great models and the principles and methods derived from them are set aside, once personal expression is valued as 'authenticity', we have to accept extremism of an overreaching sort and incompetent image-making along routine lines. Paints and brushes, boards and canvases are available to everyone, together with the message that there is an artist (next to the novelist?) within each one of us. And next to each one of us is someone willing to sit for his or her portrait. Great art has always needed deep and well-stocked soil to grow out of, and

nothing is gained from dividing what is likely to yield lasting quality from what may turn out to be expendable. Such lines would almost certainly be drawn in the wrong place and deprive the world of great achievements: think, for example, of Henri Rousseau's a hundred years ago, or William Blake's a century before that.

Romanticism called not only for freedom from inherited models but also for a revaluation of the categories of art – the genres, by which academic theory and, by and large, practice steered. The Greeks and the Romans had discussed literature in terms of genres; the Renaissance had adopted these for, principally, painting. The French academy enshrined the genres as a hierarchical system, in which the history painting, delivering major themes from history and literature in grandiose and instructive forms suited to them, is accorded the highest value, and demands the most serious attention from artists and the educated public. Portraiture, in so far as it deals with eminent individuals and serves to establish or support social structures, was next in importance. Below that came depictions of the life of ordinary people, 'genre' pictures, calling for a simpler, often more realistic, manner and format. Landscape and still life came lower down, and only gradually made their way into the official exhibitions at which the academies marketed their wares, displayed their abilities and awarded themselves prizes.

There were sub-sections within these genres, and combinations in which the lesser categories supported the greater, as when landscape settings or still-life props add meaning to history subjects or portraits. The process could also be inverted. In the eighteenth century, narrative and symbolism were brought in from history painting to add value to society portraits, notably in France but also in Britain, where history painting had been the preserve of foreign artists while natives were best employed on portraits. Reynolds, capable of portraying his friends most convincingly, made it his business to present more eminent sitters in a variety of historical or allegorical roles, adapting his idiom to accommodate this fusing of genres.

Mingling the genres in ways that questioned their old valuation became one way of marking progress in nineteenth-century art. Landscape and still-life painting, in which the human image played little or no part, were given unprecedented attention and were used to develop new methods of representation, from Turner, say, to Cézanne. But they were also charged with new meaning – think, for example, of Friedrich and Munch who used landscape to communicate intense religious or deeply personal experiences. These four were giving major roles to minor genres so that, by the end of the century, in spite of the efforts of such as Lord Leighton and Bouguereau, history painting had lost not only its status but also its leading role in art's development. Other artists meanwhile besieged the heights of history painting for ahistorical purposes, as when Courbet presented his fellow townsmen and women as a compendious combination of group portrait and genre scene in *A Burial at Ornans* (1850; Musée du Louvre, Paris); he gave it the size and solemnity of the grandest sort of history painting, but also a

plain manner at odds with this. Manet in *Déjeuner sur l'Herbe* (1863; Musée d'Orsay, Paris) fused an unconventional sort of open-air group portrait, in a bleak present-day style, of a naked woman sitting with men dressed in the current urban fashion, with an echo of Giorgione and a quotation from Raphael. Both paintings stirred up what was called 'bourgeois disgust'; they were indeed offensive and were partly meant to be. Manet followed his assault on taste with another, the naked portrayal of a model he called *Olympia* (1863; Musée d'Orsay, Paris), offered as a modern, in-your-face equivalent of reclining Venuses by Giorgione and Titian.

Generally, though, it was landscape and still life that were most susceptible to adventurism until, in the 1880s, figure subjects and even portraits attracted avant-garde attention again. The human image was taken in hand in order for it to be detached not only from the idealizing themes but also from the classically perfect forms that had accorded it its moral and aesthetic gold standard in academic practice. Perhaps this was stimulated by the contemporary Symbolist painters' emphasis on figure subjects, sometimes academic, sometimes fantastical in manner. Gauguin was partly a Symbolist, but whereas most Symbolists worked in delicate and inoffensive styles he adopted and invented primitive elements that denied everything good taste demanded. Seurat, more of a realist, insisted on contemporary scenes but delivered them in a manner controlled by rules of design and colour notation that seemed unpoetic and devoid of painterly skills. Another kind of realist, Degas, well rooted in the classical tradition, chose to paint and sculpt figures as though art had no subject other than visual fact. Van Gogh, whose roots were in Dutch realism and who learned Impressionism in Paris, went on to deliver intense poetic ideas via carefully constructed but always expressive forms and colour, which worked well for landscapes but achieved miracles when he painted portraits. His sitters were the people around him in Arles, poet and postman and postman's wife, and he celebrated them in compositions that ring out like fanfares. If any nineteenth-century painter warranted canonisation as the saviour of the human image in art, it was this northerner-gone-south . . . unless it was his contemporary, the much older and much longer-living painter of Provence, Paul Cézanne. Cézanne treated his sitters like still lifes. 'Be an apple!' he is said to have barked at his wife. More vocal sitters complained at the hours they were expected to invest so that the painter might achieve something that satisfied himself. The results were images that, for us, combine humanity with iconic permanence. But then Cézanne treated landscape and still-life subjects like portraits, subjecting them to endless scrutiny to convey for ever the particular character of each. We cannot but see Provence or a cluster of apples through his eyes and spirit. In the three great *Bathers* canvases that crown his career (1898–1905), he created what plainly are figure compositions of a classical sort yet could almost be mistaken for peopled landscapes. At the same time they feel rather like still lifes treated with the grandiloquence of the best history painting

When these paintings became known, soon after his death in 1906,

progressive painters paid them art's best and most lasting compliment by redirecting their work in terms of them. They followed Cézanne's example by means both of imitation and dissent, trying to understand it as best they could and as time and accumulating experience instructed them. The greater the artist the more contradictory his example, and Cézanne posed as many problems as he offered pointers towards solutions. In a moment of optimism he said he considered himself the 'primitive', the pioneer of a new sort of painting. Younger painters struggled to find its essence. Fastening on this or that aspect of him, they mostly missed it.[6] Some quoted his emphasis on 'the sphere, the cone, the cylinder' as pictorial building-blocks, though that echoed conventional teaching methods. Especially perceptive eyes, like Matisse's, attended to his way of using colour richly yet with discernment, and his way of achieving fullness of form in compositions that feel quite flat – something to do with the visual structure he gave to each as well as his several ways of laying on paint. Generally it was claimed that he had opened up a new classicism by 're-working Poussin from nature', as he himself had said. In France he was especially honoured for connecting art back to the great French tradition. Picasso said of him that he was 'like a mother who protects her children', adding warmth to the widely echoed cliché that had him 'the father of modern art'. But it was Picasso, the alien, who also voiced the essentially modern recognition that 'what forces our interest is Cézanne's anxiety – that's Cézanne's lesson'.

An exceptionally wise critic might at this point have prophesied that modern artists would have their work cut out to determine where and whether the old categories of art still had any virtue in them. Awareness of the genres had been basic to an effective communication system. They continue to be valuable in associating some sort of form with each type of message. Say 'history painting' or 'still life' or 'portrait', and we are armed with expectations which meeting the actual picture may confirm or deny or extend. Many twentieth-century portraits are essays on this theme. Both the most routine and the most adventurous of them are located in the network of old, recent and current types and anti-types and become part of it.

The arrangement of this exhibition is chronological, presenting something like a history of twentieth-century portraiture. It might indeed amount to *a* history. It might have been pleasant to claim that all the key portrait paintings of the century were assembled: one would then have to argue each exhibit's right to that status, which might be tiresome in an age that enjoys demystification. It would be pleasant to offer visitors the special experience of seeing just about all the best portraits the century left us, even without insisting on each of them being a sort of milestone. But there, too, we would have the problem of justifying the selection: what makes a portrait 'best'? And what would such an exhibition convey? Is a landscape properly represented by its peaks? What is certain is that this exhibition will prove the

diversity and inherent interest of an activity that has not merely continued, in spite of all reasons for its demise, but has engaged a widening range of methods and approaches. The title, *Painting the Century*, is clear: this exhibition is about modern art of one category in one medium. That the boundaries defining that category are occasionally ignored or even shifted goes with the period under scrutiny. 'Painting' itself has become a looser term since 1900, just like 'art'.

The exhibition may well work against the tendency of recent times to take the past as a settled matter. The champions of Postmodernism claim that Modernism needed laying to rest because it was a bad thing: utopian, content to promote fictions and false hopes, and narrowly orthodox to the point of dogmatism. There is some disagreement as to when this old movement sickened or died, or when the new movement cut in to shrink its corpse. Many of us doubt the utility of movements as a way of retailing art history; they enable us to refer to groups of artists, theories and instances without naming each of them repeatedly, but the more we know about movements the better we know what ill-defined and often contradictory formations they were. Major shifts of attention and valuation do occur over time, like what we call Romanticism, which came out of but also stood against the eighteenth century. It does look as though something important happened there, though we still struggle to define it. The few selected movements we still use in telling the story of modern art – out of the many that arose – are much slighter things, whether we refer to, say, Fauvism (more a moment than a movement), or De Stijl (which actually had a form of membership but began to disintegrate and re-form the instant it became public), or Abstract Expressionism (which embraces a variety of methods and intentions and tends to be thought of as a New York development, though outsiders are sometimes included), or Surrealism (which adjusted its priorities and membership according to the thought and shifting friendships of André Breton, one of its founders). Or any other movement of that sort: the more apparently specific, the less their value to any unprejudiced account. I conclude that those who present the Modernism of the first half of the last century as a closed and narrow subject wish it to be just that in order to give Postmodernism some sort of rationale.

It would be convenient if history could truthfully be encapsulated in neat terms of some kind, say decade by decade for the twentieth century. But its first decade was the decade of varieties of Impressionism and Post-Impressionism (as we have called it since 1910): Fauvism + early Cubism + early Expressionism and, in America, a powerful wave of Realism. In that summary, we ignore the more tradition-bound art that actually dominated those years as far as the public was concerned: Bouguereau, Ingres's successor and Matisse's teacher, died in 1905; Sargent, represented here by a portrait of 1904 (p.59) worked on ambitiously until 1925; Boldini, that outrageously gifted purveyor of evanescent charms, was famous until his death in 1931: his double portrait of the Marlboroughs, done in 1906 (p.63),

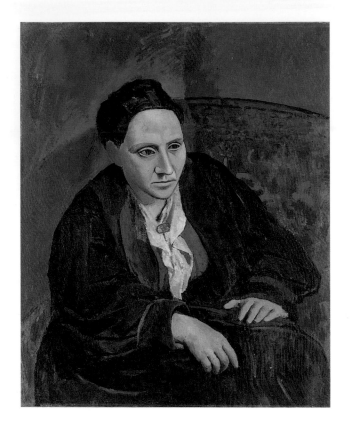

1. *Gertrude Stein*
Pablo Picasso, 1906
Oil on canvas
1000 × 813mm (39⅜ × 32″)
The Metropolitan Museum of Art,
New York. Bequest of Gertrude
Stein, 1947

tremendously seductive in itself, shines even more brightly in the context
of Munch's painful self-examination of 1907 (p.65) and of Larionov's
aggressive primitivism (see fig.10) or of the Expressionists' rejection of
all charm (pp. 72, 83).

 To see such contradictory works together is to understand better what
the Modernists were contending with, and how proper their impatience was.
It also helps us to empathise with the traditionalists' horror at Modernism
and the general public's rejection of it. When they wanted to paint portraits,
the first Modernists had to ask their family, friends or professional associates
to sit: Matisse painted his wife and Derain; Derain painted Matisse; Picasso
painted his girlfriends Madeleine (p.60) and Fernande, and his important
new patron Gertrude Stein (fig.1), and then his dealers; Kokoschka painted
his friends, the actress Else Kupfer, the architect Adolf Loos, the artist
William Wauer (p.72). Serious commissions for portraits did not come to
the Modernists until the second decade, and then to the less radical ones
and to these only rarely: see Corinth's 1911 portrait of the creator of the
Hagenbeck Zoo, a clever but not especially Modernist work that shows the
painter's roots in naturalism (p.75), or Pankok's just pre-war portrait of the
creator of the Zeppelin, incisive in its way but traditional in method (p.78).
This exhibition's account of twentieth-century portrait painting is properly
pluralist, as a whole and whichever period or section we look at.

Would an exhibition of twentieth-century landscape painting, or still life, lead to the same conclusion? I suspect it would, on the whole. Some difference might arise from the fact that the century produced a good number of specialist landscape painters and still-life painters, or indeed painters of landscapes and still lifes but little else, to whom painting portraits would have been wholly against the grain. But few of the painters represented here specialised in portraiture. Long ago I heard Lawrence Gowing speaking of the tension, the embarrassment even, that develops in the studio between the portrait-painter and the sitter. He was lecturing on Cézanne but his point was a general one and made from wide observation as well as personal experience, and it makes one wonder to what extent the career of the professional portraitist depends on a combination of thick skin and bedside manner. Think of William Nicholson, for instance, whose first career was that of one of the two 'Beggarstaff Brothers', producing brilliantly succinct woodcut and lithographs of diverse subjects, including portraits of eminent individuals (fig.2), and who went on to become a well-liked society portraitist, good at flattering his sitters (p.111), who painted exquisite little landscapes and still lifes for relaxation. No hint of embarrassment there, but rather a natural charmer who had found his *métier*. And many a modern portrait has been produced without the presence of a sitter – from studies and sketches or photographs specially taken, or from others' portraits and photographs and thus without any personal contact at all, or, as so often in the case of Picasso's countless variations on the theme of the women closest to him, from intimate knowledge but without dedicated sessions. As this suggests, what can count as a portrait is continually revised and extended, and it is partly a matter of convention, partly one of curiosity, whether this or that painting is titled as representing an anonymous figure or a named sitter. The greater the role of metamorphosis, the wider the definition has to become if we want to enroll an image as a portrait. This is equivalent to saying that we have learnt to read and appreciate the human being in many kinds and degrees of representation, and there can be little doubt that all image-making has joined in developing this sensibility. The more the early Modernists spurned literature, the more they became their own authors, writing their own scripts.

Having questioned the value of trusting movements as stepping stones through the stream of twentieth-century art and thrown serious doubt on labelling the decades or other periods that made up the century, I am perhaps not in a good position to offer a synopsis of its contribution to portraiture. It must be attempted, however: the exhibition will both illustrate it and offer a context for what must seem closer to progress across a parade ground rather than a leisurely ramble through a park.

Symbolism in literature and art was well under way in France, England and Belgium by the time it was launched and labelled in Paris in 1886, and soon spread to other parts of Europe, notably Scandinavia and Russia. Next to the weakening classicism of the academics and the emphatic contemporaneity of Realism and Impressionism, it marked a renewed emphasis on

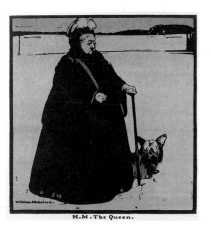

2. *Queen Victoria*
William Nicholson, 1899
Coloured woodcut
229 × 203mm (9⅜ × 8")
National Portrait Gallery, London

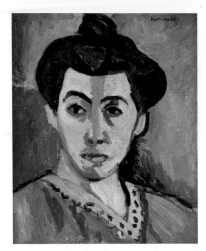

3. *Mme Matisse*
Henri Matisse, 1905
Oil on canvas
600 × 410mm (23⅝ × 16⅛")
Statens Museum for Kunst,
Copenhagen

poetic vision as providing access to the immanent. Often religious or quasi-religious in its means, Symbolism also included erotic images as well as the sort of sensuous exoticism pursued so influentially by Gauguin. Symbolism was not a matter of style, though its avoidance of the mundane did lead to a preciousness which, in the writing of Mallarmé, resulted in lines at once luminous and economical. Moreau painted over-heated mythological fantasies, Puvis de Chavannes spread fine but somewhat lacklustre compositions over many a wall in France and the United States, and Redon worked with paints and pastels or in black-on-white to stun the viewer with images the best of which are either terrifying or enchanting. Mentioning a few star names misrepresents Symbolism, however. It was a broad church, with conflicting aims and methods, ranging from medievalism to near-abstraction. Portraits as such could not be central to it. Those that came out of it tended to be fully representational but sometimes combined naturalism with Symbolist fantasies, as in Akseli Gallen-Kallela's self-portrait with friends, *Symposium (The Problem)* (1894; private collection), in which the wings of some dread apparition intrude on a convivial evening. Such sinning against the principle of unity of language is interesting in itself. Symbolism, like Post-Impressionism, also witnessed an emphasis on the materials and means of art which became programmatic in Art Nouveau and Jugendstil art and design. All this continued in modern art, though it can look like its opposite. The specific urge to use art to open up realms of the imagination, using whatever idiom was available, re-surfaces in Surrealism.

Landscape and still life, sometimes also allegorical and mythological subjects, occupied the painters bundled together as the Fauves, who were noted for their unskilled use of the brush and of often bright, anti-naturalistic colours. They came out of the divisionism of Seurat as practised and promoted by Signac: seen colours split up into their constituent hues and set down side by side to be re-assembled in the eye. Signac adapted the system, dropping its scientific premise and using larger brushstrokes and more assertive colours. He lived in the south of France, where Matisse and his friends visited him, learned from him and applied what they learned to their seaside paintings. Matisse, in particular, developed Fauvist methods in portraits. Using his wife as his subject, he moved within weeks from the chaotic-seeming colours and brushstrokes of *Woman in a Hat* (1905; Statens Museum for Kunst, Copenhagen) to the powerful colour construction, paraphrasing what he saw, of *Mme Matisse* (fig.3). Portraits and portrait-like paintings of specific models were to be a large part of Matisse's output, as well as more abstracted figure subjects. Fauvism's links with aspects of German Expressionism are specific rather than general. More to the point is the fact that Fauvism, in spite of its brief notoriety in Paris, was picked up as part of Post-Impressionism in eastern as well as western Europe, always as a counter to bourgeois taste and academic techniques.

Cubism, too, was hardly a movement. Its creators, Braque and Picasso, neither countenanced a movement nor needed one. Kahnweiler bought and

showed their work; it was the others, working at some distance from those two, who sought strength through combination. Braque's and Picasso's closeness is always emphasised for the first, so-called Analytical years of Cubism, roughly 1908–11. One of the great differences between them was that Picasso, always a painter primarily of figures, kept on painting figures, including portraits, while Braque went on painting still lifes and landscapes. Still life was the engine that drove the development and re-development of the languages of Cubism, for Picasso too, so that one can imagine him saying to his 'sitters' (he portrayed them in their absence), 'Be a Cubist still life!' Having long struggled over a portrait of Gertrude Stein and, without looking at her again, finishing it so convincingly that she had to become its likeness, Picasso painted his partner Fernande repeatedly and Vollard, Uhde and Kahnweiler once each as though to prove he could go on being not-Braque even when adopting Braque's invention (fig.4). He found ways of adjusting Braque's delicate pictorial structures to suggest the presence of anonymous persons, partly by clustering Cubist signals where Raphael and Titian had taught us to expect a face or hands, and partly by imposing vertical scaffolding that would invite being read as figures. Braque followed

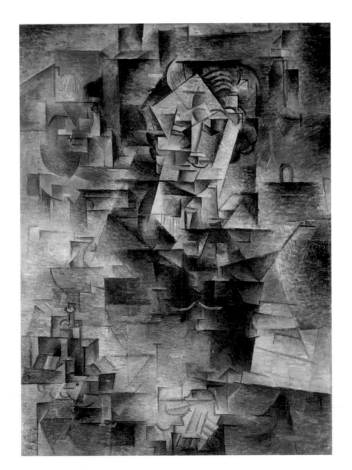

4. *Portrait of Daniel-Henry Kahnweiler*
Pablo Picasso, 1910
Oil on canvas
1001 × 733mm (39⅜ × 28⅞")
The Art Institute of Chicago.
Gift of Mrs Gilbert W. Chapman in
memory of Charles B. Goodspeed

him in this, but not in his desire to dedicate, so to speak, particular structures to specific individuals. Braque did not paint portraits.

Most of the 'outer Cubists', as I will call them for now – de La Fresnaye, Gleizes, Metzinger, Le Fauconnier, etc. – painted portraits as well as allegorical or descriptive figure subjects (pp.77, 81). How Cubist they were is another question, depending on how Cubism is defined. Each adapted what they saw of Braque's and Picasso's Cubism in his own way, at first as a spicing up of traditional methods of representation, then with more conviction and energy as they saw collage and other constructive means entering Braque's and Picasso's Synthetic Cubism from 1912 on. Gleizes went on to focus his attention on the flat geometry proposed by Synthetic Cubism (p.81), but developed it in a Symbolist spirit to convey religious themes. Delaunay, who had done some portraits earlier, adopted a Cubist patterning of the picture surface for architectural subjects, but then went on to set those patterns free in rhythmic colour paintings with titles such as *Sun and Moon*. No portraits any more, and figures for a while only from newspaper clippings as celebrations of modern communal life.

Juan Gris, too close to Picasso to be called an outer Cubist, painted his friend in a striking but not really Cubist manner which owes something to Seurat and something to Delaunay but is at heart a traditional represent- ation. He soon followed it with a *Portrait of the Artist's Mother* (1912; private collection), more convincing as a pictorial invention yet still clearly rooted in a conventional close-up, possibly from a photograph. When, about 1916, Gris initiated the dialogue between architectonics and description that was his idiom for the remaining years of his short life, portraits were out and figures very rare; still life was the essential theme and form. International Cubism, which had its local blossomings but was rarely radical or persistent, derived mostly from the outer Cubists and usually stayed with giving modern, urban airs to conventional imagery. Mondrian, coming to Paris in 1912 to take his measure of Cubism, re-invented it as a way of structuring still lifes and townscapes; portraits and figures disappeared from his work. Back in Holland during the war, he was one of the leaders of the De Stijl movement which aimed at generalising art and design into one coherent language that could in theory cope with figurative subjects but that did so only very rarely. Portraits could not be its concern.

Italian Futurism surfaced in Paris in 1909 as Marinetti's literary movement, and in 1912 with its first comprehensive exhibition, mostly a mixture of Post-Impressionism and Cubism, partly of a Cubism pressed into service for poster-like diagrammatic symbolism. Its programme called for encapsulating the dynamics of urban life and the energies of technology as complex experiences not so far encompassed by art. Portraits were exceptional, but possible if a sitter could be fused with his or her environment and thus be shown, materially as well as psychologically, as part of a larger whole. Instantly promoted internationally, Futurism was effective as a means of spreading aspects of Cubism. It encouraged a reading of what

some sensibly called Cubo-Futurism as a conceptual as much as perceptual idiom. This could serve as a public address system ready to carry specific messages. Futurism itself, always fond of political action, re-surfaced after the First World War in alliance with Fascism, and for a time contributed its promotional skills to exalting political and military power and glorifying Mussolini as the leader of the campaign to unite and rejuvenate a country burdened by history and division (p.123).

Russian Futurism took its name from the Italians but looked in other directions. Marinetti, visiting Moscow, accused the Futurists he met there of being *passé* and they booed him for his pains. They wanted to be not leaders but rebels, having fun with the heroes and rules of Western academic art and belabouring culture with primitivism of several sorts, from word and form-play that delivered nonsense to ancient Slav and continuing Russian folk images and idioms. Picasso's example had encouraged their own taste for crude and skilless imagery, which included portraits of themselves and each other. In many ways they were Dadaists before Dada but, to a surprising extent, they were also Symbolists, seeking religious or at least otherworldly meanings in their creative work. They took Cubo-Futurism to represent new dimensions of human physical and spiritual endeavour, and this faith drove the progressive arts in Moscow and St Petersburg, especially when war isolated Russia from the West.

The Expressionism of central Europe was more than one movement and embraced important detached individuals. Individualism, indeed, was its most often stated aim. Van Gogh seemed to point the way; he shot to international fame around 1910, twenty years after his death, together with El Greco, almost three hundred years after his. The Norwegian Edvard Munch provided a powerful impetus, working in Berlin from 1892 to 1908. He said he wanted to dissect souls, but it was of course his own soul he knew and conveyed best, with landscapes and interiors, as much as other people, mirroring his own desires and perplexities. The *Brücke* painters of Dresden (Ernst Ludwig Kirchner, Karl Schmidt-Rottluff and Erich Heckel) found their style around 1908, and it was a matter mainly of spirited primitivism, both in their use of colour and form and in their rhetoric of untutored, impulsive action. They welcomed Emil Nolde, the almost-Danish German, into their group but he found them too unserious; an instinctive Fauve, he wanted to be a man of the people as well as a leader, used religious themes in hopes of engaging the rural communities of northern Germany, and then also fiercely conveyed landscapes and flower paintings as well as figure subjects of a fairy tale sort. Above all he wanted to prove his own and his art's Germanness, and was cut to the quick when the Third Reich did not want him as its artistic star. When the Dresden three moved to Berlin, in 1910–11, their group attracted other members and their art became more diverse, partly in that it took on a metropolitan claustrophobia and urgency. It is often said that every worthwhile painting is the artist's self-portrait. In Expressionism this has to be so: art originates in the individual's

apprehension of the world. This is both the strength and the limitation of their work in portraiture. Kirchner, the dominant *Brücke* artist from the start, drew and painted friends and other people around him. The *Brücke* painters were adept at attracting patrons, initially through their graphic work, and these sometimes commissioned portraits.

The Expressionism associated with the *Blaue Reiter* almanach and exhibitions was something quite different, in many ways inimical to the Expressionism of Dresden and Berlin. The *Blaue Reiter* artists were in Munich, a cosmopolitan lot in spirit and sometimes in origin. They were in close touch with Paris, especially with Delaunay. Vassily Kandinsky, the Russian, was dominant; close to him were other Russians, notably Jawlensky; Franz Marc, Kandinsky's co-pilot, was German, as were August Macke and some of the others of this little circle; Paul Klee was Swiss-German. They looked far beyond national frontiers and away from the Renaissance-rooted art traditions they had inherited. The *Blaue Reiter* almanach, published in 1912, illustrated all sorts of art, ancient and modern, sophisticated and primitive, that supported their urge to take art beyond naturalism and realism in search of spiritual dimensions. In this way they were latter-day Symbolists. Kandinsky preached the Romantic concept of 'inner necessity' as a justifying discipline; he held that the new spiritual art for which he was campaigning would be reached either through abstraction, turning away from the material world, or through innocent naturalism as manifested in the art of Henri Rousseau. Klee stimulated his creative invention by responding to the suggestions he sensed in the marks he was making as well as to the potential of his materials. Portraits are rare in the mature work of the *Blaue Reiter* artists.

They are, however, frequent in the work of the Austrian painters we think of as Expressionists – Oskar Kokoschka, who managed to be rebellious throughout his long and mobile working life, and Egon Schiele, who died too young to have had a definable career. Both rapidly developed distinct personal styles, sharp and nervous, with edgy silhouettes and colours signalling sensations more than visual facts, so that one wonders how much the personality of the sitter penetrated the narcissistic gaze of either artist. Both reached patrons as well as willing friends; the cultural world of Vienna, even more than that of Berlin, enjoyed conflict. Kokoschka in fact established himself in Berlin, where he painted, drew and worked for that multi-media champion of Modernism, Herwarth Walden, until 1914. After the war, both Kokoschka and Schiele moved into calmer, more descriptive modes, in Schiele's case sadly shortlived. His positive, even optimistic picture of himself, with models standing in for his wife and unborn child is all strong and calm and is a visionary image of completion that fate refuted before the year was out; all three died that October (fig.5).

The war itself, officially so purposeful, added advances and retreats on artistic fronts to a complex, already pluralistic situation.[7] Many turned against specific forms of Modernism as being alien to the national spirit that alone would breed the fortitude that war, and later peace, demanded.

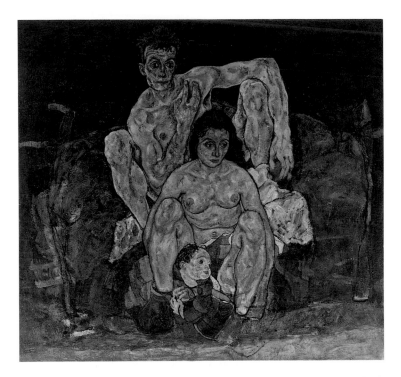

5. *Family*
Egon Schiele, 1918
Oil on canvas
1500 × 1500mm (59 × 59″)
Österreichische Galerie, Vienna

Others, artists themselves, turned against Modernism because it had not,
still generally did not, take a stand against the international carnage. Had not
civilization proved itself a veneer, without moral anchorage? The Dadaists of
Zurich, an international cluster sheltering in a neutral country, used the arts
to attack the arts and cabaret as a ready vehicle – the verbal arts most fiercely,
visual art more mockingly. There were others, in other places, similarly
undermining the old faith in culture – Marcel Duchamp in New York, where
Modernism was a thrilling newcomer; Francis Picabia, rich, able to elude
war service and of no instinctive allegiance, everywhere. Works of art
could be made silly enough to mock all thoughts of art's high-mindedness.
Nonsense poetry could undermine sense, yet also sound a warning note of
the primordial power of shamanistic incantation. Short-lived, outrageous
journals proved the convergence of culture and satire, and could be
illustrated with specially made images and reproductions that gave
international visibility to shocking novelties. Picabia invented his 'symbolic
portraits', combining machine forms to make suggestive emblems of
colleagues and of types of humanity. Duchamp's notorious *Fountain* (1917),
refused exhibition even in this libertarian situation, could be defended in
words and exhibited in the New York journal *The Blind Man* thanks to Alfred
Stieglitz's awesome photograph of the urinal aiming itself at us. Symbolic
portraits became an international game, with Stieglitz represented by
Picabia as a broken camera, Arp making two- or three-dimensional forms
and titling them *Head* or *Portrait of . . .*, and his Dada colleague Hans Richter
making Expressionistic 'visionary portraits' of no one in particular as well as

drawings of abstract forms he titled *Dada Head*. The anonymous or vaguely named 'head' was prominent in art as never before or since. Lenin in Zurich is thought not to have bothered with the Dada goings-on across the road from him, but when Dada came to Berlin to upbraid the German bourgeoisie it was at the level of politics as well as of taste. The Berlin Dadaists were eager to engage art in the class struggle. Some of their portraits, often made by means of collage and photo-montage, are openly political; even their portraits of each other are satirical. They were not concerned with the artist's or the subject's personality or history so much as with their stance in the present situation.

The post-war present meant a pained, self-questioning peace in some countries, and more fighting, even outright war, in others. The Bolsheviks who had taken power in Russia in 1917 would surely not last long; to hurry them on their way the West encouraged war between the Reds and the Whites and sent in foreign troops. In Germany, street fighting and assassinations brought the country close to civil war. Soon the Fascists were marching in Italy. In France and Britain, enjoying relative peace, calls to order invited a retreat to older cultural standards. 'Realism', meaning some degree of truth to appearances, flourished as a conscious trend in most countries.[8] In some it confronted Modernist extremes. In Russia, abstract art – especially Malevich's Suprematism and the Constructivism associated with Tatlin – came close to becoming the state's official idiom, but was pushed aside by realistic art of the nationalistic sort that had flourished in the late nineteenth century and now pressed forward again; before long the state would require Socialist Realism. In Italy, a similar tendency led painters back to Giotto and the calm clarities of pre- and early-Renaissance painting. In France, amid a general call for a return to the classical values considered French by nature, Modernism continued in various forms, with and without classicizing structures. Picasso painted his great classical figures, not 'neo-classical' so much as proto-classical, pointing towards high classicism from archaic beginnings. Léger produced his magnificent figure groups, at once ancient and honed-down modern. In Le Corbusier's designs modern architecture could embody classical systems, while in his paintings he, together with Ozenfant, made Cubism into a dignified, lucid style, going for wholeness and harmony, not fragmentation or paradox. Such an art would confirm modern values in design and thus find its place in the world of machine forms and functionalism.

This was true in Germany, too, but here it was mostly abstract art that took up a similar position, stimulated by Dutch and Russian example. The new art-and-design academy of the Bauhaus was one institution among others working for this harmonization, its aims and idiom becoming impersonal and international where *Brücke* Expressionism had looked to individualism and national or regional character. Of course, the *Brücke* painters went on painting. The gap between them and the *Blaue Reiter* artists became even wider when Kandinsky and Klee taught at the Bauhaus.

The New Objectivity or the New Sobriety (*Die Neue Sachlichkeit*) was a movement invented by art critics to fill this gap. A 1925 exhibition with that title brought together painters of various origins and persuasions whose imagery drew on the real world even if it processed this material in diverse ways. Fantasy and satire were accepted alongside demure simplifications of an almost childlike sort. It was a figurative movement, of still lifes and townscapes sometimes but mostly of contemporary life and thus also portraits. The most potent artist included was Max Beckmann, who brought to it his sense of pictorial drama, developed empirically with early Renaissance painting, Impressionism and Munch among his resources. After 1918 he attained his characteristic synthesis, deploying figures and actions on a narrow stage. His scenes could portray the violence committed around him; they could also, as in *Family Picture* (p.95) convey persons we accept as real in an almost real situation. The individuals are indeed portraits but the totality is symbolic, inviting our empathy. George Scholz's realistic self-portrait (p.107) seems filmic where Beckmann gives us a staged tableau, and close to journalism where Beckmann is complex and poetic even though staying close to fact. The characters of both artists become more distinct if we compare their pictures with some of their contemporaries', such as Tamara de Lempicka's modish, superficial naturalism (p.105) and the insistent spiritual-ization employed by Pavel Tchelitchew in his portrait of Edith Sitwell (p.108). Another Russian, Kuz'ma Petrov-Vodkin, portrayed another poet, Anna Akhmatova, in a way that fuses spiritual implications with refined naturalism (p.98). Both of these painters reveal themselves to be latter-day Symbolists.

Where Surrealism differed from Symbolism was in its claim to release human urges that civilization had always repressed, and in its denigrating order and beauty as values. 'Beauty', wrote Breton, 'must be convulsive or it is not beauty.' Surrealism was a literary movement first and foremost, though Breton allowed for the possibility of means other than words. Verbal expression had to break the rules of rational discourse. Automatic writing and employing chance (as by cutting words and phrases out of printed matter and copying them without selection) were ways of achieving it, and stimulated a more controlled but apparently wild, frantic and disjointed narrative. Visual Surrealism could apply a range of methods, from collaging found images and other materials, to discovering suggestive imagery in forms and patterns accessed by various methods. Even at its most potent, its most cooperative – there was much joining and leaving the movement, for a variety of reasons – Surrealism never intended to develop a general style. Kandinsky had argued that the spiritual art the world needed could be reached through a patient pursuit of reality, as demonstrated in the paintings of Henri Rousseau – officially primitive, certainly untutored, but by no means naïve. In Rousseau's *The Muse Inspiring the Poet* (fig.6), the painter Marie Laurençin links the poet and critic Guillaume Apollinaire to the heavens whence inspiration comes. They sat for the portraits; the Luxembourg Gardens provided the setting. Nothing in the picture is very like, yet its

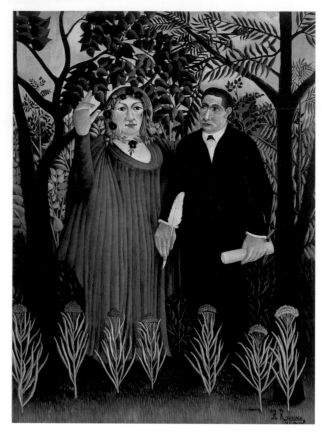

6. *The Muse Inspiring the Poet*
Henri Rousseau, 1909
Oil on canvas
1460 × 970mm (57½ × 38¼")
Öffentliche Kunstsammlung Basel,
Kunstmuseum

monumentality overrides what should be a handicap. Everything is painted with conviction as having value; everything is attended to with a sharpness of focus that makes it super-real, almost supernatural. Rousseau died in 1910, long before Surrealism was thought of; one might otherwise imagine Breton enrolling him as a proto-Surrealist, a pathfinder akin to Giorgio de Chirico.

The Surrealist artists worked in diverse personal ways; without thinking of Kandinsky's two paths to significance, they tended to abstraction on the one hand and detailed naturalism on the other. Heightened consciousness, whether from hunger or from drugs, could weaken the control of self-censorship; obsessive self-examination and self-display could become a programme. Whatever method was used, the energy of the result would spring from the imagination's focus on the desires driving it. The individual imagination would touch on common human property and illuminate myths that had long fascinated mankind. Surrealism made public the private, the scarcely admittable even to oneself. In fact, Surrealism wanted to change the world. At times it sought association with Communism, but the allegiance was never close, not least because Russia saw Surrealism as bourgeois self-indulgence.

By definition, Surrealist art justifies more than any other the Romantic idea that every work of art reveals the artist. But it included images called

Portrait (as well as many a portrait called something more mysterious), and these could range from symbolic representations of known and unknown individuals, such as Juan Miró's *Head of Georges Auric* (1929; Kunsthaus, Zurich), worked in the spirit of Dada heads, to commissioned portraits of prominent individuals from such a star performer as Salvador Dalí, who in the 1940s enjoyed global notoriety (p.154). Picasso's portrait of Lee Miller ignores her beauty to expose tensions that may have been the painter's in that year of stridency (p.130). Jean Dubuffet is not counted among the Surrealists, though his interest in the art of children, psychotics and scribblers on walls was shared with them and became a primary resource for him. Henri Michaux, poet and artist, was his friend; to associate him with a one feature was a symbolic act of the sort Dubuffet employed repeatedly in the new portraits he exhibited together in 1947 (p.151). The catalogue of that show described them as 'portraits with a resemblance extracted, with resemblance cooked and conserved in the memory . . . of M. Jean Dubuffet, painter' – a description that links him both to Surrealism and, *avant la lettre*, to Conceptualism in its focus on the processing of something known or seen as idea rather than on its representation. But it also separates him from Surrealism in revealing his essentially humorous stance. He is not, so to speak, psychologizing, either his subjects or himself. The description also suggests another association, with Howard Hodgkin's lyrical transcriptions of friends and the settings in which the painter encounters them, at once humorous and incisive, representational and symbolic, with memory and an appetite for succinct pictorial delivery controlling his process (p.183).

Abstract Expressionism – which, under diverse names, became dominant on both sides of the Atlantic after the Second World War – could not lend itself to portraiture, but gave priority to self-revelation. It was not a style, but it did propose a manner of working, abstract until some practitioners wearied of that instruction, and freehand as well as freely expressive of what appeared to be the painter's spiritual situation. American abstract painting had been geometrical and impersonal but not (unlike, say, De Stijl painting) programmatic, and it had been satisfied with a modest scale. Now paintings tended to be very large, fit for museums and wealthy homes, but made that size because they were to be encountered as arenas in which the painter enacted his work. The painting records an action, not primarily an image. None the less, Picasso's face has been encountered in Jackson Pollock's dribbled paintings, and Willem de Kooning, who had painted portraits before 'going abstract' (as we said then), returned at the start of the 1950s to generalised representations of women of several recognizable types. The French painter Jean Fautrier's wartime and post-war abstract heads, titled *Hostages*, can be seen as symbolic portraits. European art readily dealt in and valued themes of violence and misery, or at least of existential anguish.

Philip Guston, a lyrical and then increasingly dramatic maker of abstract images, relaunched himself in the 1970s as a guttersnipe-painter of disgust and protest. 'He was off on an irreversible orgy of grostesquerie' that

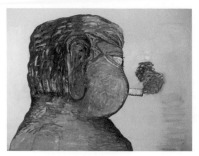

7. *Friend – To M. F.*
Philip Guston, 1978
Oil on canvas
1727 × 2235mm (68 × 88″)
Des Moines Art Center, Iowa

appalled the pundits of the day and delighted the young.[9] His new idiom came somewhere between comic-strip graphics and the obsessional heaping up of things and symbols found in the art of the insane, and its power is such that it still leaves us perplexed: are these pictures funny, or are they the most plangent accusations of viciousness the twentieth century has seen? The new Gustons echoed paintings and drawings he had done as a young man, but those were measured and stylish, whereas the late work was done in an anti-style, a loutish style, even when the results are monumental. He said he painted with 'colored dirt'. He had painted some portraits earlier; now he included symbolic portraits, often of himself, sometimes of his wife, occasionally of his friends. More often he pictured the enemy, agents of oppression. But for their huge size and brusqueness, we might see these paintings as belonging to the same campaign as George Grosz's wartime protest images, which were done in America and witnessed by the young Guston. These owed something to caricatures and something to Grosz's own early Expressionism (p.149). Grosz was issuing a bitter lampoon not only against Hitler but, as the main title *Cain* insists, against that part of every man that expresses itself in violence. Guston's *Friend – To M. F.* (fig.7) refers to the composer Morton Feldman, a friend already when Guston was painting his delicate, atmospheric abstractions. Over 5-feet high, the head averts itself from the world, capable only of smoking cigarettes, staring with its one eye and, to judge by that Buddha-like ear, listening. It takes longer to notice that the brushstrokes delivering this uncouth sight are those we delighted in when Guston was painting his seductive abstracts. Much the same could be said of his *Figure* (p.221). It, too, must picture himself, though here Guston is a much younger man, a flashback image delivered in his new, unmannerly manner. Head and shoulders, one eye, one cigarette and trace of smoke, a blind pulled down to tell us not to think of that cheerful blue background as sky, a glimpse of a chair, an offensively bare light bulb. That apart, Guston has built his uncouth, self-distancing representation with the same brushstrokes as those he had pleased us with when he painted his lyrical abstracts.

Before this, waves of Pop Art had swept across England and the USA during the 1960s to give representation new energies and new purposes. Figuration was now prominent again in an avant-garde development. The official gravity of Abstract Expressionism was replaced by a patent appetite for the imagery and manners of the marketplace and the media. Where the Abstract Expressionists had invoked ancients myths, the Pop artists drew on, and generally seemed to celebrate, recent and contemporary mass themes and icons, commonplace material that may often have originated in sophisticated design studios but was aimed at the consumer society. Whether subtle advertisements or comic-strip entertainment were being re-presented by these artists, or critical and more personal material was being conveyed, the mode of Pop was popular and indulgent when it was not plainly scurrilous. The results could be tough, even aggressive; mostly

they were amusing, cheeky. Many critics complained that Pop dragged art down from the sublimity it had just attained through heroic efforts. Where the Abstract Expressionists' image was that of the recluse, at work on solitary journeys into timeless depths, or that of the pioneer risking life and limb in his urge to open up new territories, the Pop artist was the urban *flâneur* and at times the urban activist, using art to mirror values that were wholly contemporary. Pop artists did not need or want distance.

The American painter R. B. Kitaj, working in London, and the English painter David Hockney, working first in London and then mostly in the USA, gave particular prominence to representing individuals in their art, in narratives or as portraits. Hockney, whose early work included a brilliant, Hogarthian account of his first visit to New York in a suite of etchings (fig.8), became one of the great portraitists of the century. He did drawings and paintings of his parents and friends and at times made commissioned portraits. Kitaj, whose early work often referred to political events and continued to reflect on history and on individuals, liked to draw or paint writers – such as Isaiah Berlin, who was, he said, 'an abiding master of the strange phenomenon sometimes loosely called "identity" which I have wished to paint as if it were a tree.'[10] Some American poets were among his close friends. Robert Creeley and Robert Duncan were both staying with Kitaj in London when he painted them 'from life' (p.218). They are 'very different poets', he said. 'There was *every* reason to celebrate them together in a painting. They are like Picasso and Braque, something like that – very often coupled in the history of modern poetry.'[11] Kitaj used tall formats repeatedly in the 1970s, for portraits and other figure subjects, presumably deriving them from Chinese painting. Here the 3:1 canvas is also exceptionally large, and the composition leaves the two poets separate as well as different,

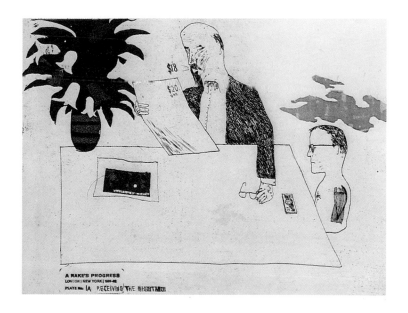

8. *Receiving the Inheritance*, from
A Rake's Progress
David Hockney, 1961–3
Etching and aquatint
381 × 813mm (15¼ × 32½")
Tate Gallery, London

both at much the same distance from the viewer in spite of the table that seems to locate Creeley in the background. The prominent use of charcoal, and oil paints mainly as tints (apart from the two patches of solid black that establish the shallow pictorial space, front and back) enhances the painting's Oriental character. All this, together with the homage it pays to two great modern poets, shows how far Kitaj had travelled from his association with Pop Art.

Richard Hamilton's *Swingeing London 67* (p.199) took its image from a newsprint photograph and marks his response to an event that touched him closely. On 12 February 1967, his friend the art dealer Robert Fraser and Mick Jagger were arrested at the house of one of the other Rolling Stones and charged with being in possession of prohibited drugs. Subsequently they were sentenced to imprisonment. The press took a keen and prurient interest in the event. Hamilton made a collage and then a print of cuttings supposedly reporting the story yet full of misinformation. He also worked with one particular press photograph, showing the two men handcuffed together and seen through the window of a police van. *Time* magazine had in 1966 featured 'London: the Swinging City', where recent developments in *mores* and the growth and social effect of the new pop music had led to an unprecedented permissiveness. The judge presiding over the Fraser–Jagger hearing spoke of a 'swingeing sentence'. Hamilton made several studies and complete versions of the image, in various media and combinations of media; each of the developed paintings was overprinted with black ink from a silkscreen. A deep sense of injustice initiated the sequence: Hamilton was appalled at the contrast between the media's delighted response to the vivacity of contemporary life and their hunger for scandal and sudden air of moral rectitude, as also between the broad social sharing of this vivacity and the laws designed to control private behaviour. The image itself fascinated him, most obviously the protective action of the two hands and the glinting of the handcuffs. Variations of colour, and of symbolic elements such as what can be seen through the windows in the far side of the van, kept Hamilton reworking it. Each of the paintings is unique; the one shown here is the only one in which the window of the van, through which the photograph was taken, is realized three-dimensionally, complete with glass. In some respects a precursor of the Pop art movement, Hamilton has remained a keen analyst of style and context on both the visual and the communicative planes. It is partly thanks to his example that Pop art, for all its apparent jollity, at times commented on social and political themes. (Hamilton was at this time also exploring thoughts of visual and social reversal in his painting *I'm Dreaming of a White Christmas* (1967–8; Ludwig Collection, Kunstmuseum, Basel), in which a cultural icon, Bing Crosby, becomes a prosperous black man, and the title of a smash hit, launched in 1954, becomes an ironic comment.) [12]

American Pop artists, unlike the British, rapidly found themselves prominent factors in the consumer society their art chose as its source and subject. Andy Warhol was the most expert contributor to that situation

and an outstanding manipulator of it. The superficiality he claimed for himself should not stop us taking the surface of his pictures seriously and recognizing his generous artistic purpose. Technically he worked within clear limits; thematically he ranged more widely than is sometimes allowed – from, dare one say, the life-enhancing properties of greenbacks and soup cans, not to mention flowers and cows, to the violent terminating of life in car crashes, the electric chair and other disasters. He chose images and rubbed our noses in them, the ones we want to see and the ones we don't: the most wanted woman, Marilyn Monroe, and the *Thirteen Most Wanted Men* (1964; New York World's Fair), taken from police mugshots. Repetition, *pace* Walter Benjamin, spreads an image's aura, as churches and temples know.[13] Warhol turned stars into saints. As also in the case of mass-produced 'holy pictures', we may wonder how close we get to the individual. Warhol's Marilyn Monroe portraits, the most plentiful, give us her public image, the cosmetic façade, with all the variations he can play on it. With Elvis Presley we seem to be on surer ground: Warhol, 'The King' himself and their many fans agreed on the pop star's status. Nevertheless, confronting Warhol's over-life-size renditions of Presley – single, double, triple and quadruple, with colour or with the projection-screen gleam of aluminium paint – we wonder why the artist picked on Elvis's least likely persona, the resolute gunfighter that audiences saw in the 1960 film *Flaming Star* (p.189). The singer, as actor, playing a glamorous but standard part, associates himself with other celluloid heroes such as Henry Fonda and Gary Cooper – saints again, not film-star villains. Warhol's Presley image is, exceptionally, the whole figure and too large for the picture surface, but we don't mind. With his *Mao* we are less comfortable, less transported. Size again: we see Mao's bust on surfaces the same height as the Elvises or, in the case of four large canvases, almost two and a half times that height – vast heads have always been made to intimidate us. Mao was still in power when Warhol took him on. We note the liberties he took in processing the sitter, and are reassured. Their example comments obliquely on what the right-wing Futurist Dottori and the left-wing realist Guttuso did with their promotional heads of Mussolini and of Togliatti, not taking liberties but adding symbolic stagecraft to enhance a head's presence (pp.123, 192).

'Political or moral motivation is hard to handle for an artist,' Hamilton wrote, having obviously given the matter his characteristically serious attention in thought and deed.[14] Portraits are almost inevitably implicated in such motivation, by the artist's choice or compliance and by the rhetoric employed. The emergence of Conceptual art in the late 1960s – in which the motif is a thought rather than a visual object, and the work of art surrenders its traditional availability as a material object in favour of a host of alternative means of delivery – gave ideas a role that art since Impressionism had often seemed to deny and that the public had largely ceased to look for. Portraits are not generally associated with ideas, though of course they can be rich in them – from those borne by the subject alone to settings, stage

props and symbolic elements, and of course what the manner of representation implies. Hindsight suggests that modern painting and sculpture can carry ideas and centre our attention on them in a way that Old Master painting cannot, though the latter is charged with literary material and thus with the ideas that are its messages. Neo-Expressionist painting is often polemical in a way that Expressionism was not, and includes portraits, symbolic portraits and what I will call 'latent' portraits.

It is useful to think of Francis Bacon in these terms. He is an expressionist in the sense that, without being part of any movement or succession, he developed his own declamatory idiom in which his urge to find a paint equivalent for the emotional and visual qualities of memory confronts his super-subtle sense of décor. His skidded and blotched faces and figures haunt our minds all the more for the immaculate, sometimes also blatantly bespattered, interiors in which we find them. Working from photographs freed him from the constrictions on behaviour, and the embarrassment, that the presence of a sitter, even a close friend, might impose. He needed the opportunities of privacy. Whether we recognize his subjects is immaterial; likeness of the public sort is not on offer. Bacon's emphasis was not on 'being able to set a trap with which one would be able to catch the fact at its most living point. . . . suddenly there comes something which your instinct seizes on as being for a moment the thing which you could begin to develop. . . . as an artist you have to, in a sense, set a trap by which you hope to trap this living fact alive.'[15] He implied that, for him as perhaps for Breton, convulsion was the beautiful moment, to be caught like an animal, like a human.

In 1969 Georg Baselitz began his upside-down pictures. Before then he had been painting emblematic images, essentially Romantic in their lineage, of heroic rustic men, types rather than individuals. In 1962 Bacon had inverted Cimabue's crucified Christ in the right-hand panel of his *Three Studies for a Crucifixion* (Tate Gallery, London). Russian literary theorists were evolving their principle of 'making strange' (Bertolt Brecht's *Verfremdungseffekt*) when Breton was constructing his Surrealist programme; in both cases, the aim included recapturing the public's attention, bemused as it had become from the assault of words and images in profusion. How, in the post-war and post-Dada 1920s, might the arts again claim importance? How, in the post-war, Cold War, 1960s, after Abstract Expressionism and with a renewed appetite for recognizable figuration, could art assert itself again not just as a leisure pursuit, but as a necessity? In 1961 Baselitz had shown with Eugen Schönebeck in Berlin, in an exhibition they named 'Pandemonium'. Their manifesto included words like these, attributed to Baselitz: 'The many killings which I endure [within myself] every day and the ignominy of having to defend my immoderate productions lead to an illness of the ageing of experience.'[16] He had been painting trees and men; his first upside-down paintings were of trees but, almost at once, during 1969–71, he painted a series of portrait busts. The act of painting them upside down calls for a different sort of attention from the painter and from us.[17] It is striking that his handling of

paint is more painstaking than before, when it was more instinctive: painting without regard to the right way up takes practice. Soon after, he reverted to his looser touch, even inviting difficulty and strangeness by painting only with his fingers. For the moment, working from photographs, he wanted to be sure of giving his subjects portrait-like presence, and that meant a degree of naturalism not unlike that conveyed by Corinth decades earlier. His subjects were his wife, his dealer, painters (p.217). Pictures get hung. The portrayals hang. Hung the other way up, they look *less* real because the appearance of the paint does not confirm gravity. Seen the way Baselitz painted them, they force us to scan each image with care, even with tenderness: they, and the painter too, are at their most vulnerable. Again we sense an underlying affinity with Bacon's figures, especially when these are portraits. But is not their individuality or their value that is in question. It is art at large and painting in particular that has to be distanced, because painting has become too familiar, too everyday and everywhere, and the human image with it.

One of the subjects in the series of portraits by Baselitz is the painter Penck: its title states his real name 'Ralf W.' (i.e. Winkler), as well as the pseudonym A. R. Penck which he has used more or less continuously since 1968.[18] Penck's first solo exhibition, in 1968, was of paintings of stick figures enacting complex events or situations suggested by contemporary life. He was adopting the drawing modes of children and bushmen, yet his appeal was to a modern mentality. Such communications would be as primitive, as primordial, as, say, dribbled abstract swirls of paint but, being simply figurative, would address a wide public. This simplicity remained one of his idioms, but Penck went on to raid other artistic treasure chests, excluding only that of academic and Socialist Realist representation and of the rather elegant Neo-Expressionism of his friends, including Baselitz. With his imagery he has also varied his material means, and that process continues. What remains constant is his questioning of art as a system, even while he makes it carry insistent implications of meaning. This applies to his self-portraits. These were dourly realistic at first, but soon became masks or façades of paint which obscure his presence. *Me in Hamburg* (p.244) was quickly followed by *Me in New York*, a very different image but the same size and also frontal. They leave us asking whether any one mode of self-representation is more valuable than any other, whether visual accuracy has to be the criterion for assessing them, and even whether self-representation must not, of its nature, always go beyond reportage. Given time, we start asking similar questions in front of Rembrandts.

In the art of recent decades we often meet what I shall call the 'latent' portrait. There have been many pointers towards it in art and in literature. The 'identity crisis' invited it and may help us accept it. For painters it represents an attitude both to the business of capturing a likeness and to the search for essential truths. King Duncan says, 'There's no art / To tell the mind's construction in the face'; in his next sentence he greets Macbeth,

hero of the hour but soon to be his murderer. Most of us believe we can read faces well enough. When, in front of portraits whose sitters are otherwise unknown to us, we speak of psychological insights, we are guessing out of our experience of life and of art. The world we live in asks us to carry certified photographs to prove our identities, but painters know that the multidimensionality of truth cannot be pocketed. They know that a likeness is a compromise or, at best, a foreclosure. Some of them are marvellously talented for producing these *pro tem* solutions, others see another sort of truth in refusing it. They let the process of examination be the work, and decline acts of appropriation. For them, portrayal is betrayal – of art, of the sitter, of the artist's conception of his role.

In painting his self-portraits Penck starts from a visage that he knows and doesn't know, in the way we all know and do not know our own faces – only he knows his better, being a painter and having laboured over his likeness in the past. He also knows that a painting is a construction of successive marks that can be of many kinds and may refer to many things other than the act of portrayal. Each self-portrait is such a construction, more than it is a likeness approached or exceeded; it is akin to the illiterate's 'mark' because that at least bears no falsehood. Stephen Finer paints portraits in which the brush-strokes speak of time and light as well as of presence; what they do not do is delineate a foreseeable likeness (p.258). For such a painter, the issue is partly that of working as though the formulas invoked by the word 'portraiture' did not exist. John Beard, a British painter now working in Australia, has painted large self-portraits he calls *Head*, leaving the image very indistinct. He says they are metaphors; they suggest metaphors for particular kinds of seeing and knowing, musical perhaps but known to us also in literature. There is no law whereby a picture, even one we call a portrait, has to be descriptive. His *Wanganui Heads* (p.265), all the same size, can be shown clustered together, as here, or separately, but with them comes a video showing the nine sitters not only 'from the life' but as though living. Evidently our notion of a representation being 'lifelike' is itself conditional and educated, rather than absolute. What if the sitters were there in person? Of course they would have to be life-like since they could not fail to be themselves, yet a perhaps superstitious fear arises that they might not live up to their larger-than-life painted images.

Thinking of portraits in any visual art form and medium, we think at once of a naturalistic account of a person as seen. We know people's appearance is not fixed, but hope that a portrait will provide a satisfactory likeness that can stand for its subject. What precisely this likeness has to supply is not clear. In surveying the range of portraits the twentieth century offered, this exhibition also shows us the variety of information and effects available from the start and augmented over time. 'Naturalism' continues to be one of these, and remains the standard: the portrait 'done from life'. But

there is many another 'ism'. I should like briefly to discuss some of these.

Naturalism is a broad category and calls for distinctions within it. What we might call straight naturalism tends to look photographic and often derives from photographs. In the 1960s and 1970s a movement called both Superrealism and Photorealism achieved notice with a naturalism so detailed as to connect with the *trompe l'œil* tradition of (usually) still-life painting. Franz Gertsch's painting, *Marina making up Luciano* (p.215), is a strong example: in reproduction it looks like the photograph that was its source; in reality it has qualities of painting as well as the fact of sheer size to give it its particular character. The close-up view and the intimacy of the action shown involve us as does a still from a film, but here it is frozen in deliberately worked paint, a value-adding process. Chuck Close still makes monumental portraits from photographs. His process of transcription has changed but the creating of a supposedly unmediated image by means of paint and extraordinary enlargement has remained much the same. It makes the intimate super-heroic. In this respect it is close to Warhol, but Warhol distances himself and us from his portraits by means of patent manipulation, both by his multiplying of images and by his cosmetic use of paint over printed faces. He insists on giving us a media image: he finds it there and he returns it there. His subjects are almost exclusively those who wholly or largely live for or through the media. 'Everything is sort of artificial,' he has said. 'I don't know where the artificial stops and the real starts.'[19] Close mediates differently. He normally takes his own photographs, squares up the selected print and works from it patiently, semi-mechanically. Whereas he used to find the exact tone for each part of a black-and-white image using acrylic, as with *Bob* (p.200), he now paints in oils, using each square for a little adventure in freehand abstract design, not unlike some of the details in Kandinsky's first abstract paintings. Scale is again all-important. Where Warhol's decisions come out of his roots in media images, often encountered on a large screen or hoarding, Close's relate to painting, not least the large-scale canvases of De Kooning and Pollock. Like Alex Katz, he wanted to take what then looked like a very modest programme of picture-making, insistently realistic portraits of people close to him, on to the demandingly public stage occupied by Abstract Expressionism and challenged by figurative painters such as Katz. The familiar is, once again, made strange. The sheer size of Close's paintings forces us into their grain. We leave the world we thought we were in – of pictorial imitation – for the mysterious one of purposeful but abstract, almost primordial, mark-making.

We enter the familiar world of portraits with the first item in this exhibition, one of several versions produced of an admired picture of the widowed queen and empress, Victoria (p.50). People enjoyed the informality of this image at the time; today we hardly notice it, living as we do in an era of royals on bicycles and buses. A long history of solitary figures in painting links it to Renaissance hermits and repentant Magdalens. Byam Shaw's

portrait of his sister mourning a near one's death in the Boer War (p.53) is a very modern thing, conveying the reality of a moment and a setting we can readily engage with and a young woman who invites our empathy. Yet the richness of his naturalistic detail reminds us of Byam Shaw's status as a second-generation Pre-Raphaelite. His secular narrative suggests the contemporary novel. The detail of Philip Harris's double portrait of himself and his partner (p.254) competes with that of *trompe l'œil* still-life painting and suggests kinship with Photorealism and Gertsch. But Harris's painting is rigorously structured, with the two bodies placed very exactly in their permitted areas and on a carpet of natural and man-made material organized along strict geometrial lines, mostly at forty-five degrees to the coordinates of the canvas. Thus a picture in which facts seem dominant to a perhaps discomforting degree takes on a hierarchical, other-worldly, character.

Already the span covered by 'naturalism' seems too broad to be of serious use, but it also has to accommodate the celebrations of the elegant life presented by the Sargent, the Furse and the Boldini. They are brilliant and slight – 'hand-made pieces of craftsmanship,' as David Piper wrote of Sargent's portraits, 'often wonderfully skilful, and satisfying to the immemorial human delight in sleight-of-hand'[20] – the Boldini almost outrageously so, a confection of brushstrokes that assumes our taste for such things. Truth really does not seem to be the issue (p.63). The Furse too is all charm and *élan*, studio work with a brushed-in background (p.56). One wonders at his achievement of the wind-blown pose of the woman and the straining greyhounds: portraits are rarely of moving sitters. The Sargent is exceptionally severe (p.59). It is a retirement portrait of the Governor of Malaya, imperial and imperious, relieved only by the Malayan brocades displayed on the left. To disdain such art on principle is to forbid ourselves the pleasure of super-deft brushwork, and of the artist's self-advertising performance that flatters both the sitter and our palates as it reaches back to Frans Hals and to Venetian painting. Corinth's portrait of the zoo-man Carl Hagenbeck (p.75), lively and firmly contemporary in its presentation, at the same time hints back at Old Master accounts of gentlemen with their horses, even emperors with their dogs, yet we know we are in a world that can cope with impressionistic images and enjoys vigorous, not elegant, brushwork. Of course, Corinth knew something of Munch's paintings, which ask to be seen as proto-Expressionist and certainly resonate differently; he was also close to the German tradition of contemporary subjects presented naturalistically, sometimes with emphatic realism, strengthened by impulses from Courbet and Manet. Bernhard Pankok's differently naturalistic account of Graf Zeppelin (p.78) uses more graphic means though the picture is large, and indeed Pankok was well known as a graphic designer and had worked proficiently as a Jugendstil illustrator. Again, we are offered primarily a lively silhouette of the 76-year-old inventor, but Pankok also had fun with the hardware setting in which we find him. Art Nouveau influences are surely at work in both.

Brodsky's monumental picture of Lenin (p.102) combines naturalism

with a compositional device taken from Art Nouveau: the hero isolated in the foreground, somewhat over life-size, while the crowd, St Basil and the Kremlin are gathered into a decorative border occupying the top third of the picture. Because of this, and in spite of the recession implied in the cobble-stones, the image remains essentially flat, like an icon, and reminds us how much the new Soviet state adopted from Russian Orthodox practices in order to gain a pious population's heart. Other artists, then and since, have adopted religious formulae in order to move spectators. Artists know their inheritance even when they are turning their backs on it, and avant-garde art, especially in Russia, signalled seriousness when it used religious prototypes.

There can be no clear answer to the question at what point selection or stylization takes an image beyond the bounds of naturalism. The precision of Meredith Frampton's painting of Sir Ernest Gowers and his two colleagues in the wartime Civil Defence Control Room give it a hyper-realistic character that brings it close to Surrealism (p.145). Its insistent factual picturing of everything – the cup, the milk bottle, the hanging telephone flex – and the compression of everything, space as well as matter, together with those resolute, dependable British faces, give the firmly traditional painting its peculiar modernity. It has nothing to do with the swagger portraits of Furse and Boldini, though status is certainly implied: every inch is valuable. Wartime feel-good films were like this. (Sir Ernest Gowers, who had a first in classics from Cambridge, was also the author of two books on decent English. *Plain Words* was the first, in 1948; they are in print today as one volume, *The Complete Plain Words*. He and Frampton must have seen eye-to-eye on many points.) Coldstream, too, was intent on intense naturalism but, whereas Frampton saw everything in terms of an efficiently finalised whole, Coldstream focused on the process of seeing and notating, dispassionately but never mechanically (p.147). This involved him in repeated visual measuring and mapping, yet it is clear that we are in a post-Cézanne world of sensations rather than of facts. The process is tentative: the eye seems to touch, the brush touches gently to hold the moment yet allow for reconsideration; our eyes scan and we discover poetry in the transient quality of the image. Everything is temporary and living. Everything but the sitter is excluded. We do not doubt the mediating presence of an artist. His activity and indeed his hesitations are felt in every inch of the picture, yet his personality intrudes so little that we easily identify with him and his task.

With Stanley Spencer we are also in the realm of exact naturalism, but his urgency is possessive. The same emotional drive that made him paint and talk and often write empowered his urge to own the world he engaged with. In this world the spiritual mingles with the earthly and the bodily. Spencer painted many portraits, including commissioned ones, and self-portraits. He painted his niece Daphne four times during 1951–3 (p.162), always from close to. There is little space between the stripes on her skirt and the coloured bars of the curtain; there is little space between her and him. The

sitter becomes the artist's prisoner, subjected to a slow, intense gaze which, fascinated by all surfaces, goes beneath her skin where it can. A similar intensity is sensed in Lucian Freud's paintings of male and female bodies. Their scale lifts some of them on to a heroic plane but without diminishing the sense of personal scrutiny and of domination. Freud painted Leigh Bowery repeatedly, in a variety of poses. In *Leigh Bowery (Seated)* (p.249) he enlarged the canvas as he worked, thus presenting the whole man from head to toe but also removing him a little way from us. The setting is strangely empty, recalling the staging Freud's friend Bacon prepared for many of his figures.

The religious note sounded by some of these naturalistic paintings can become dominant when a religious formula is directly appropriated. Cuno Amiet was Swiss-German. He studied art in Munich and Paris and spent some time in the post-Gauguin world of Pont-Aven. He may have caught his Symbolism there; it would have been reinforced by his contact with Ferdinand Hodler, and his work was shown in Paris Symbolist exhibitons alongside Hodler's. *Hope* (p.55) is a true triptych of the domestic and travelling sort: its wings are hinged to close over the main panel. It pictures the painter's wife as a *quattrocento* Madonna and, framed separately above her head, their child. This is shown full of life, yet represents a baby that was stillborn. The mother seems rapt in some kind of vision, her hands perhaps praying, perhaps reaching out. Decayed bodies occupy the wings, he on the left with a scythe, she on the right pulling petals one by one from an ox-eye daisy. The outer sides of the wings are neatly patterned with trellised roses: fat rosebuds springing from horizontal stems, firm as bars, with clearly silhouetted thorns. The theme of life and death is partnered by suggestions of spiritual realms, with naturalistic descriptions given symbolical roles. Stylistically, Amiet is here closer to Hans Holbein the Younger than to modernism or to the sub-Impressionist naturalism that was spreading around Europe at that time. Sonia Boyce similarly combines naturalism with symbolism in order to make a point (p.238). Hers is a much larger picture, a tall format to accommodate the double presentation of her self-portrait and, on a smaller scale as a frieze across the top, her family. The figures are broadly naturalistic but the composition is visionary. She seems to be 'holding them up' but the title tells us otherwise, and we are left with ambivalent thoughts about family ties and feelings as well as about a black woman's place in British society. She uses domestic life as a parable for life at large. The figures are naturalistic and echo photographs, but pattern ties the composition together and gives it an Elizabethan flatness, while stereotyped roses reign over Boyce's dress, denying it volume.

Hans Haacke's bitter portrait of Margaret Thatcher as prime minister echoes state portraiture as well as altarpieces (p.233). Naturalistic in manner, it speaks to us through its symbolism, from the Queen's image on the chairback and the cracked plates picturing Charles and Maurice Saatchi on the bookshelves to the small version of Harry Bates's *Pandora* on the table.

This sculpture of 1890 is of a nude contemplating a casket ornamented with Pandora ('the all-giving' who, like Eve, brings misery to mankind) and other mythical figures. The message of Michael J. Browne's *The Art of the Game* (p.263) is more ambiguous and certainly less hostile. The idiom here is borrowed stylized naturalism: the foreground group is adopted from a painting of Christ's Resurrection (*c*.1472; Pinacoteca, Borgo Sansepolaro) by that greatly admired star of the early Renaissance, Piero della Francesca; the procession passing just behind him is taken from the work of another great Italian of the period, Mantegna, and is part of his *Triumph of Caesar* (*c*.1486; Hampton Court). Both painters were potent innovators who kept one eye on the past, on Byzantine art in the case of Piero, on Roman antiquity in the case of Mantegna. Eric Cantona, the football and now also film star, is French. Mantegna pictured the 'Gallic triumphs' of Caesar, those achieved in France. Cantona rises like a new god from the tomb, with the manager of Manchester United, Sir Alex Ferguson, sitting in for Caesar. A large and elaborate painting, a rich example of Postmodernist appropriation of esteemed models from the past, it is also a parody, but it is surely not the painters who are being mocked. Ben Shahn's posthumous portrait of Dag Hammerskjöld (p.185), commissioned shortly before the United Nations' secretary-general was killed in an air crash, speaks of admiration of and empathy with this hard-working politician's enormous task. Shahn was primarily a graphic artist and a photographer. A childhood immigrant from Lithuania, he was always alert to hardship and injustice. Hammerskjöld's pose may owe something to a photograph, and is easily read, but the picture as a whole is an emblem. The secretary-general, whose resignation had recently been demanded by the Russians, is thinking of a speech while all sorts of warring demons swirl about above his head. There is a hint of fortitude, enhanced perhaps by the lines of the bridge outside his window; there is nothing authoritative about his image.

Expressionism remains a vague term. Unmitigated naturalism satisfies few artists for long and even the spirited naturalism of the Impressionists, which placed new values on light, colour and brushwork itself, produced a reaction for which Expressionism seemed an apt name. Today we use it to imply a stress on personal imperatives, revealed in distortion (i.e. departure from conventional norms) and in presentational modes that seem driven by the artist's emotion. As a movement, or cluster of movements, Expressionism is associated with north European art and with Edvard Munch as a progenitor. His *Self-Portrait* (p.65) is by no means his most emotional painting of those years, yet it has compressed into it signals of perplexity and pain that his upright, formally dressed image cannot hide. It contrasts keenly with such affecting but more impersonal portraits as Bernd Heinrich's *Thomas Keneally* (p.241) and Maggie Hambling's *Charlie Abrew* (p.213). In both, the mode of representation is inconspicuous and we seem directly confronted by the sitter, isolated in a mute setting. This applies also to two self-portraits by Gwen John, painted on the eve of the last century when she was in her

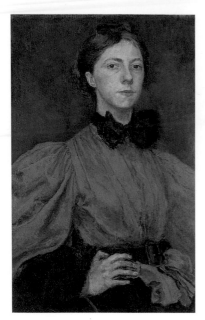

9. *Gwendolen Mary (Gwen) John*
Gwen John, *c.*1900
Oil on canvas
610 × 378mm (24 × 14⅞")
National Portrait Gallery, London

early twenties. We know today that she was both a remarkable artist and a passionate lover; she considered herself 'a waif' isolated by extreme timidity. In fact, the National Portrait Gallery's picture presents a confident social persona (fig.9). This is partly a matter of pose and dress – the confident look, the prominent hand, the brusquely painted blouse and black bow – and partly the way we are made to look up at her. Was her mirror tilted a little away from her? We cannot but admire her. In the other picture (Tate Gallery), we have a half figure, frontal, no hands. If fig.9 has some Baroque swagger about it, this one is iconic, an almost symmetrical image gently adjusted to admit some life and individuality. A private image, perhaps, of a young woman gazing at herself and reporting with approval on the beauty of her eyes and mouth. Both pictures are at once naturalistic and expressive, but the more modest-seeming of them is the one that haunts the memory.

Michel Larionov's portrait of his artist-friend Vladimir Burliuk could well be classed with Expressionism because of its primitivism and assertive style (fig.10). But this assertiveness is not, essentially, personal. It represents a headstrong position in art, taken by Larionov when abandoning a broadly Impressionist method in favour of what he called Neo-Primitivism. This looked to Russian folk art for its methods, but also to the brutal primitivism Picasso explored between his *Demoiselles d'Avignon* (1907; The Museum of Modern Art, New York) and his adoption of Braque's Cubism.[21] Larionov's forms and brushwork are intended to outrage polite taste, but they do not spring from perplexities and dread so much as from his desire to lead Russian art away from its bourgeois conventions.

It is not easy to determine to what extent Expressionism is wrung from artists by their personalities and situation or is, to an important degree, a choice of idiom made to accentuate one's distance from the dominant artistic product of the day. Perhaps it is essentially a personal matter. I feel it was ineluctable in the case of Munch, whose work long centred on themes of sexual jealousy, sickness and death before he suffered a major breakdown in 1908. In the case of Kokoschka, his temperament and consciously chosen role in Viennese culture, as well as the encouragement he received from progressive individuals there such as the architect Adolf Loos, may together have resulted in his much admired portraits of 1909–11. His concentration on faces and hands, and his formulation of these by means of brushwork and disconcerting touches of colour, deliver 'their smouldering psychological charge'.[22] There are hints of Vincent van Gogh in them, and a more general debt to Rembrandt. Their 'psychological charge', though of variable intensity, seems to me so reliable as to suggest either a stylistic choice or an externalizing of the painter's own emotional drama, possibly both at once (see *William Wauer*, 1910; p.72). Just as Bernini's marble bust of Charles I, made from Van Dyck's triple portrait without seeing the sitter, seemed, according to David Piper, 'to project a typically Bernini robustnesss, almost swash-buckling, on to Charles',[23] so Kokoschka fathered his own neuroses on the intellectuals who were his sitters in those years.

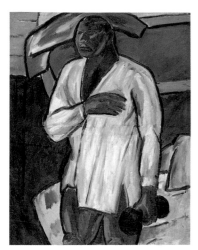

10. *Portrait of Vladimir Burliuk*
Michel Larionov, c.1907
Oil on canvas
1330 × 1040mm (52¼ × 41″)
Musée des Beaux Arts de Lyon

Artists know very well that they are exercising rhetoric. To say this is not to question their authenticity but to assert their awareness of the complex tradition in which they operate. Lucian Freud at the age of 20 was working in more than one idiom, painting *The Refugees* in a semi-naïve manner that stemmed from his teacher Cedric Morris and partly from Alfred Wallis, the Cornish primitive, and then *Evacuee Boy* (p.143). This may owe something to the paintings of Otto Dix during and after the First World War, but it is not certain how Freud could have known of these. He may have felt a particular sympathy with this boy, having himself been a child refugee from Germany. The boy's perplexity is written into his face and body by a brush that seems to have forgotten how to paint flesh and is in no hurry to reinvent the art. By the time he painted John Minton, at Minton's invitation, he had begun his investigation into the epidermis as a witness to mortality (p.165). Minton had asked to be painted from close to, and Freud brought out the elements in his friend's character and appearance that suggest the sitter's self-doubt as an artist and his forebodings as a man, ignoring the boyish vivacity most of his circle saw in him.

As long as Expressionism is taken to imply compelling emotions in the artist and the intention to draw an emotional response from the viewer, painters of enhanced naturalism such as Freud cannot be associated with it. This applies also to the work of Frank Auerbach. He paints slowly, in silence and out of long concentration. His portraits are of friends (p.223). They strain the term 'portrait' in that they are rarely recognisable, yet they confirm it by depending on the live presence, even close knowledge of, the chosen sitter. Paint is his material, and he could be said to construct paint surfaces, sometimes in relief, which incorporate that presence through his apprehension of it in a particular place and at a particular distance. These are portraits 'from the life' but realized through the artist's life. His master was Bomberg, who taught painting as a finding of strong and economical marks in which to fuse the motif with one's appreciation of it. Auerbach's own practice has refined the process further. 'It is a question of rendering the object raw and newly perceived,' as he said to one of his sitters, Catherine Lampert, referring not to himself but to Cézanne.[24] It implies, of course, that we must join the artist in a perceptual process new to us and meanwhile give him our trust. Thus Auerbach's portraits may belong to the category I have called 'latent', though his way of using paint suggests Expressionism just as Finer's suggests Impressionism and Penck's suggests, indeed is, Primitivism.

'Stylization' is a word that could be applied to most of the pictures in this exhibition, though some demand it more than others. Some artists patently present their subjects through a style: Boldini's sitters are almost all style and little else; R. B. Kitaj employs styles discreetly; Michael J. Browne, for the portrait of Cantona, openly appropriates styles and even their subjects from two painters and imposes the modern faces. We tend not to allow for the degree to which what we call 'naturalism' and 'realism' depend on style, on agreed codes which we know how to read and identify as standing for the

actual thing. (Are we still capable of knowing 'the actual thing' directly?) Photography, too, depends on codes. The codes that are given by the technology are impersonal, but photographers of quality develop an 'eye' that one learns to recognize. Hamilton, for *Swingeing London 67* (p.199), worked from a found photograph and incorporated it in the final image. Bacon departed from a photograph in his *Three Studies of Isabel Rawsthorne* (p.197). Chuck Close and Franz Gertsch work from specially taken photographs and stay close to them in producing their paintings, though departing from them in some respects, most obviously size (pp.200, 215). Cindy Sherman has made her name with photographs and photo-based paintings that record herself in a wide range of what used to be called tableaux, silent enactments. She finds her scripts, so to speak, in the media, often in film stills or magazine images; for one series she 'performed' Old Master paintings. This means preparations of many sorts: she is her own actor and designer as well as director. She chooses her prototypes for the meaning she finds in them, which may not be those consciously intended by the originator. She leaves them untitled in order not to short-circuit our reading. We do not read them as portraits, but as performances. Rubens and Rembrandt enjoyed portraying themselves dressed up to be not quite their normal selves; Sherman hides herself behind the roles she chooses and what they demand of her in the way of disguise, costume, pose and props. The portrait is latent behind the performance (p.230).

Sutherland's portrait of Somerset Maugham (p.156) persuades us of its unmitigated truthfulness, enhanced by the artist's verve, but in fact it is a major piece of artifice. It was the painter's first portrait. He chose an exceptionally tall format to present the over-life-size image, and kept the pictorial space quite shallow, locating his sitter close to the front, against a bright yellow-to-orange ground that presses forward. His graphic style supported this. We are struck at once by the total silhouette, and then by the man's character as delivered by his pose and by his face. Maugham was taken aback by the result. 'I was really stunned,' he said. 'Could this face be really mine? And then I began to realize that here was far more of me than I ever saw myself.' He came to speak of the portrait as 'magnificent', adding, 'There is no doubt that Graham has painted me with an expression I some times have, even without being aware of it.' Sutherland worked from sketches and synthetised the image away from the sitter; he introduced the stool from somewhere else in preference to a chair that might have asserted space and implied relaxation instead of the perched look conveyed in the picture. There is little sense of a body; light and shadows, deployed this way and that, do not make for solidity. The stool and the hints of palm fronds at the top, as well as the format, give the image an Oriental flavour, which fits a novelist with a taste for exotic settings well enough.[25]

This portrait is obviously stylized, and blatant rather than latent. It is so insistent a characterization of one man by another that one wonders where the line between portraiture and caricature should be drawn. Is Guston's

head in fig.7 (p.26) a caricature? Yes. It is a self-mocking shorthand *alter ego* that he used repeatedly, a comic-strip typification that never looked much like him though one recognizes the constant cigarette. Beckmann's picturing of his family (p.95) comes close to caricature in his exaggerations, notably in the poses, but also in his 'Happy Families' combination of rather large heads with small bodies. Sutherland's *Maugham* bestrides the line. The mandarin pose and the sardonic expression may be close to the reality of the man, but are insisted on and underlined to the point of exaggeration by the concentrated, distractionless delivery. These characteristics are not those of the painter; we accept them as essential Maugham. At the same time, this is Sutherland's Maugham in much the same way as Picasso's Gertrude Stein is Picasso's Gertrude Stein. The tragic story of Sutherland's portrait of Churchill, commissioned in 1954 by a special committee of Parliamentarians to celebrate the great man's 80th birthday and to be hung in the Palace of Westminster, comes to mind. The finished picture (fig.11) was praised by many, including Lady Churchill, but much disliked by the subject and by some members of the committee. A few months later it was quietly destroyed, it is said on Lady Churchill's orders. We have the studies Sutherland made for it and photographs of the painting. It was a powerful portrait of a powerful

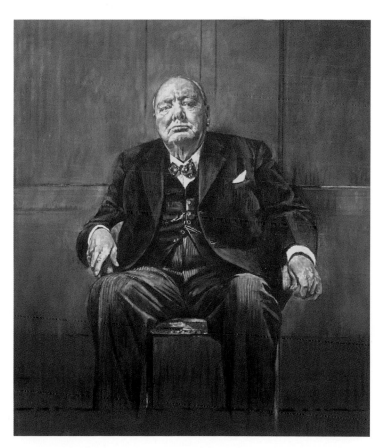

11. *Sir Winston Churchill*
Graham Sutherland, 1954
Destroyed

man, and shows him as someone still to be reckoned with, still the bulldog he considered himself to be, but definitely an old man at the age of 80. The pose is a little aggressive; the manner of painting, like that in *Somerset Maugham*, is emphatic and in light colours. It is not a suave or ingratiating image: it is a Sutherland. Presumably the committee went to Sutherland for a Sutherland. He got all the blame, from eminent individuals and from the press. No one asked whether the committee or eminent parliamentarians had made a sensible choice for this celebratory public occasion.[26]

Stylization can be a trademark. Sutherland's portraits have a family resemblance, though each speaks volumes about its subject. Modigliani's portraits are exercises in refined linear organization. His male portraits also convey character; his female portraits emphasize an elegant silhouette and faces delicately abstracted in the manner of Brancusi's perfect heads of 1912 and after. He painted Lunia Czechowska once in 1916 and six times in 1919. We would not learn much about her from seeing all seven, but they are exquisite images of a young woman of the time (p.91). Roger de La Fresnaye's portrait of his sister-in-law (p.77) uses Cubist devices in the setting and in simplifying the sitter's arms and hands, but otherwise pays naturalistic homage to her *gamine* face and her modish hat; the painter had no wish to sacrifice likeness to the new pictorial idiom. Léger constructed a number of reliefs of Charlot, as the French called Charlie Chaplin, and used one of them in the film *Ballet Mécanique* he made in 1924 with the cameraman Dudley Murphy. Chaplin's jerky image appears at the start, before the words, 'Charlot présente le Ballet Mécanique', and again at the end, when it dances about before disintegrating. Its elements could be moved for successive shots to convey the star's characteristic movements (p.101). Léger had made a sketch of Chaplin in 1920, using much the same forms. He was creating a post-Cubist idiom that took its character from machines and mechanical motion. Chaplin took ideas from *Ballet Mécanique* when he made his feature film *Modern Times* in 1936, centring on the little man's enslavement to the factory. Tamara de Lempicka, Russian-Polish but living in Paris from 1918, learned her art from the outer Cubists, directly from Lhote who ran a Cubist academy, indirectly from Léger, probably also from another Russian in Paris, the sculptor Archipenko, adopting their simplifications and hard surfaces. She also borrowed from Ingres's erotic compositions. In this way she gave a modern flavour and a lot of chic to her essentially academic vision. This combination, plus hints of her busy, well-funded bisexual lifestyle, have made her work fashionable again as part of our renewed interest in Art Deco design. For all their shallowness, perhaps because of it, some of her paintings are quite irresistible. She celebrated sexual magnetism in a showy manner that catches the eye without engaging the imagination. At her best she does not put a brushstroke wrong; indeed her brushstrokes are smoothed away like Ingres's. But the appeal of her art is that of fashion photographs. Behold her, eyeing us coolly from her smart new car (p.105). But notice also how well

she structured her self-portrait to fill and adhere to the surface of her canvas. Juan Gris would have approved of that.

Machine-like forms in an impersonal painting style are met with in several places during the 1920s, mostly associated with left-wing politics and a challenge to bourgeois culture. In post-war Cologne, under British occupation, a Dada group did its best to subvert fine-art values and to mock authority. Max Ernst was one its leading members until he went to Paris. With the collapse of the German economy, Dadaism came to seem negative, and a number of artists and designers, and the now famous photographer August Sander, formed the Group of Progressives in 1924. They had little to lose, there was no art patronage to speak of. They saw themselves as pioneers of a new art, serving a world that would reveal itself as new if only the garbage and ruins of the old could be cleared away – the self-glorification of the rich and the powerful, all signs of sentimental nationalism, all artistic vanity. With one (critical) eye on the new Russia, and another on technology as the sphere of benign collaboration, they developed idioms speaking of human decency and equality. In many ways their art was classical, as was that of French Purism and Lhote's academic Cubism, but it gave priority to contemporary real-life subjects, often working-class scenes of labour and of strikes and unemployment, as well as public attractions such as the cinema and the theatre. Occasionally, they painted portraits. Heinrich Hoerle was one of the leading figures in the group, editing its journal *a–z* during its brief life from 1929 until 1933. His frontal, mask-like self-portrait of 1931 is entitled *Worker*. In the same year he painted the only slightly more descriptive group portrait *The Contemporaries* (p.118). Here, Konrad Adenauer's head gives us a measure of how likeness survives the standardization employed by Hoerle and his colleagues, which translates their townscape setting into a geometrical pattern. This is a basic art, without grace but not without dignity.

In England a similar position was taken in the 1920s by William Roberts and held until his death in 1980. His idiom was as firmly classical as it was modern, with compositions rigorously governed by geometrical schemes and with subjects reformed to fit into them. He painted many scenes of ordinary people doing ordinary things – bathers, sportsmen, London buses and their passengers and so forth – but sometimes also mythological scenes with the same modern air. Also portraits – and the best of these combine a great deal of character with his structuring and simplifying of forms. *Maynard and Lydia Keynes* (p.121), the renowned economist and the admired dancer Lydia Lopokova, conveys character and even a sense of a particular moment in their social life: they are at home, looking at and in conversation with others not on camera. The artist's hand is gentle and his control feels totally benign. Without Expressionist interjections, without the distancing hyper-realism of Meredith Frampton, without the intrusive scrutiny of Stanley Spencer or Lucian Freud, Roberts delivers his sitters as good people as well as gifted individuals. The representation may lack humour, which

we don't like to say about anything, but then portraits are not always the right occasion for levity. William Nicholson's portrait of *Sidney and Beatrice Webb* (p.III) makes an interesting contrast. Here are another two eminent people, at home and in conversation, shivering by their fireplace as English domesticity then required. Their characterization is wholly convincing – in pose and gesture, in faces, figures and clothing. We know the dog and the chimney breast with its high shelf; we understand the litter on the floor, evidence of their busy lives. They are not chatting. Most of Nicholson's portraits flatter glamorous society figures. Here he is being a friendly and amused observer, taking pleasure in what seems to be an apparently styleless account, almost a still from an Ealing comedy.

Is Werner Tübke's *Group Picture* (p.209) styleless? It is certainly naturalistic, perhaps even realistic in its detailed portrayal of builders on site in their working gear. But the hierarchical grouping (heads all on one level), the symmetry, the posed action without expression, all say something else. It is a secular version of many an altarpiece of, say, the Madonna and flanking saints, as developed in the *quattrocento* and perfected in the High Renaissance. So organized is it that when we have finished reading it as an account of particular men we start noting their uniformity and recognize Tübke's closeness to Hoerle. Richard Lindner's *The Meeting* (p.167) is an autobiographical collection of friends and others, including a cat. Lindner was of German origin; his picture mingles past and present. The mad King Ludwig II is almost as prominent as the corseted woman, who holds centre stage and is closest to us, but (a sixteenth-century invention) lets us see only her back. There is no pretence at making the figures into a social unit as in a 'conversation piece'. Their images are collaged together in the cell-like space, without regard for volume, position or relative size. At the same time, they have something of the machine-form character of Léger, Hoerle and Roberts, and Lindner's touch is as impersonal as theirs. Reading his composition as a group brings out its Surrealist character, and underlines the classical basis of Tübke's. A very different effect – different both from Tübke's and Lindner's – is worked by John Bratby in his portrait of *Nell and Jeremy Sandford* (p.177). Bratby was the best-known member of the Kitchen Sink school, named too narrowly in 1954. Since then critics have echoed each other in speaking of its 'dour and sordid themes and [its] harsh aggressive style', and associating what they saw as a movement with the Angry Young Men of British drama.[27] Bratby's picture of the two writers is up-front in every sense and entirely celebratory. That he goes on garrulously about all sorts of detail, relishing it like Stanley Spencer but rendering it all *fortissimo*, tells us of his enthusiasm for these people and for everything around them, from the wood grain in one corner to the telephone in the other, from the cups, record player and playing cards to the magazines and books. It is one of the noisiest paintings of the century and, with its unrelenting account of the current lifestyle, could be counted a forerunner of Pop Art.

Lindner left Germany the day after Hitler took power. At about the same

time, Felix Nussbaum returned to Rome where he had been completing his studies, but anti-Semitism caused him to move to Brussels, where he was interned as an enemy alien in 1940. He painted his self-portrait (p.138) in a camp at Bordeaux. He was a New Objectivity painter and therefore denounced by the Nazis, his idiom disconcertingly sharp and realistic. He stares at himself as at a specimen of uncertain value and interest, frowning slightly. His stubble, unkempt hair and slept-in shirt are noted unemotionally, but the setting, behind him and on a much smaller scale, is the camp: barbed-wire fence, two huts, men and other detritus like glimpses from a Bosch nightmare. We believe the truth of it, and accept that this is what the man in the foreground saw and needs to report on but it is as though a glass screen divides the two realities. After a while, Nussbaum escaped from the camp and made it back to Brussels and to his lover Felka. They hid in a garret, in growing danger and fear. There he painted himself again, in 1943, again more sharply than anyone could wish for but with a pipe between his teeth, a one-eyed mask on the wall just behind him, and a bottle of something poisonous among bottles marked '*humeur*', '*nostalgie*' and '*souffrance*' on the table between him and us, next to his palette. I paint therefore I am. In June 1944, as the Allies advanced on Brussels, Felix and Felka were carried off to the death chambers of Auschwitz.

Portraits not only of, but by, the victims of ethnic cleansing must be an invention of the twentieth century. The human being lives and then dies, too often at the hands of other human beings. The artist, as the Egyptians said, 'keeps alive'. Art, portraiture especially, has always provided a kind of virtual reality. Now that a more encompassing virtual reality is to be made available by technological means, limited only by our imaginations and courage, we may well wonder what will be left for art to do. It is difficult to foresee, on the strength only of futuristic reports that raise many questions while apparently being satisfied by filmic criteria. The twentieth century proved that, amid all the hubbub, all the communication designed for short attention spans, art endures. It calls for slow, patient engagement. It stays and, though we may never experience the same picture twice, we can rely on its willingness to serve our needs. The variousness of twentieth-century portraiture answers a variousness within ourselves even as it satisfies a core and common desire to meet and know others. I look forward to driving my virtual reality kit, and hope it will empower me to enter the virtual reality of others. It is knowing others that gives life and purpose to knowing oneself.

NOTES

1. Iris Murdoch, in 'The Sublime and the Beautiful Revisited', first published in *Yale Review*, December 1959; reprinted in Iris Murdoch, *Existentialists and Mystics*, Chatto and Windus, London, 1997, p.283.
2. Andy Warhol, in Andy Warhol and Pat Hackett, *Popism: the Warhol '60s*, Harcourt Brace Jovanovich, New York, 1980, p.248.

3. Robin Gibson, introduction to *The Portrait Now*, exh. cat., National Portrait Gallery, London, 1993. His selection as organiser of the exhibition drew on portraits done since about 1980, and complemented his earlier National Portrait Gallery exhibition *20th Century Portraits*, 1978, for which he also wrote texts for the catalogue. I want to acknowledge my debt to these exhibitions and to Robin Gibson's engaging and intelligent writing about them, as well as his patient and multifarious help to me over the present essay.

4. See, for example, Joanna Woodall's reference to 'the early twentieth-century rejection of figurative imagery', in her introduction to J. Woodall, ed., *Portraiture – Facing the Subject*, Manchester University Press, Manchester 1997, p.7.

5. The case is well outlined and illustrated in Norbert Schneider, *The Art of the Portrait*, Benedikt Tachen Verlag, Cologne, 1994. But see also, among other surveys, John Walker, *Portraits: 5,000 Years*, Harry N. Abrams, New York, 1983.

6. Roger Fry's subtle account of Cézanne's work came two decades later, in 1927, and differed remarkably from the first commentaries on it made soon after the artist's death in 1906. These had centred on words such as 'naïve' and 'illogical' even when the aim was to speak well of him, just as earlier critics, for or against, had repeatedly called him 'clumsy'.

7. See Richard Cork, *A Bitter Truth: Avant-Garde Art and the Great War*, exh. cat., Barbican Art Gallery / Yale University Press, London, 1994.

8. I find it useful to distinguish between 'realism' and 'naturalism'. Both start from a high degree of truth to nature, but 'naturalism' allows for a wide range of attitudes and methods, whereas 'realism' indicates an emphatic limitation on what can be seen to exist – often urban conditions and the unglamorous world of the industrial underdog to, as the phrase goes, the harsh realities of everyday life – and is always polemical.

9. The quoted words are those of Dore Ashton, in *Yes, but . . . – a Critical Study of Philip Guston*, Viking Press, New York, 1976, p.156. Ashton associates what she aptly calls Guston's 'Ubuism' with the protests and violence occasioned in America by the Vietnam War and with his recent friendship with the writer Philip Roth, whose denounced but popular novel *Portnoy's Complaint* had been published in 1969. In 1975 Roth described 'one of my continuing problems as a writer' as that of holding on to two 'inimical realms of experience': 'the aggressive, the crude and the obscene, at one extreme, and something a good deal more subtle, and, in every sense, refined at the other.' Ashton quotes this as particularly relevant to Guston (ibid., p.159), but also points to his reconsidering the essence of the art of Piero della Francesca. Having long ago adopted Piero as a master both of formal relationships in space and of 'a certain wisdom of forms, sweet to my eye', in 1965 he began an essay on Piero, subtitled 'The Impossibility of Painting', with the words 'A certain anxiety persists in the painting of Piero della Francesca', adding: 'What we see is the wonder of what it is that is being seen. Perhaps it is the anxiety of painting itself' (quoted, ibid., p.123).

10. Quoted in the Chronology of *R. B. Kitaj: A Retrospective*, exh. cat., Tate Gallery, London, 1994, p.64.

11. See Julián Ríos, *Kitaj: Pictures and Conversations*, Hamish Hamilton, London, 1994, p.67.

12. This account derives primarily from the artist's own writings and from the commentary provided in the catalogues of two Tate Gallery retrospectives of Hamilton's work, both in the care of Richard Morphet; see Richard Hamilton, *Collected Words*, Thames and Hudson, London 1982, pp.104–5; *Richard Hamilton*, exh. cat., Tate Gallery, London, 1970, pp.75–83, and *Richard Hamilton*, exh. cat., Tate Gallery, London, 1992, pp.165–8.

13. Benjamin asserted that art loses its aura when it is reproduced, and this statement, from his essay 'The Work of Art in the Age of Reproduction', first published in 1936, is quoted as self-sufficient fact so often that it warrants questioning. Perhaps multiplication through mass reproduction creates a different kind of aura, not associated with pilgrimage to a unique instance but with worldwide possession. Benjamin went on to speculate on the positive effects of the mass production of imagery for mass society.

14. See Richard Hamilton, op. cit., p.104.

15. Francis Bacon to David Sylvester; see David Sylvester, 'Interview 2 (May 1966)', in *Interviews with Francis Bacon*, Thames and Hudson, London, 1975, pp.54–7.

16. See Franz Dahlem et al., *Georg Baselitz*, Benedikt Taschen, Cologne, 1990, p.27; I have added the words in brackets to return to his statement a meaning expressed in the original German (cited on p.11).

17. Perceptual psychology teaches that babies see things 'upside down' (as we would say) and learn to read the images inverted.

18. The name A. R. Penck was taken from that of the geologist Albrecht Penck (1858–1945). It was not unusual for German artists and writers to use *noms de plume*, or to identify themselves with their places of origin by joining place-names to their own. A well-known instance is Karl

Schmidt, who was born in Rottluff and used the name Schmidt-Rottluff. The lists of artists in group exhibitions traditionally distinguish between them by adding their places of origin to their surnames in this manner. Baselitz's proper name is Hans-Georg Kern. He was born in Deutschbaselitz, in what became East Germany. He moved to West Berlin in 1958 and used the name Georg Baselitz for the first time in the 1961 'Pandemonium' exhibition and manifesto (a second exhibition and manifesto with that name followed in 1962). The name stems from the Greek word for king and royal, which also gives us the word 'basilisk', the fabulous creature whose glance can kill.

19. Quoted by Nicholas Baume in his essay, 'About Face', in *Andy Warhol Portraits*, exh. cat., MIT Press, Cambridge, Massachusetts, 1999, p.89.

20. David Piper, *The English Face*, Thames and Hudson, London 1957, p.321.

21. It is known that during his late years Larionov tended to pre-date the early work still in his hands. 1907 may well be too early for his *Portrait of Vladimir Burliuk*. He and his associates launched Neo-Primitivism in 1909. Picasso painted his most primitivist works in 1908, and some of these were brought to Russia by collectors who made them accessible to artists. A comparison of this portrait with more certainly dated Larionovs suggests it was painted in 1910–11. See Anthony Parton, *Mikhail Larionov and the Russian Avant-Garde*, Thames and Hudson, London, 1993. Larionov visited the Burliuks in the Crimea in the summer of 1910, and painted a portrait of Vladimir during his visit as well as one of the poet Khlebnikov, but the Khlebnikov portrait looks earlier than this of Burliuk. Parton, ibid., pp.31–32, fig.29.

22. See Richard Calvocoressi, *Oskar Kokoschka 1886–1980*, exh. cat., Tate Gallery, London, 1986, p.53. Professor E. H. Gombrich in 1962 resisted the cliché by which Kokoschka's portraits were said to 'represent the sitter's soul', but conceded their exceptional poignancy. He suggested that it was 'the intensity of the artist's personal involvement which made him sweep aside the protective covering of conventional "decorum" to reveal his compassion with a lonely and tormented human being'; see his introductory essay in *Kokoschka*, exh. cat., Tate Gallery, London, 1962, pp.13–14). In 1945, towards the end of World War II, Gombrich had foreseen that 'There will be no portrait left of modern man because he has lost face and is turning back towards the jungle' (quoted by Marcia Pointon, 'Kahnweiler's Picasso; Picasso's Kahnweiler', in J. Woodall, op. cit., p.189). In his letters of 1910–12, Kokoschka complained of the number of portraits he was having to paint, and also of his nervous condition and outsider status; see Olda Kokoschka and Heinz Spielmann, eds., *Oskar Kokoschka Briefe I, 1905–1919*, Claassen, Düsseldorf, 1984, pp.15 and *passim*.

23. David Piper, op. cit., p.101.

24. See *Frank Auerbach*, exh. cat., Hayward Gallery, Arts Council, 1978, p.22. These words are also quoted by Richard Morphet in *The Hard-Won Image*, exh. cat. (exhibition organized by Richard Morphet), Tate Gallery, London, 1984, p.27. Through juxtaposition he implies a link to Lucian Freud's statement (published in *Encounter*, July 1954) that 'The subject must be kept under closest observation . . . It is this very knowledge of life which can give art independence from life, an independence that is necessary because the picture in order to move us must never merely remind us of life, but must acquire a life of its own, precisely in order to reflect life.'

25. I am indebted for this summary account and the quotations to Roger Berthoud's detailed biography of the artist, *Graham Sutherland*, Faber and Faber, London, 1982; see particularly pp.140–3.

26. Ibid., pp.183–200.

27. Descriptions of this sort were always too narrow and never fitted even Bratby, the most vehement painter in the group, but they stick, being convenient and not inviting further thought. The words quoted here are from Ian Chilvers, in *The Dictionary of 20th Century Art*, Oxford University Press, Oxford, 1998, under 'Kitchen Sink School'.

1900s

The social and material ostentation of the Edwardian era in Britain found parallels in most other Western countries. The bourgeoisie reaped the rewards of a century of unprecedented industrial and imperial expansion, in a world that, despite local wars in far-off places and the rumblings of growing nationalist movements, was at peace. Einstein, Freud, Proust, Picasso, Schoenberg and Stravinsky – many of the great geniuses who would question old certainties and help to transform and shape the new century came of age during this decade.

HISTORICAL EVENTS

1900	1901	1902	1903	1904
In South Africa, the Boer War continues (the Boers had declared war on Britain on 12 October 1899).	The Boer War rages on.	End of the Boer War on 31 May (the Boers accept British sovereignty).		
In Britain, a number of socially progressive bills are passed, including The Mines Act (prohibiting young children from working underground), a Workmen's Compensation Act and a Railway Act.	Death of Queen Victoria; succession of her son Edward VII.	In Britain, coronation of King Edward VII and Queen Alexandra at Westminster Abbey.	After years of fighting, the British gain control over Northern Nigeria.	Establishment of the *Entente Cordiale* between traditional enemies Britain and France; they move together and away from Germany.
In China, the Boxer Rising failed in its attempt to rid the country of foreign interests.	In China, the signing of the Peking Protocol commits China to paying compensation for the Rising to the European Powers.	Arthur Balfour becomes Prime Minister.	Foundation of The Women's Social and Political Union by British suffragist Emmeline Pankhurst.	War declared between Japan and Russia on 10 February.
In Italy, assassination of Umberto I.	In Ireland, mounting protest against British rule.	In Martinique, French West Indies, Mt Pelée erupts without warning, destroying the city of Saint-Pierre and killing 38,000 people. The day before, Soufrière volcano on St Vincent Island (British West Indies) had killed 1,000.	The first powered aircraft flown by Wilbur and Orville Wright at Kitty Hawk, North Carolina.	In South-West Africa, the Herrero people begin an uprising against the Germans who control their land; thousands lose their lives.
In Germany, Ferdinand Graf von Zeppelin conducts the first trial flight in his new airship.	In the US, President McKinley succeeded by Theodore Roosevelt.		Foundation by Henry Ford of the Ford Motor Co.	The SS *General Slocum* disaster on the Hudson River, with the loss of 1,030 lives.
	In Australia, Edmund Barton becomes the first Prime Minister.	Foundation of The Carnegie Institution in Washington, D.C., to study and work for international peace.	The first Tour de France cycle race.	
	Famine in India.			
	Slavery abolished in Nigeria.			

CULTURAL EVENTS

1900	1901	1902	1903	1904
Art Nouveau at its height.	Scott Joplin popularises Ragtime with *The Easy Winners*.	Composition of Edward Elgar's *Coronation Ode*.	Käthe Kollwitz begins series of revolutionary etchings, *The Peasants' War*.	Composition of Claude Debussy's *Preludes for Piano*.
Exposition Universelle in Paris.	Composition of Edward Elgar's *Land of Hope and Glory*, the first of five *Pomp and Circumstance Marches*; Sergei Rakhmaninov's *Piano Concerto No. 2*.	Publication of J. M. Barrie's *The Admirable Crichton*; Arthur Conan Doyle's *The Hound of the Baskervilles*; Rudyard Kipling's *Just So Stories*; Joseph Conrad's *The Heart of Darkness*; André Gide's *The Immoralist*.	Composition of Arnold Schoenberg's symphony *Pelléas and Mélisande*.	First performance of Giacomo Puccini's opera *Madam Butterfly*.
Publication of *The Interpretation of Dreams* by Austrian psycho-analyst Sigmund Freud.	First performance of Claude Debussy's opera *Pelléas and Mélisande*; Richard Strauss's opera *Feuersnot*.		Publication of Jack London's *The Call of the Wild*.	Publication of Gabriele D'Annunzio's *The Daughter of Jorio*.
First jazz bands originate in New Orleans.	Publication of Rudyard Kipling's *Kim*.		Edwin S. Porter directs 12-minute epic film, *The Great Train Robbery*.	First of the revived Olympic Games held in St Louis, Missouri.
First performance of Giacomo Puccini's opera *Tosca*.	First Nobel prizes awarded.		Oscar Hammerstein builds the Manhattan Opera House.	Rolls Royce motor company founded in Britain.
English cricketer W. G. Grace, a major celebrity of the Victorian era, retires after scoring 54,000 runs.				

Formation of a political party by Ireland's Sinn Fein movement, dedicated to an independent Ireland.

Defeat of Russia in the Russo-Japanese war.

Tsar Nicholas II ends autocracy in Russia.

Norway gains independence from Sweden.

Appointment of Marie Curie to the post held by her husband after he dies in a road accident; she becomes the first woman professor at the Sorbonne.

Earthquake in Valparaiso, Chile, leaves 20,000 dead; typhoon in Hong Kong kills 10,000.

Armament limitations proposed by Hague Peace Conference refused by Germany.

In South Africa, young Indian lawyer Mohandas Gandhi organises his first *satyagraha* ('holding to the truth'), a passive resistance campaign among Indians in reaction to a Boer government bill restricting Indian immigration.

Messina earthquake strikes south Calabria and eastern Sicily; the resultant massive tidal wave destroys 90 per cent of Messina's buildings and kills 150,000 people.

Introduction of contributory Old Age Pension scheme in Britain.

Women's Suffrage Movement becomes militant.

Navy Bill passed in Britain in response to growing concern over growth of the German navy.

Invention of Bakelite, the first plastic.

1905 1906 1907 1908 1909

Formation of the Expressionist *Brücke* group in Dresden, which became influential on the graphic arts in Germany.

The Fauves create a sensation in Paris at the Third Salon d'Automne, with their *Cage aux fauves* (cage of wild beasts).

First performance of Debussy's *La Mer*

Posthumous publication of Oscar Wilde's essay *De Profundis*, written while he was in prison.

Porter's film *The Great Train Robbery* is shown in cinemas to wide acclaim.

Publication of five seminal papers by Albert Einstein, including the *General Theory of Relativity*

Completion of the first of Ralph Vaughan Williams's *Norfolk Rhapsodies.*

First animated cartoon released by US company Vitagraph.

Frank Lloyd Wright completes Unity Temple in Oak Park, Illinois, the first public building to display its concrete construction.

Completion of Pablo Picasso's *Les demoiselles d'Avignon.*

First Cubist exhibition takes place in Paris.

Publication of Rainer Maria Rilke's *New Poems,*

Invention of colour photography by Auguste and Louis Lumière.

Foundation of the Boy Scout movement by Lt.-Gen. Sir Robert Baden-Powell.

Composition of Maurice Ravel's piano duet *Mother Goose Suite.*

Publication of Kenneth Grahame's *The Wind in the Willows*; E. M. Forster's *A Room with a View.*

Release of Luigi Maggi's film *The Last Days of Pompeii.*

Henry Ford introduces mass-produced Model 'T' motor-car, which goes on sale for an expensive $850.

The Italian Filippo Marinetti's *Futurist Manifesto* published on the front page of the French newspaper *Le Figaro.*

Sergei Diaghilev takes Paris by storm with the *Ballets Russes.*

Frank Lloyd Wright builds *Robie House*, Chicago.

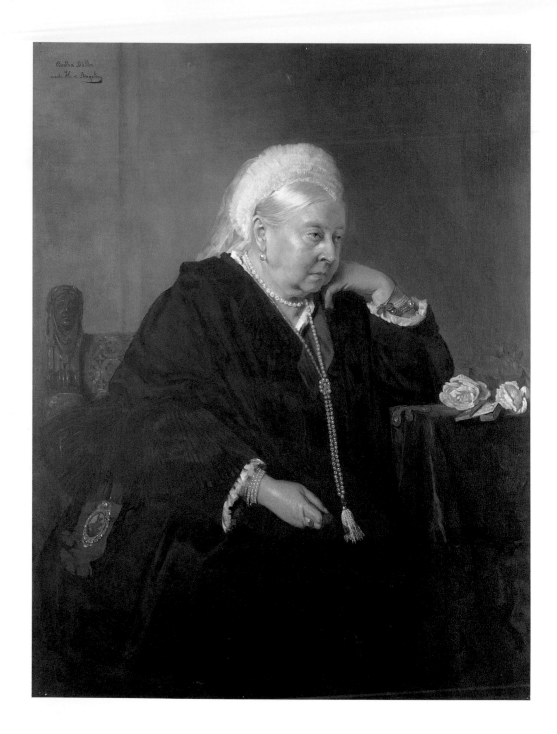

Heinrich von Angeli
Queen Victoria, 1900

HEINRICH VON ANGELI 1840–1925

Precocious painter of portraits and historical genre, born in Odenburg, Austria; produced some of his best-known historical work in Munich (1859–62), but returned to Vienna in 1872 and devoted the rest of his career to portraiture; a favourite with the European courts, he became Queen Victoria's preferred portraitist and first painted her in London in 1875.

Although this was not the last portrait painted of the 80-year-old Queen-Empress (1819–1901), it has become one of the best known. The Queen was especially fond of von Angeli, who was constantly successful at amusing her. She sat for him in May and July 1899, the sixty-third year of her reign, and was particularly impressed with the result, declaring it 'the best and likest he ever painted of me'. The original portrait (now in the Royal Collection) was sent to Vienna late that year to be copied by Berthe Müller (1848–19??); sister of a well-known Viennese painter of Egyptian and Turkish scenes, Leopold Müller, she had been a pupil of von Angeli and later worked as his assistant. In the early months of 1900, she produced replicas of the portrait for both the Royal Collection and this one for the National Portrait Gallery.

Victoria no longer took an active part in public life, but still showed a keen interest in public affairs. It was known for instance that she had been upset by the war in the Sudan (the early disasters of the Boer War in South Africa, which were to hasten her final illness, still lay ahead). During sittings with von Angeli she discussed the recent suicide of Crown Prince Rudolph of Austria. It is as a widow that von Angeli depicts her here (although Prince Albert had died nearly forty years previously), wearing black and in a contemplative pose that can be traced back to antiquity; the blue sash of the Order of the Garter is the only concession to her royal rank. She died just over a year later, nearly thirteen months into the new century.

Copy by Berthe Müller
Oil on canvas
1181 × 914mm (46½ × 36")
National Portrait Gallery, London

REFERENCES

R. Ormond, *Early Victorian Portraits*, National Portrait Gallery, London, 1973, I, p.475

O. Millar, *The Victorian Pictures in the Collection of Her Majesty The Queen*, London, 1997, I, pp.6, 7, 16

Byam Shaw
The Boer War, 1901

BYAM SHAW 1872–1919

Painter and illustrator, born in Madras; studied at St John's Wood and Royal Academy Schools and made his name with *The Blessed Damozel*, 1894–5 (Guildhall Art Gallery); a conscientious painter of state occasions, he later became overtly Pre-Raphaelite in style and increasingly mannered and obscure in subject matter; eventually he took up teaching and, together with his biographer Rex Vicat Cole, founded the Byam Shaw School of Art in 1910.

The war in South Africa broke out in October 1899. During the course of 1900, the number of British troops involved rose to almost a quarter of a million, more than six thousand of whom were to die before the defeat of the Boers in June 1902. For two and a half years British newspapers and magazines, many of whose readers had relatives fighting in South Africa, were totally given over to daily dispatches and commentaries from war correspondents; some magazines also sent out war artists to provide illustrations for their reports. At the Royal Academy in 1901 paintings of the war were a focus of popular attention, and Byam Shaw's title, for what is clearly not in any sense a formal portrait, was an obvious if sentimental attention-grabber. The sentiment was compounded by the ruse, beloved of Victorian artists, of a subtitle in the form of lines from a popular poet, here Christina Rossetti:

> *Last Summer green things were greener,*
> *Brambles fewer, the blue sky bluer.*

Like many young artists with few sitters but anxious to attract patronage, Byam Shaw was adept in producing paintings of his family members in various guises. His family, like many others, was directly touched by the war: the painting depicts his sister Mrs Reginald Warren, after she has received the news of the death in action of a favourite cousin.

The forlorn figure of the long-suffering woman receiving or waiting for news of a loved one away at sea or at war had been a familiar theme in exhibitions for about fifty years. If the sentiment is a little obvious, Shaw's virtuoso Pre-Raphaelite treatment of the somewhat claustrophobic landscape detail is a *tour de force*; it is both strangely unsettling and anachronistic, and would have seemed especially so to an audience that had just grown used to the Impressionist-influenced brushwork of Sargent and his contemporaries. An old subject treated with the hallucinogenic Pre-Raphaelite detail of fifty years earlier, it remains nevertheless a contemporary painting of a fashionably stylish young woman, in which both the composition and focus were entirely derived from current photographic practice. Despite, or perhaps because of, these disparities, it is in its own way unforgettable, and probably Byam Shaw's masterpiece.

Oil on canvas
1000 × 749mm (39¾ × 29½")
Birmingham Museums and Art Gallery

REFERENCES

P. Skipwith, 'A Pictorial Storyteller', *Connoisseur*, CXCI, 1976, pp.192–3

G. Taylor, *Byam Shaw 1872–1919*, exh. cat., Ashmolean Museum, Oxford, 1987

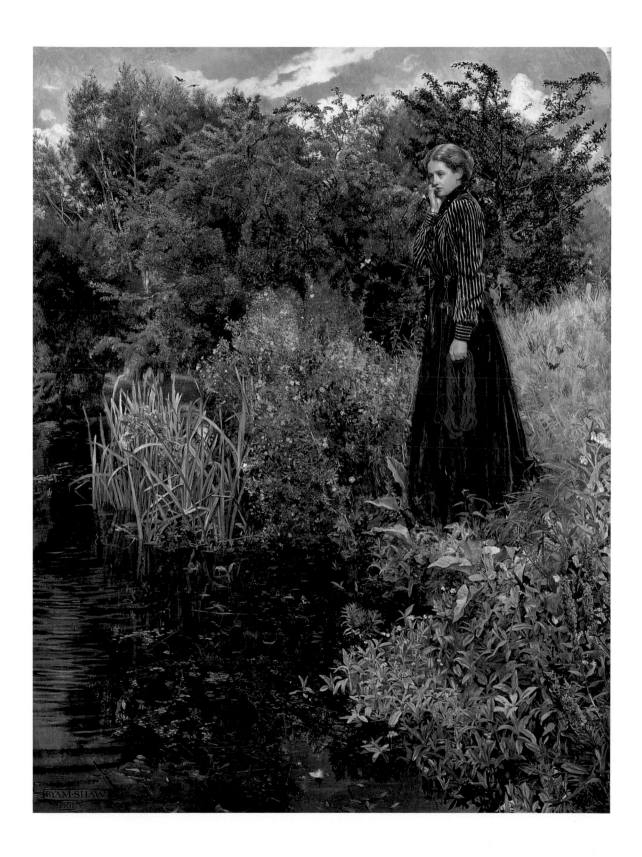

Cuno Amiet
Hope, 1902

CUNO AMIET 1868–1961

Born in Solothurn, Switzerland; studied in Munich, and in Paris at the Académie Julian (1888–91); returned to Switzerland and settled in Oschwand, Berne, in 1898; exhibited with Ferdinand Hodler in Zurich in 1904, and held a solo exhibition in Dresden the following year after which he was invited to join *Die Brücke* group; later he also produced civic murals and sculpture.

The contrast between the gentle, matter-of-fact nature symbolism of Byam Shaw's *The Boer War* (p.53) and Amiet's full-blown, central-European, *fin-de-siècle* altarpiece could not be more marked, although both portraits deal with bereavement. *Hope* (Die Hoffnung)was one of the star exhibits at the *Vienna Secession* in 1904, its memorial status underlined by its being exhibited above an arrangement of real flowers. Despite Amiet's well-documented stay in 1892–3 with Gauguin and his circle in Pont-Aven, Brittany, where he acquired a fully post-Impressionist palette and technique, *Hope* reminds us that he was also a fellow-countryman of Böcklin and Hodler, whose individual interpretations of symbolism were based both on classical and medieval examples. Amiet became friends with Hodler after his return from Pont-Aven and shared the honours with him in the *Vienna Secession* exhibition, where each was represented by thirty paintings.

Like much of Amiet's work, *Hope* is autobiographical. In 1898 he married one of his landlord's four daughters, Anna Luder, and by 1901 they were expecting their first child. Two earlier versions of this painting (one in the Kunsthaus Aarau) are without the ominous figures of death on the side-wings and this work clearly started out as a tribute to the pregnant Anna and their joint hope for a child. The unborn infant (reminiscent of the famous early Romantic painting *Der Morgen* (1808; Kunsthalle, Hamburg) by the German Phillip Otto Runge) lies symbolically on a cloth in the panel above Anna's head. Her elegant gesture, very much like one of Hodler's balletic figures, is not fully explained, but seems halfway between an attitude of prayer and perhaps that of cradling the baby to come. The blue dress, homespun but aesthetic, inevitably reinforces a comparison with representations of the Virgin Mary.

Infant mortality at this time was far more common than it is today, and their baby was stillborn. Amiet then added the side-wings with two skeletons, one male and one female, and twining roses painted on the reverse sides, transforming *Hope* into a memorial for their lost child. The triptych has also been known as *Die Vergänglichkeit* (Transience), though Amiet apparently preferred the more positive earlier title. Since Anna was unable to have more children, the dual representations of a male and a female death may refer to the barrenness of their future life. Significantly, however, the couple adopted a niece in 1904, and subsequently fostered other children. Parenthood and family life were to dominate the subject matter of much of Amiet's later work.

Main panel of triptych: tempera on card
645 × 470mm (25⅜ × 18½")
Top: tempera on card
115 × 470mm (4½ × 18½")
Side wings: tempera on plywood
795 × 195mm (31¼ × 7¾")
Kunstmuseum, Olten, Switzerland

REFERENCE
G. Mauner, in *Kunstmuseum Olten Sammlungskatalog*, Olten, 1983, pp.113–16

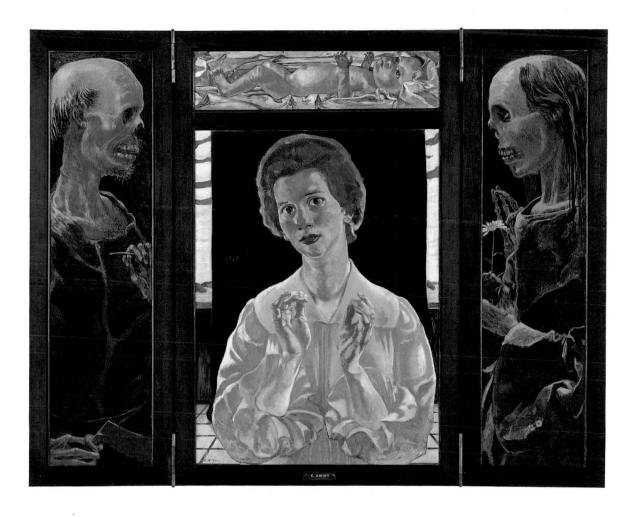

The closed triptych showing the
reverse of the side-wings.

Charles Wellington Furse
Diana of the Uplands, 1903–4

CHARLES WELLINGTON FURSE
1868–1904

Portrait and figure subject painter, born in Staines, Middlesex, studied at the Slade School of Fine Art, Académie Julian, Paris, and under Fred Brown; a sufferer from tuberculosis, he regularly wintered abroad although he was an active exhibitor at the Royal Academy and New English Art Club; painted decorations in Liverpool Town Hall, 1899–1901.

Oil on canvas
2370 × 1790mm (93¼ × 70½″)
Tate Gallery, London

REFERENCES

M. Chamot, D. Farr and M. Butlin, *The Modern British Paintings, Drawings and Sculpture*, exh. cat., Tate Gallery, London, 1964, I, pp.196–7

K. McConkey, *Edwardian Portraits*, London, 1987, pp.168–9

Just four years before his premature death, Charles Furse married Katharine Symonds (1875–1952), daughter of the aesthetic poet and writer J. A. Symonds. They met in Davos, where she grew up and where he regularly spent the winter for his health, and their relationship seems to have provided a new source of inspiration for his work. Although he had been an accomplished painter of equestrian and outdoor portraits, there is a new sense of exuberance and fresh air in his work after 1900 and an increasing confidence and maturity of style, technique and composition. Apart from modelling for him, Katharine also provided very practical assistance; among her many accomplishments she had learned to carve, and she helped to produce some of his picture frames. She carved the frame for this painting, but was disappointed that it had to be enlarged because of an error in measurement.

The rather Thomas Hardy-ish title for what is, in effect, an attempt to out-Gainsborough Gainsborough is thoroughly in line with Furse's other major portraits of these years, such as *The Return from the Ride* (Tate Gallery, London) and *Cubbing with the York and Ainstey* (private collection). *Diana* is a portrait of the new woman for the new century – windblown, independent and liberated, released from the gilded salons of Sargent and the hot-houses of the late Victorians. Katharine organised the V.A.D. during the First World War, and was Director of the Women's Royal Naval Service from 1917 to 1919. She was active in various skiing organisations, and from 1928 to 1938 was Director of the World Bureau of Girl Guides and Girl Scouts. This painting caught the public imagination and was immensely popular for a time, its composition being used for a great many advertisements and even for a political cartoon of Balfour with Joseph and Austen Chamberlain.

When the Tate Gallery was preparing its 1964 catalogue, Dame Katharine (as she had become in 1917) described the circumstances of the portrait, which was painted at their home in Yockley, Surrey: 'Charles had the design of the wind-blown figure in his mind . . . so I dressed up and stepmother-in-law Gertrude was brought in to try the bellows under the skirt, which was tied up to a support to help the "wind". We hired two greyhounds for the picture, a white and a black, and when he wanted a piebald, Charles made a *combinazione* of the two.'

John Singer Sargent
Sir Frank Swettenham, 1904

JOHN SINGER SARGENT 1856–1925

Portrait and landscape painter, born in Italy of American parents; attended the Academy in Florence; first exhibited at the Paris Salon in 1878 before moving to England around 1885 and establishing himself as a portraitist to high society; by 1907 he had largely given up portraiture for landscape and decorative painting, producing murals for the city of Boston.

The diplomat Sir Frank Swettenham (1850–1946) spent most of his professional life in Malaya, after entering the service of the Straits Settlement in 1871. After an extremely successful colonial career, he was Governor of the Malay States from 1901 until his retirement in 1904. At a dinner of the Straits Association in London in 1903, he was invited to have his portrait painted for the Victoria Hall, Singapore, by an artist of his own choosing. Sargent, by this time the most highly esteemed portrait painter both in Britain and the US, was an obvious choice: he produced a flattering image of colonial magnificence of which its subject can scarcely have dreamed. In his early fifties (relatively young for retirement by modern standards), Swettenham is presented at the height of his powers and influence, in a seductive image of both imperial authority and masculine supremacy. His immaculate white uniform and Van Dyckian pose emphasise the trimness of his figure and his nonchalant charm.

The original painting (now in the Singapore History Museum) shows Swettenham at full-length in a slightly different pose, standing on a leopard-skin rug; it was exhibited at the New Gallery, London, in 1905 before being sent overseas. The National Portrait Gallery painting, smaller in every way, was originally a copy made by an assistant. By this stage, however, artist and sitter had become good friends, and Sargent entirely repainted the copy, receiving further sittings for the head and altering the uniform (in conformity with new regulations for governors' uniforms issued by the Colonial Office). If it is tempting to view this portrait as the epitome of empire, it is nevertheless, with its golden glow, also an image on which the sun appears to be slowly setting. Two years later, Sargent began refusing commissions for most painted portraits and the challenge of representing society in the manner in which it wished to be seen. For the remainder of his career in this field, he restricted himself almost entirely to rapidly executed charcoal drawings.

Oil on canvas
1708 x 1105mm (67¼ × 43½")
National Portrait Gallery, London

REFERENCES

J. Lomax and R. Ormond, *John Singer Sargent and the Edwardian Age*, exh. cat., Leeds Art Galleries and National Portrait Gallery, 1979, pp.66–7

E. Kilmurray and R. Ormond, *John Singer Sargent*, exh. cat., Tate Gallery, London, 1998, pp.166–7

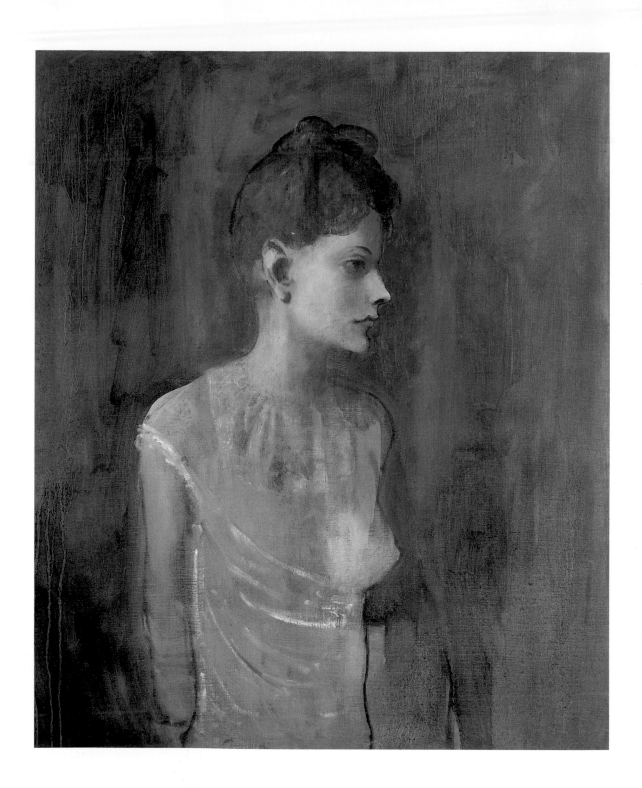

Pablo Picasso
Woman in a Chemise, 1905

PABLO PICASSO 1881–1973

Born in Malaga, Andalusia; studied
in Barcelona and Madrid; settled in
Paris, 1904; 'rose period' and paintings
of circus folk, 1905; began series
of revolutionary developments
in painting with *Les Demoiselles
d'Avignon*, 1906–7; met Braque 1907
and created Cubism; experimented
with sculpture from this date and
moved through a number of original
styles in both media; after the
monumental *Guernica*, 1937, output
continued unabated but was less
dramatically innovatory.

Oil on canvas
727 × 600mm (28⅝ × 23⅝″)
Tate Gallery, London

REFERENCES

C. Zervos, *Pablo Picasso*, Paris, 1932,
vol.I, no.270

R. Alley, *The Tate Gallery's Collection of
Modern Art*, London, 1981, pp.592–3

W. Rubin, ed., *Picasso and Portraiture*,
exh. cat., Museum of Modern Art,
New York, 1996, pp.244–6

Only with the groundbreaking 1996 exhibition in New York did it become clear how much of Picasso's work was concerned – if not precisely with portraiture – at least with the notion of portrayal. The idea that his bewildering succession of styles and 'isms' might usefully be associated with the women who shared his private life was raised by several of the scholars contributing to the catalogue, though usually to be rejected. Nevertheless, the role of Marie-Thérèse Walter, for instance, who became his mistress in 1927, is crucial in much of his painting for the following seven or eight years, as is that of Dora Maar who followed her.

Around the turn of the century and while he was still living in Barcelona, Picasso had been perfectly willing to do portraits of friends and acquaintances. Many of the hundred or so drawings that constituted his first successful exhibition at Els Quatre Gats in 1900 were portraits executed somewhat in the style of his friend, the illustrator Ramon Casas. At the end of his so-called 'blue period' (which included a number of melancholy portraits of Jaime Sabartés, as well as studies of the poor and other social outcasts), Picasso moved to Paris in 1904. Nothing is known about the subject of this portrait, except that her name was Madeleine; she seems to have enjoyed a brief affair with Picasso and she first appears in drawings done that year. Looking fashionably emaciated and with a rather deadpan sort of beauty, her delicate features and long hair loosely piled up on top of her head are instantly recognisable from a number of major works by Picasso, such as *Woman Ironing* (Guggenheim Museum, New York) and several of the pictures of acrobats that define his 'rose period'. Though the well-known *Woman with Helmet of Hair* (The Art Institute of Chicago) is the most individual and provoking of these 'portraits', *Woman in a Chemise*, with its quietly insistent eroticism, unforgettably defines the 'look' that characterises these works. What passes for an undergarment serves in fact to reveal the left breast, precisely echoing the line of her delicate nose. The subtle gradation of colour, from blue through mauve to the palest pink, emphasises that this is an aesthetic exercise in an almost Whistlerian manner. However, this was a path that Picasso soon abandoned. The more robust charms of Fernande Olivier, whom he met in 1905 and who was his mistress until 1911, triggered dramatic formal simplifications and innovations, which transformed his painting – and ultimately the course of western art – over the next few years.

Giovanni Boldini

Consuelo, Duchess of Marlborough, and her Son,
Lord Ivor Spencer-Churchill, 1906

GIOVANNI BOLDINI 1845–1931

Born in Ferrara, Italy; received his
earliest training from his father, the
painter Antonio Boldini; in 1862 he
attended the Scuolo del Nudo at the
Accademia di Belle Arti in Florence
and became associated with the
'Macchiaioli'; he was introduced to
English high society while in Florence,
subsequently travelled to London
and settled in Paris in 1871 where he
became one of the city's leading
portraitists; from 1927 he executed
only charcoal drawings due to failing
eyesight.

Oil on canvas
2215 × 1702mm (87¼ × 67")
The Metropolitan Museum of Art,
New York. Gift of Consuelo Vanderbilt
Balsan, 1946

REFERENCES

C. Vanderbilt Balsan, *The Glitter and
the Gold*, London, 1953, pp.108–9

G. A. Reynolds, *Giovanni Boldini and
Society Portraiture*, Grey Art Gallery
and Study Center, New York
University, 1984, pp.42–4, 61

P. Mauriès, *Boldini*, FMR, Milan, 1987,
pp.70–1

Unforgettably dismissed by Sickert as belonging to the 'wiggle and chiffon school of portraiture', the work of Giovanni Boldini can now be seen as an important staging post in Italian painting between the rococo of Tiepolo and the futurism of Marinetti and Boccioni. Indeed, the portrait of Consuelo Vanderbilt and her son is almost vertiginous in its dynamics: the viewer seems impelled down into the whirling centre of the composition where the boy's head rests on his mother's *décolleté*. The composition seems all the more extraordinary when it is realised that it was based on a small and cheerful half-length portrait of the Duchess alone, done in Paris. She asked Boldini for a larger version to hang in a particular spot in Sunderland House, the Marlboroughs' London residence, where she had moved after separating from the Duke that year.

Instead of simply starting again, Boldini had the original portrait photographed, and used an enlargement as the basis for a sketch in oils for the new composition. This sketch (Collection: Vito Doria, Bologna), an extraordinary hybrid, is compositionally a veritable vortex. In the finished painting, there seems to be no physical evidence as to how the boy stays upright, but such is the conviction of the composition that we are able to suspend disbelief and imagine that, in one brief instant, he has thrown himself from his chair into his mother's lap and that both have been caught in the flash from the camera of a very tall photographer. This apparent spontaneity of gesture and expression and his formidable technical fluency render Boldini's work unique in an era when accomplished society portrait painters such as Sargent and de Laszlo were two-a-penny.

The reckless spaciousness of the composition is not only unusual in Boldini's oeuvre, but also somehow symbolic of the fusion of Old and New Worlds that the painting represents: Consuelo Vanderbilt was from one of the very richest American families, and was married in 1895 to Charles, 9th Duke of Marlborough, with whom she had two sons. Boldini had made his own conquest of the United States on a visit in November 1897. Although he did not paint many portraits there, wealthy Americans were happy to stop off at his Paris studio during their trips to Europe and they became his best clients. Consuelo first met him on a trip to Paris, and the enlarged portrait seems at least in part to have been commissioned as a gesture of independence immediately after her separation. The decision to include her younger son Ivor, of whom she had been granted custody, also seems designed to make a point.

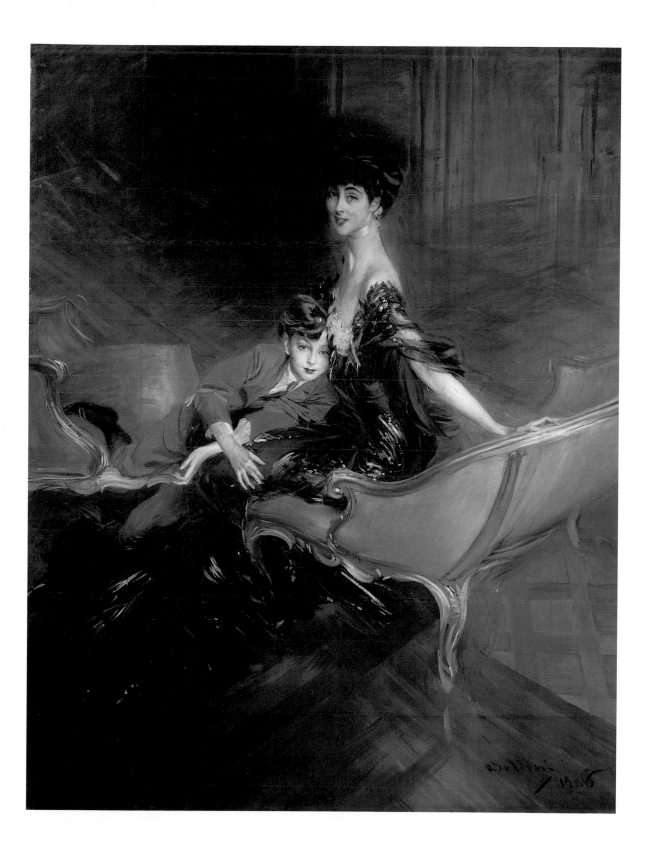

Edvard Munch
Self-portrait against Red Background, 1906

EDVARD MUNCH 1863–1944

Born in Løyton, Norway; after an unhappy childhood attended Arts and Crafts school, Oslo; in Paris 1889–92, where he was influenced by Impressionists, Seurat and Gauguin; exhibited works in Berlin, 1892, causing a scandal leading to the creation of the Berlin Secession and, indirectly, of Expressionism; his Symbolist-influenced woodcuts date from 1894–5; much of his work centred on a cycle of *The Frieze of Life*; after a serious nervous breakdown, 1908–9, returned to Norway for good; worked on murals for Oslo University.

The magnificent and psychologically acute portraits that Munch exhibited in Berlin in the years either side of the turn of the century were among the most influential in the subsequent development of the genre. He was also a prolific self-portraitist (seventy-two have been recorded) and used his own image to explore the turbulent inner life and the sexual and emotional undercurrents that are a feature of much of his major work. In 1902 he bought a small camera and began taking a series of highly inventive self-portrait photographs, some of which he used directly in constructing his paintings. In 1906, when this work was painted, he was travelling restlessly throughout Germany, visiting spas to try to settle his acute nervous condition; his fame was such that he was presented at court in Weimar.

This little-known self-portrait was done at around the same time as the famous *Self-portrait with a Wine Bottle* (1906; Munch-museet), the embodiment of all his loneliness and negative feelings during this period. This one is, by contrast, totally unexpected in its urbanity and the comparative straightforwardness of its approach to the problem of self-likeness (an alternative title, *Half-length Portrait, Wearing Low-cut Waistcoat*, draws attention to his fashionable dress). While the image may represent a period of comparative calm in his troubled private life, there is nevertheless a strongly self-assessing feel about his serious, slightly downward look, as if he were somehow trying to see himself as others saw him, the successful *enfant terrible* of the Berlin and Norwegian art worlds. The solid red background is perhaps a confirmation of unease at what he sees; though not a patch on the burning inferno of the better-known *Self-portrait/In Hell* (1904–5; Munch-museet), it is nevertheless the colour of violence and anguish.

Oil on canvas
1195 × 705mm (47 × 27¾″)
Munch-museet, Oslo

REFERENCES

J. Langaard, *Edvard Munchs Selvportretter*, Oslo, 1947, pp.70–1

J. P. Hodin, *Edvard Munch*, London, 1972, pp.96, 112

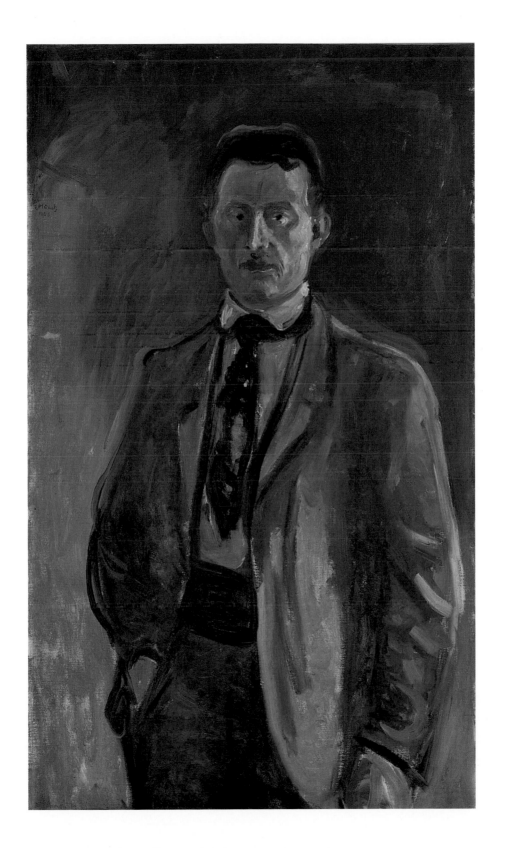

Alphonse Mucha
Josephine Crane Bradley as Slavia, 1908

ALPHONSE MUCHA 1860–1939
Painter and graphic designer, born
in Moravia; studied at the Académie
Julian in Paris and became one of the
leading forces in the Art Nouveau
movement; in the 1890s he created
theatre posters for the actress Sarah
Bernhardt, as well as commercial
advertisements, window displays and
exotic interiors; after 1913 he turned
to painting mostly large historical
canvases.

Oil and tempera on canvas
1540 × 925mm (60¾ × 36½″)
National Gallery, Prague

REFERENCES

J. Mucha, *Alphonse Mucha, The Master
of Art Nouveau*, London, 1966, pp.226, 239

V. Arwas, J. Brabová-Orliková,
A. Dvořák, *Alphonse Mucha, The Spirit
of Art Nouveau*, London, 1998, p.236

Though hardly remembered as a portrait painter, it was in painting that
the great decorative artist Mucha's ambitions lay, and with his unforget-
table Art Nouveau poster images of Sarah Bernhardt that he made his
name in 1890s' Paris. In 1906 he married, and in order to capitalise on
connections made on previous trips to America, moved his household
to the United States. From 1907 to 1910 he taught at The Art Institute of
Chicago, where he came into contact with Charles Crane, a plumbing
supply magnate, notable philanthropist and later public servant who was
a supporter of various Slav causes. In about 1907–8 Crane commissioned
portraits of both his daughters from the impecunious Czech artist.

The portrait of the younger daughter, Mrs Frances Leatherbee, was to
be an artistic *tour de force*, a large traditional group in the grand manner
complete with child and dog, drapes and flowers. A perfectly acceptable
and ambitious *belle époque* painting, it is otherwise unremarkable and
caused the artist enormous trouble. It was not completed and exhibited
until 1910, and was still being altered in 1913. Mucha's failure to recognise
that his greatest gift was not in painting but in his unrivalled graphic skills
plagued much of his career. With the portrait of Josephine, the elder
daughter, he wisely stayed with what he knew best and produced a
masterpiece of decoration.

This portrait, commissioned as part of the interior decoration of a
house that Crane was building for his daughter, began life as a poster in
1907 for the Czech bank insurance house Slavia, although it is not clear
whether Mucha used his sitter's features for this symbol of Slav nationalism.
The painting that he completed in 1908 differs principally in the primitive,
tambourine-like instrument she holds which was apparently added on
Crane's instructions in 1910. The swallows, eagle and sword are Czech
allusions, as is the linden tree behind her elaborate chair (not easy to discern).
The delicate colour scheme of pink and grey-blue is unexpectedly light
and airy within the ornate floral borders and frame. In 1920, this image
was used for the hundred-crown banknotes of the newly independent
Czechoslovak Republic. Crane remained a loyal patron, supporting
Mucha's ambitious scheme for a monumental historical series of paintings
The Slav Epic (Moravsky Krumlov, Prague).

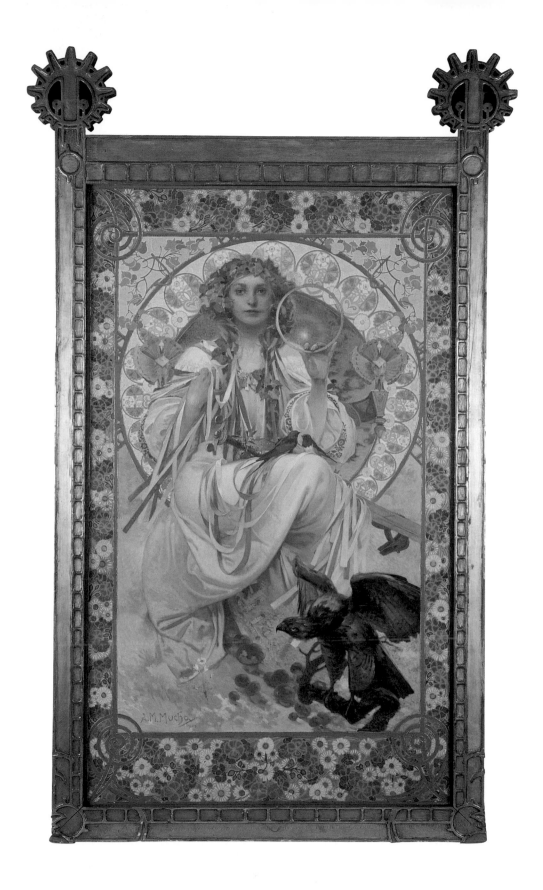

Sir William Orpen
Homage to Manet, 1909

SIR WILLIAM ORPEN 1878–1931

Born in Blackrock, County Dublin;
studied at the Metropolitan School of
Art, Dublin (1891–7), and at the Slade
School of Fine Art, London (1897–9);
official war artist 1917–19, and held a
London exhibition of his wartime art
in 1918; knighted in the same year;
appointed official artist to the British
Peace Delegation (1919) and elected
RA in 1921; was a friend of Augustus
John and an active member of the
New English Art Club; established a
large and successful portraiture practice.

Oil on canvas
1629 × 1300mm (64⅛ × 51⅛″)
Manchester City Art Galleries

REFERENCES

B. Arnold, *Orpen: Mirror to an Age*,
London, 1981, pp.228–36

K. McConkey, *Orpen and the
Edwardian Era*, exh. cat., Pyms Gallery,
London, 1987, pp.82–3

There had been one or two isolated exhibitions of French Impressionist paintings in London before the turn of the century, but its first real impact on the British public and on the younger generation of British painters, of whom William Orpen was one of the most promising, came with the large 1905 exhibition of Impressionists at the London branch of the Paris dealers Durand-Ruel. Remarkably, it was by then over thirty years since Monet had first exhibited his famous *Impression: Sunrise* in 1874 – rather as if the British public today was only now waking up to Minimalism and Carl André's notorious 'bricks'. Manet's magnificent portrait of his pupil *Eva Gonzalès* (1870; National Gallery, London), which forms the centrepiece of Orpen's tribute, had been one of nineteen Manets in the 1905 London exhibition; some time before late 1906 it had been acquired by the wealthy dealer and patron Hugh Lane (1875–1915), possibly on a continental tour he made with Orpen.

Orpen's decision to undertake this ambitious group seems to have been as much in tribute to Lane and to leading members of the Anglo-Irish art world who supported Impressionism as it was to Manet himself (who had died long before, in 1883). It was also something of an exercise in self-promotion for Orpen, who may have wished to cast himself as a future leader of the 'progressives'. One of at least four preliminary drawings shows that he began work in 1906. The Irish novelist George Moore (1852–1933) is seated on the left, reading his paper on Manet to a group of friends and colleagues. Clockwise, these are: the painter Philip Wilson Steer (1860–1942) seated behind the table; the painter and recently appointed Keeper of the Tate Gallery D. S. MacColl (1859–1948); the painter Walter Sickert (1860–1942), standing on the right (known to have been a late addition when the painting was extensively revised just before its first exhibition); Hugh Lane, seated below Sickert; and, to Lane's left, the painter Henry Tonks (1862–1937), who was Orpen's teacher at the Slade.

The painting was enthusiastically received when it was exhibited in 1909. In 1910, however, Roger Fry (who was popular neither with Tonks nor Orpen) returned from New York and organised his revelatory first Post-Impressionist exhibition at the Grafton Galleries, followed by a second in 1912. The aspirations demonstrated in *Homage to Manet* were, in effect, swept overnight into the dustbin of history.

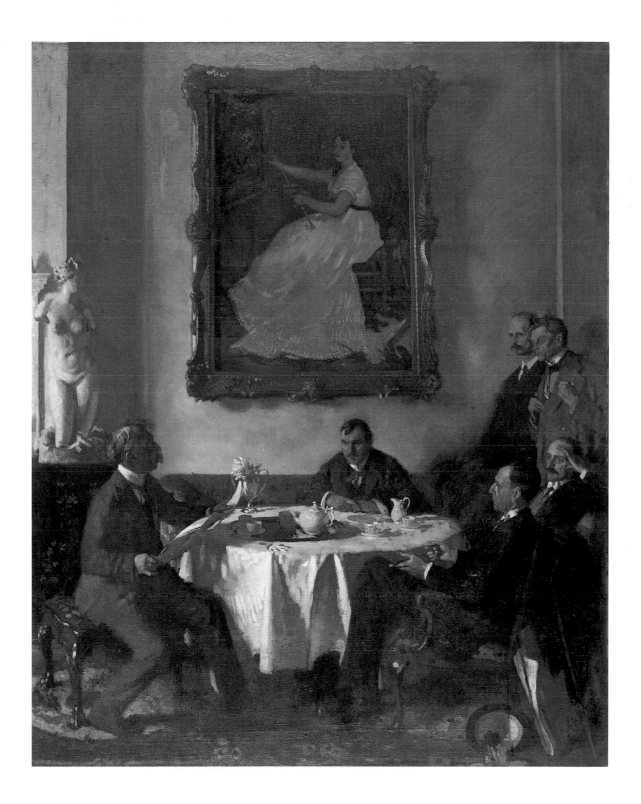

1910s

The series of small conflicts that preceded the First World War might be seen as analogous to contemporaneous cultural revolutions such as Cubism, which seemed intent on fragmentation of the old order, and Futurism and Expressionism, which were prophetic of things to come. But after the long drawn-out carnage of 1914–18 disillusion began to set in, and in Europe the political old order was virtually reinstated. In Russia, artists and intellectuals who had welcomed the ideals of the 1917 Communist Revolution found themselves rapidly oppressed by a rigid new bureaucracy.

HISTORICAL EVENTS

1910	1911	1912	1913	1914
Death of Edward VII; succession of his second son, George V.	Revolution in Mexico.	British ocean liner *Titanic* sinks on her maiden voyage on 14–15 April, with the loss of 1,500 lives .	Second Balkan War, February to April; Third Balkan War, May to August.	Boer Rebellion against the British.
Revolution in Portugal.	Italo–Turkish War.	First Balkan War, October to December.	Assassination of George I of Greece.	Assassination of Archduke Ferdinand in Sarajevo; Austria-Hungary declares war on Serbia; Germany declares war on Russia and France; Britain declares war on Germany.
Annexation of Korea by Japan.	Strikes by dockers, railwaymen and weavers in Britain.	Capt. Robert Scott and his companions reach the South Pole, to find they have been beaten to it by Roald Amundsen. They all perish on the return trip.	Suffragist Emmeline Pankhurst sentenced to three years' imprisonment for placing a bomb in the new home of the Chancellor of the Exchequer, David Lloyd George.	Closure of London and New York Stock Exchanges to prevent panic trading.
Foundation of Girl Guides' Association in Britain.				War fuelled by new technology: the first bombing raid from a German Zeppelin.
				Mexico embroiled in civil war.
				First heart surgery (on a dog) performed by French-American surgeon Dr Carell.

CULTURAL EVENTS

1910	1911	1912	1913	1914
First performance of Igor Stravinsky's *Firebird*, with Diaghilev's *Ballets Russes* in Paris.	Egon Schiele is arrested for 'immoral' drawings.	First performance of Ravel's *Daphnis and Chloe*, ballet for Diaghilev; Debussy's *Jeux*.	First performance (in Paris) of Igor Stravinsky's *The Rite of Spring*, with Diaghilev's *Ballets Russes*, causes riots at the theatre.	First performance of Ralph Vaughan Williams' *London Symphony*.
Publication of E. M. Forster's *Howards End*.	*Mona Lisa* stolen from the Musée du Louvre (recovered in 1913).	Publication of G. B. Shaw's *Pygmalion* and *Androcles and the Lion*; Alain Fournier's *Le Grand Meaulnes*	Publication of D. H. Lawrence's *Sons and Lovers*.	Publication of James Joyce's *Dubliners*; Edgar Rice Burroughs' *Tarzan of the Apes*
Charles Rennie Mackintosh completes Glasgow School of Art; Antoní Gaudi completes Casa Milá, Barcelona, in Art Nouveau style.	First performance of Richard Strauss's opera *Der Rosenkavalier*.		Charlie Chaplin, British music hall star, appears in his first film, *Making A Living*.	Marconi transmits first wireless telephone messages, between Italian ships fifty miles apart.
			Enrico Guazzoni's silent film *Quo Vadis?* is a worldwide box office hit.	

1915

Introduction of compulsory military service in Britain.

Despite international protest, Edith Cavell, an English nurse stationed in Belgium, is executed by the Germans for aiding the escape of Allied prisoners.

Formation (in Philadelphia) of The League to Enforce Peace, anticipating The League of Nations.

Earthquake at Avezzano, Italy, kills 30,000 people.

Albert Einstein announces his general theory of relativity.

Marcel Duchamp's *Fountain* (a porcelain urinal) submitted to the Salon des Indépendants, New York; as he hoped, it was rejected.

Publication of Rupert Brooke's *1914 and other Poems*; Ford Maddox Ford's *The Good Soldier*; Joseph Conrad's *Victory*.

Release of Charlie Chaplin's artistic masterpiece *The Tramp*.

Popular songs inspired by the war include *Keep the Home Fires Burning* and *Pack up your Troubles in your Old Kit Bag*.

1916

Execution of fifteen leaders of The Irish Republican Brotherhood, a branch of Sinn Fein, after the Dublin Easter Rising.

Russian monk Rasputin murdered following concern over his influence on the Tsar and his family.

British scholar and archaeologist T. E. Lawrence assigned to investigate Arab revolt against the Turks.

First special ward for plastic surgery established at Cambridge Military Hospital in Aldershot.

Foundation of the Dada (Fr. 'hobby-horse') movement in Zurich, including the artist Marcel Duchamp and the writer Tristan Tzara.

Publication of James Joyce's *Portrait of the Artist as a Young Man*.

Composition of Gustav Holst's suite *The Planets*.

1917

US finally enters European conflict by declaring war on Germany.

Return of T. E. Lawrence to Arabia as military adviser to King Faisal.

The February Revolution: Tsar Nicholas II forced to abdicate following strikes and riots in Petrograd.

Leading a group of Bolshevik revolutionaries, Vladimir Ilyich Lenin returns to Russia from exile in Switzerland, and receives a hero's welcome.

The October Revolution: Bolsheviks seize power after storming the Winter Palace.

In Paris, execution of the exotic dancer Mata Hari for allegedly passing military secrets to the Germans.

Foundation (in Holland) of the magazine *De Stijl* (The Style) by Piet Mondrian; it gives its name to the International Style of art and architecture.

Composition of Sergei Prokofiev's *Classical Symphony*; Stravinsky's *The Soldier's Tale*.

Publication of Norman Douglas's *South Wind*.

First performance of Luigi Pirandello's play *Right You Are If You Think You Are*.

1918

Peace treaty signed by Bolsheviks at Brest-Litovsk.

Major German offensive attempts to split the French and British forces along the Western front.

U-boat becomes Germany's new instrument of war.

Spanish 'flu epidemic sweeps Europe.

Murder of Tsar Nicholas and his family at Ekaterinburg, on the directions of the local communist council who feared a counter-revolutionary plot to free them.

Formal end to hostilities on 11 November, with signing of Armistice in Paris.

The Original Dixieland Jazz Band, on tour, introduces jazz to Europe.

Composition of Edward Elgar's *Cello Concerto*; Igor Stravinsky's *Ragtime for Eleven Instruments*.

Publication of Rupert Brooke's *Collected Poems*, after his death on a troopship; Gerard Manley Hopkins' *Poems*; Alexander Blok's poem *The Twelve*, celebrating the Russian Revolution; Lytton Strachey's collection of brief biographies, *Eminent Victorians*.

Release of Charlie Chaplin's *Shoulder Arms*, a parody of the war in the trenches.

1919

Treaty of Versailles signed in Paris on 28 June.

Weimar Constitution adopted by New German Republic.

Spanish 'flu has succeeded in taking almost as many lives as the war.

In Germany, Adolf Hitler joins the German Workers' Party.

In Italy, *Fasci del Combattimento* formed by Benito Mussolini.

Militant nationalist group under poet Gabriele D'Annunzio seizes the Adriatic port of Fiume and declares its independence from Italy.

In Britain, Lady Nancy Astor becomes the first woman elected to the House of Commons.

Foundation of the Bauhaus School in Weimar by architect Walter Gropius.

Picasso designs the set for *The Three-Cornered Hat*, a ballet by Manuel de Falla.

Composition of Richard Strauss's opera *Die Frau Ohne Schatten*; Béla Bartók's music for the pantomime *The Miraculous Mandarin*.

Publication of W. B. Yeats's poems *The Wild Swans at Coole*; Somerset Maugham's *The Moon and Sixpence*.

Expressionism introduced to cinematography in director Robert Wiene's *The Cabinet of Dr Caligari*.

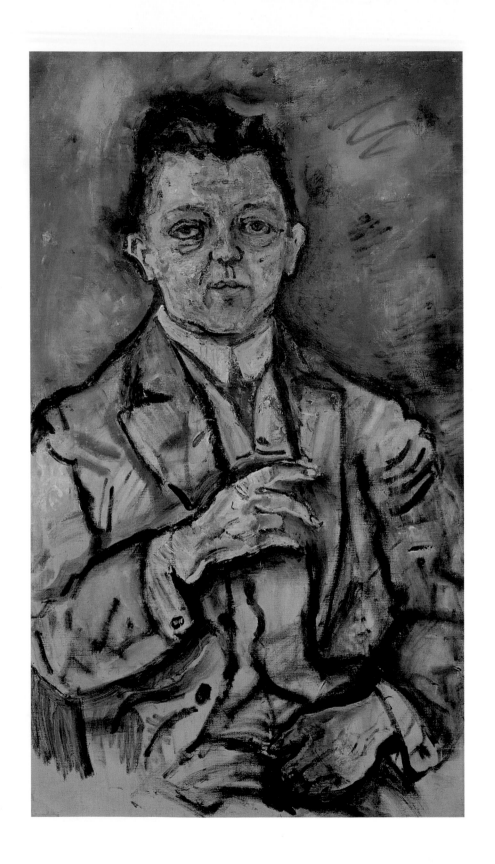

Oskar Kokoschka
William Wauer, 1910

OSKAR KOKOSCHKA 1886–1980
Austrian painter and writer, born at
Pöchlarn; first exhibited at Vienna
Kunstschau, 1908, where his highly
original Expressionist paintings
aroused anatagonism; friend of Adolf
Loos and contributor to Herwath
Walden's *Der Sturm*; Professor at
Dresden School of Art, 1918; altered
his style in the 1920s under the influ-
ence of the Impressionists; travelled
extensively between the wars and came
to England in 1935; naturalised British
subject, 1947.

Kokoschka left the Vienna School of Arts and Crafts in 1909, and by the
outbreak of war in 1914 had painted approaching seventy-five portraits, one
of the most remarkable bodies of work in any genre at any time. Widely
interpreted on account of their visionary and unflattering nature as
'psychological portraits' influenced by Freud's new discipline of
psychoanalysis, they are in effect linked by a remarkable similarity which
is as much a reflection of the artist's intense response as of any inner life
of the sitter. Kokoschka was a lightning draughtsman who liked his sitters
to move and talk to him while he worked. The results are therefore due
more to his rapid observation than to hours of considered analysis.

That Kokoschka's early clientele included many of the most
distinguished artists and intellectuals of central Europe is due to his
friendship with the Austrian architect, Adolf Loos. In the winter of 1909
Loos invited him to Leysin in Switzerland, where he painted not only the
most important of his early landscapes but also a number of the wealthy
occupants of the sanatorium where Loos's wife Bessie was being treated
for tuberculosis. On his return to Vienna, Loos packed him off to Berlin
with Herwath Walden, creator and editor of the influential arts magazine
Der Sturm. Kokoschka was engaged as an associate to work on the
magazine for several months; his pen drawings, and the reputation that
preceded them, had an enthusiastic reception from the Berlin
Expressionists (the *Blaue Reiter* group) and *Die Brücke*.

In Berlin Kokoschka met his future dealer, Paul Cassirer, who gave him
an exhibition and continued to support him for many years to come. But
Kokoschka continued to paint portraits, including that of Herwath Walden
(frequently considered his masterpiece of this period), and of fellow
associates on *Der Sturm* such as William Wauer (1866–1962). Wauer has
been described as a sculptor, painter, draughtsman, poet, art critic and
theatre producer, though Kokoschka's biographer states that 'at the time
he was still working in the Maggi factory'. There is a distinct shift in gear
for Kokoschka's approach to his north German colleague, with his correct
attire and more restrained mode of self-expression. The raised right hand
indicates that he is reacting to the artist, and it is a far more sympathetic
appraisal than many other portraits of this period. It is less easy to grasp
that it was made several years before many of the portraits by his compatriot
Egon Schiele (see p.86), and by an artist who was only 24.

Oil on canvas
940 × 545mm (37 × 21½″)
Stedelijk Museum, Amsterdam

REFERENCES

J. Winkler and K. Erling, eds., *Oskar
Kokoschka: Die Gemälde, 1906–1927*,
Salzburg, 1995

J. P. Hodin, *Oskar Kokoschka: The Artist
and his Time*, London, 1966, p.106

Lovis Corinth
Carl Hagenbeck in his Zoo, 1911

LOVIS CORINTH 1858–1925

Prussian-born painter of portraits and landscapes; studied at Königsberg, Munich and Paris, living in Berlin from 1900; along with Max Liebermann and Slevogt, he led the Secession movement against the Berlin academic school, becoming its president in 1915.

In 1911 Corinth was commissioned by the Director of the Hamburger Kunsthalle, Alfred Lichtwark, to produce three major portraits and a view of the port for a series of 'Pictures from Hamburg'. Carl Hagenbeck (1844–1913), a native of Hamburg, had been a big-game hunter and animal dealer, attracting attention in 1907 with the opening of Hagenbeck's Zoo. As the painting shows, he was an early pioneer of the display of animals in 'natural' settings, as opposed to the small cages of the Victorian era. Pallas the walrus was one of the zoo's principal attractions in the years before the the First World War and presumably also a special favourite of its founder.

The painting's vigorous execution, albeit in the chilly colours appropriate to a northern winter, is typical of the brash German Impressionism that Corinth made his own. The year 1911 was a hectic one for him: as well as the Hamburg commissions he produced a number of other major works, including the well-known portrait *The Artist's Wife at her Dressing Table* (Hamburger Kunsthalle). On 19 December he lost the full use of his right arm in a stroke, but by February 1912 was painting again and teaching himself to use his left hand.

The portrait of Hagenbeck, despite its by now discredited view of animal welfare and conservation, is very much of the new century. Gone is the Romantic image of nature as an uncontrollable force with which man can only grapple. Corinth's unflatteringly observed old patrician, in the last few years of his life, places a protective hand on the head of the walrus, in acknowledgement that man alone is responsible for the survival and well-being of the animal kingdom. The polar bears and the deer on the horizon stop and look enquiringly at the painter and his model, who are the controllers of their future destinies.

Oil on canvas
2000 × 2710mm (78¼ × 106¾″)
Hamburger Kunsthalle

REFERENCES

C. Behrend-Corinth, *Lovis Corinth: Die Gemälde; Werkverzeichnis*, Munich, 1992, pp.123, 556

H. Uhr, *Lovis Corinth*, Berkley, 1990, pp.186–91

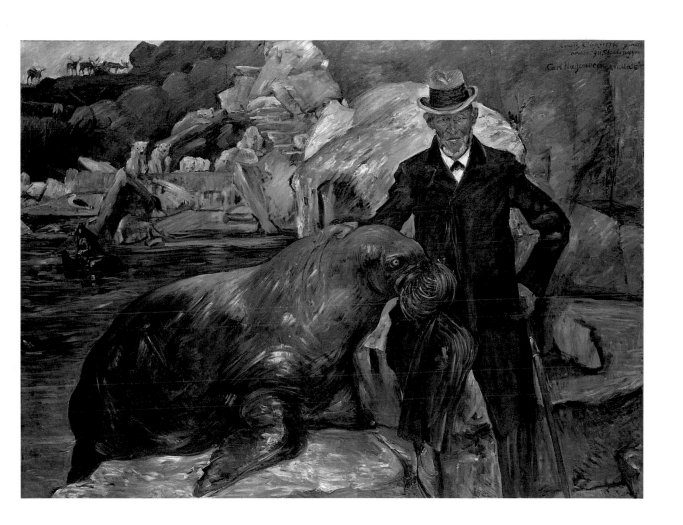

1912

Roger de La Fresnaye
Alice wearing a Big Hat, 1912

ROGER DE LA FRESNAYE 1885–1925

Born in Le Mans, France; studied at the Académie Julian (1903–4) and at the Ecole des Beaux-Arts until 1908; from 1911 he was associated with the Puteux Group, which led to the establishment of the Section d'Or, in whose exhibitions he participated; enlisted in the army on the declaration of war and served until 1918, when he was sent home with tuberculosis; poor health limited his output to drawing in the final years of his life.

The mature Cubist works of Picasso and Braque begin to appear around 1910–11, and it is perhaps astonishing that the style established itself so thoroughly among a whole host of young French painters within a matter of months. Roger de La Fresnaye approached Cubism with the same caution with which he had approached Expressionism when he was in Munich in 1909. In 1910 he began to apply his study of Cézanne to increase the significance of formal structure in his own work, gradually bringing a geometric simplification to his carefully balanced compositions, but never veering towards abstraction or losing traditional perspective. In 1911 he met Jacques Villon and in 1912 collaborated with Raymond Duchamp-Villon on the Maison Cubiste, which was exhibited at the Salon d'Automne that year.

This portrait of his sister-in-law, Alice, is one of his most important works from these formative years and pre-dates his best-known paintings *Conquest of the Air* (The Museum of Modern Art, New York) and *The Fourteenth of July* (Centre Georges Pompidou, Paris) by only two years. Alice's correct posture and well-to-do appearance betray the fact that de La Fresnaye came from an aristocratic family.

Despite his undogmatic approach to the tenets of pure Cubism, however, he took an intellectual interest in its formal application; his principal concerns here (as with *Cuirassier* of 1910–11, Centre Georges Pompidou, Paris) are the arrangement and composition of the figure within a given space, and the deployment of the decorative elements of the background. Here, the sitter's raised right arm for instance exactly echoes the line of her hat, and the left arm the parallel horizontals of the birdcage in the background. The florid fantasy of the feather in her hat in the same way echoes the spikey diagonals of the palm fronds on the right. This indeed was a revolutionary approach to the traditional society portrait.

Oil on canvas
1300 × 970mm (51¼ × 38¼")
Musée des Beaux-Arts de Lyon

REFERENCES

G. Seligman, *Roger de La Fresnaye: catalogue raisonnée*, London, 1969, pp.70, 76, 151

E. Hild, *Roger de La Fresnaye*, exh. cat, Musée de l'Annonciade, Saint-Tropez, 1983, cat. no. 33

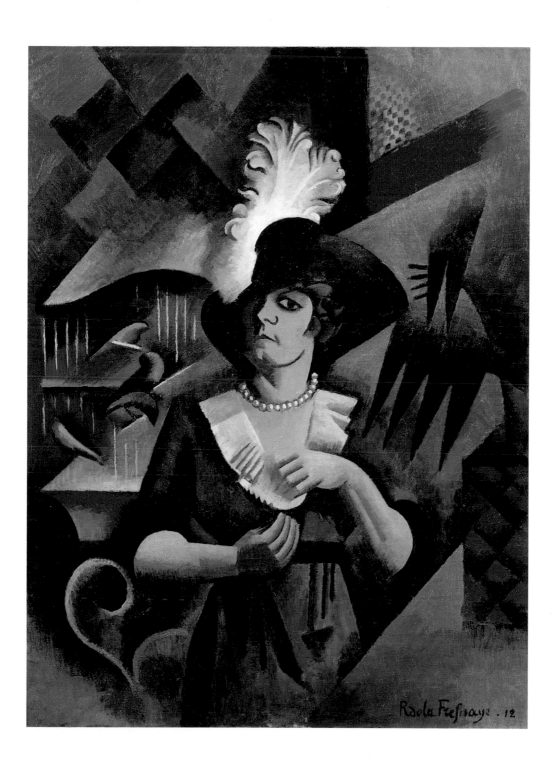

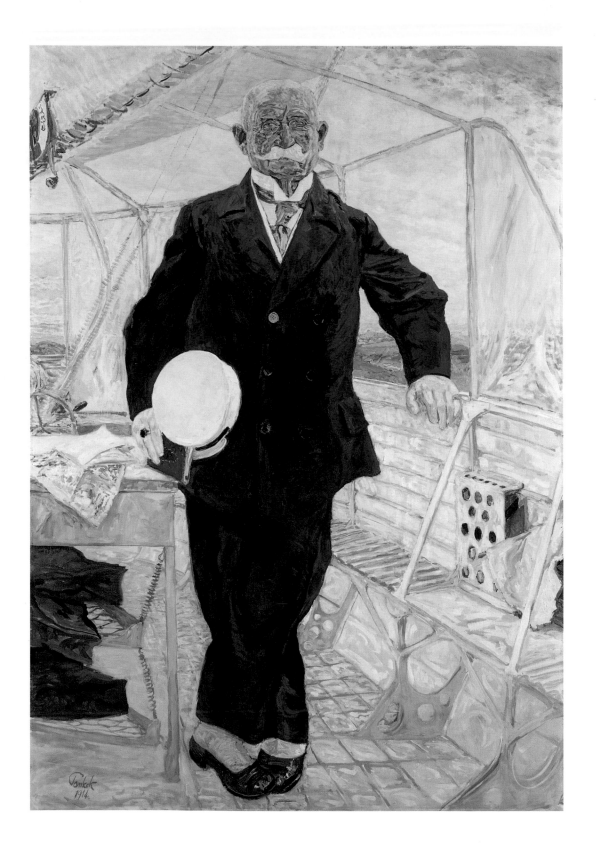

Bernhard Pankok
Graf Zeppelin, 1914

BERNHARD PANKOK 1872–1943

Designer, architect, sculptor and painter, born in Bavaria; studied in Düsseldorf and Berlin before settling in Munich in 1892; worked as a portrait painter and graphic designer but is known primarily for his furniture and interior designs; won international acclaim for his designs for the 1900 *Exposition Universelle* in Paris.

This is one of very few 'airborne' portraits, and may even be the first. Count Ferdinand von Zeppelin (1838–1917) is shown standing on the deck of one of the airships that bear his name. Having retired as a general from the German army in 1891, Zeppelin devoted himself to the design of rigid, motor-powered, dirigible balloons, the first of which flew on 2 July 1900. They became the first means of regular passenger air transport from 1909, and in the early stages of the First World War made fifty-three bombing raids on England. Their vulnerability to gunfire discredited them by 1917, but from 1928 a regular transatlantic passenger service was restored until the disastrous loss of the *Hindenburg* in New Jersey on 6 May 1937.

Zeppelin's choice of artist for this unexpectedly informal portrait of a German military man was not made by chance. Far better known in Europe as a designer of Jugendstil furniture and interiors, Pankok came into his own as the designer of an Alcove Room for the Munich Vereinigte Werkstätten at the Paris *Exposition Universelle* of 1900. As a member of the Deutsche Werkbund, he designed interiors for the huge steamships of the period including the *Friedrichshafen* in 1908–9. From these it was only a small step to the steamships' chief rivals, the airships, and he was recruited by Zeppelin in 1911; between 1911 and 1919 he designed the luxurious passenger compartments of four airships.

It is presumably on the viewing deck of one of these airships that Zeppelin is shown – dapper, jovial and, like all the best inventors, eccentric. Despite the fact that at this period airship décor was far from futuristic, Zeppelin's portrait makes a telling contrast to Sargent's grandiose, imperial and backward-looking image of Sir Frank Swettenham (p.59), encumbered with gilt and symbolic paraphernalia. Zeppelin's gaze is visionary and enigmatic, whereas Swettenham's betrays little but confidence in a job well done. Here, hovering uncertainly in the bright light of a new element in a new century, is the unlikely conqueror of the air.

Oil on canvas
2000 × 1400mm (78¼ × 55⅛")
Hamburger Kunsthalle

REFERENCES

Bernhard Pankok, 1872–1943, exh. cat., Württembergisches Landesmuseum, Stuttgart, 1973

Bernhard Pankok: Malerei, Grafik, Design im Prisma des Jugendstils, exh. cat., Westfälisches Landesmuseum, Münster, 1986

Albert Gleizes
Portrait of an Army Doctor, 1914–15

ALBERT GLEIZES 1881–1953

Born in Paris; began his career in his father's textile design studio; founder member of an artists' commune, l'Abbaye de Créteil, 1906; met Delaunay, Metzinger, Picasso and the Duchamp-Villons, c.1909–10, and exhibited with the Cubists at the Salon des Indépendants, 1910–11; an important writer on Cubism, his painting reaches maturity in the synthetic Cubist style of 1913–15; his later work is mostly in an abstract form of this style.

Oil on canvas
1198 × 951mm (47½ × 37⅜″)
The Solomon R. Guggenheim
Museum, New York

REFERENCES

D. Robbins, *Albert Gleizes*, exh.cat, Lyon and Guggenheim Museum, New York, 1964, p.30, no.33

A. Z. Rudenstine, *The Guggenheim Museum Collection: Paintings 1880–1945*, New York, 1976, pp.145–49

A convinced pacifist, Albert Gleizes was conscripted in August 1914 and posted to Toul, an important arsenal town in Lorraine, south of Verdun. By a stroke of good fortune, the officer in charge of his unit turned out to be aware of his work as an artist and organised his military assignments so that he had time to paint. A temporary studio was found in the house of the regimental surgeon, Dr Lambert, who had been a professor of medicine at the University of Nancy. Both Gleizes and his fiancée Juliette Roche became close friends of Lambert; before the end of 1914, Gleizes had produced at least one study for a head and shoulders portrait of the doctor.

A prime motive in the development of Gleizes's painting style towards Cubism had been his enthusiasm for his colleague Henri Le Fauconnier's Cézannesque portrait of Pierre Jouve, which he had seen at the Salon d'Automne exhibition in 1910. Portraits and figure paintings immediately began to dominate his output, culminating in the fully fledged Cubism of the *Portrait de Figuière* (1913; Musée des Beaux Arts de Lyon) which incorporates lettered book titles and extraneous elements such as a clock. By the summer of 1914, he had begun work on a colourful portrait of the composer Stravinsky (Richard S. Zeisler, New York) which demonstrates a drive towards abstraction similar to that in *Portrait of an Army Doctor*. Although the French authorities were arranging access to the Front for selected artists (the British war artists' scheme came later, in mid-1916), the nearest many French avant-garde painters came to producing pictures about the war were portraits like this one of their friends in uniform.

Portrait of an Army Doctor is one of Gleizes's most magisterial works of this period. He is assumed to have worked on it over the winter of 1914–15, though the blue and green rectilinear shapes in the top left corner could be interpreted as suggesting an outdoor setting. Seven pencil-and-ink studies (also in the Guggenheim Museum) show the evolution of the work from a complex head and shoulders study to an abstract arrangement of vertical, diagonal and curved lines squared up for transfer for the three-quarter-length seated oil portrait. Unlike the slightly earlier portrait by de La Fresnaye of his sister-in-law (see p.77), this has few concrete references – a moustache and an eyelash or monocle perhaps, and the curved arm of a chair. Gleizes allows it to create its own logic, structure and rhythm.

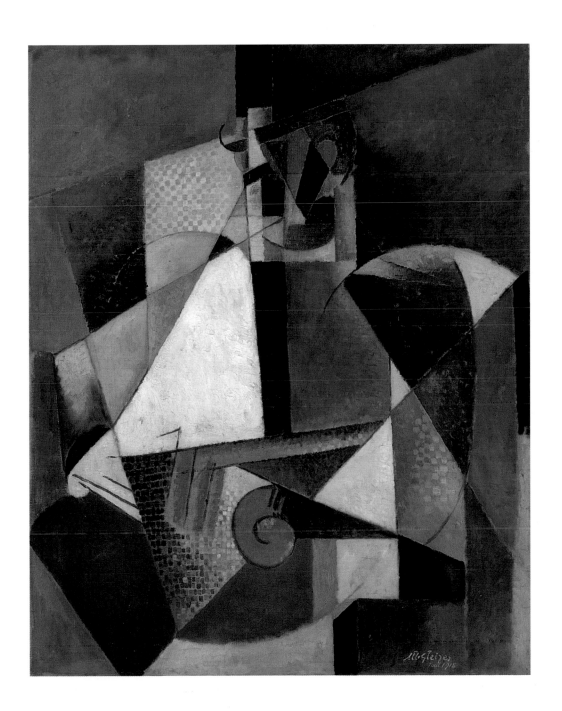

Otto Dix
Self-portrait as Mars, 1915

OTTO DIX 1891–1969

Born near Gera, Germany, where he was later apprenticed to a decorative artist; studied at Dresden School of Art (1909–14) and then at the Düsseldorf Academy, 1919–22; earliest works characterised by intense social criticism and protest against the horrors of war; leading figure in the *Neue Sachlichkeit* (New Objectivity) movement, 1925; Professor at Dresden Academy from 1927 to 1933, when he was dismissed by the Nazis (his work was later suppressed); later work modelled on sixteenth-century German masters and often neo-Romantic.

Despite the chaotic elements in this portrait – fragmented buildings, battlefield landscapes, bullet wounds and the grotesque faces of dying men – the 24-year-old Dix had yet to see active service and was still training as a heavy machine-gunner near Dresden. While this work is normally designated as part of his Expressionist phase between 1912 (when he saw an exhibition of Van Gogh's work at Dresden) and 1919 (when as an art student he came into contact with the Dada movement), it is perhaps the nearest he ever came to painting a Futurist work. In a boldly centrifugal composition, the artist with typically rigid chin confronts the viewer from beneath his spiked helmet – the self-styled classical god of war plumbs the depths of his turbulent imagination for innumerable images of death and destruction from the conflict in which he has volunteered to take part. If the swirling simultaneity of the imagery is pure Futurism, the bold primary colours evoke the basic emotions of Expressionism.

Dix's well-known anti-war paintings did not appear until the early 1920s; they continued well into the 1930s with such devastating indictments as the great *War* triptych of 1932 (Gemäldegalerie, Dresden). This early apotheosis of himself as a warrior and the apparently aggressive acceptance of his role in the conflict is generally considered to be a reflection of Dix's admiration for the works of Nietzsche, the popularity of whose ideas was widespread in turn-of-the-century Europe. Dix took two books with him to war: one was the Bible, and the other a volume of Nietzsche, and one of his earliest recorded works is a plaster bust of the philosopher. The Futurists who gave Dix the model for this portrait were, with their self-proclaimed glorification of violence and conflict, equally heavily influenced by Nietzsche, and the approaching war was welcomed by many European intellectuals as the conflict to rid contemporary society of its decadence and sweep away for ever the 'old order'. It is possible to see a touch of the Nietzschean 'superman' in Dix's image of himself or, at least, in a passage he had underlined in his copy of *Twilight of the Idols*: the 'bravery and composure in the face of a powerful enemy, great hardship, a problem that arouses great aversion – it is this victorious condition which the tragic artist singles out, which he glorifies'. It would be foolish, however, to ignore the powerful undercurrents of irony and satire that characterise nearly all the rest of Dix's mature figure paintings, certainly up to the next war; even the title evoking a long-lost mythical god suggests an element of satire in this self-portrait of a young working-class boy, dressed to the nines in the fancy uniform of the Kaiser.

Oil on canvas
810 × 660mm (32 × 26″)
Städtische Sammlungen, Freital

REFERENCE
K. Hartley, S. O'Brien Twohig, et al., *Otto Dix 1891–1969*, exh. cat., Tate Gallery, London, 1992, p.79 (14)

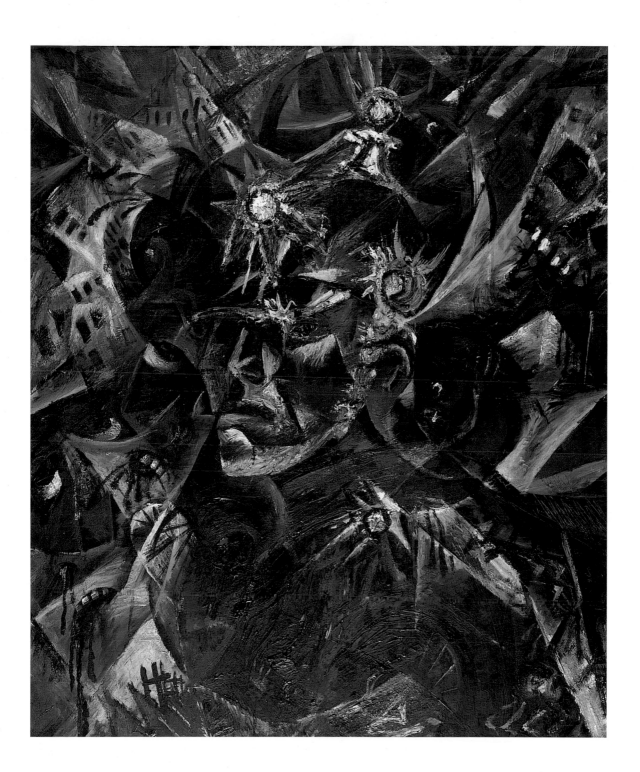

Boris Dmitriyevitch Grigor'yev
Portrait of Vsevolod Meyerhold, 1916

BORIS DMITRIYEVITCH
GRIGOR'YEV 1886–1939

Born in Rybinsk, Russia; studied in
Moscow (1903–7) and in St Petersburg
until 1912; created caricatures for the
satirical journals *Satirikon* and *Novy
Satirikon* (1912–14) while living mainly
in Paris; a prominent member of
bohemian circles in St Petersburg,
he taught at the Free Art Studios and
designed for the Bolshoi Theatre in
Moscow; emigrated to France in 1921
and eventually settled in New York
where he became Dean of the School
of Applied Arts in 1935.

Oil on canvas
2470 × 1630mm (97¼ × 64¼")
The State Russian Museum,
St Petersburg

REFERENCE

Boris Grigoriev, exh. cat., Château-
Musée, Cagnes-sur-Mer, 1978–9

Widely considered to be one of the most influential of all twentieth-century theatre directors, V. E. Meyerhold (1874–1940) covered in his career in St Petersburg and Moscow the whole development of early twentieth-century Russian theatre – from idealistic aestheticism at the Moscow Art Theatre (1898) through revolutionary experimentalism to socialist realism in the 1930s – before he was interned in a Stalinist purge and eventually shot in 1940. Working with (though not always in tune with) Stanislavsky in 1905–6, he developed a stylised form of presentation, experimenting with bas-relief, rhythmic and puppet-like movement and intonation, which he applied to Symbolist dramas by Maeterlinck, Ibsen and Blok before becoming director of St Petersburg's Imperial opera and drama theatres (1908–18). Welcoming Bolshevism with the rallying cry, 'Put the October Revolution into the theatre', Meyerhold embarked on a remarkable decade of experimental dramas. Some utilised Constructivist sets by Popova, Stepanova and others, in which he propagated his system of 'bio-mechanics'; others were derived from agit-prop political productions, which eventually got him into trouble with his Communist masters.

Grigor'yev's astonishing portrait dates from the St Petersburg years, when Meyerhold was combining his work as director of the Imperial Theatre, with experimental work in various small theatres and studios under the pseudonym of Dr Dappertutto (Dr Everywhere). The *commedia dell'arte* was an important source of inspiration, and he was developing a theory of the actor-*cabotin*, a combined singer-dancer-juggler-tumbler whose mask-like presence would unite primitive and contemporary dramatic forms in a new universal theatre. Grigor'yev – who, like a number of other young Russian artists, had begun his career as an illustrator and caricaturist and had spent several years in Paris – was a member of the artistic milieu of St Petersburg. This larger-than-life work is one of his greatest portraits of the city's Bohemian circle, and a monument to its theatre and cabaret life. Drawing on what he had learned from the French avant-garde, but also from the Russian folk tradition, his dynamic expressiveness seems closer to the Otto Dix of the 1920s than to the increasing formalisation of his fellow Russian artists. In highly stylised gestures and carrying his mask on his sleeve, Meyerhold demonstrates the sort of puppet-like movements for which he had become famous while, behind him, the colourfully dressed arrow-shooting warrior evokes the world of Stravinsky's *Firebird* and the great Russian historical drama.

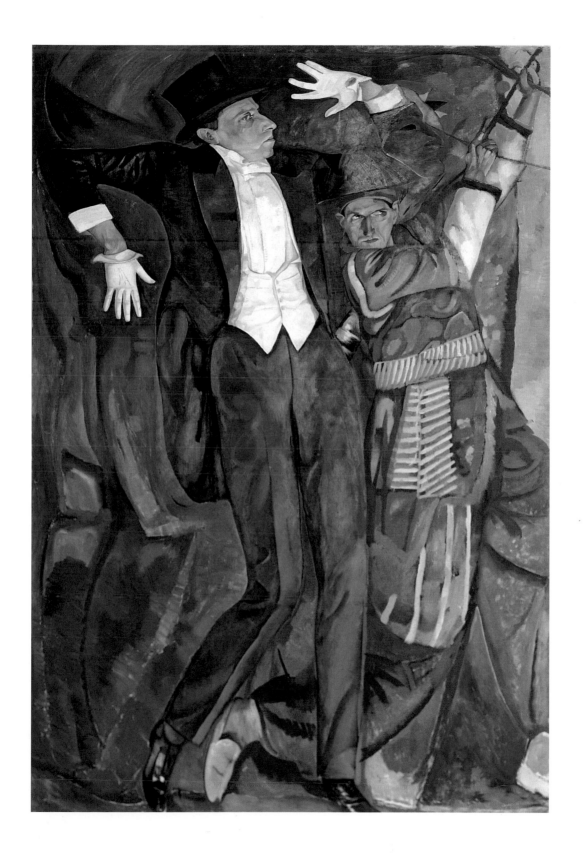

Egon Schiele
Portrait of Dr Hugo Koller, 1918

EGON SCHIELE 1890–1918

Born at Tulln an der Donau, Austria; produced Impressionistic work at the Vienna Academy, 1906–9; joined the Wiener Werkstätte and was influenced by Klimt; his mature tortured and Expressionistic style developed about 1910, when his work was constantly attacked; arrested and gaoled for making 'immoral' drawings, 1911; called up four days after his marriage in 1913; took part in the *Vienna Secession* exhibition, 1918, where his work at last received international acclaim; died shortly afterwards of Spanish influenza.

As the work of Kokoschka (p.72) also demonstrates, the Viennese appetite for contemporary art in the early years of the century unexpectedly extended to commissioned portraits, and Schiele executed a number throughout his brief career. From 1915 to 1916 there had been a distinct period of consolidation in his work towards a greater calmness and solidity and the shedding of the Jugendstil mannerisms that he had acquired from Klimt. Most noticeably as regards the portraits, a move towards greater realism involved the allocation of a specific background instead of an abstract space; as Alessandra Comini so aptly put it: 'Space is no longer regarded as a void but as environment.' Here, the extraordinary heaps of higgledy-piggledy books that surround the bibliophile and industrialist Dr Koller clearly have a symbolic and decorative purpose, even to the extent of hiding the sitter's feet (a part of the figure that Schiele often seems to have been reluctant to deal with). His wish for accuracy and a congenial setting, however, is witnessed by a number of preliminary drawings, including a study of the armchair.

Despite poor health Schiele had been called up in 1915, but by early 1917 he had been transferred to office duties in Vienna and he never saw the horrors of active service at the front. Scarcely a ripple of apprehension about the war disturbs the increasingly calm surface of his later work. Like many other intellectuals, Schiele seems to have felt that, although the war was lost, Austria would emerge a better place. Other portraits of the enlightened Viennese bourgeoisie appear to reflect a similar attitude, though Dr Koller's abstracted air and the precariously stacked emblems of the old civilisation might be interpreted as conveying an underlying sense of anxiety. The success of Schiele's contribution to the 1918 *Vienna Secession* exhibition was to be short-lived: the appalling influenza epidemic that had carried off his friend Klimt in February robbed him of his pregnant young wife and unborn child on 28 October. He followed them three days later.

Oil on canvas
1400 × 1100mm (55 × 43¼")
Österreichische Galerie, Belvedere, Vienna

REFERENCES

A. Comini, *Egon Schiele's Portraits*, London, 1974, pp.166–7, pls.160, 161, 163

G. Malafarina, *L'Opera di Schiele*, Milan, 1982, p.170, pl.XLVI

Claus Bergen
The Commander (On the Deck of a German U-Boat), 1918

CLAUS BERGEN 1885–1964

Born in Stuttgart; studied at the Munich Academy and became an illustrator like his father Fritz Bergen; official marine war artist from 1916; after 1945 reverted to scenes of historical naval warfare, unpopulated seascapes much prized by collectors and landscapes from the neighbourhood of Lenggriess, Upper Bavaria where he spent the rest of his life.

Oil on canvas
1600 × 2290mm (63 × 90¼″)
National Maritime Museum,
Greenwich, London

REFERENCES

K. Neureuther and C. Bergen, *U-Boat Stories: Narratives of German U-Boat Sailors*, London, 1931, pp.v, 15

B. Herzog, *Claus Bergen, Leben und Werk*, Gräfelfing, 1988

As part of the general re-armament in the years leading up to the First World War, all the major powers were developing submarines which would operate both on the surface and beneath the sea, using torpedoes against conventional shipping. The projects were costly both financially and in terms of human lives: in January 1911 the German submarine U-3 sank in Kiel harbour with the loss of all twenty-six crew. Within months of the outbreak of war, however, the loss of hundreds of men in a few minutes became commonplace: in one day, 22 September 1914, the German U-9 sank three British cruisers off the Dogger Bank – *Aboukir*, *Hogue* and *Cressy* – with the loss of 1,459 lives. By October 1916 the Kaiser was congratulating the German U-boat service on having sunk one million tons of Allied shipping. Small wonder then that the Germans were confident that their continuing U-boat offensive would eventually break British resolve.

In 1917, with Germany stepping up U-boat warfare, the leading German marine painter, Claus Bergen, obtained permission to accompany U-53 and its commander Hans Rose on a long mission; he later recalled it, both in this painting and in a book he published with Karl Neureuther in 1930, *Wir leben noch!* [We're still alive!] (translated as *U-Boat Stories*, 1931). Interestingly, Bergen had spent a considerable number of years before the war (1908–13) painting in Polperro, Cornwall, before becoming an official war artist to the German navy in 1916. In 1922 he became an early member of the Nazi party and an efficient propagandist painter who produced glorifications of the Second World War at sea for Admiral of the Fleet Dönitz. In 1939, he co-operated with Commander Rose on another U-boat book, *Auftauchen!* [Surface!].

With its date of 1918, it is tempting to view Bergen's rear-view portrait of the commander as an image of defeat. It is, however, primarily a painting in the German Romantic tradition going back to Caspar David Friedrich, of man in communion with the grandeur of nature. The artist's patriotic view of the *Boys' Own*-style anecdotes in *U-Boat Stories* makes it clear that this is a painting about the loneliness of command, of responsibility for the crew and for the huge craft, which dominates the foreground of the painting but which will never dominate the boundless ocean of which Bergen is the painter par excellence. This is academic painting at its very best.

Amedeo Modigliani
Lunia Czechowska in Black, 1919

AMEDEO MODIGLIANI 1884–1920

Born in Livorno, Italy, the son of a Jewish banker; studied at the Venice Academy and settled in Paris, 1906; after meeting Picasso, Soutine, Max Jacob and others, was influenced by African sculpture and radically altered his style; met Brancusi in 1909, and subsequently worked on his own distinctive sculpted heads 1911–12; tuberculosis and extreme poverty, drink and drugs hastened his premature death in January 1920.

Unlike the many portraits by his slightly older contemporary Matisse which always have a sense of development, the several hundred portraits done by Modigliani between 1914 and 1919 are remarkably consistent (exhibited *en bloc* they would undoubtedly look repetitive). Having learned from the sculpture with which he was experimenting in 1911 and 1912, he was able to apply similar principles of pseudo-primitive simplification to his paintings; broken only by a series of incandescent nudes, these proceeded almost without a break until his premature death. At times, Modigliani's portraits have an almost wilful egotism and over-stylisation, rather like the early portraits of Egon Schiele, but they differ fundamentally from Schiele's in their inscrutable calm and pathos. The consistency of his work and his apparently insatiable desire to record the faces of his friends and lovers is in strong contrast to the irregularity of his lifestyle and may well have been the one constant on which he could rely.

There has often been speculation about the direction Modigliani's art might have taken had he lived longer than his thirty-five years. Clues in the later portraits, especially in highly simplified ones such as *Lunia Czechowska with a Fan* (1919; Musée de l'Art Moderne, Paris) suggest that he might have moved into something approaching abstraction. Lunia Czechowska was one of a small group of *émigré* Poles in the circle of the poet Léo Zborowski. She became a close friend of Modigliani, sitting for about ten portraits and recording her memoirs of him for one of the many posthumous biographies.

Léo Zborowski met Modigliani in 1916 and soon became, in effect, his dealer and mentor, supporting him with a regular income. Modigliani painted portraits of him, his wife Hanka and of Lunia at Zborowski's flat. In 1918, with Modigliani's health in a parlous state and Paris under German bombardment, Zborowski paid for the artist and his pregnant mistress Jeanne Hébuterne to live in the south of France for more than a year. Experience of the Mediterranean lightened Modigliani's palette and provided him with new subject matter in the form of the local people and, for the first time in his career, landscapes. The late portraits, such as this gravely beautiful image of Lunia, were all produced after his return to Paris in May 1919. It is a serene, almost cool painting, the lightly sketched-in iron bedhead heightening the all-pervading sense of melancholy. Lunia recalled later that although their relationship remained platonic, Modigliani's feeling for her at the time was one of intense love.

Oil on canvas
914 × 609mm (36 × 24″)
Private collection

REFERENCE

L. Piccioni and A. Ceroni, *I Dipinti di Modigliani*, Milan, 1970, p.104 (no.318)

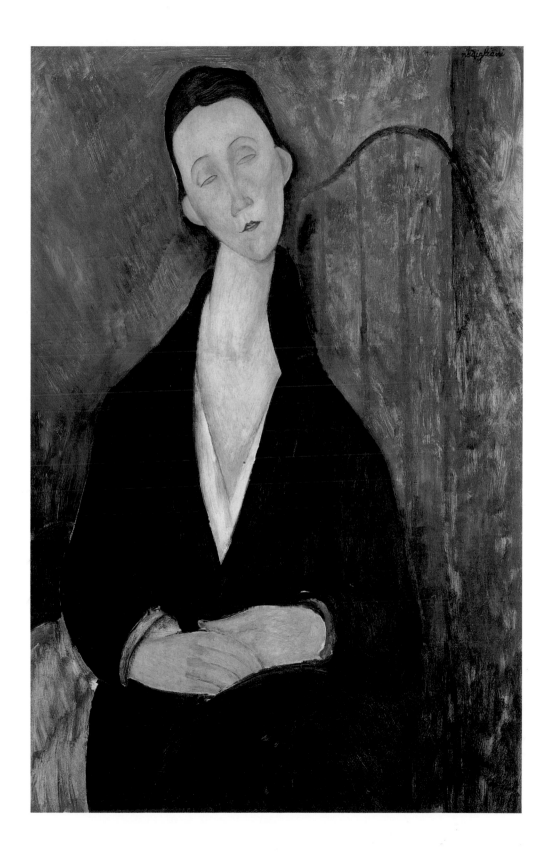

1920s

The 'Roaring Twenties', largely confined to the United States, contrasted jazz bands and speakeasys with the realities of prohibition, political repression and isolationism. Berlin, during a period of runaway inflation, led Europe as the centre of intellectual activity and hedonism. Motor cars, aeroplanes, radio and Hollywood films shortened distances between nations, and 'modernism' – in the form of abstraction, Surrealism and Bauhaus architecture – became fashionable. Britain's General Strike and the Wall Street Crash were symptoms of general economic instability.

HISTORICAL EVENTS

1920

Home Rule Act gives independence to Ireland, but retains Ulster as part of Britain.

Estonia, formerly a Russian province, declares independence and signs a peace treaty with the USSR.

Inauguration of the League of Nations.

American women are given the vote.

Prohibition introduced in the US.

In China, earthquake in Kansu Province kills 180,000 people.

1921

Anglo-Irish Treaty ratified by British Parliament.

Hitler made president of the new National Socialist Party.

Germany defaults on its Treaty of Versailles reparations.

Fascist riots in Florence.

Famine in Russia.

1922

In Ireland, death of President Arthur Griffith; ten days later, Commander-in-Chief Michael Collins murdered; Civil War ensues.

Gandhi sentenced by the British to six years' imprisonment for civil disobedience campaign (he served 22 months).

Murder by the Nazis of German Foreign Minister Walther Rathenau, who was Jewish.

In Italy, Mussolini becomes Prime Minister.

Insulin isolated from the pancreas, and found to provide a treatment for diabetes.

In Egypt, tomb of King Tutankhamun discovered by Britons Carter and Carnarvon.

1923

German hyper-inflation at its peak.

Hitler, in prison, dictates to Rudolf Hess his plan for the conquest of Europe, *Mein Kampf* (My Struggle).

Mussolini orders the bombardment and occupation of Corfu.

Calvin Coolidge elected President of the US.

In the decade of Prohibition, over 300,000 people convicted for bootlegging under the Volstead Act.

In Japan, an earthquake strikes Tokyo and Yokohama; 140,000 people are killed.

In Britain, The Duke of York marries Lady Elizabeth Bowes-Lyon.

1924

In Britain, first Labour Government takes office.

Death of Lenin.

Murder by Fascists of Italian Socialist party leader Giacomo Matteotti; Mussolini takes full responsibility.

First Winter Olympic Games held at Chamonix, France.

Republic of Turkey proclaimed under Mustapha Kemal.

Introduction in the US of a new immigration law, limiting numbers to just 2 per cent of any nationality; Japanese are totally excluded.

CULTURAL EVENTS

1920

In Moscow, Vladimir Tatlin presents his constructivist tower, *Monument to the Third International*.

Realist Manifesto for the newly created Constructivist movement launched by sculptor Naum Gabo and his brother Antoine Pevsner.

Publication of D. H. Lawrence's *Women in Love*; H. G. Wells's *Outline of History*.

1921

Production of Meyerhold's constructivist play, *The Magnanimous Cuckold*.

Composition of William Walton's musical 'entertainment', *Façade*.

Publication of Aldous Huxley's *Crome Yellow*.

Release of Rex Ingram's silent film adaptation of *The Four Horseman of the Apocalypse*, starring Rudolph Valentino and Alice Terry.

Mies van der Rohe experiments in Berlin with transparent buildings made of glass.

Publication of Ludwig Wittgenstein's highly influential *Tractatus Logico-Philosophicus*.

1922

Publication (in Paris) of James Joyce's *Ulysses*; T. S. Eliot's poem *The Waste Land*.

Release of F. W. Murnau's film *Nosferatu the Vampire*.

First regular broadcasts by the BBC.

1923

Publication of Wallace Stevens' collection of verse *Harmonium*; Rainer Maria Rilke's *The Duino Elegies*; P. G. Wodehouse's *Leave it to Psmith*.

Tallulah Bankhead arrives in Britain from New York, and takes the London stage by storm.

Release of the comic Western film *Our Hospitality*, directed by and starring Buster Keaton in his first feature-length masterpiece.

1924

Artist and filmmaker Fernand Léger makes *Le Ballet mécanique*, an experimental short film exploring rhythm and motion.

Manifesto of Surrealism published by André Breton.

Composition of George Gershwin's *Rhapsody in Blue*.

First performance of Noel Coward's play *The Vortex*.

Publication of E. M. Forster's *A Passage to India*.

Britain returns to the gold standard.

In Italy, Mussolini's cabinet formed entirely of Fascists.

In Germany, Field Marshal Paul von Hindenburg elected President.

In the USSR, Josef Stalin and Leon Trotsky have battled for leadership; Trotsky steps down from his chair at the Russian Revolutionary Military Council.

Iraq's first parliament is opened by King Faisal in Baghdad.

Germany admitted to the League of Nations.

In Poland, coup staged under Josef Pilsudski.

In the US, first rocket-powered guided missiles demonstrated by Robert H. Goddard.

World Economic Conference takes place in Geneva.

Trotsky expelled from the Communist Party as a 'deviationist'.

In Austria, riots against the Nazis.

Italy and Hungary sign a treaty of friendship.

In China, young Chinese communist Mao Tse-tung leads several hundred peasants to the Ching-Kang Mountains.

In the US, flooding of the Mississippi River causes damage to property of $285 million.

First solo non-stop Atlantic crossing, from New York to Paris, made by Charles Lindbergh in his monoplane, the *Spirit of St Louis*.

Kellog–Briand Pact, outlawing war and providing for world opinion and diplomacy, signed by 62 nations.

In Britain, women get the vote on equal terms with men when the female qualifying age is reduced from 30 to 21.

Scottish bacteriologist Alexander Fleming discovers penicillin.

First commercial flight by Zeppelin airship from Germany to New Jersey takes 4½ days.

Wall Street Crash causes widespread bank failure and unemployment in the US; economic repercussions spread to Europe.

Kellog–Briand Pact accepted by Germany.

In the USSR, Trotsky exiled; Stalin establishes first Five-Year Plan.

Lateran Treaty signed by Mussolini and the Vatican, giving Vatican City status of an independent state.

Turkey adopts women's suffrage.

Herbert Hoover becomes President of the US.

In Britain, Ramsay MacDonald becomes Labour Prime Minister.

1925 1926 1927 1928 1929

First performance of Alban Berg's opera *Wozzeck*.

Publication of John Dos Passos's *Manhattan Transfer*; Gertrude Stein's *The Making of Americans*; Virginia Woolf's *Mrs Dalloway*; F. Scott Fitzgerald's *The Great Gatsby*.

Release of Sergei Eisenstein's film *The Battleship Potemkin* at Moscow's Bolshoi Theater, making him a celebrity overnight; Charlie Chaplin's film *The Gold Rush*.

The Charleston dance introduced to the screen by American actress Bessie Love in *The King of Main Street*.

First commercial phonograph records released for sale.

Publication of André Gide's *The Counterfeiters*; T. E. Lawrence's autobiographical *The Seven Pillars of Wisdom*; Franz Kafka's *The Castle* (posthumously).

Mae West's first play *Sex*, which she wrote, produced and directed, causes a sensation on Broadway.

Release of Fritz Lang's *Metropolis*.

Composition of Maurice Ravel's *Violin Sonata*.

Release of *The Jazz Singer*, the first full-length talking film, starring Al Jolson; the silent comedy *Long Pants*, directed and co-written by Frank Capra; Abel Gance's epic film *Napoleon* at the Paris Opera, the only film ever to be shown there.

Clara Bow, a popular symbol of the flapper era, stars in *It*, from a story by Elinor Glyn; she becomes known as the 'It' girl.

Publication of Martin Heidegger's philosophical tract *Being and Time*.

Le Corbusier begins work on the Villa Savoye, Poissy.

Composition of Maurice Ravel's ballet music *Bolero*.

Publication of D. H. Lawrence's *Lady Chatterley's Lover*; Virginia Woolf's *Orlando*; Evelyn Waugh's *Decline and Fall*.

Release of *Steamboat Willie*, the first Mickey Mouse cartoon, by The Walt Disney Company.

Tallulah Bankhead appears in two British films, *His House In Order* and *A Woman's Law*.

Publication of Evelyn Waugh's *Decline and Fall*; Graham Greene's *The Man Within*; Erich Maria Remarque's *All Quiet on the Western Front*.

First performance of Jean Cocteau's *Les Enfants Terribles*.

Release of the Surrealist film *Un Chien Andalou* by Luis Buñuel and Salvador Dalí.

Mies van der Rohe's *German Pavilion* constructed for the Barcelona International Exhibition.

First awards ceremony for the film industry (later known as the Oscars) takes place in Hollywood.

Kodak develops 16mm colour film.

Max Beckmann
Family Picture, 1920

MAX BECKMANN 1884–1950

Born in Leipzig; studied in Weimar (1900–03) in 1910 was briefly connected with the Berlin Secession; reacted against his early Expressionist work with the New Objectivity movement, but soon developed his mature style with boldly painted figure subjects, often on mythological themes; Professor at Frankfurt from 1925 until dismissed by the Nazis, 1933; exiled in Amsterdam until 1947, when he emigrated to the USA.

This is a classic example of the verist approach that Beckmann developed in Frankfurt after the First World War, which caused him briefly to become one of the leading figures in the New Objectivity movement in 1925. Ostensibly a fairly straightforward painting of a family evening at home, even the most cursory of glances shows that it is far from objective and is riddled with the anxieties of post-war Germany. The artist, stretched out on the long piano stool, imagines himself together (though by no means communicating) with his family, from whom he in fact lived apart. His corseted wife, Minna Tube, the symbol of his sexual desires, appears totally engrossed in her own reflection; his mother-in-law stops what she is reading and covers her face with her hand; a sister-in-law gazes moodily at the candles, while a servant on the right reads the newspaper. Stretched out on the floor, ignored by and ignoring all, is Beckmann's son Peter.

While the scene is obviously claustrophobic, the feeling of unease is heightened both by the instability of the perspective (which Beckmann had probably learned from a study of Gothic painting) and by innumerable small and unexplained details which are too specific to be accidental. There is no clear way in or out of the room (both doorways are blocked by furniture), and only the mysterious crowned figure arriving in the space behind the piano seems to have found a way in. The piano itself has a small dog sitting on the keyboard and a recently snuffed, still smoking candle – symbols perhaps of artistic creativity that cannot function in this situation. The artist is the bearer of a message (symbolised by the horn), but cannot arouse himself from lethargy; the kite on the floor cannot be flown in this room. While this is clearly a 'modern' painting in both concept and technique, it carries no hint of the bright new world that the war had been expected to usher in. The corset, the hairstyles, the oil lamps and candles, and the old-fashioned piano are relentlessly Edwardian in detail. As in many great works of art, the *minutiae* and emotion of the artist's own experience are here translated into imagery of far wider contemporary significance.

Oil on canvas
651 × 1010mm (25⅝ × 39¾")
The Museum of Modern Art, New York
Gift of Abby Aldrich Rockefeller, 1935

REFERENCE

P. Selz, *Max Beckmann*, New York, 1950, pp.34–5

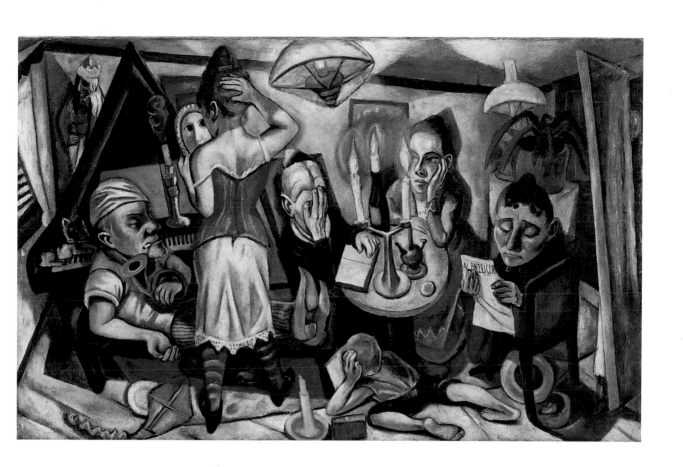

Meredith Frampton
Winifred Radford (Mrs Douglas Illingworth), 1921

MEREDITH FRAMPTON 1894–1982

Painter, born in London, son of sculptor Sir George Frampton; attended Royal Academy Schools from 1913; exhibited thirty-two paintings at the R.A. 1920–45; specialised in portraits but poor eyesight caused him to give up painting after 1945.

Oil on canvas
892 × 746mm (35⅛ × 29⅜")
National Portrait Gallery, London

REFERENCE

R. Morphet, *Meredith Frampton*, exh. cat., Tate Gallery, London, 1982, pp.34–5 (no.5)

1921 was one of those years when the Royal Academy of Arts in London periodically decided to bring itself up to date. As it was, the dropping of the usual run of 'problem' pictures by favourite artists such as the Hon. John Collier, the election to Associate of Augustus John and the inclusion of a painting by Henry Lamb were enough to secure headlines such as 'An Artistic Revolution' and 'A New Spirit'. As one older exhibitor, Frank Salisbury, grumbled, many works by young artists (one of whom was only fifteen) were included at the expense of more mature ones. Amongst the exhibits was Meredith Frampton's portrait of the young singer, Winifred Radford, commissioned by her husband.

In British terms, this portrait was of course 'modern art' in 1921. Its neo-classicising perfection and tonal modelling were a long way removed from the work of those older painters who were still working in the watered-down Impressionism of Sargent and his followers, or even of the Post-Impressionism of the painters associated with the Bloomsbury group. The primary influences at work here are clearly those of Italian *quattrocento* painters; this portrait would sit quite happily with the work of a number of Italian painters of the day who were connected to the Valori Plastici group. The return to early Renaissance values was to prove something of a dead end in Britain, and Frampton was left to pursue a lonely path, though his work in the 1930s and 1940s did occasionally lead to comparisons with Salvador Dalí (see p.154). While the symbolism of a bird in a cage might suggest some sort of allegory for the subject's singing career, the bird appears to be a lovebird and it is probably a mistake to read too much into its inclusion. What was new here was the serene simplicity and the totally arbitrary setting.

Winfred Radford (1901–92) was still a student when the portrait was painted, but became quite well known in the years before the Second World War. She sang in the first ever opera production at the Glyndebourne Festival in 1934 and toured with the Intimate Opera Company, including a season on Broadway. After the war, she formed a radio partnership with Constance Carrodus called 'City and Countryside'. She went on to study with the great French singer Pierre Bernac and became a teacher and specialist in French song. She gave the first performance in Britain of some of Francis Poulenc's songs, and translated his *Diary of My Songs* (1985) and related works by Bernac.

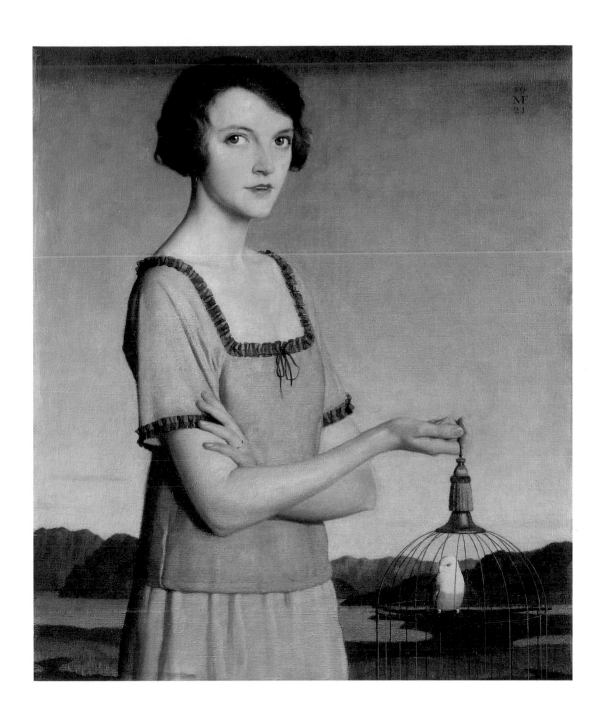

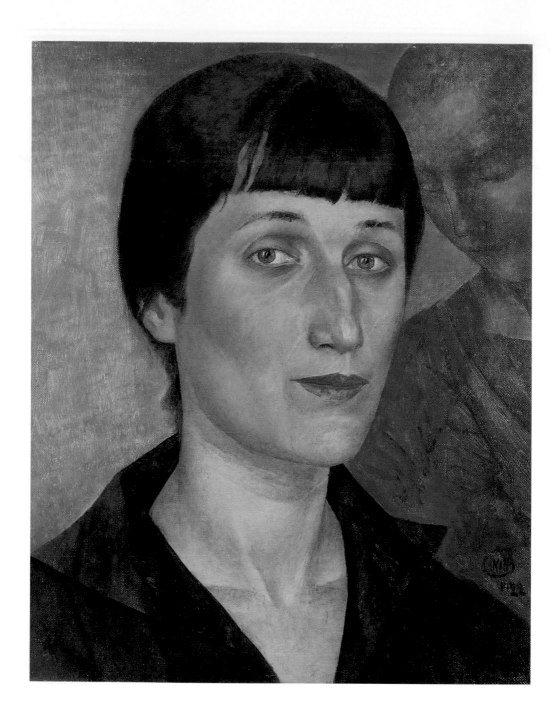

Kuz'ma Petrov-Vodkin
Portrait of the Poet Anna Akhmatova, 1922

KUZ'MA PETROV-VODKIN
1878–1939

Painter and illustrator, studied drawing
and painting in St Petersburg and
Moscow; worked in Paris (1905–8) and
travelled widely in the Mediterranean;
influential in the artistic life of
St Petersburg; participated in the
decorating of Petrograd following
the Revolution.

Oil on canvas
545 × 435mm (21½ × 17⅛")
The State Russian Museum,
St Petersburg

REFERENCES

E. N. Selizarova, *Petrov-Vodkin
(1838–1939) in the Russian Museum*,
Leningrad, 1976, p.9

I. A. Rusakov, *Kuz'ma Petrov-Vodkin:
Paintings, Graphics and Theatre Designs*,
Leniningrad, 1986, p.157

Petrov-Vodkin's early work is perhaps the most purely Symbolist to emerge from early twentieth-century Russia. Well-known paintings, such as *Red Horse Bathing* (1912, Tretyakov Gallery, Moscow), may be seen as arising from his desire to represent eternal values, specifically in his advocacy of the three-colour palette (blue, green, red) to which he remained faithful for the rest of his life. In the 1910s he painted a number of religious canvases and church murals which in part indicate the folk origins of his style. After the 1917 Revolution (which he perceived as 'an elemental and cathartic force'), he was able to adapt his principles to Soviet subjects such as *Death of the Commissar* (1928; The State Russian Museum, St Petersburg).

Anna Akhmatova (1888–1966, pseudonym of Anna Andreeyevna Gorenko) is now acclaimed as one of the greatest Russian poets of the twentieth century. With her husband, the writer Nicholas Gumilev, she launched the neo-classical Acmeist movement in St Petersburg in 1910, reaffirming Russian lyrical traditions and remaining, when possible, neutral to the Revolution when it came. Gumilev, from whom she parted in 1918, was shot for counter-revolutionary activity in 1921. The Christian undercurrent in much of her work seems to have aroused a response in Petrov-Vodkin that shines through his radiant portrait of her. A figure of suffering womankind, perhaps taken from one of Akhmatova's poems, appears as a shadowy figure in the background. This device, often used by Petrov-Vodkin, is sometimes thought to have been influenced by cinematographic superimposition. With the celestial blue of the painting, it is equally possible to sense the traditional Christian image of the madonna as its logical inspiration.

The year this portrait was made, Akhmatova published her *Anno Domini MCMXXI* and was officially silenced until 1940. In 1941 she was evacuated from Leningrad to Tashkent, where she remained until 1944. In 1946 her verse was banned as being 'too far from socialist reconstruction', and her son was arrested during the Stalinist purges. Her great works, *Poem without a Hero* and the banned *Requiem* (a cycle of poems about the purges), were published abroad. Although officially rehabilitated in the 1950s, her work was not fully appreciated in her native country until after her death.

Fernand Léger
Cubist Charlie Chaplin, 1923–4

FERNAND LÉGER 1881–1955

Born in Argentan, Normandy; apprenticed in an architect's office, he finally gained admission to the Ecole des Arts Décoratifs, 1903; produced major Cubist works from 1909; his paintings first called 'tubist', 1911; military service during the First World War spurred his interest in modern machinery; painted series of abstract murals, 1924–6; believed art should be accessible to all ranks of society, and later work was primarily figurative though still concerned with contrast between cylindrical and rectilinear forms.

Painted wood construction
700 × 300 × 50mm (27½ × 11¾ × 2″)
Musée Pierre Noël / Musée de la vie dans les Hautes Vosges, Saint-Dié-des-Vosges. Legacy: Claire Goll

REFERENCES

G. Néret, *F. Léger*, London, 1993, pp.97, 119–28

Fernand Léger et le Spectacle, exh. cat., Musée national Fernand Léger, Biot, 1995, pp.117–20, 194

Hollywood discovered the British-born Charles Chaplin (1889–1971) in 1915 after he toured America with the Fred Karno music hall troupe. The popularity of his early short films spread like wildfire; by the early 1920s his little tramp was one of the best-known characters in the world, the universally recognised underdog at odds with almost every aspect of modern life. Léger, whose interest was beginning to veer away from his Cubism towards machinery, first discovered Chaplin on a visit to the cinema with the poet Guillaume Apollinaire in 1916. 'I was completely captivated,' he wrote in 1926. 'That little man is not a man at all but a kind of *living object*, dry and mobile in black and white. There's nothing theatrical about his acting . . . he was the first "man of the screen" (man as screen image). . . He's part of the great tradition of ancient and primitive peoples who invented the mask.' Chaplin's early slapstick robotics attracted Léger when he came to make his own first film.

Léger was one of the earliest members of Paris's first film club, formed in 1920, and was involved in a number of film productions throughout his career (including H. G. Wells's *Things to Come*, 1934). A concert of work by the American composer George Antheil in October 1920 was apparently the inspiration for his film of 1924 which, in essence, was the logical conclusion of his work of 1922–3 for Rolf de Marés' Swedish ballet productions of *Skating Rink* and *La Création du Monde*. As Léger explained: 'everything is done with machinery and the play of light.' 'Painters had already destroyed the *subject*. In avant-garde films it was a matter of destroying the descriptive scenario.' Léger employed the young American director Dudley Murphy, and with the assistance of photographs from Man Ray they put together a series of sequences lasting twelve minutes. *Ballet Mécanique* was the first film to be made without a scenario. With a score by Antheil and quick cutting and repetition, Léger established analogies between mechanical and human actions. One sequence is devoted to the jerky, Chaplin-inspired movements of an articulated figure that Léger constructed in three slightly differing versions. This version (which belonged to Yvan Goll, whose *Chaplinade* Léger had illustrated in 1920) is the only one with a stick; another version (private collection) has the tramp's bowler hat. *Ballet Mécanique* survives as something of a curiosity. Antheil's outrageous score (featuring car horns, anvils and an aeroplane propeller) lives on, however, as do Léger's constructions – a tribute from one great visual poet of the twentieth century to another.

Isaak Brodsky
Lenin in Red Square, 1924

ISAAK BRODSKY 1884–1939

Painter of historical and revolutionary pictures and portraits, born in the village of Sofiyevka, Ukraine; entered the Odessa Art Institute in 1896 and also trained in Repin's studio; exhibited from 1907, and lectured at the Academy of Arts in Leningrad.

One of the most faithful and talented pupils of the great Russian realist painter Il'ya Repin, Brodsky was associated with the revolutionary movement from an early stage and became known as a political caricaturist in 1905–7. In 1917 he drew a series of portraits of the Provisional Government, and won first prize in the 1919 Great Russian Revolution competition for *Lenin and the Demonstration* (Central Lenin Museum, Moscow). Irrevocably associated with grandiose canvases depicting events from the October Revolution and portraits of Lenin and Stalin, Brodsky was a highly skilled traditionalist painter who could produce figure paintings and interiors of great beauty – for instance, *The Artist's Wife Sewing* (1930, Kalinin Art Gallery).

Something of this more personal side of his work is discernible in this uncharacteristically unrhetorical portrait of the great political leader of the Revolution, Vladimir Ilyich Lenin (1870–1924). It is unlikely that Lenin posed specifically for this dated work: he had been ill with a succession of strokes since an assassination attempt in 1918 and died early in 1924, on 21 January. All of Brodsky's paintings, however, were based on meticulous research and detailed preparatory sketches and studies (a pencil study of Lenin from life, dated 1920, is in the Central Lenin Museum, Moscow, for which this painting was also destined). The small, rather truculent figure in working man's garb is seen standing isolated from, but undisputably responsible for, the huddled masses who observe expectantly and from a respectful distance the saviour of their nation. Presumably depicting the aftermath of a demonstration, it is likely that the painting represents a particular moment in Lenin's life, but it was transformed by his premature death into an almost personal memorial tribute from the painter. An autograph replica of this portrait was sold at Christie's on 5 October 1989 (lot 415).

Oil on canvas
2850 × 1425mm (112¼ × 56⅛")
State Historical Museum, Russian Federation, Moscow

REFERENCES

I. A. Brodsky, *I. I. Brodsky*, Moscow, 1956

I. I. Brodsky. 1884–1939, exh. cat., Russian Museum, St Petersburg, 1984

Tamara de Lempicka
Auto-portrait, 1929

TAMARA DE LEMPICKA 1898–1980
Painter and portraitist, born in Poland;
lived in St Petersburg until 1917, then
studied in Paris; associated with the
Art Deco movement, she is best known
for her depictions of sophisticated
Paris society and portraits of
aristocratic sitters; eventually settled
in the USA in 1939.

Oil on panel
350 × 270mm (13¾ × 10⅝″)
Private collection

REFERENCES

K. de Lempicka-Foxhall and C. Phillips,
*Passion by Design. The Art and Times
of Tamara de Lempicka*, London, 1987,
pp.76–7

A. Blondel, *Tamara de Lempicka:
Catalogue Raisonné 1921–1979*, London,
1999, pp.196–7 (B.115, titled *Mon
Portrait*)

For many years dated to 1925 on the hazy recollections of the artist, this now famous self-portrait has been shown in a recent catalogue raisonné of Lempicka's work to have been painted in 1929. The artist remembered correctly that the painting had been commissioned by the editor of the German fashion magazine *Die Dame* for a cover illustration, but this in fact appeared in July 1929. Further research suggests that it may have been inspired by a photograph by André Kertész of a woman in high fashion Hermès motoring gear at the wheel of her car, published in *Vu* in 1928.

For some time the painting was known as *Tamara in her Green Bugatti* (and also as *Mon Portrait*), although in the biography that her daughter, Baroness Kizette de Lempicka-Foxhall compiled from her reminiscences, the artist admitted only to driving a yellow Renault. One story goes that the editor saw her in the car and left a note on the windscreen asking her to make contact; when she discovered who the driver was, she commissioned the painting.

Whatever the various legends behind this work, it has assumed an iconic status, the ultimate image of the new twentieth-century woman, free to do as she pleases and go where she chooses. *Auto-portrait* is of course a pun; by the 1920s, car-ownership in Europe became commonplace, and served as *the* symbol of modern life, of speed and of personal independence. The late 1920s were the years of the slinky and predatory vamp, photographed for countless magazines in close-fitting helmet-like headgear, with a hand resting negligently on the bonnet of a car or the head of a borzoi dog. The look is of Diana the huntress, steely-eyed and imperious, painted in the watered-down Cubism that Tamara had learned from her teacher, André Lhote; the style was given its definitive stamp as Art Deco by the 1925 Paris *Exposition Internationale des Arts Décoratifs et Industriels Modernes*. De Lempicka had divorced her Russian husband the year before, and with a reputation herself for sexual ambiguity, capitalises on this and on her contempt for bourgeois niceties. Her greatest paintings show women as decorative sexual playthings; her occasional portraits of men depict cruel-eyed and deeply flawed predators. She placed herself somewhere in between: 'I live on the fringes of society,' she wrote, 'and the rules of normal society have no currency for those on the fringe.'

Georg Scholz
Self-portrait in front of an Advertising Column, 1926

GEORG SCHOLZ 1890–1945

Born in Wolfenbuttel, Germany; studied at the School of Fine Art in Karlsruhe (1908 and 1912) and in Berlin with Lovis Corinth; founding member of the Novembergruppe, 1919; responsible for decorating the Church of St Urban, Freiburg; in his later career turned to painting urban and industrial landscapes; professor at the School of Fine Art in Karlsruhe from 1925 until dismissed by the Nazis in 1933.

The inter-war years in Germany produced a staggering number of gifted artists, many of whose careers (and, as a consequence, their international reputations) were cut short by Nazi censorship of their work. In the early 1920s Scholz, whose style underwent a number of radical transformations, produced some of the most bitterly satirical work associated with the New Objectivity movement. His well-known *Industrial Farmers* (1920; Von der Heydt Museum, Wuppertal) with its Grosz-like collages, even provoked a parliamentary question in the Reichstag. As a paid-up member of the Communist Party, his paintings of small-town life around Karlsruhe, where he was teaching, mercilessly exposed the bigotry of bourgeois life and politics.

When Scholz was appointed professor at the Baden State Academy in 1925, he was in his mid-thirties and his work was already beginning to take a more conventional, if 'magic' realist, turn. His devastatingly frank self-portrait shows him transformed into a member of the bourgeoisie he had so bitterly attacked a few years earlier; it may be a sardonic comment on his new appointment. Looking slightly bewildered in his new role, Scholz presents himself as an observer, peering intently through round spectacles. No longer the scourge of small-town bigotry, he now finds himself confronted, and probably alienated, by the tokens of modern city life – on one hand, its ephemerality and tackiness symbolised by the bombardment of advertising (the 'most beautiful woman in Europe' is one of the attractions on offer); on the other, the lure of wealth (unobtainable for many) and speed symbolised by the de luxe automobile behind the plate glass window. Scholz's search for new modes of expression in a time of political upheaval later led him to a detached neo-classicism based on the *valori plastici* of de Chirico and Casorati, and thence to a more experimental style related to the work of French figurative painters such as Matisse and Bonnard. Banned in 1933, he retired to small-town life to escape the Nazis, and converted to Catholicism. In a final irony, shortly before his death in 1945, the French occupying forces created him mayor of his adopted town of Waldkirch.

Oil on pasteboard
600 × 778mm (23⅝ × 30⅝")
Staatliche Kunsthalle, Karlsruhe

REFERENCE

S. Michalski, *New Objectivity*, Cologne, 1994, pp.98–102, 217–18

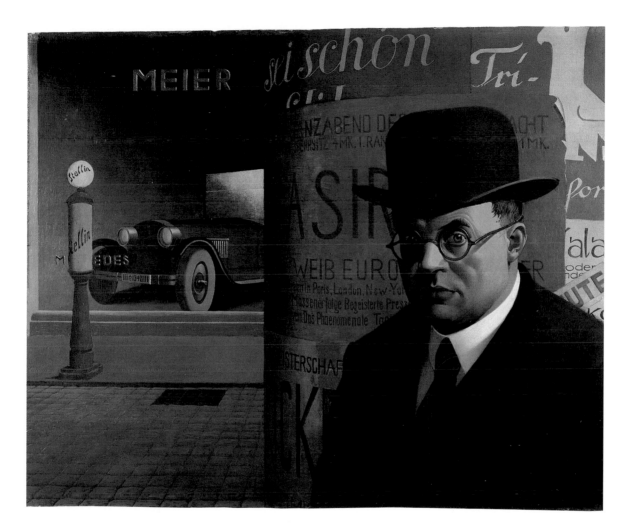

Pavel Tchelitchew
Edith Sitwell, 1927

PAVEL TCHELITCHEW 1898–1957

Painter and designer, born and studied in Russia; worked in Berlin and then in Paris (1923–34) as a scenic designer for ballets, and earned a reputation as one of the most innovative stage designers of his period; moved to New York in 1934 where he produced a series of large allegorical and meta-morphic works; eventually settled in Italy in 1950.

Gouache with sand on paper
619 × 473mm (24⅜ × 18⅝″)
National Portrait Gallery, London

REFERENCES

The Sitwells and the Arts of the 1920s and 1930s, exh. cat., National Portrait Gallery, London, 1994, pp.133–7, no.4.8

L. Kirstein, *Tchelitchev*, Santa Fe, 1994, pp.55–8

An *émigré* from Russia like his exact contemporary Tamara de Lempicka (see p.105), and openly homosexual, Tchelitchew's artistic talents were less obviously brash and commercial than his compatriot's. He was taken up by the formidable American writer and patron Gertrude Stein after his arrival in Paris in 1923, probably in around 1927 when the brightest stars of Stein's salon such as Picasso and Matisse had begun to drift away. Stein had become friends with the English poet Edith Sitwell (1887–1964) in 1924. Doubtless keen to be recognised as the British Gertrude Stein, Sitwell cultivated the friendship; eventually, with her brothers Osbert and Sacheverell, she stage-managed Stein's lectures in Oxford and Cambridge in the spring of 1926. Stein introduced her to Tchelitchew in 1927, and she gradually replaced the American as Tchelitchew's champion and muse. She always called him 'Pavlik', and their relationship soon began to resemble a love affair. Described by the Australian painter Stella Bowen as 'each of them a packet of nerves, infusing therefrom a palpitating and sensuous life into their respective work', they wrote to each other constantly after Tchelitchew's move to New York in 1934. Their relationship, however, did not survive their reunion when Sitwell made her first visit to America in 1949.

Tchelitchew painted six major portraits of Edith Sitwell. This is probably the first, the last being a large painting of 1937 depicting her as a 'sibyl' which was in the collection of the artist's other major patron, Edward James. Writing from Monte Carlo, where he was working on the Diaghilev ballet *Ode*, Tchelitchew told her that Gertrude Stein had thought it a good likeness and was pleased that Edith liked it. The following year, 1928, the portrait was included in his London exhibition, which was arranged by Sitwell at the Claridge Gallery; it was also used in the extensive press coverage that she drummed up. She had it printed as the frontispiece in the special first edition of her *Collected Poems* (1930). While it is one of the most interesting of the six portraits, it is distinctly less personal than its successors, and is clearly influenced by Picasso's monochromatic and pre-Cubist work, which Tchelitchew would have seen in Stein's apartment. Indeed, it somewhat resembles the 'Easter Island idol', which was how Sitwell described Stein's appearance when she first met her. The textured and pitted surface and photographic coloration distinguish the work as a creation of the late 1920s, but its incandescence and idealisation are prophetic of the poetic and Symbolist vein in Tchelitchew's work which occasionally relate it to Surrealism.

William Nicholson
Sidney and Beatrice Webb (Lord and Lady Passfield), 1928–9

WILLIAM NICHOLSON 1872–1949

Born in Newark, Nottinghamshire; studied in London and Paris; established a fashionable practice painting portraits from 1917, but is also remembered for the posters he and his brother-in-law James Pryde jointly produced under the pseudonyms J. and W. Beggarstaff; also painted still lifes and landscapes.

Oil on canvas
1346 × 1740mm (53 × 68½")
The London School of Economics and Political Science, London

REFERENCES

M. Steen, *William Nicholson*, London, 1943, pp.217–18

A. Nicholson, ed., *William Nicholson, Painter*, London, 1996

Writing in 1942, Marguerite Steen (who was William Nicholson's companion for the last ten years or so of his life and who therefore presumably reflected to some extent his own opinions) compared this portrait with one he had recently completed, *Lord and Lady Strafford in their Library*: 'the two together . . . afford an almost Hogarthian commentary on the old and the new aristocracy. The one, with its ugly modern fireplace of a suburban villa, its litter of documents, the earnest shapelessness of Lord Passfield's trousers, his carpet-slippers, his wife's hand clawing absently towards an economical fire, epitomises low living and high thinking as thoroughly as the other epitomises high living and as little thinking as possible . . . Simplicity to the point of austerity, self-sacrifice and the art of living for others have somehow found their way on to the Webb canvas.' Although the huge Arts and Crafts fireplace of their house (Passfield Corner at Liphook, Hampshire) now seems nothing like a 'suburban villa', and 'simplicity to the point of austerity' is not the first thing that would strike us about this obviously upper-middle-class couple, Steen is of course correct, and this is an archetypal image of the affluent British left-wing intellectual at home. Even the Webbs' clothes and appearance – he with the intellectual's beard and she in a loose-fitting dress of good material, her hair sensibly swept back in a practical bun – differ little from what we might expect of a similar couple now.

The portrait is not, however, just Hogarthian commentary. It was an official commission from the London School of Economics, which the Webbs had founded in 1895. Sidney Webb (1859–1947), who had been introduced to the socialist Fabian Society by G. B. Shaw in 1885, is shown as the man of action, the MP and cabinet minister in the Labour Government, his briefcase by his chair, reading his correspondence and ready to go out again. Beatrice (1858–1943), daughter of a wealthy industrialist, is the visionary, the thinker and writer, perhaps making a cogent point to which her husband is paying careful attention. After a series of massively influential volumes of social and political history which they published jointly, and a lifetime of social campaigning and public service, they visited Russia in 1932 (as many intellectuals of the period did), and published their impressions in *Soviet Communism: a New Civilisation?* (1935). Nicholson, one of Whistler's most imaginative British followers, gives us a narrative of their lives with telling detail and great sensitivity.

Mikhail Nesterov
Academician Ivan Petrovich Pavlov, 1930

MIKHAIL NESTEROV 1862–1942

Born in Bashkirskaya, Russia; studied at the Moscow School of Painting, Sculpture and Architecture, (1877–81) and under Chistyakov at the Academy of Arts, St Petersburg (1881–3) early work mostly of religious and Symbolist subjects, but became known as a portrait painter, especially after the Revolution.

Ivan Pavlov (1849–1936) won the Nobel Prize in 1904 for his work on the digestive system, but he will always be remembered instead for his experiments on dogs and the 'conditioned reflex'. *Conditioned Reflexes*, published in 1927, described how dogs could learn to salivate at the sound of a bell; Pavlov then applied these findings to human behaviour with far-reaching consequences leading to the development of behavioural psychology. Based throughout his career in St Petersburg, Pavlov was constantly critical of the Soviet government, which refused his request to move his laboratory abroad but continued to support his work. Suspicion remains that, despite his stated opposition, the regime imagined that his research would confirm its theories of social engineering.

Nesterov's early works around the turn of the century, such as *The Hermit* (1890) and *The Great Taking of the Veil* (1898; both The State Russian Museum, St Petersburg), are basically Symbolist, influenced to an extent by Puvis de Chavannes, and he painted a number of wall paintings for churches. From 1900 he turned increasingly to portraits, including one of the writer Tolstoy (1907; Tolstoy Museum, Moscow); after the Revolution, portraiture and landscape provided an uncontroversial outlet for his art. The portrait of Pavlov betrays something of the scientist's impatience at having to pose. It shows him sitting in his study at home in the little town of Koltushi near St Petersburg, and is painted in the standard academic Impressionism that Nesterov used in his later work. 'Despite his eighty-one years, his white hair and beard, he appeared thriving with a very youthful air about him,' the artist wrote later. 'His speech, his gestures . . . the very sound of his voice, his surprising lucidity and the youthful spirit of his ideas all attracted me.' Pavlov and Nesterov (himself also an *éminence grise*) became friends; another portrait appeared in 1935, shortly before Pavlov's death (Tretyakov Gallery, Moscow).

Oil on canvas
800 × 770mm (31½ × 30¼")
The State Russian Museum,
St Petersburg

REFERENCES

L. Singer, *Mikhail Vasilievich Nesterov*, Moscow, 1959, pp.12–13

A. Lebedev, ed., *Soviet Painting in the Tretyakov Gallery*, Leningrad, 1976, pp.10–11, 84–5

1930s

The rise of nationalism against a background of economic depression gave rise to fascist dictatorships in half of western Europe and most of eastern Europe. In 1933 President Roosevelt offered the US a New Deal, while Hitler was appointed Chancellor in Germany. The Spanish Civil War united Western intellectual opinion and inspired major artistic works such as Picasso's *Guernica*, but it also provided a testing ground for the weapons and tactics of the next world war. In the face of inevitable conflict, popular culture and cinema became increasingly escapist and glamour-orientated.

HISTORICAL EVENTS

1930

President Hoover signs Hawley–Smoot Tariff, raising duty on some goods to a prohibitive degree; depression spreads around the world.

Naval treaty signed by Britain, France, Italy, Japan and the US.

In Germany, Nazis gain 107 seats in the Reichstag, mainly from moderates, and become the second largest party in government.

Treaty of friendship signed between Turkey and Greece.

Death of Empress Zaudito in Ethiopia; Ras Tafari, with whom she had shared control, proclaims himself Emperor.

Discovery of the planet Pluto.

Amy Johnson flies solo from Britain to Australia in 19 days.

1931

Formation of the fascist New Party by Sir Oswald Mosley.

Gandhi released from prison to participate in discussions that result in the Delhi Pact.

In Austria, bankruptcy of Credit-Anstalt leads to economic collapse of central Europe.

In Britain, Ramsay MacDonald resigns because of financial crisis, and a coalition government is formed; riots in London and Glasgow; Britain goes off the gold standard.

Japan invades Manchuria.

In China, Mao Tse-tung establishes the first Chinese Soviet Republic in remote Kiangsi Province.

1932

Bill establishing a Reconstruction Finance Corporation signed by President Hoover.

Hitler defeated by Hindenburg in German presidential election.

Civil disorder in Germany, resulting from actions of Nazi Stormtroopers.

Non-aggression pacts concluded between Russia and its western neighbours Poland, Estonia, Latvia, Finland and, later, France.

In Ireland, Eamon de Valera elected President.

In US, Theodore Roosevelt becomes President.

In Japan, Prime Minister Ki Inukai assassinated by military reactionaries.

1933

In Germany, Hitler becomes Chancellor.

National boycott of Jewish businesses and professionals; Reichstag building destroyed by fire; burning of books considered subversive begins in Berlin.

Austrian Nazis riot in Vienna.

Formation of the Spanish Fascist Party.

Japan leaves The League of Nations.

Renewal of diplomatic relations between the US and Russia, suspended since 1919.

In the US, Prohibition repealed.

American aviator Wiley Post completes the first solo flight around the world, covering some 15,600 miles.

1934

Non-aggression pact concluded between Germany and Poland.

Death of Hindenburg; Hitler appointed Führer (Leader) of Germany.

Balkan Pact forged between Greece, Turkey, Rumania and Yugoslavia .

Assassination of King Alexander of Yugoslavia and French foreign minister Louis Barthou in Marseilles.

Mao Tse-tung and his Red Army set out on their 'Long March' across China.

CULTURAL EVENTS

1930

First performance of Dmitri Shostakovich's ballet *The Golden Age*.

Publication of W. H. Auden's first collection, *Poems*; Evelyn Waugh's *Vile Bodies*; T. S. Eliot's *Ash Wednesday*.

First performance of Noel Coward's *Private Lives*.

Release of Lewis Milestone's film adaptation of Remarque's *All Quiet on the Western Front*; Jean Cocteau's Surrealist film *Le Sang d'un poète*; Luis Buñuel's *L'Age d'or*, which caused riots in Paris.

Publication of John Maynard Keynes's influential *Treatise on Money*; Sigmund Freud's *Civilisation and its Discontents*.

1931

Sergei Rachmaninov's music outlawed in Russia as 'decadent' and 'bourgeois'.

Publication of Virginia Woolf's *The Waves*; Anthony Powell's *Afternoon Men*.

Release of Charlie Chaplin's film *City Lights*, made at the height of his career; Josef von Sternberg's film *Dishonoured*, starring Marlene Dietrich as a Mata Hari style spy who dies in front of a firing squad.

Opening of the Empire State Building, New York, the tallest structure in the world.

Construction begins on Pier Luigi Nervi's Communal Stadium in Florence.

1932

Publication of Ernest Hemingway's *Death in the Afternoon;* Aldous Huxley's *Brave New World*.

Release of Duke Ellington's *Creole Rhapsody*.

Release of Norman McLeod's comedy film *Horse Feathers*, set in Prohibition America and starring the Marx Brothers; Howard Hawks's gangland film *Scarface*.

Hollywood's first all-star spectacular *Grand Hotel* opens in London to rave reviews.

Completion of the Philadelphia Savings Fund Society Building, one of the first international-style skyscrapers.

1933

First performance of Richard Strauss's opera *Arabella*.

Publication of André Malraux's *La Condition humaine;* Gertrude Stein's *The Autobiography of Alice B. Toklas*; George Orwell's *Down and Out in Paris and London*.

Release of Nazi propaganda war film *Morgenrot* about the crew of a German U-boat.

Release of Merian C. Cooper and Ernest B. Schoedsack's fantasy film *King Kong*, starring Fay Wray; Mae West's *She Done Him Wrong*.

Musical *Forty-Second Street*, choreographed by Busby Berkeley, lifts American spirits during the Depression.

1934

School of American Ballet founded by Russian choreographer George Balanchine.

Start of Glyndebourne Festival Opera in Britain.

Release of Sergei and Georgi Vasiliev's socialist-realist film *Chapayev*, based on the Russian Civil War; Leni Riefenstahl's propaganda film *Triumph of the Will*, commissioned by Hitler to celebrate the power of Nazi Germany.

Publication of Dylan Thomas's *Eighteen Poems*; Robert Graves's *I, Claudius*; Jean Cocteau's *The Infernal Machine*.

'Polymer 66' (nylon) developed by Du Pont laboratories.

1935

Hitler denounces terms of Treaty of Versailles and re-introduces conscription.

In Britain, Stanley Baldwin becomes Prime Minister.

Agreement reached between Britain and Germany that Germany will limit its navy to 35 per cent of the force of Britain's.

George V celebrates his Silver Jubilee.

In the USSR, Communist leaders convicted of treason and conspiracy in a series of show trials.

In the US, the controversial New Deal (The Works Progress Administration), puts millions of unemployed Americans back into work.

First performance of Sergei Prokofiev's ballet *Romeo and Juliet*.

Benny Goodman introduces 'swing' to a wider audience.

Nazi Germany bans jazz, along with any music considered to be of black or Jewish origin.

Publication of Christopher Isherwood's *Mr Norris Changes Trains*.

Release of Clarence Brown's film adaptation of Leo Tolstoy's *Anna Karenina*, starring Greta Garbo; Alfred Hitchcock's *The 39 Steps*, based on the novel by John Buchan; Mark Sandrich's *Top Hat*, starring Fred Astaire and Ginger Rogers; Sam Wood's *A Night at the Opera*, starring the Marx Brothers.

1936

Outbreak of the Spanish Civil War.

China declares war on Japan.

In Austria, conscription reinstated.

In France, the franc devalued twice.

Italy captures Ethiopia; Victor Emmanuel III proclaimed Emperor of Abyssinia by Mussolini.

Death of George V; succession of Edward VIII.

Abdication on 10 December of Edward VIII so that he can marry American divorcée Wallis Simpson; succession of his brother the Duke of York, who becomes George VI.

Olympic Games held in Berlin; four gold medals won by the black American athlete Jesse Owens.

International Surrealist Exhibition held in London.

Publication of Margaret Mitchell's American Civil War novel, *Gone with the Wind*.

Frank Lloyd Wright begins Falling Water house at Bear Run, Pennsylvania.

Publication of John Maynard Keynes's *The General Theory of Employment, Interest, and Money*.

Leni Riefenstahl's film of the Berlin Olympics, *Olympia*, is internationally acclaimed; she falls out of favour in Nazi Germany for including footage of the victory of the black American Jesse Owens.

1937

Baldwin retires; Neville Chamberlain becomes Prime Minister.

Pope Pius XI issues encyclical '*On the Condition of the Catholic Church in the German Reich*'; Hitler reacts with the expulsion of churchmen.

Basque town of Guernica destroyed by Nazi bombers assisting Gen. Franco in the Spanish Civil War.

The world's largest airship, the German *Hindenburg*, destroyed at Lakehurst, New Jersey, after transatlantic crossing.

First successful jet engine tested in Britain

American aviator Amelia Earhart and co-pilot Frederick Noonan vanish over the Pacific Ocean.

Exhibition held in Nazi Germany of 'Degenerate Art'.

Pablo Picasso paints *Guernica*, homage to the Basque town destroyed by bombing.

Publication of Edgar Snow's *Red Star over China*; George Orwell's *The Road to Wigan Pier*; John Steinbeck's *Of Mice and Men*; J. R. R. Tolkien's *The Hobbit*.

Release of Jean Renoir's film *La Grande Illusion*, which gives him his first international success; James W. Horne's comedy *Way Out West*, starring Stan Laurel and Oliver Hardy; Walt Disney's first feature-length animation, *Snow White and the Seven Dwarfs*.

1938

Anschluss (union) between Germany and Austria; persecution of Austrian Jews begins.

In the USSR, purges continue with trial, conviction and execution of Bolshevik leaders such as Bukharin.

At the Munich Conference, the Czech Sudetenland ceded to Germany. German troops enter Czechoslovakia; persecution of Czech Jews begins.

Resignation of Britain's foreign secretary Anthony Eden in protest at Prime Minister Chamberlain's appeasement of Hitler.

In Germany, an official of the Paris embassy murdered by a Jewish refugee; the ensuing Nazi pogrom became known as *Kristallnacht*.

Publication of Graham Greene's *Brighton Rock*.

Broadcast by Orson Welles of a radio play adapted from H.G. Wells's *War of the Worlds* causes widespread confusion in New York; listeners take to the streets in panic.

Release of Sergei Eisenstein's epic patriotic film *Alexander Nevsky*, with music by Sergei Prokofiev.

1939

Albania is invaded by Italy and a Fascist government put in place.

Hungary withdraws from The League of Nations and introduces anti-Semitic laws similar to those in Germany.

The ten-year Pact of Steel signed by Hitler and Mussolini.

Germany invades Poland, which is partitioned in a Soviet–German Treaty of Friendship.

Britain and France declare war on Germany.

The USSR invades Finland.

Publication of John Steinbeck's *Grapes of Wrath*; James Joyce's *Finnegan's Wake*; Christopher Isherwood's *Goodbye to Berlin*.

Release of Victor Fleming's film adaptation of Margaret Mitchell's bestseller *Gone With the Wind*, starring Clark Gable and Vivien Leigh.

Ivor Novello's *The Dancing Years* the most popular musical in London.

We'll Hang Out The Washing on The Siegfried Line becomes popular song during the war.

Marie-Louise von Motesiczky
At the Dressmaker's, 1930

MARIE-LOUISE VON MOTESICZKY
1906–1996

Painter, studied at the Hague and in
Vienna until 1922, influenced by Max
Beckmann, whose master-class she
joined in Frankfurt in 1927; left Vienna
for England in 1939; held her first
solo show at the Beaux Arts Gallery,
London in 1960.

This supremely confident self-portrait by the 24-year-old artist was one
of several major works completed on her return to Vienna after studying
with Max Beckmann in Frankfurt in 1927–8. This and *Still Life with Photo* of
the same year are among her most Beckmannesque works, although his
influence seems to have recurred at irregular intervals, especially perhaps
in some of her set-piece allegorical works of the 1950s. It is always tempting
to view a lesser-known artist in terms of someone else's work, but it must
be remembered that otherwise Marie-Louise von Motesiczky worked in
more or less complete isolation throughout her life. Although many of her
paintings are of herself and latterly of her ageing mother Henriette, what
distinguishes her work among that of other women painters excluded from
normal artistic circles and influences is a strong sense of more universal
issues, not only of life in general but specifically of her time. Beckmann is
said to have told her that she could be the successor to the distinguished
German painter Paula Modersohn-Becker who had died young in 1907.

Despite its specific title (and the awkward attempt at mirror-writing on
the wall), *At the Dressmaker's* is a self-portrait of almost symbolic significance.
The virginal whiteness of the dress and the subject's surroundings, her
questioning expression and the indecision of the upraised arm, the darkness
of the heavy shadow she casts, the willing but passive assistance of the
dressmaker – all these seem to pose the classic conundrum of many youthful
self-portraits: 'I'm on my own now, but where do I go from here?' The
following eight years were a period of consolidation in von Motesiczky's
work. Then, at the Anschluss in March 1938, she and her mother left
Vienna for Holland. A year later they crossed to England and spent the
war years in Amersham, where they met other distinguished *émigrés* such
as Elias Canetti and Oskar Kokoschka, both of whom were to play an
important role in her life.

Oil on canvas
1130 × 601mm (44½ × 23½")
Lent by the Syndics of the Fitzwilliam
Museum, Cambridge

REFERENCE

*Marie-Louise von Motesiczky: Paintings
Vienna 1925–London 1985*, exh. cat.,
Goethe Institute, London, 1985,
pp.25, 66

Heinrich Hoerle
The Contemporaries, 1931

HEINRICH HOERLE 1895–1936

Painter, born in Cologne and attended the Cologne School of Arts and Crafts; became a member of the Lunisten group (which included Max Ernst and Otto Freundlich); co-founded the Group of Progressive Artists, 1919, and produced magazines including *Ventilator* and, in 1929, *a–z*; his work was condemned by the Nazis in the 1930s.

Wax on plywood
1200 × 2000mm (47¼ × 78¾")
Kölnisches Stadtmuseum, Cologne

REFERENCES

D. Backes et al., *Heinrich Hoerle: Leben und Werk 1895–1933*, Cologne, 1981

S. Michalski, *New Objectivity: Painting, Graphic Art and Photography in Weimar Germany 1919–1933*, Cologne, 1994, pp.113–18

Heinrich Hoerle is one of those German artists who is ironically better known outside his native country for being the subject of a photograph by August Sander than he is for any of his own work. After the First World War Cologne, despite its inherent aesthetic conservatism, was well placed between the influences of Paris and Berlin. A modest growth in contemporary art began to take root there in the early 1920s, and one of the most distinguished photographers of the era was at hand to record its protagonists. With his colleagues Franz Wilhelm Seiwert and Otto Freundlich, Hoerle founded the Group of Progressive Artists, Cologne, in 1924, with half an eye on Russian Constructivism and a common belief in purpose-orientated art and a desire for social change. Seiwert was the principal theoretician and his contributions appeared in the magazine *a–z*, which was published by Hoerle between 1929 and 1933. Seiwert's paintings are altogether more didactic and sombre than Hoerle's, his workmen, factories and street scenes painted in dark and uncompromising colours and pictograms. Although their beliefs had much in common with Communism, the Progressives rejected any political system that appeared to limit the freedom of the individual. This was the period when the centrist politician Konrad Adenauer (1876–1967), better remembered for his role in the reconstruction of post-war Germany, was exercising his long mayoralty of Weimar Cologne.

Hoerle's colourful assemblage of Cologne citizens is a positive and optimistic celebration of the city's political and cultural future. Next to the politician Willi Ostermann (seen in profile on the left) stands Adenauer, his hands clasped in characteristic fashion. Beside him is Hoerle's wife, then the boxer Domgörgen, and finally (on the right) a self-portrait of the artist himself, dressed informally and clutching a small city flag. The approach is a sort of provincial version of Léger (see p.101). Behind the verticals of Hoerle's complex and sometimes rather arbitrary figurative Constructivism, it is possible to discern the banks of the Rhine with a boat and a factory in a 'garden city' vision of the city's future. Prominent by its absence is the city's chief landmark, the cathedral, with all its associations of Cologne's bourgeois and medieval past. Hoerle's vision was to fade all too rapidly. Adenauer was dismissed by the Nazis in 1933 and imprisoned the following year. Hoerle's art was condemned as degenerate in 1933, and he died a few years later.

1932

William Roberts
Maynard and Lydia Keynes, 1932

WILLIAM ROBERTS 1895–1980

Painter, born in London and educated at the Slade School of Fine Art and St Martin's School of Art; involved in the Vorticist movement; taught at the Central School of Art, London, and was elected to the Royal Academy in 1966; later work focuses on scenes from everyday life.

William Roberts never quite fulfilled the promise of his early brush with Vorticism, but nevertheless developed a distinctive and original Constructivist-influenced style which makes an interesting comparison with the work of Hoerle (see p.118). His achievement in portraiture, though not well known, is a considerable one; unlike Hoerle, Roberts tended to modify the stylised and tubular forms of his figure compositions to a more gentle simplification and stylization in his portraits. Before he gradually withdrew from all social life after the war Roberts accepted a number of portrait commissions, including one of T. E. Lawrence in uniform in 1921 (Ashmolean Museum, Oxford), a year after he had approached Lawrence for work on the illustrated de luxe edition of *The Seven Pillars of Wisdom*. His best work, however, was reserved for the almost annual portrayals of his wife Sarah which he began in the early 1920s.

Like Lawrence, the Cambridge economist Maynard Keynes (1883–1946) was an important patron of young artists. As well as buying several works from Roberts, he supported him financially for a number of years, and commissioned this portrait of himself with his wife, the Russian ballerina Lydia Lopokova (1892–1981), whom he had married in 1925. A slightly abstracted and reserved work, it does capture something of Keynes's formidable personality and led to a couple of other commissions from Cambridge colleges. The two elegantly curling hands holding apparently unlit cigarettes at the lower centre of the picture keep the composition together but scarcely unite the two figures psychologically. It is probably this implicit and underlying tension that gives the portrait so much of its power.

Oil on canvas
724 × 806mm (28½ × 31¾")
National Portrait Gallery, London

REFERENCE

William Roberts: An Artist and His Family, exh. cat., National Portrait Gallery, London, 1984, pp.3–4

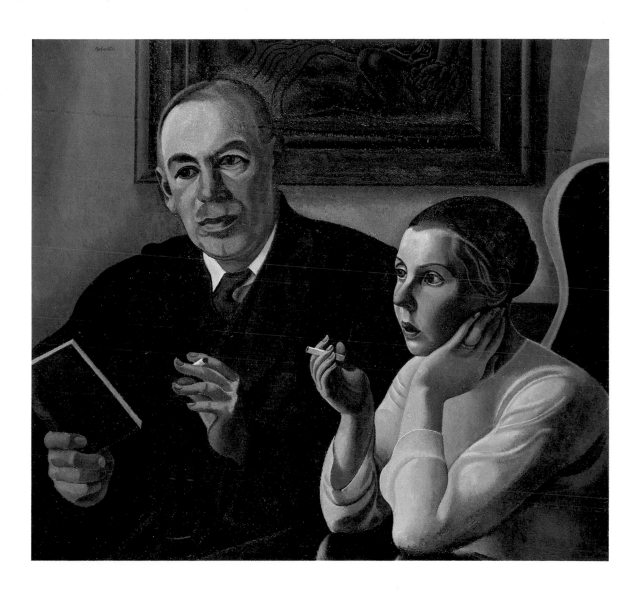

Gerardo Dottori
Portrait of Il Duce, 1933

GERARDO DOTTORI 1884–1977

Born in Perugia, Italy; studied at the Accademia di Belle Arti, Perugia (1904–12); supported himself by working as a mural painter; aligned himself with Futurism from 1912; lived mostly in Rome during the 1930s and took part in the first *Esposizione Internazionale d'Arte Sacra* held in Rome; also participated in Futurist group shows and the *Venice Biennale* in 1924 and 1926; Director of the Accademia, Perugia, 1940–7.

Oil on board
1010 × 1060mm (39¾ × 41¾″)
Civico Museo D'Arte Contemporanea, Milan

REFERENCES

E. Dalla Noce and M. Duranti, *Gerardo Dottori: Futurista*, exh. cat., Galleria San Carlo, Milan, 1989

G. Ballo, *Dottori aeropittore futurista*, Rome, 1970

Benito Mussolini (1883–1945) came to power in Italy in 1922 and quickly established a Fascist dictatorship. Unlike the Nazis in Germany, and despite widespread political repression, he never set out to create a clearly defined state art, his party theorists merely emphasising that Fascist art should not simply imitate the styles of the past but should above all represent a continuation of the grand Italian tradition. While controls were effectively operated through the various official artists' organisations, this relatively enlightened policy allowed numerous different schools and 'isms' to jostle for state favours. The Milan-based Novecento group around Sironi was the most active, and by 1932 had all but assumed reponsibility for dissemination of the official Fascist style. Marinetti and the Futurists, with their obsession with war and the machine, held a prior claim to be regarded as the artists of Fascism, but by the time Balla and Depero launched the second Futurist manifesto in 1915 the movement was already outdated in international terms.

Initially a major manifestation of the European avant-garde, Futurism survived at an increasingly provincial level throughout the 1920s, rather like Vorticism in Britain. By 1929 a fascination with aircraft and flight caused a group of artists, led once more by Balla and Depero but this time including Gerardo Dottori, to issue a *Manifesto dell' Aeropittura*, thus launching the third and final phase of the movement. Dottori, with his theories on 'total landscape' was a significant contributor. He was a major participant in all the exhibitions of Aeropittura (Milan in 1931; Paris in 1932; and Berlin in 1934, sponsored by Goebbels). Portraits of Mussolini were a staple component of the political machine, though it seems likely that those by Futurists such as Dottori and Prampolini were an attempt to gain political favour rather than official commissions.

Dottori's head of Il Duce is a monstrously inflated piece of propaganda, showing the dictator's torso rising like a gigantic monument from the rolling Umbrian hills. By sheer effrontery, Dottori manages to combine most of the tenets of Aeropittura in one unlikely composition: the portrait, rooted in the 'total' landscape, ascends to the azure skies, where half a dozen planes performing aerobatics echo the visionary gaze of the leader. Outdated in its use of early Futurist–Cubist devices, politically and philosophically indefensible, Dottori's decorative portrait (like a number of Fascist architectural schemes) is nevertheless a minor tribute to one of the more enlightened policies of Mussolini's state.

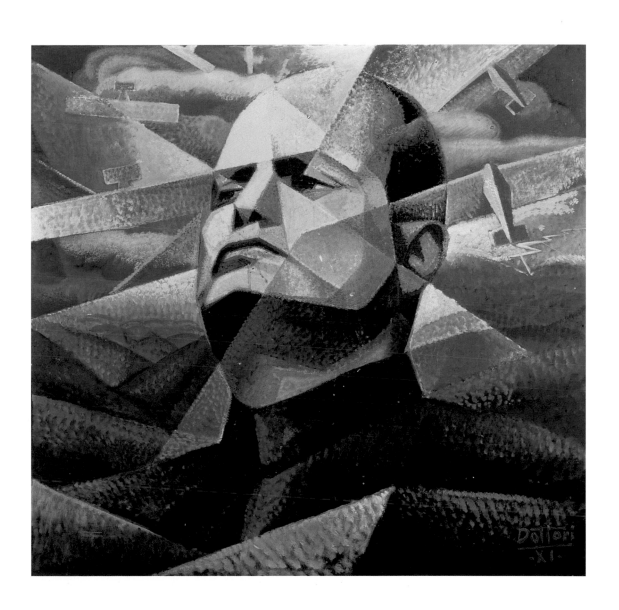

George Gershwin
Self-portrait, 1934

GEORGE GERSHWIN 1898–1937
American composer, born Jacob
Gershvin in Brooklyn, New York, son of
a Jewish-Russian immigrant originally
called Gershovitz; began career as an
in-house pianist for a music publisher
in Tin Pan Alley, 1916; made his name
and fortune with *Swanee* (1919) which
sold 2,500,000 records; the ground-
breaking *Rhapsody in Blue* (1924) was
followed by other symphonic jazz
works including *Piano Concerto* (1925),
and *An American in Paris* (1928); his
opera *Porgy and Bess* (1935) became
one of the very few operas after Puccini
to have entered the standard repertory;
he died of a brain haemorrhage.

Oil on canvas board
399 × 298mm (15¾ × 11¾")
National Portrait Gallery, Smithsonian
Institution. Gift of Ira Gershwin

REFERENCES

E. Jablonski and D. Lawrence,
The Gershwin Years, New York, 1973
(appendix)

M.C.S. Christman, *Fifty American Faces
from the American National Portrait
Gallery*, Washington, D.C., 1978,
pp.228–31

Gershwin, renowned as a major twentieth-century composer, was also a painter of some skill. He was not the only one to combine such talents: Arnold Schoenberg's paintings of the early 1900s are significant enough to be included in exhibitions of Viennese Secession painting. By a strange coincidence, Schoenberg, who had fled to Los Angeles from Nazi Germany in 1933, became a good friend of Gershwin, and the two were regular tennis partners in the last few months before the American composer's untimely death. The last painting Gershwin completed was a portrait of Schoenberg.

Gershwin began painting in about 1929, at the same time as he started collecting art. When he died, his collection included Picasso's *L'Absinthe* (1901) and significant works by Utrillo, Kandinsky, Chagall and – a particular favourite – Georges Rouault. He was advised both as collector and painter by his cousin, the artist Henry Botkin, who accompanied Gershwin and his assistant to Folly Beach near Charleston, South Carolina, in the summer of 1934 where the composer was to work with his librettist Du Bose Heyward on *Porgy and Bess*. There, in close proximity to a remote community of black farmers and fishermen, Gershwin worked at his opera and painted several small works, including this self-portrait.

Perhaps a better draughtsman than painter, Gershwin gave his art works the vigour and enthusiasm that characterised everything he did. This self-portrait, one of at least four or five, was described by his brother Ira as 'whimsical'; perhaps on the basis of its resemblance to the little cartoon profile he sometimes added to autographs, it is sometimes called a self-caricature. While there may be an element of exaggeration in his boxer's broken nose and jutting jaw, it is nonetheless a vivid likeness in which Gershwin succinctly and powerfully identifies himself with his music. The empty manuscript is equated with his head, the source of the music, while the hand poised on the keyboard shows the means by which he shared it with the world. A brilliant pianist, he was never happier than when playing virtuoso renditions of his songs to a group of friends. When he died at the age of thirty-eight, he was working on Hollywood musicals, talking about a new opera and planning a one-man show of his paintings. The exhibition took place six months after his death.

James Cowie
Two Schoolgirls, 1934–5

JAMES COWIE 1886–1956

Born in Cuminestown, Aberdeenshire; studied at Aberdeen University (1906–9) and at Glasgow School of Art (1912–14); held various teaching positions, 1918–47; first solo show at the McLellan Galleries, Glasgow, 1935; Associate of the Royal Scottish Academy, 1936, member 1943; moved to Edinburgh, 1948, and became Secretary of the R.S.A.

Examples of realist artists working in relative isolation crop up throughout art history, but perhaps more consistently during the 1920s and 1930s which saw a general reaction against many of the various 'isms' – Impressionism, Expressionism, Cubism – that had dominated the art of the previous forty years. In Britain, the work of Stanley Spencer comes immediately to mind (see p.162); although his name is seldom mentioned in connection with Cowie, both had particularly individual styles, that went against most of the prevailing trends of the time. Both also shared a deep-rooted affection for the topography and people of their birthplace – for Cowie, this was the upland country round Cuminestown, north-west of Aberdeen.

Unlike Spencer, Cowie was both a late starter and a slow worker: he produced scarcely ten major works. Most of these date from the 1930s and are based on his experience as an art teacher at Belshill Academy outside Glasgow, where he taught from 1918 to 1935. During lessons he observed his pupils and made notes, slowly formulating ideas for compositions to work on later in his studio. *Two Schoolgirls*, like several similar groups, is known to be a composite work, and it is likely that Cowie worked on several paintings simultaneously. The magnificent *Portrait Group* of older students (Scottish National Gallery of Modern Art, Edinburgh) is known to have been begun in 1932 at Belshill, but not completed until about 1940.

A first impression suggests two country schoolgirls during a needle-work lesson, but closer inspection reveals that they have been given the blue cloth to hold, and that they are in an art room. The grey material serving as a backdrop has been pinned up on a pair of easels – and where else but an art room would one find a battered plaster copy of the *Discobolus*? The Symbolist element in Cowie's work, which he may partly have inherited from his teacher Maurice Greiffenhagen, becomes a form of *pittura metafisica*, if not Surrealism, in his works of the later 1940s. Here, with two young girls sitting among the traditional paraphernalia of western art, there may be a rather hermetic suggestion of *ars longa, vita brevis*, but this is primarily an exercise in the much more modern concept of 'picture-making'. At about this time Cowie wrote in response to a questionnaire: 'a picture . . . must be an idea, a concept built of much that in its total combination it would never be possible to see and copy.' This is a masterly rendition of vulnerability and timid expectancy in two young lives from what now seems like a long-lost era of innocence.

Oil on canvas
1156 × 1162mm (45½ × 45¾")
Aberdeen Art Gallery and Museums

REFERENCES

R. Calvocoressi, *James Cowie*, National Galleries of Scotland, 1979, pp.12, 22, 36

C. Oliver, *James Cowie*, Edinburgh, 1980, pp.15, 16, 18, 19, 26

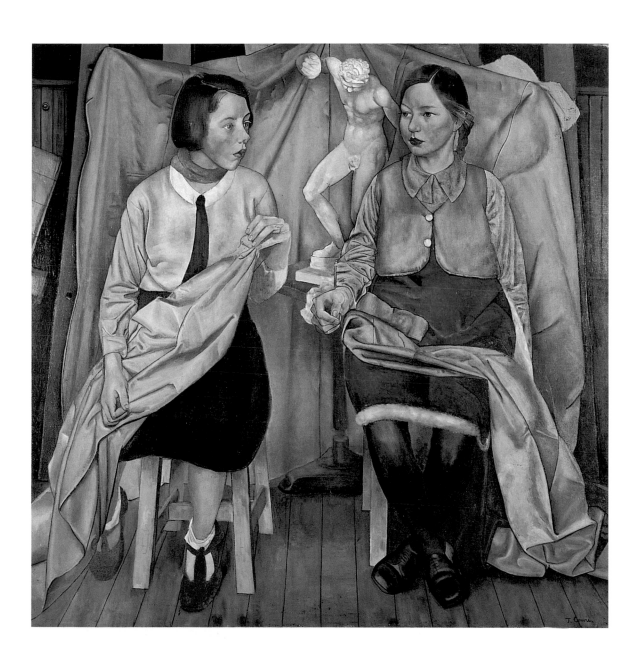

Walter Richard Sickert
Jack and Jill, c.1936–7

WALTER RICHARD SICKERT
1860–1942

British painter of Danish parentage, born in Munich; studied under Legros and Whistler from whom he learned etching; met and was influenced by Degas, 1883; with the progressive New English Art Club, exhibited paintings of Dieppe, Venice and Camden Town, 1888–1914; founder member of the Camden Town/London Group, 1913; elected member of the Royal Academy, London, 1934; retrospective at the National Gallery, London, 1941.

After an illness in the winter of 1926–7 Sickert became increasingly house-bound, and many of his later paintings were derived from photographs, sometimes cut from magazines and newspapers and sometimes taken by himself or his wife Thérèse Lessore. Whereas the use of photographs in painting often implies a slavishly descriptive approach, its effect on Sickert was quite the reverse. In part perhaps because they were sometimes taken from poor reproductions, he treated them almost solely in terms of light and shade, modelling with brushstrokes of bright colours and sometimes leaving the underpainting (here blue) to show through to create both intermediate shade and textural interest. In his treatment of popular imagery, Sickert anticipated several post-war developments in painting, though he avoided the brash colours of conventional Pop Art.

It is not known why Sickert chose this classic image of Hollywood 'film noir', nor where he got it from. Probably derived from a publicity still, it shows Edward G. Robinson as Johnny Broderick, a real-life New York city detective, with Joan Blondell as his girlfriend in the Warner Brothers film *Bullets or Ballots*, first released in London in 1936 (it is doubtful that Sickert ever saw the film). The dramatic lighting from below clearly appealed to the artist's love of the theatre. Joan Blondell's hand, both protective and restraining, seems absolutely crucial in the centre of the composition: as well as providing the tension which may have been the deciding factor in Sickert's use of the picture, it also perhaps suggested the presumably ironic nursery rhyme title. 'Jill' tries to restrain an over-confident 'Jack' before he takes a tumble and drags her with him.

The Rumanian-born Edward G. Robinson (1893–1973) was not only a film star but also a distinguished art collector; he found this painting at a London dealer's after the war and added it to his collection. The archetypal Hollywood gangster following on from his role as the racketeer *Little Caesar* in 1930, his smiling, cigar-chomping brute influenced not only American gangster movies of the 1930s and 1940s, but also our everyday visual heritage in imagery such as this. Sickert had (rather like Andy Warhol) a knack of seeing images that were inherently of far wider significance than their face value would suggest.

Oil on canvas
620 × 750mm (24¾ × 29½")
Private collection

REFERENCE

W. Baron and R. Shone, eds., *Sickert Paintings*, exh. cat., Royal Academy, London, 1992, pp.344–5 (no.131)

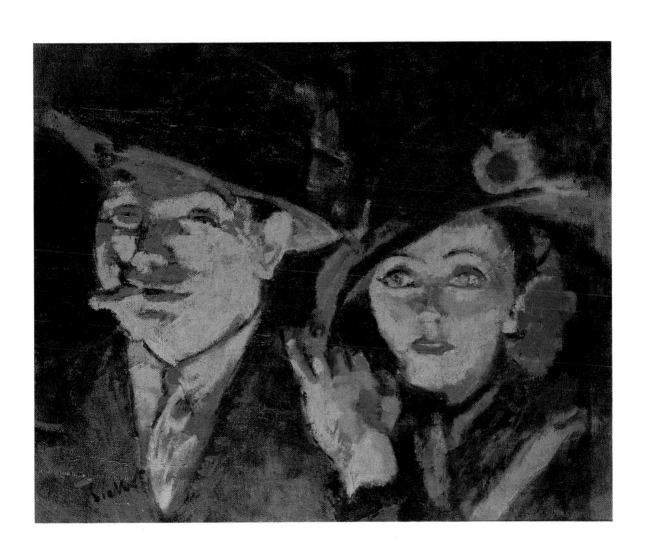

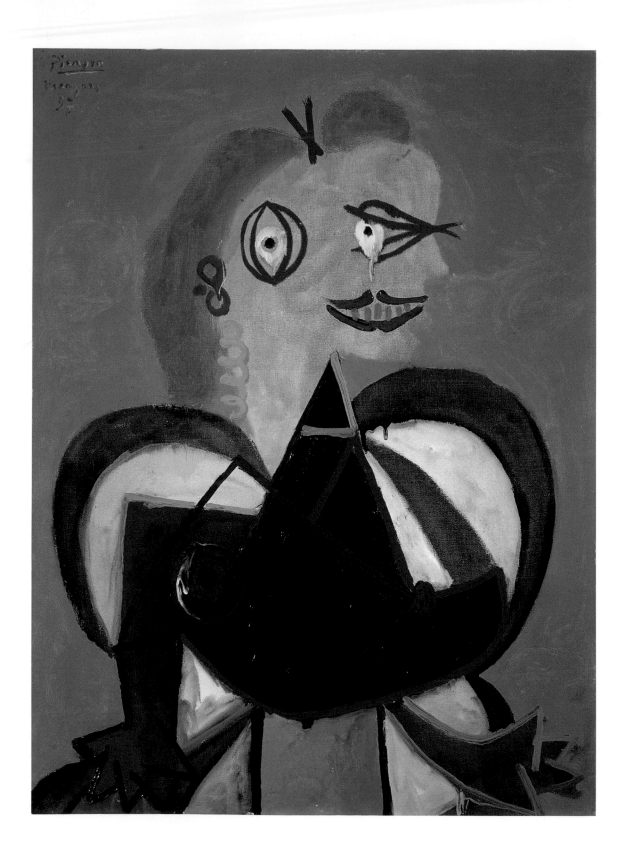

Pablo Picasso
Lee Miller, 1937

For biography, see p.61

Picasso's individual figure paintings of the 1930s and 1940s frequently reflect his work on larger projects, but are dominated by issues of form and what has been described as 'figuration and dissociation'. From May to June 1937 he was working on *Guernica*, his monumental indictment of the Spanish Civil War. Not only was this both aesthetically and philosophically one of his greatest masterpieces, it was also the work that established the formal idiom that was to remain with him for the rest of his life, and the style with which we now associate his name. In July 1937 Picasso left Paris after seeing *Guernica* installed at the *Exposition Universelle* and went with his mistress Dora Maar to Mougins in the south of France where he was soon joined by Paul Eluard and his wife Nusch, Man Ray, and the British Surrealist painter and writer Roland Penrose with his new girlfriend, the American photographer Lee Miller (1907–77).

With the Spanish Civil War still on his mind, Picasso produced drawings and at least one major portrait of Dora, and several paintings and drawings of both the Eluards. Penrose described the moment when he showed them this portrait of Lee. 'On a bright pink background Lee appeared in profile, her face a brilliant yellow like the sun with no modelling. Two smiling eyes and a green mouth were placed on the same side of the face and her breasts seemed like the sails of ships filled with a joyous breeze. It was an astonishing likeness. An agglomeration of Lee's qualities of exuberant vitality and vivid beauty put together in such a way that it was undoubtedly her but with none of the conventional attributes of a portrait.' Like the portraits of Dora Maar (Picasso Museum, Paris) and Nusch Eluard done at the same time, the eyes, bust and hands show the sort of irrational dissociation that led Picasso's work of these years to be linked with Surrealism. The long, thin lips are the same as those that inspired Man Ray's huge painting of lips floating in a landscape, *Observatory Time – The Lovers* (1934). We might imagine that the enormous eyes are a reference to Lee Miller's avocation as a photographer, but it is arguable whether we can deduce from the portrait that she was also a great beauty. Reorganisation and exaggeration of an individual's features are also the stock-in-trade of the caricaturist, and it is sometimes difficult to tell how far Picasso was making gentle fun of some of his subjects. Roland Penrose purchased the painting for £50 and gave it to Lee to take back to Cairo, where she was living with her first husband. By 1939 she had left for England to be with Penrose, and in 1947 they were married.

Oil on canvas
800 × 590mm (31½ × 23¼")
Private collection (on loan to
the Scottish National Gallery of
Modern Art, Edinburgh)

REFERENCES

R. Penrose, *Picasso: His Life and Work*, London, 1958, p.279

A. Penrose, *The Lives of Lee Miller*, London, 1985, pp. 75–7

Wyndham Lewis
Stephen Spender, 1938

WYNDHAM LEWIS 1882–1957

Born in Nova Scotia of an American father and British mother; studied at the Slade School of Fine Art, London, (1898–1901); exhibited with the Camden Town group, 1911, and at the second Post-Impressionist Exhibition; influenced by Futurism, he founded the Vorticist group and edited *Blast*; his early post-war paintings are an attempt to continue pre-war Vorticism but are basically figurative; continued to write major satirical novels and critical works even after losing his sight in 1957.

Oil on canvas
1005 × 595mm (39½ × 23½″)
The Potteries Museum and Art Gallery, Stoke-on-Trent

REFERENCES

W. Michel, *Wyndham Lewis. Paintings and Drawings*, London, 1971, p.86

J. Meyers, *The Enemy. A Biography of Wyndham Lewis*, London, 1980, pp.179, 180, 205, 240, 241

The civil war that followed General Franco's military revolt against the Republican government in Spain in 1936 succeeded in uniting and mobilising left-wing intellectuals from the rest of Europe and America in a way that few events have done before or since. Stephen Spender (1909–95), a Communist by the time he left Oxford in 1931, was the only British delegate to evade visa restrictions and get to the International Writers' Congress in Spain in 1937. Once there, he stayed for several months contributing propaganda for the Republican cause and commemorating his experiences in one of his most highly regarded volumes of verse, *The Still Centre* (1939).

The strange relationship between the avowedly right-wing and querulous Wyndham Lewis and Spender, along with Lewis's friendships with other left-wing intellectuals and writers of the period, has not been fully documented or explained. They had known each other since Spender had invited Lewis to give a talk to the English Club at Oxford in 1928. Spender was the most Byronic of all the young British writers of the 1930s (he was known for wearing his shirt collar open, as shown here). Lewis's portrait, completed after Spender's return from Spain, is normally interpreted in the light of his extraordinary satire on Spender in his novel *The Apes of God* (1930), in which the poet is depicted as the effeminate and moronic Dan Boleyn. Protégé of the guru hero Zagreus, Boleyn is described as 'a latter day metropolitan shepherd, fashioned in quick-silver, who melts into shining tears at a touch', a would-be poet and potential 'genius' with 'passionate velvet eyes of the richest black'. In the early days of their acquaintance, Lewis considered Spender to be lacking in strength, and he loathed the decadence of Berlin for all the reasons that attracted Spender, Isherwood and other writers.

Spender, shown here in Lewis's studio in the usual easy chair (which featured in his first and well-known portrait of T. S. Eliot, (1938; Durban Art Gallery, South Africa), seems never to have held a grudge against Lewis, and always reviewed him favourably. Whether or not there was ever any rapport between the two, the portrait is not only a good likeness but also a not unsympathetic character analysis. A less successful preliminary drawing shows Spender as more vacuously good-looking and wearing a jacket and tie; if Lewis had wanted to be satirical in the painting, he could have been devastating. The portraits by Lewis dating from about 1925 to 1940 rank among his very best work, and stand well above any personal or political agenda.

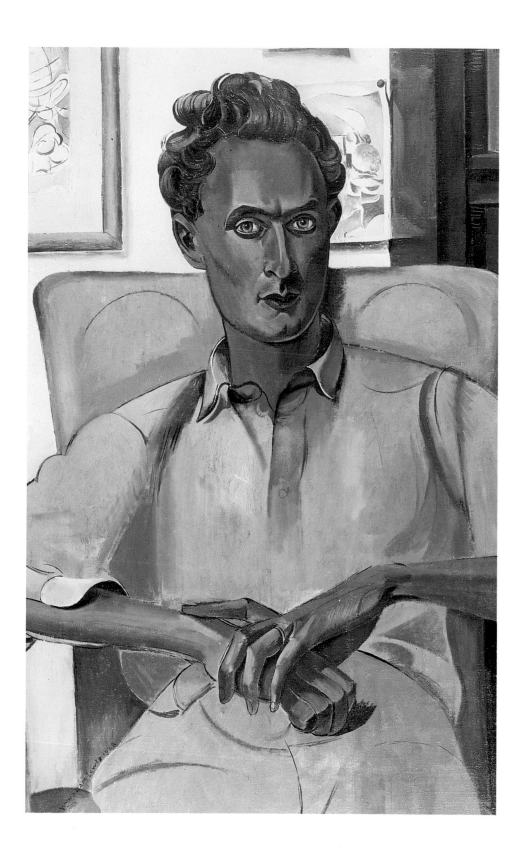

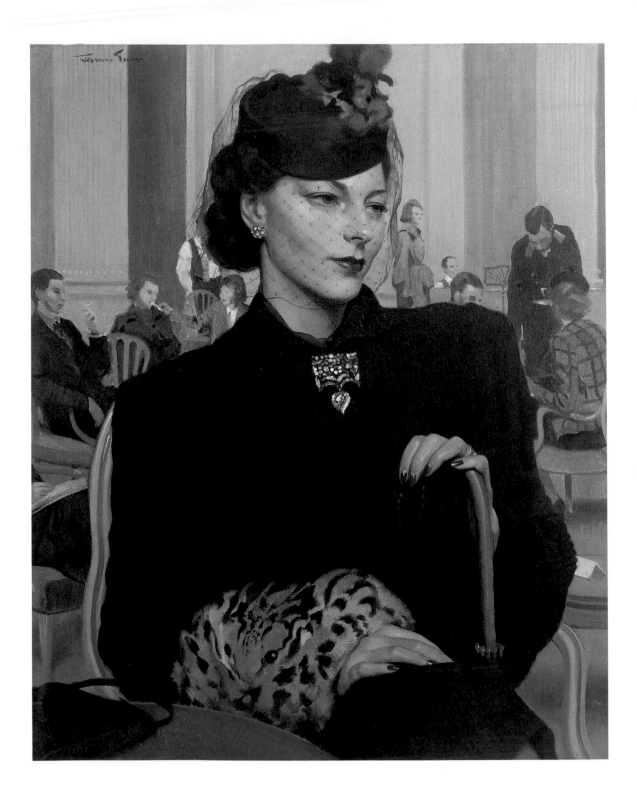

Sir (Herbert) James Gunn
Pauline Waiting, 1939

SIR (HERBERT) JAMES GUNN
1893–1964

Born in Glasgow; studied at the
Glasgow School of Art, the Edinburgh
College of Art (1910–11) and the
Académie Julian (1911–12), awarded a
gold medal at the Paris Salon of 1939;
elected to the Royal Academy in 1961
and knighted in 1963; lived in London
and created a reputation as a
portraitist; painted HM The Queen
(1953–4); exhibited at the R.A. from
1923, and at the R.S.A., Fine Art
Society, Cooling Galleries and Goupil
Gallery; retrospective held at the
Scottish National Portrait Gallery,
Edinburgh 1994–5.

The subjects of Sir James Gunn's paintings are not normally shown doing anything. Despite an affiliation in his early work with the Impressionism of Sir John Lavery and even, in the portrait of his first wife *Gwen Sewing* (*c.*1920), with the Post-Impressionism of the Scottish colourists, his reticence and reluctance in his mature work to allow a ripple of discordant colour or movement to cross the surface of his immaculately observed and finished paintings often makes them less than riveting. What is it, then, about this portrait of his beautiful second wife Pauline (née Miller) that suddenly brings life, atmosphere and a psychological dimension to a genre that in Gunn's hands was sometimes more akin to still life?

The *mise-en-scène* clearly suggests a specific memory or situation, confirmed by the setting, which is the lobby at Claridge's Hotel in London. The detailed observation of the background activity – the woman lighting a friend's cigarette, the waiter serving cocktails, the pianist (and singer?) – creates a narrative almost without precedence in Gunn's work, against which Pauline's thoughts can be allowed to create their own space. His other portraits of Pauline – the inspiration and model for a number of his most outstanding works – tend to show her responding to his instructions in traditional studio situations. Although this is not the most sensuous of his portraits of her, both the title and her demeanour suggest an assignation, and perhaps not a legitimate one.

This suggestiveness is combined with a wealth of period detail in the setting and in Pauline's highly fashionable appearance (hats, gloves and elaborate and brightly coloured make-up were de rigueur in 1939). It is one of the few instances in Gunn's work of a portrait of contemporary society, and he thought highly enough of it to present it to the Royal Academy as his diploma work in 1961. An evocative portrait of a woman about town, it seems to anticipate the social and personal upheaval the war would bring to many lives – it could be a still from any number of wartime films, perhaps a metropolitan version of David Lean's *Brief Encounter* of 1945.

Oil on canvas
762 × 635mm (30 × 25″)
Royal Academy of Arts, London

REFERENCE

Sir James Gunn 1893–1964, exh. cat.,
Scottish National Portrait Gallery,
Edinburgh, 1994, pp.38, 74 (no.55)

1940s

The Second World War, in which about forty-five million people died, ended with the revelation of the horrors of the Holocaust, the atomic bomb in Japan and half of Europe behind the 'Iron Curtain'. By the end of the decade there was another conflict (in Korea) and the world was divided again, this time by the Cold War. Sponsored by wartime government, scientific research had made huge advances – not only in rocketry and nuclear energy, but in radar, telecommunications and the development of antibiotics. Television emerged to sweep across America, while the cinema came of age as a major art form.

HISTORICAL EVENTS

1940

In Poland, the Germans begin construction of a concentration camp at Auschwitz.

In Britain, Winston Churchill becomes Prime Minister.

Between 27 May and 4 June, over 300,000 trapped British and French troops evacuated from Dunkirk; on 4 June, Churchill broadcasts his famous speech: 'We shall fight on the beaches . . .'

In September, the Blitz begins.

In Italy, Mussolini declares war on Britain and France.

Assassination in Mexico City of exiled Soviet Communist leader Leon Trotsky, by a Stalinist agent wielding an ice axe.

In the USA, Roosevelt is re-elected President for a third term.

1941

Deposition of Prince Paul of Yugoslavia; German forces invade Yugoslavia and Greece.

Capture of the deputy leader of the Nazi Party, Rudolf Hess, in Glasgow.

In June, Germany invades Russia.

Roosevelt and Churchill agree the Atlantic Charter, blueprint for the United Nations.

Japan orders the bombing of Pearl Harbor, Hawaii, leading the US into the war.

In December, Japan invades The Philippines; Britain and the US declare war on Japan; Germany and Italy declare war on the US.

Establishment of the American Red Cross Blood Donor Service; first patient treated with penicillin.

1942

Plans for a 'Final Solution of the Jewish Question' presented to and approved by Hitler at a Berlin conference.

Darwin bombed by the Japanese in one of the few attacks on Australia.

Japan takes control of Java.

Malta holds out against devastating air attacks; George VI later awards Malta the George Cross for the collective heroism of its people.

Allied invasion of French North Africa under Gen. Eisenhower; Casablanca and Oran fall to US troops.

1943

In Russia, surrender of German troops at Stalingrad.

Uprising of Jews in the Warsaw Ghetto; in May, Nazi troops blow up the synagogue.

Invasion of Sicily by Allies; Churchill and Roosevelt leaflet Italy, calling for surrender and the overthrow of Mussolini; Victor Emmanuel forces his resignation.

By October, Italy has changed allegiance and declared war on Germany.

Roosevelt, Churchill and Stalin meet in Iran, where Stalin agrees to join war against Japan once Germany is defeated.

Establishment of UN Relief and Rehabilitation Administration to assist in rebuilding countries devastated by war.

1944

The D-Day landings in Normandy.

Launch of the German V1 rockets ('doodlebugs') in June, followed in September by the V2s.

Hitler narrowly escapes assassination. Field Marshall Rommel, who was implicated, was later forced to commit suicide.

Warsaw Uprising leaves 200,000 Poles dead and the city of Warsaw in ruins.

The popular Servicemen's Readjustment Act (the 'GI Bill') signed by Roosevelt.

Roosevelt re-elected for a fourth term.

Research on an atomic bomb continues in the US.

One of the first digital computers, the Mark 1, completed at Harvard University.

CULTURAL EVENTS

1940

Henry Moore makes a series of drawings of Londoners sheltering from the Blitz.

Publication of Graham Greene's *The Power and the Glory*; Dylan Thomas's *Portrait of the Artist as a Young Dog*.

Release of Walt Disney's *Fantasia*, combining animation and classical music.

The last appearance of Charlie Chaplin as the little tramp in *The Great Dictator*.

Completion of Mies van der Rohe's prestigious Illinois Institute of Modern Technology.

1941

Release of Orson Welles's film *Citizen Kane*; it is hailed as a masterpiece of artistic direction.

First performance of Bertolt Brecht's *Mother courage and Her Children*.

Debut of John Huston as writer-director of *The Maltese Falcon*, a private-eye thriller starring Humphrey Bogart.

1942

Completion of T. S. Eliot's *The Four Quartets*.

Release of Michael Curtiz's *Casablanca*, starring Ingrid Bergman and Humphrey Bogart; George Stevens's *Woman of the Year*, starring Spencer Tracy and Katharine Hepburn together for the first time; Noël Coward's wartime sea saga *In Which We Serve*, for which he received a special Academy Award.

Glenn Miller and his orchestra receive RCA Victor's 'golden disc' for over a million copies sold of *Chattanooga Choo Choo*.

1943

First solo exhibition of the work of Jackson Pollock at Peggy Guggenheim's gallery 'Art of this Century'.

Pulitzer Prize awarded to Richard Rodgers and Oscar Hammerstein's musical collaboration *Oklahoma!*

Publication of Jean-Paul Sartre's *Being and Nothingness*; Antoine de Saint-Exupéry's *Flight to Arras* and *The Little Prince*.

1944

First performance of Jean-Paul Sartre's play *Huis Clos (In Camera)*, a reaction to the corruption and claustrophobia of the war years.

Debut of Sir Laurence Olivier as a film director with Shakespeare's *Henry V*; it receives great critical acclaim and Olivier wins a special Academy Award.

Judy Garland's career launched in Vincente Minnelli's musical film *Meet Me in St Louis*.

Publication of Carl Jung's *Psychology and Religion*.

Tokyo and Dresden devastated by Allied incendiary bombing.

Death of President Roosevelt.

Extermination camps at Belsen, Buchenwald and Dachau liberated by British and American forces.

United Nations Charter agreed in San Francisco by representatives of fifty nations.

In Italy, Mussolini is murdered by Italian partisans.

Hitler and Goebbels commit suicide.

Surrender of Germany and end of the war in Europe; the Allies celebrate VE (Victory in Europe) Day on 8 May.

In Britain, landslide victory for the Labour Party.

In Japan, the US air force drops atomic bombs on Hiroshima and Nagasaki.

In France, resignation of President de Gaulle.

In Fulton, Missouri, Churchill speaks of an 'iron curtain' that has descended across Europe.

At Nuremberg, only three people are acquitted in 22 trials.

In Vietnam, French forces bomb Haiphong, killing 6,000 Vietnamese. The Indo-China war begins.

Atomic bomb tests at Bikini atoll in the Pacific, designed for 'ultimate impact', give their name to the new two-piece women's bathing suit.

Foundation of UNESCO (The United Nations Educational, Scientific and Cultural Organisation).

Independence in India is followed by partition into India and Pakistan. Nehru becomes India's Prime Minister and Jinnah Governor General of Pakistan.

US Secretary of State George Marshall calls for a European Recovery Plan, to which he gives his name.

Formation of the Cominform (Communist Information Bureau), following a secret convention in Warsaw.

In Britain, marriage of Princess Elizabeth to Philip Mountbatten, who is given the title Duke of Edinburgh.

Capt. Charles 'Chuck' Yeager flies the Bell X-1 through the sonic barrier, attaining the greatest speed ever travelled by man.

Assassination of Gandhi; later in the year, Pakistan's governor Jinnah also dies.

Recognition of the Jewish State of Israel, with Chaim Weizmann its first President. Israel invaded almost immediately by the Arab League Nations.

In South Africa, the Nationalist Party wins parliamentary elections and pledges to uphold 'white supremacy'.

In July, the National Health Service Act becomes effective in Britain.

In Japan, ex-Prime Minister Tojo and others are hanged for war crimes.

In the US, Harry S. Truman elected President.

In Egypt, assassination of Prime Minister Pasha by a member of the Muslim Brotherhood.

Resignation of Chiang Kai-shek as President of China; the Communist People's Republic proclaimed under Mao Tse-tung.

North Atlantic Treaty agreed in Washington by twelve nations, including Britain, the US, France and Canada; this defence treaty lays the foundations for NATO.

Proclamation of the Republic of Ireland (Eire).

Official introduction of apartheid to South Africa.

Withdrawal of US troops from Korea.

End of three-year civil war in Greece.

1945 | 1946 | 1947 | 1948 | 1949

First performance of Benjamin Britten's opera *Peter Grimes*.

Beginnings of the Bebop music craze, pioneered by Dizzy Gillespie, Charlie Parker and Thelonius Monk.

Publication of André Malraux's *L'Espoir* (Days of Hope); Simone de Beauvoir's *Le Sang des autres* (The Blood of Others); George Orwell's *Animal Farm*; Evelyn Waugh's *Brideshead Revisited*.

Release of Michael Curtiz's *Mildred Pierce*, starring Joan Crawford who wins an Oscar; Alfred Hitchcock's *Spellbound*, which includes a dream sequence designed by Salvador Dalí; Marcel Carné and Jacques Prévert's *Les Enfants du paradis*.

Henri Michaux opens a show at the Galerie Rive Gauche; Jean Dubuffet's exhibition *Mirobulus, Macadam et Cie*, opens at the Galerie René Drouin, Paris.

First performance of Benjamin Britten's opera *The Rape of Lucretia*.

Publication of Dylan Thomas's *Deaths and Entrances*.

Release of John Ford's Western film *My Darling Clementine*, starring Henry Ford; David Lean's adaptation of Charles Dickens's *Great Expectations*.

First performance of Sergei Prokofiev's opera *War and Peace*.

First performance of Jean Genet's play *Les Bonnes*.

Publication of *The Diary of Anne Frank*, the young Jewish girl who hid from the Nazis for two years in Amsterdam before her discovery and subsequent death at Belsen; Thomas Mann's *Dr Faustus*.

First tape recorder system for home use unveiled in the US.

Demonstration by Edwin Land of his Polaroid Land Camera, which can shoot, develop and print photographs within one minute.

Publication of Norman Mailer's *The Naked and the Dead*; Jean-Paul Sartre's *Les Mains Sales*.

Release of Vittorio De Sica's *Bicycle Thieves*, in collaboration with author and screenwriter Cesare Zavattini; Laurence Olivier's *Hamlet*, his second Shakespeare adaptation, which wins best picture and best actor Academy Awards, along with a number of Oscars.

Columbia Records introduces the first commercially accessible long-playing phonograph record.

Publication of George Orwell's *1984*; Simone de Beauvoir's *Le Deuxieme sexe* (The Second Sex), a study of women's oppression.

First performance of T. S. Eliot's *The Cocktail Party*, which achieves popular success.

Release of Jacques Tati's *Jour de Fête*.

Publication of *The Elementary Structures of Kinship* by the French anthropologist Claude Levi-Strauss.

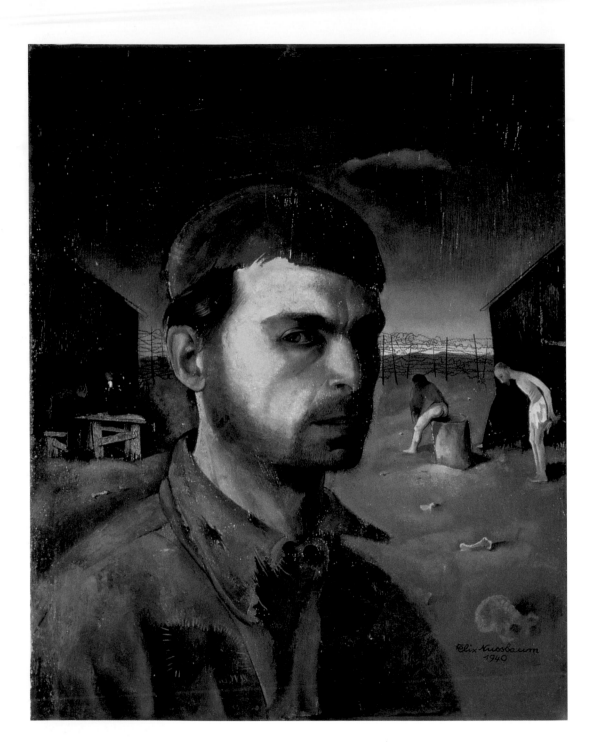

Felix Nussbaum
Self-portrait in the Camp, 1940

FELIX NUSSBAUM 1904–44 (?)

Born in Osnabrück; studied in Hamburg (1922–3) and Berlin (1924–9) won Villa-Massimo scholarship to Rome, 1932; the same year, he participated in the *Berlin Secession* exhibition, and his Berlin studio and early work were destroyed in a fire. Due to increasing anti-Semitism he left Rome in 1933 and, unable to return to Germany, travelled in Italy, France and Belgium; lived in Brussels with his fiancée Felka Platek, 1937; was arrested and interned in St Cyprien, France, 1940, but escaped while being transferred to Bordeaux. He returned to Brussels where he went into hiding, but he and Felka were arrested and deported to Auschwitz, 1944. The Felix-Nussbaum-Hausmuseum, Osnabrück, opened in 1998.

Oil on panel
525 × 415mm (20¼ × 16¾")
The Marvin and Janet Fishman
Collection, Milwaukee

REFERENCES

All paintings mentioned, except for that shown, are in the collection of the Kulturgeschichtliches Museum, Osnabrück.

Felix Nussbaum: Verfemte Kunst, Exilkunst, Widerstandskunst, exh. cat., Osnabrück, 1990

S. Michalski, *New Objectivity*, Cologne, 1994, pp.194, 199–201

Felix Nussbaum's existence as an artist was effectively wiped out of the records by his exile and persecution from the mid-1930s onwards. Knowledge of his work was virtually nonexistent until a cache of over a hundred of his paintings was recovered by his heirs in Belgium in 1970. The work revealed him to be an important late figure in the German New Objectivity movement; and, documenting as it does his life in hiding from the Nazis for over four years, it is also a profoundly moving chronicle of man's inhumanity to man, an equivalent in painting of the famous diary of Anne Frank. The self-portraits, which are predominant, range in mood from resignation to hope and to despair. In 1941, *Fear* shows the artist, his face disfigured with terror, clutching the tearful head of his young niece Marianne. By 1943, there is a certain grim humour in *Self-portrait at the Easel*, in which he is seen painting from ingredients labelled '*humeur*', '*nostalgie*', '*souffrance*', and a bottle marked with the skull and crossbones. Dating from the same year is the well-known *Self-portrait with Jewish Identity Card,* in which Nussbaum, standing in for millions of his fellows, shows the humiliation and fear engendered by the yellow star on his overcoat and the pass stamped in large letters 'JUIF–JOOD'.

Self-portrait in the Camp (which has a still life on the reverse) was presumably painted shortly after Nussbaum's successful escape back to Brussels from internment in France. In this and other paintings of the camp, the barbarity of the life depicted also carries overtones of his virtual imprisonment in occupied Brussels. The landscape both in the camp and beyond the wire is desolate and without hope. The inmate sitting in front of the shed on the left has given himself up to despair; the two on the right have already been reduced to the lowest level of existence. Nussbaum's expression, however, is one of defiance; he wears his tattered cap with pride. The small black cloud over his head echoes the anger within him.

Nussbaum appears again wearing the same cap in his last major completed work, *The Damned* (1944). In what looks like a bomb site, the artist and a ragged group of fellow sufferers in varying degrees of deprivation, despair or madness await a sinister procession of skeletal figures in black, carrying coarse wooden coffins. The unimaginable has become the inevitable. In June 1944, Nussbaum and his wife Felka were taken to the death camp at Auschwitz, on the last deportation train to succeed in leaving occupied Brussels before the advancing Allies.

Dame Laura Knight
Corporal J.M. Robins, MM, WAAF, 1941

DAME LAURA KNIGHT 1877–1970

Born in Long Eaton, Derbyshire, and studied at Nottingham School of Art from age thirteen; married the painter Harold Knight, 1903, and had joint exhibition at the Leicester Galleries, London, 1906; moved from Staithes in Yorkshire to join the Newlyn group in Cornwall, 1908; became full member of Royal Academy and created D.B.E. 1933; turned increasingly to subjects from the theatre, circus and ballet; as official war artist, painted the Nuremberg trials, 1945; first woman to be given a retrospective at the Royal Academy, 1965.

During the First World War, Laura Knight was not considered for official commissions – she was relatively obscure, lived in Cornwall and was married to a conscientious objector, the painter Harold Knight. By 1939, however, she was one of the best-known and most popular artists in the country, and the War Artists' Advisory Committee, under the chairmanship of Kenneth Clark, approached her before the end of the year with a request for a poster for the Women's Land Army. In January 1940 she was asked to go to London from her home in Malvern to paint scenes in air raid shelters – although the Blitz was still six months away, Harold was justifiably worried about her safety, and she refused. By August the Battle of Britain was under way, and the Committee made another request, this time for her to paint a Women's Auxiliary Air Force officer who had been recently decorated. They were so pleased that they followed it with a request for three more the next year.

The role of the WAAF during the Battle of Britain was mostly to provide administrative support, but its members also worked as plotters in the operational control rooms, as radar operators, and in the RAF Signals interception branch (the 'Y' service). The three portraits of 1941 were of the first members of the WAAF to be awarded the Military Medal. Corporal Josephine Robins had been in a dug-out when a number of men were killed and injured during a direct hit in a bombing raid; she had immediately given assistance and first aid to the wounded, fetched a stretcher and remained with them until they were evacuated. Her citation in the *London Gazette* of 20 December 1940 stated: 'She displayed courage and coolness of a very high order in a position of extreme danger.' Whereas the previous year's portrait had shown an idealistic young woman out of doors, gazing up to the sky, Dame Laura seems to have been at pains here to stress the unfeminine aspects of the work. Looking shy, and perhaps tired and bewildered after many long nights' work, the young corporal seems weighed down by the deeply unattractive helmet and the cumbersome gas-mask and carrying-case spread out on her lap. In its matter-of-fact way, this is a sympathetic character study, transformed by the acute observation that the artist brought to a wide range of significant wartime paintings. The most problematic and challenging of these were the records she made of the Nuremberg trials in late 1945. The mixture of fact and symbolism in *In the Dock: The Nuremberg Trial* (1946), with which the 69-year-old artist summed up the proceedings against Nazi war criminals, was a brave attempt at an impossible subject.

Oil on canvas
914 × 609mm (36 × 24″)
Imperial War Museum, London

REFERENCE

J. Dunbar, *Laura Knight*, London, 1975, pp.157–8

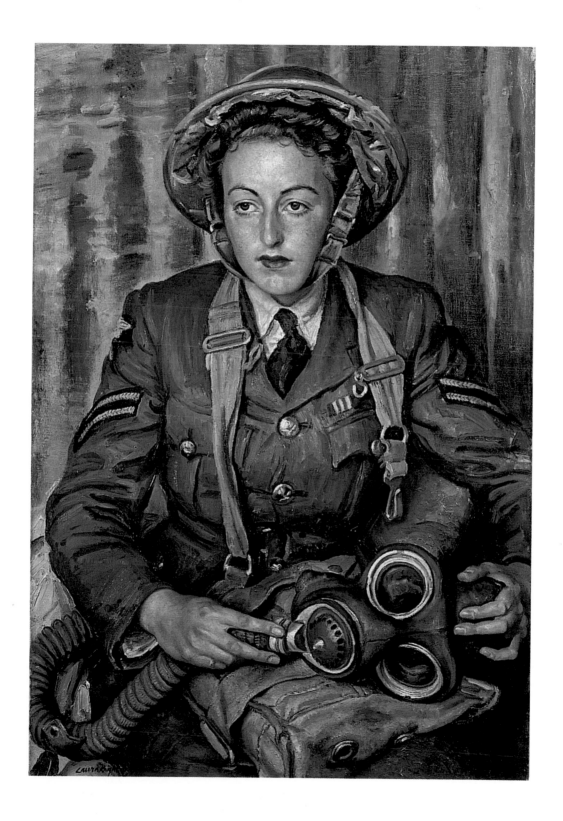

Lucian Freud
Evacuee Boy, 1942

LUCIAN FREUD b.1922

Born in Berlin; came to England 1932;
studied at the Central School of Arts
and Crafts, under Cedric Morris and
Lett Haines at Dedham, and at
Goldsmiths College of Art (1938–43)
first exhibited Lefevre Gallery, 1944;
won Arts Council Prize, Festival of
Britain, 1951; exhibited with Ben
Nicholson and Francis Bacon, *Venice
Biennale*, 1954; retrospectives,
Hayward Gallery, London, 1974;
Washington, Paris and Berlin (British
Council tour), 1988; Whitechapel Art
Gallery, London, 1993.

Oil on canvas
610 × 508mm (24 × 20″)
Private collection

REFERENCES

B. Bernard with D. Birdsall, *Lucian
Freud*, London, 1996, pp.10, 351 (pl.21)

R. Calvocoressi, *Early Works: Lucian
Freud*, exh. cat., Scottish National
Gallery of Modern Art, Edinburgh,
1997, pp.16, 54 (no. 12)

In 1939, in expectation of German bombing raids, roughly one million children were evacuated from Britain's larger cities, many to lodge with families in rural areas. Since the threatened raids did not immediately materialise, some children returned home after just a few months, but others remained exiled from their families for the rest of the war. In retrospect, the government's move has been seen as something of a progressive social experiment, in which the rural middle classes finally learned how the other half lived. In fact, it was often a traumatic experience for both evacuees and hosts. The city children, frequently from the poorest sections of society, found it difficult to adjust to an alien way of life or to make friends with local children, who often found their poverty and their accents a source of both fear and amusement. Freud's awkward adolescent appears to be one of these, perhaps a Cockney lad adrift in small-town East Anglia.

Freud, himself an immigrant, might well have felt some sympathy for such outcasts from local society. After a spell at the Central School of Arts and Crafts, he moved in 1939 to Dedham in Essex to study at the painter Cedric Morris's East Anglian School of Drawing and Painting. He left for a brief period under a cloud, suspected of having burnt down the school by careless smoking, but returned to its new premises in Hadleigh, Suffolk. Apart from a spell in the Merchant Navy for four months and subsequent hospitalisation in 1941, he worked there on and off for the next few years. His style at this period was a strangely evolving hybrid, his exaggeratedly quaint portraits and figures almost certainly influenced by Morris's uncompromising portraits (once described as 'shrieking likenesses'), his occasional excursions into Surrealist dottiness possibly influenced by Morris's companion and co-teacher Lett Haines. Bruce Bernard has described *Evacuee Boy* as a 'brilliant emulation of Otto Dix', though it is open to question whether Freud knew anything of Dix's work at this time.

Despite his aggressive, almost expressionist, depiction of the working-class boy with lop-shoulders, sallow skin and concave chest, this is much more than a clinical examination of some strange specimen under the painter's lens. The brick wall suggests both the urban environment to which the boy belonged and perhaps the sort of solitary imprisonment to which his evacuation had brought him. Unlike the much more comfortable and well-fed *Village Boys*, Freud's other most important surviving canvas of 1942, this is a war-time lament for a lost childhood conveyed with memorable sympathy, insight and conviction.

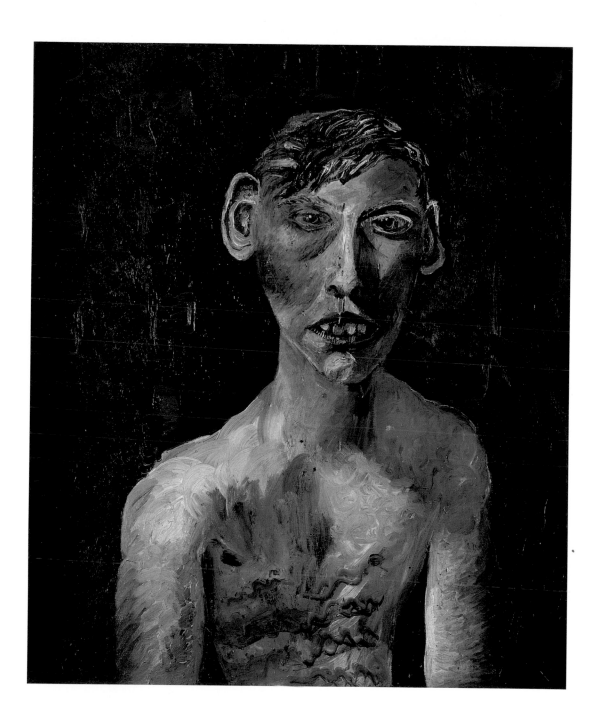

Meredith Frampton

Sir Ernest Gowers, K.C.B., K.B.E., Senior Regional Commissioner for
London, Lt.-Col. A. J. Child, O.B.E., M.C., Director of Operations and
Intelligence, and K. A. L. Parker, Deputy Chief Adminstration Officer,
in the London Regional Civil Defence Control Room, 1943

For biography, see p.96

In December 1941 Meredith Frampton was commissioned by the War
Artists Advisory Committee to paint the first of two portraits, the sitters
to be nominated respectively by the Ministry of Home Security and the
Admiralty. Although a routine half-length or even head-and-shoulders
portrait would have sufficed, Frampton seems to have accepted the
commission as a challenge (it was his first group portrait since one of 1923,
now lost). In his impeturbably 'classic' style he produced the ultimate
depiction of British war-time behind-the-scenes boffinry.

The windowless setting is clearly an underground bunker (in fact, the
Control Room was a semi-underground building in South Kensington
between the Geological Museum and the Natural History Museum), in
which the three protagonists are maintaining the firmest of stiff upper lips
with the aid of cups of tea, special issue coloured telephones, maps and
charts, and not a hint of an ashtray. As K. A. L. Parker (standing at rear) told
Richard Morphet in his detailed discussion of this portrait: 'The function
of the Control Room was to co-ordinate civil defence operations . . . and to
collect and evaluate information about the [bombing] raids and their
effects. It was manned by a very small permanent staff augmented when
raids took place by the staff normally engaged on administrative work at
Regional Headquarters. . . . The painting . . . is intended to provide an
appropriate background (painted with meticulous accuracy) for the work
of the Senior Regional Commissioner.'

The commission was initially for a portrait just of Sir Ernest Gowers
(1880–1966), a senior civil servant who had in effect been created
'Commander-in-Chief . . . for the broad policy and strategy of the "battle
of London".' Characteristically, after a lifetime of public service (and
authorship of *Plain Words*, 1948), he suggested that Parker and Child might
be included, since 'it would look rather absurd for him to appear as if he
operated the Control Room on his own'. As Morphet states in the Tate
Gallery catalogue, this painting is a *tour de force* both as a group portrait
and as an interior. It is therefore remarkable that Frampton's second
commission, for the W.A.A.C., never materialised.

Oil on canvas
1476 × 1683mm (58⅛ × 66¼")
Imperial War Museum, London

REFERENCE

R. Morphet, *Meredith Frampton*, exh. cat.,
Tate Gallery, London, 1982, pp.72–5

William Coldstream
Havildar Kulbir Thapa, 1943–4

WILLIAM COLDSTREAM 1908–87

Painter and teacher of art, born in Northumberland; studied at the Slade School of Fine Art (1926–9) joined the London Group in 1933 and helped to found the Euston Road School, 1937; appointed official war artist, 1943; after the war appointed Professor of Fine Art at University College, London, before becoming Chairman of the National Committee for Art Education; knighted in 1956.

Oil on canvas
915 × 710mm (36 × 28″)
Imperial War Museum, London

REFERENCES

B. Laughton, *The Euston Road School*, 1986, pp.233–9

L. Gowing and D. Sylvester, *The Paintings of William Coldstream 1908–1987*, exh. cat., Tate Gallery, London, 1990, p.17

Coldstream joined the Royal Engineers as a camouflage officer, 2nd Lieutenant, in 1940, and was commissioned as an official war artist three years later. In July 1943 he was on a troopship bound for North Africa; an overland journey from Algiers in blazing heat seems to have lasted several weeks before he eventually arrived in Cairo. Given his already legendarily time-consuming system of painting with measurements and marks, it is perhaps difficult to imagine a less suitable artist to have been despatched to paint portraits in the Egyptian desert. By September, however, he had been posted to an Indian army transit camp six kilometres outside Cairo.

Coldstream's first two portraits in Egypt were of Sikhs, an officer and an N.C.O., painted in an empty storeroom that served as a studio with the south-facing windows covered. These, interrupted in November for sittings for an unsatisfactory portrait of a General Scobi, were more or less completed by early December. One of them, *Havildar Ajmer Singh* (1943; Tate Gallery), briefly became one of Coldstream's most popular war portraits. He then began work on two further portraits, *Rifleman Mangal Singh* (Imperial War Museum, London) and *Havildar Kulbir Thapa*. Thapa was a sturdy sergeant from the 2/3 Gurkha Regiment, one of many thousands of fighting men who had traditionally been recruited from the hill country of Nepal to serve with the British army. The portrait was begun in early December, and was still unfinished in mid-March 1944 when Coldstream was asked to go to Italy.

Although Lawrence Gowing was of the opinion that 'the one personal quality that Coldstream found it difficult to define in terms of form was [the] uncomprehending obedience [of the soldiers]', Coldstream himself seems to have been quite confident about the second two portraits. Discussing the line of vertical proportions that passes though the pupil of Thapa's eye and down to the lower edge of his cuff, Bruce Laughton wrote: 'There is not a detail that is not measured in proportion to the whole figure, so that a feeling of harmony is attained, both in the large and in the small shapes.' It is surely also 'uncomprehending obedience' that, in the end, gives the subject its tremendous dignity. Stranded halfway round the world in a desert inferno, with an interminable wait for their next orders from their British commanders, a small handful of Indian and Gurkha soldiers sat willingly for hours on end for an alien procedure that was of no conceivable benefit to them. It seems symbolic of the unquestioning loyalty and commitment for which the Gurkhas have been legendary.

George Grosz
Cain *or* Hitler in Hell, 1944

GEORGE GROSZ 1893–1959

Born in Berlin; attended the Dresden School of Art (1909–11); studied with Emil Orlik at the Kunstsgewerbeschule in Berlin, 1912, and at the Academie Colarossi in Paris; volunteered for military service in 1914; joined the Dada movement in 1918 and took part in the first *Internationale Dada-Messe*, 1920; settled permanently in New York in 1933; visiting professor at the Art Students League until 1955.

One of the great satirists of the century, Grosz's mordant misanthropy began to mellow in the 1930s, partly no doubt as a result of his move in 1933 to the USA, a country he had long admired. Exiled from his background and from the sources of his art, like Otto Dix he turned increasingly for inspiration to the great sixteenth-century German masters – Altdorfer, Grünewald and Dürer. A caricaturist of Hitler and the Nazis since the late 1920s, he continued to tackle anti-Semitism and anti-Bolshevism in his search for acceptance as an illustrator in the USA, although his real ambition was to be a painter. Some of these drawings were published in *Interregnum* in 1936 but, as Grosz discovered, at this time 'Hitler was still considered a fairly local, harmless and temporary problem. The critics took scant notice of them.' The romantic landscapes he began to paint in America took on a distinctly apocalyptic air. In 1934 he learned about the murder of his friend, the writer Erich Mühsam, in a concentration camp; in 1937 he discovered the realities of Nazi brutalities at first hand from Hans Borchardt, who had escaped from Dachau.

Grosz was conscious both of the Spanish Civil War and the outbreak of the Second World War as the inevitable outcome of Fascism. In a number of self-portraits from the late 1930s, he depicted himself as the lone prophet of the carnage that was taking place on the other side of the Atlantic. As news of the progress of the war reached America, his paintings became increasingly allegorical and gothic, with skeletal and apocalyptic figures in scenes of devastation reminiscent of First World War trench warfare. The first mention in his diaries of the Hitler painting shown here dates from October 1942. In the autumn of that year, the first news had reached the Allies of the mass deportation (though not yet the extermination) of Jews; by mid-1944, when Grosz completed this painting, something of the magnitude of the Nazi atrocities was finally becoming known.

Grosz portrays Hitler as the pathetic little man finally overcome by the horror of his deeds. Undoubtedly one of his most important wartime works, it has always met with a mixed reception from critics who have compared it unfavourably with the bitter anti-militarism of his First World War drawings. In *Cain and Abel*, a drawing of 1935 graphically depicting the murder of a peaceful protester by a jack-booted soldier, he equated Nazism with the biblical murderer. To carry the analogy further and equate Cain with Hitler was perhaps naïve; although Hans Hess's suggestion that Hitler is shown here as 'almost penitent, and so the picture becomes a

Oil on canvas
990 × 1245mm (39 × 48¾")
George Grosz Estate

form of absolution' is patently unjust. There being no convincing way of depicting the magnitude of the suffering for which Hitler was responsible, to show him symbolically as a pathetic psychopath inevitably misses the fact that he was also one of the greatest monsters in history. Grosz's language of gothic and biblical allegory is none the less a brave attempt undertaken in the midst of the war to express something about Hitler that was ultimately inexplicable.

REFERENCE

H. Hess, *George Grosz*, London, 1974, p.225

Jean Dubuffet
Henri Michaux, 1947

JEAN DUBUFFET 1901–85

Born in Le Havre, France; studied at
the Académie Julian but abandoned
painting twice before devoting himself
to it full time in 1942; first significant
exhibition, Paris, 1944; founded the
Compagnie de l'Art Brut (Outsider Art),
1948; major work produced in series
and periods, including sculptures in
painted resins in the 1970s.

Oil on canvas
1307 × 973mm (51½ × 38⅜")
The Museum of Modern Art,
New York, The Sidney and Harriet
Janis Collection, 1967

REFERENCES

A. Franzke, *Dubuffet*, New York, 1981,
pp.40–7

M. Paquet, *Dubuffet*, Paris, 1993, pp. 54–5

M. Loreau, ed., *Catalogue des travaux de
Jean Dubuffet*, Paris, 1966, vol. III
(no.112)

On a trip to Switzerland with the writer and editor Jean Paulhan soon after
the Armistice in 1945, Dubuffet conceived his enthusiasm for the untutored
art of asylum inmates and others on the fringes of society. He was to call
his new movement Art Brut; one of its first public manifestations was in
his exhibition *Mirobolus, Macadam et Cie* at the Galerie René Drouin in 1946.
Causing outrage among the conservative critics, most of the graffiti-like
images on roughened surfaces were of generalised 'types' engaged in basic
activities such as smoking and drinking. Features such as the use of red
blobs for cheeks and a red crescent for the mouth were a clear reference
to drawings by children, but the paintings also owed much to Brassaï's
famous photographs of the graffiti on Paris walls.

Paulhan introduced Dubuffet to a Mrs Florence Gould, who held a
weekly salon for Parisian intellectuals. When she asked him to do a portrait
of the writer Paul Léautaud, Dubuffet not only rather surprisingly
acquiesced, but took it as a cue for a whole series of portraits of his friends.
He worked on these between August 1946 and September 1947, exhibiting
the results at the Drouin Gallery in October 1947 under the ironic heading
'les gens sont bien plus beaux qu'ils croient' (people are much more
beautiful than they think). This portrait is one of at least six paintings
of the Belgian-born poet and visionary draughtsman Henri Michaux
(1899–1984), all dating from December 1946 or January 1947 (another,
Monsieur Plume with Creases in his Trousers, is in the Tate Gallery). This,
inscribed 'gros cerne crème' (large cream-ringed eyes) on the reverse,
is one of the most aggressively simplified, both in outline and colour;
the stance is one of authority, suggesting perhaps a prophet-like figure.

One may of course view this series of 'anti-portraits' as part of general
post-war iconoclasm – a desire to demolish the relics of the 'old order' and
of outmoded traditions, and to *épater les bourgeois*. Dubuffet was, however,
extremely articulate; he wrote at length both about his technique, which
often involved the addition of ashes or dirt to the paint, and also his
intentions. 'I have attributed to an insignificant detail – hairy ear, long
tooth – an enormous but entirely arbitrary importance . . . elevating it to
the scale of a myth. In doing so, I had the impression that I was managing
better to cancel out totally all the other minor distinctive traits – physical
or mental – of my model which others might quite rightly have judged
more significant than that fortuitous detail. All in all, a procedure for
blocking any likeness.'

Jack Levine
Reception in Miami, 1948

JACK LEVINE b.1915

Born in Boston, Massachusetts;
studied painting at Harvard (1929–33);
intermittently employed by the Works
Progress Administration's Federal
Art Project in Boston; served in the
US army 1942–5; first solo exhibition
1939 at the Downtown Gallery,
New York; known for his scenes of
social comment and protest, he also
experimented with printmaking and
turned to painting biblical works in
the 1980s.

The artist records: '*Reception in Miami* was the result of reading one day in Earl Wilson's column in the *New York Post* that the Duke and Duchess of Windsor had come to Miami, and that at one of their appearances in the lobby there was much bowing and curtsying on the part of our fellow Americans. I thought this disgusting. That was the basis for something like a drawing-room comedy, with all kinds of effete snobs . . . bowing and scraping, like puppets at the end of a string . . . I think I probably considered my entry into painting on the basis of subject matter. It's something I would never discard. Subject matter is all important.' Levine was a brilliant draughtsman with a sharp eye for social comment whose work established him as something of a mid-twentieth-century American Hogarth. The work that made his reputation in 1939, *The Feast of Pure Reason* (The Museum of Modern Art, New York) shows a politician, policemen and capitalist engaged in disreputable collusion, in the same way that *Election Night* (1954; The Museum of Modern Art, New York) is also an attack on the American political system. A dated drawing for *Reception* (Fogg Art Museum, Harvard) shows the incident occurred in 1947; there is also a sketch for it (Sheldon Memorial Art Gallery, University of Nebraska-Lincoln).

The exiled Duke of Windsor (1894–1972) and his American-born wife Wallis, who lived in France, paid annual visits to the USA where they were royally received by the American plutocracy. Levine's attack (which seems so far to have escaped the notice of British historians and biographers) is as much a criticism of American society as it is of the unfortunate couple, and is by any standards a *tour de force*. While the closest comparison might be with one of the later figure paintings of Kokoschka, the low-key colouring and unique 'lightning' brushwork (Levine's 'white writing', evolved from a study of Tintoretto) designate the painting as closer to neo-Romanticism than to Expressionism. Levine's ludicrous baroque setting is a comment both on American taste and on the 'old order'; the uniformed lackey on the right summons the viewer's attention and mockingly invites us to join the line-up to be presented. The American socialites are perhaps caricatured less than the principal protagonists, who share not only the indignity of a vulgar copy of Canova's *Cupid and Psyche* towering over them (a comment on the cause of their current situation), but also a small dog (the Duchess's?), who is scratching for fleas. 'Was it for this that the hand now holding a cigarette holder relinquished the scepter of the sceptered isle?' asked Levine's biographer, Frank Getlein.

Oil on canvas
1277 × 1426mm (50⅜ × 56⅛″)
Hirshhorn Museum and Sculpture
Garden, Smithsonian Institution,
Washington, D.C. Gift of Joseph H.
Hirshhorn, 1966

REFERENCES

F. Getlein, *Jack Levine*, New York, 1966,
p.19 (pl. 36)

M.W. Brown (with J. Levine), *Jack
Levine*, New York, 1989, p.49

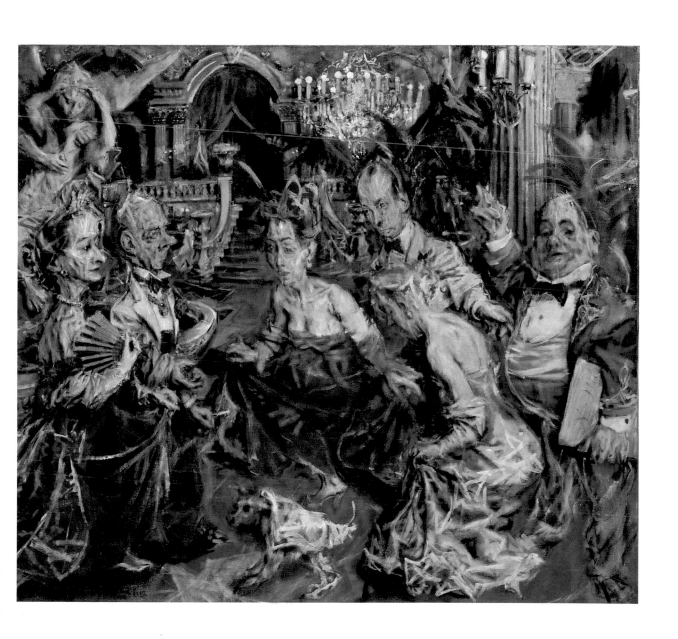

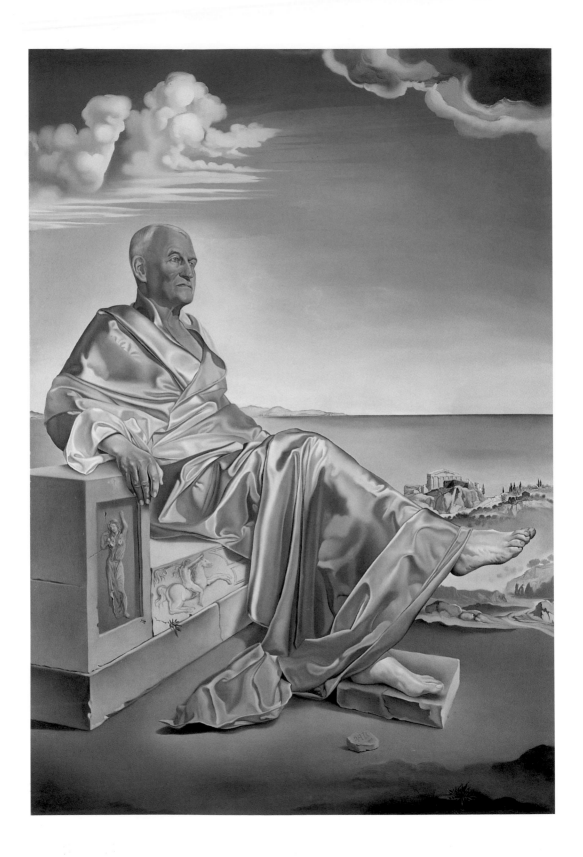

Salvador Dalí
La Turbie: Sir James Dunn, 1949

SALVADOR DALÍ 1904–89

Born in Figueras, Spain; studied at the Academy of Fine Arts in Madrid, from which he was twice expelled; joined the Surrealists in 1929 and was influenced by Miró, Tanguy and de Chirico; developed what he described as the 'paranoiac critical method' and became the master of meticulously painted irrational juxtapositions; lived in the USA, 1940–8; latter half of his career increasingly devoted to religious and classical works.

Oil on canvas
1324 × 905mm (52⅛ × 35⅝")
The Beaverbrook Canadian Foundation, Beaverbrook Art Gallery, Fredericton, N.B., Canada

REFERENCES

From Sickert to Dalí: International Portraits, exh. cat., Beaverbrook Art Gallery, Fredericton, 1976, no.5

R. Descharnes and G. Néret, *Salvador Dalí. The Paintings*, Cologne, 1994, p.446 (no.980)

Great wealth (big business) and fine art have not always proved the happiest of combinations in the history of twentieth-century patronage. Salvador Dalí, whose ambitious projects always required a substantial income, was particularly prone to money-making opportunities; society portraiture, as he discovered when he lived in the USA in the 1940s, provided a reasonable income in return for a few routine canvases a year. For ten years or so, it was the height of chic to have one's portrait done by Dalí, and sitters included Lady Louis Mountbatten in 1940 and Laurence Olivier (in the part of Shakespeare's Richard III) in 1955. Very few of these commissioned portraits would today be ranked high in Dalí's oeuvre.

Sir James Dunn (1875–1956) was a Canadian steel magnate and financier, a close friend of Lord Beaverbrook and something of an art collector. In about 1932, Dunn met Walter Sickert and commissioned no fewer than twelve portraits from him. The precise circumstances of this much later and extraordinary portrait by Dalí are not documented, but it was presumably a commissioned work. The brilliant blue sea and sky are those of the Mediterranean: La Turbie, located above Monte Carlo, is the Roman site where in 6 BC Augustus erected a huge monument topped with a bronze statue of himself said to be two hundred feet high (only the base remains today). Since there is no intrinsically surreal element in this portrait, it is not clear whether it represents an advanced state of megalomania or, as seems more likely, a private joke between artist and sitter. There is no evidence that the portrait was ever publicly exhibited in Dunn's lifetime. His 'roman' profile and perhaps a house in the south of France were probably enough to have given Dalí the idea. Apart from the fact that the sitter appears to be draped in gold lamé, presumably an allusion to the bronze statue of Augustus, Sir James might be any wealthy man sitting by a swimming pool after a bathe.

Dunn later commissioned a portrait of his wife on horseback out hawking, *Equestrian Fantasy* (1954), which again contains virtually no surreal element apart from a certain pretentiousness. A further posthumous portrait of Dunn (1958) is completely straightforward and was presumably commissioned by Lady Dunn as a corrective to the image conveyed in *La Turbie*. Of all Dalí's commissioned portraits from this period, however, this remains one of the most impressive. It is a powerful, if unlovable, likeness. It may well be accused of vulgarity, but whether on the part of the artist or the sitter, or by mutual consent, is unclear.

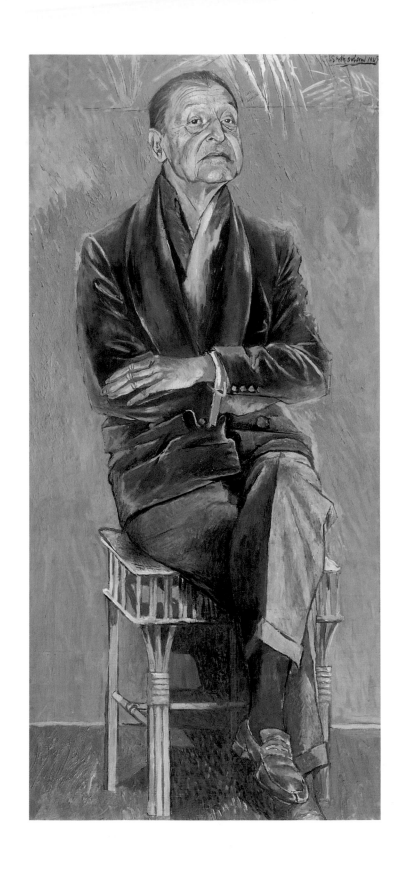

Graham Sutherland
Somerset Maugham, 1949

GRAHAM SUTHERLAND 1903–80

Studied engraving at Goldsmiths
College of Art (1921–6); taught at
Chelsea School of Art, 1928–39; began
to paint Welsh landscapes, c.1931–40;
served as a war artist; designed great
tapestry for Coventry Cathedral, 1952;
retrospective exhibitions Venice/Paris,
1952; Amsterdam/Zurich/Tate Gallery,
London, 1953; Turin, 1965; Basel, 1966;
Munich, 1967; retrospective exhibition
of portraits at National Portrait Gallery,
London, 1977.

Oil on canvas
1372 × 635mm (54 × 25")
Tate Gallery, London

REFERENCES

J. Hayes, *Portraits by Graham Sutherland*,
exh. cat., National Portrait Gallery,
London, 1977, pp.42–7

R. Alley, *Graham Sutherland*, exh. cat.,
Tate Gallery, London, 1982, pp.39, 135–7

M. Goldin, ed., *Sutherland Ritratti*, exh.
cat., Palazzo Sarcinelli, Conegliano,
1996, pp.88–95

It is difficult now to imagine the impact made by this, Graham Sutherland's first portrait, when it was first exhibited in Britain in the early 1950s. With its bright, slightly acid colours, unconventional narrow format, semi-abstract background and few concessions to conventional flattery, this was modern art adapted to an old genre and something with which people could associate. In many ways, it seemed to herald the emergence of British painting from the khakhi colours and traditional values of wartime painters such as Coldstream and the Euston Road School (see pp.146). It certainly brought Sutherland's name to a wider public, and commissions for portraits such as those of Beaverbrook, Churchill and Helena Rubinstein began to flood in. For twenty years, this was one of the best-known paintings in the Tate Gallery, until ousted by David Hockney's *Mr and Mrs Clark and Percy* (1970–71), another portrait that seems to define a whole era.

Sutherland began wintering in the south of France in 1947, where he occasionally met the famous author of *Of Human Bondage* at the houses of neighbours. Somerset Maugham (1874–1965) suggested the portrait himself and Sutherland, after some hesitation, agreed. He was obviously attracted by Maugham's gnarled features, which resemble one of the 'found objects' of his early paintings. The colours were directly influenced by the Mediterranean setting (Sutherland's palette brightened in any case after his first visits to France), but the orangey yellows are said to be a reference to the Orient because of Maugham's long association with the East. The cane stool (borrowed from a neighbouring café) reinforces the oriental impression; and Maugham's aloof and inscrutable expression, disciplined posture and folded arms give him something of the air of a mandarin. Like many of Sutherland's portraits it is an extremely flattering image, not because it enhances traits normally considered attractive, but because of its sense of power and occasion. But there is an underlying sourness – in the sitter's slightly disdainful expression, and in the colour which fades here and there to the greenish ochre of an unripe, rather than a ripe, apricot. Maugham said he was thrilled with the portrait: 'Graham has painted me with a mood and with an expression I sometimes have, even without being aware of it.' Nevertheless, he immediately gave it to his daughter, who in turn passed it to the Tate Gallery in 1951.

1950S

The anti-Communist war in Korea helped to create a climate of fear in the US, in which the McCarthy investigations flourished. Post-war recovery in Europe was symbolized by the Festival of Britain in 1951 and the Treaty of Rome in 1957, which established the Common Market. The USSR initially won the space race with Sputnik and the first moon landing. In the arts, the Theatre of the Absurd, the supremacy of American Abstract Expressionism and the invention of electronic music seemed to convey the dehumanizing effects of a technological society.

HISTORICAL EVENTS

Mutual defence pact between China and the USSR.

Start of the Korean War, after invasion of US-dominated South Korea by USSR-led North Korea.

Invasion of Tibet by China, challenging the authority of the young Dalai Lama.

In Britain, German-born scientist Klaus Fuchs found guilty of betraying British atomic secrets to the USSR.

In the US, McCarthyism at its height, and all Commmunist activities banned.

First kidney transplant performed in Chicago.

First credit cards introduced by Diners Club of New York.

Korean War continues, until ceasefire in November.

In Britain, return of the Conservative Party to government; Winston Churchill becomes Prime Minister.

In the US, Julius and Ethel Rosenberg sentenced to death for espionage.

Tests of the first Russian atom bomb.

4,000 Londoners die during a four-day smog in December.

In Britain, death of King George VI; succession of his daughter Elizabeth.

In the US, Gen. Eisenhower elected President, with Richard Nixon as Vice-President.

US explodes the first hydrogen bomb at Eniwetok island in the Pacific.

End of the post-war Allied occupation of West Germany.

In Egypt, King Farouk deposed and the monarchy overthrown.

In Kenya, Britain declares a state of emergency after Mau Mau rising.

First succesful open-heart surgery performed in the US.

In the US, marriage of John F. Kennedy and Jacqueline Lee Bouvier.

In the USSR, death of Stalin; he is succeeded by Georgi M. Malenkov.

Invasion of Laos by the Vietminh.

End of Korean War in a truce.

Election of Dag Hammerskjöld as Secretary General of the UN.

In Britain, coronation of Elizabeth II.

Mount Everest, the highest point on earth, conquered by Edmund Hillary and Tenzing Norkay.

In the US, McCarthy censored by the Senate for his anti-communist activities.

Defeat of the French at Dien Bien Phu. Vietnam is provisionally partitioned, with a communist regime in the north and a nationalist government in the south.

In China, flooding of the Yangtze River causes wide-spread destruction.

The first four-minute mile (3:59.4) achieved by medical student Roger Bannister in Oxford.

Connection made for the first time between smoking and lung cancer.

In the US, computers enter the workplace.

| 1950 | 1951 | 1952 | 1953 | 1954 |

CULTURAL EVENTS

Jackson Pollock paints *Lavender Mist*, marking emergence of Abstract Expressionism.

First performance of Eugène Ionesco's *La Cantatrice Chauve*.

Release of Jean Cocteau's late Surrealist film *Orphée* (Orpheus).

Latin American Samba becomes a popular dance craze.

The Festival of Britain held at London's South Bank.

First performance of Stravinsky's opera *The Rake's Progress*.

Publication of J. D. Salinger's *The Catcher in the Rye*.

Release of Alfred Hitchcock's film *Strangers on a Train*.

First performance of Terence Rattigan's play *The Deep Blue Sea*.

Release of Fred Zinnemann's classic Western *High Noon*; Gene Kelly's film musical *Singin' In The Rain*, draws on popular songs from the late 1920s.

In the second great era of the skyscraper, Lever House, New York, built by architect Gordon Bunshaft, of Skidmore, Owings and Merrill.

Le Corbusier's vision realised in *Unité d'habitation*, Marseilles, a skyscraper construction set in parkland.

Willem De Kooning works on *Women* series.

First performance of Samuel Beckett's play *Waiting for Godot*.

First performance of Dmitri Shostakovich's *Symphony no. 10*.

Publication of the first James Bond novel, Ian Fleming's *Casino Royale*.

Release of Howard Hawks' film *Gentlemen Prefer Blondes*, starring Jane Russell and Marilyn Monroe.

Release of Elvis Presley's first hit single, *That's All Right*.

Publication of William Golding's first novel, *Lord of the Flies*; Kingsley Amis's hugely successful *Lucky Jim*.

Release of Akira Kurosawa's film *Seven Samurai*.

Le Corbusier designs the chapel of Notre-Dame du Haut at Ronchamp, Vosges.

1955

In South Africa, forcible removal of black Africans from Johannesburg to a new town outside the city.

In the USSR, Malenkov succeeded by Bulganin.

In Britain, resignation of Winston Churchill at age eighty; succession of Anthony Eden.

West Germany joins NATO.

In Argentina, dictator and president Juan Perón deposed by the military.

Ruth Ellis is the last woman to be hanged in Britain.

Exhibition of works by Giacometti at the Guggenheim Museum, New York.

Re-release of *Rock Around The Clock* by Bill Haley and The Comets, the first single to sell over a million copies.

Publication of the second novel in Evelyn Waugh's war trilogy, *Officers and Gentlemen*; Graham Greene's *The Quiet American*, set in Vietnam; Vladimir Nabokov's 'scandalous' *Lolita*.

Release of Elia Kazan's *East of Eden* and Nicholas Ray's *Rebel Without a Cause*, both starring James Dean at the height of his career.

1956

End of Britain's 74-year military occupation of Suez Canal Zone. Nasser elected President of Egypt; Canal nationalised.

Invasion of Egypt by Israel; occupation of Sinai.

Invasion of Hungary by the USSR.

In the US, re-election of Eisenhower as President.

Emergence of Martin Luther King as leader of desegregation campaign.

In Cuba, Fidel Castro begins attempt to overthrow President Batista.

Marriage of film star Grace Kelly to Prince Rainier III of Monaco.

Exhibition *This is Tomorrow* at the Whitechapel Art Gallery, London, includes Richard Hamilton's collage *What is it that makes today's homes so different, so appealing?*

With Rock 'n' Roll at its height, Elvis Presley plays the Ed Sullivan Show.

In San Francisco, 'Beat' poet Allen Ginsberg causes a sensation with his long poem *Howl*.

John Osborne's play *Look Back In Anger* revolutionises contemporary British theatre.

Release of Don Siegel's film, *The Invasion of the Body Snatchers*.

Jorn Utzon designs the Sydney Opera House.

1957

In Britain, resignation of Anthony Eden; succession of Harold Macmillan.

In Europe, Treaties of Rome between France, West Germany, Italy, Belgium, The Netherlands and Luxembourg mark the beginning of the EEC.

In the USSR, launch of the first artificial satellites, *Sputnik I* and *Sputnik II*.

In Ghana, independence.

In Egypt, withdrawal of Israeli forces; Gaza strip handed over to UN.

Foundation of the International Atomic Energy Agency, to control the proliferation of atomic weapons.

American Althea Gibson becomes the first black Wimbledon tennis champion.

Solo exhibition of works by Jackson Pollock at the Museum of Modern Art, New York.

Publication of Roland Barthes' *Mythologies*; Boris Pasternak's *Doctor Zhivago*.

First performance of Harold Pinter's *The Birthday Party*.

First performance of Leonard Bernstein's *West Side Story*; Michael Tippett's *Symphony no. 2*.

Buddy Holly's *That'll Be The Day* is an international hit.

Publication of Vance Packard's *The Hidden Persuaders*; Noam Chomsky's *Syntactic Structures*.

1958

In the USSR, succession of Khruschev.

In Europe, the official start of the EEC.

In France, re-election as President of Charles de Gaulle, in reaction to crisis of growing nationalism in Algeria.

In the US, foundation of NASA, first American artificial satellite, *Explorer I*.

Death of Pope Pius XII; succession of Pope John XXIII.

In Britain, foundation of the Campaign for Nuclear Disarmament by Bertrand Russell and Canon Collins; the first Aldermaston March.

Race riots in Notting Hill, West London.

Mark Rothko commissioned to paint the Seagram murals (later donated to the Tate Gallery, London).

First performance of Hans Werner Henze's fantasy opera *The Prince of Homburg*.

Little Richard sings *Good Golly Miss Molly* on the *Off The Record* show.

Publication of J. K. Galbraith's *The Affluent Society*.

Completion of Andrzej Wajda's trilogy of Second World War films, *Ashes and Diamonds*.

Mies van der Rohe's prestigous Seagram Building, New York, constructed in International Modern style.

Spread of the Beatnik movement among young Americans.

1959

In Cuba, overthrow of Batista by Fidel Castro, who becomes head of state.

In Sri Lanka, assassination of Prime Minister Bandaranaike; succession of his wife, who becomes the world's first woman leader.

In the US, Alaska becomes 49th state, and Hawaii 50th.

In Singapore, self-governance.

In Japan, heir-apparent Akihito marries a 'commoner'.

The Russian *Luna II* is the first space craft to land on the moon.

Debut of the first full-size hovercraft on the English Channel.

Release of Billy Wilder's comic film *Some Like It Hot*; William Wyler's epic *Ben Hur*; Joseph L. Mankiewicz's film of Tennessee Williams's play *Suddenly Last Summer*; Alain Resnais's *Hiroshima Mon Amour*.

Buddy Holly and fellow-musicians die in a plane crash.

Frank Lloyd Wright's Solomon R. Guggenheim Museum completed in New York.

Sidney Nolan
Daisy Bates, C.B.E., 1950

SIDNEY NOLAN 1917–92

Painter, designer and illustrator, born in Australia; largely self-taught, he took up full-time painting in 1938 and made his name with the series of 'Ned Kelly' paintings begun in 1946; first went to Europe in 1950 but is primarily known for his Australian paintings; worked both in Britain and Australia as a designer for theatre productions and also as an illustrator; knighted in 1981.

While serving as a private with the Australian army during the Second World War, Sidney Nolan began painting his bright and flattish interpretations of the Australian landscape. From 1946 he began travelling in north-eastern Victoria and working on the series of paintings celebrating the notorious bushranger and Australian folk hero, Ned Kelly, which made his name. The Kelly paintings were followed by the Fraser series about an escaped convict on Fraser Island, Queensland, then a series on glass about the Eureka Stockade (the gold-miners' uprising of 1854), and then, working in outback Queensland and the Australian interior, a series about the ill-fated Burke and Wills expedition to cross the interior. This deluge of subjects from Australian history and myth would not in itself have sufficed to draw international attention to Nolan, but with his masterly and highly individual fluency and 'odd mixture of sunlight and colonial legend' he was increasingly perceived as the first purely Australian painter of stature.

Daisy Bates (1863–1951) was the next Australian legend, this time a living one (albeit in a nursing home in Adelaide). A remarkable Irishwoman, she had emigrated to Australia when she was nineteen and worked initially as a journalist. In 1899 she was commissioned by *The Times* of London to investigate alleged cruelty to Aborigines, and so began her lifelong work with and study of Aboriginal tribes. As well as making detailed reports on Aboriginal life and customs, she worked for their welfare, setting up camps for the aged and never attempting to interfere with their culture or to 'westernise' them. In 1933 she was created Commander of the Order of the British Empire for her research and welfare work. For twenty years she lived on a campsite at Ooldea (now on the railway line between Adelaide and Perth); during the winter of 1948, Nolan and his wife stopped in this bare, dry landscape with its steep sand hills and empty skies to see the place where she had lived and worked. He re-created this bleak prospect in his Sydney studio, a remarkable tribute to one woman's resilience and dedication in such an alien spot.

Acrylic on board
902 × 1093mm (35½ × 43″)
National Gallery of Australia, Canberra
A gift to the people of Australia by Mr and Mrs Benno Schmidt of New York City and Esperance, Western Australia through the American Friends of the Australian National Gallery, 1987

REFERENCE

Julian Fagan, *Uncommon Australians. Towards an Australian Portrait Gallery*, exh. cat., Art Exhibitions Australia Limited, 1992, p.130 (93)

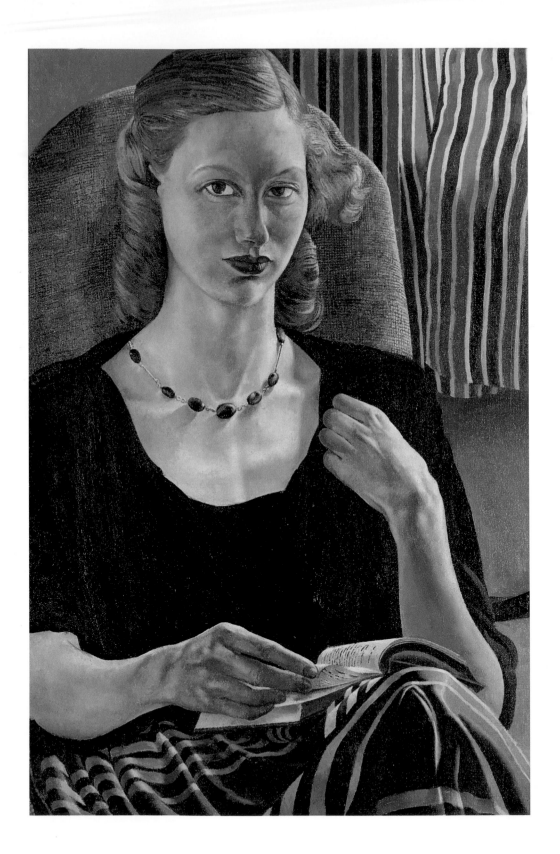

Stanley Spencer
Portrait of Daphne Spencer, 1951

STANLEY SPENCER 1891–1959

Born in Cookham, Berkshire, where he spent much of his life and which inspired many of his paintings; scholarship to the Slade School of Fine Art, 1908–12; his experiences in the First World War in the Medical Corps and Macedonia provided themes for subsequent work; exhibited for a while with the New English Art Club and later with the Royal Academy; his best and most ambitious work the *Resurrection* series (1926) and the Burghclere Memorial Chapel (1932).

In 1950 Stanley Spencer had finished his *Resurrection* paintings, was made a C.B.E. and elected a member of the Royal Academy. The combination of respectability conferred by the honours and the time to do other things secured a steady stream of portrait commissions throughout the last ten years of his life. Much of the demand was local, from friends, neighbours and even the mayor of his home town, Cookham. The portraits, although not among his greatest paintings, are nevertheless among the best work being produced in Britain at the time and provide a remarkable record of small-town British life in the 1950s. Interior decor, which Spencer considered essential to the understanding of a person's character, glimpses of gardens, and domestic and country pursuits are rendered with loving accuracy, as is his gentle analysis of character, in considerable contrast to the early work of Lucian Freud (see p.143) whose eye for detail he shared.

The portrait of his niece Daphne was one of four he painted in Merville Garden Village, Northern Ireland, on visits to his brother Harold and family (not to be confused with the earlier portraits of Spencer's mistress Daphne Charlton). Although not a commission, the portraits of Daphne are carried out in exactly the same spirit as his commissions, except perhaps for a palpable interest in the appearance and character of his pretty niece, and not so much in the details of her environment. This is, in essence, a picture of the archetypal English 'rose' of the early 1950s, painted with the deceptively simple mastery that only a lifetime's achievement can bring. The strength of the compositional structure and the close-up format with the half cut-off arm give the portrait its power and directness, the contrasting coloured stripes of the curtain and black stripes of the skirt its decorative appeal. Each stone of the necklace casts its own shadow, enabling us to gauge exactly the light of that summer afternoon in Ulster and the lie of the bones around the sitter's neck.

Oil on canvas
923 × 616mm (36 ⅜ × 24¼″)
Ulster Museum, National Museums and Galleries of Northern Ireland

REFERENCE

K. Bell, *Stanley Spencer. A Complete Catalogue of the Paintings*, London, 1992, pp.346, 495

Lucian Freud
Portrait of John Minton, 1952

For biography see p.142

One of the most devastating expressions of personal distress in all of twentieth-century portraiture, this painting was commissioned by the painter John Minton (1917–57) after he saw Freud's small head of Francis Bacon (stolen 1988; Tate Gallery) done earlier in 1952. A leading figure in the so-called neo-Romantic movement and on the London art scene, Minton seemed a popular and amusing figure with his camp and bohemian lifestyle, but behind the façade was a man unhappy both in his work as an artist and in his life as a homosexual unable to forge a serious relationship. Bruce Bernard, writing movingly of this work, saw 'no subtler sense of an individual's approaching death in modern painting than that expressed by a faint hint of the teeth's increasing separateness from the flesh.' Five years later Minton took his own life, a victim both of society's intolerance of his sexuality, and of his own intolerance of his self-perceived inadequacy as an artist. When Freud learned that Minton had bequeathed the portait to the Royal College of Art, he is said to have been convinced that he must have commissioned it with his death already in mind.

Oil on canvas
410 × 260mm (16⅛ × 10¼")
Royal College of Art Collections,
London

REFERENCES

B. Bernard with D. Birdsall, *Lucian Freud*, London, 1996, pp.13, 77, 353

F. Spalding, *Dance till the Stars Come Down*, London, 1991, pp.170–71

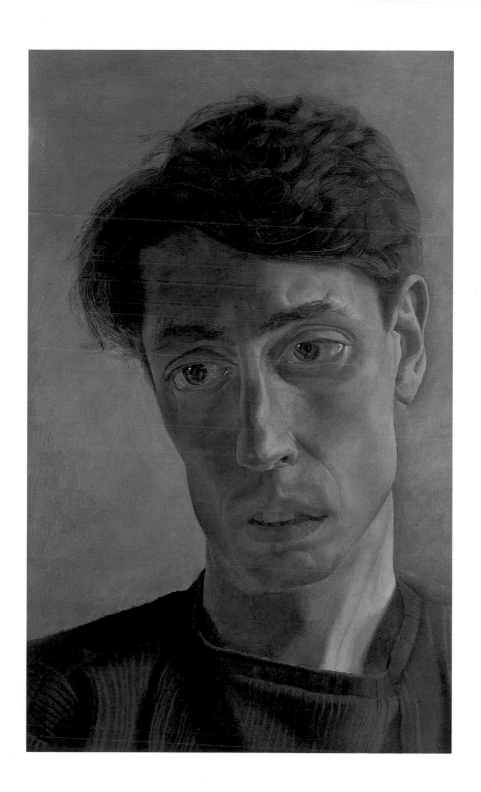

Richard Lindner
The Meeting, 1953

RICHARD LINDNER 1901–78

Born in Hamburg, Germany; his early
studies were in music but an interest
in art led him to study at the Kunst-
akademie, Munich (1925–7); lived in
Berlin and Munich during the late
1920s where he worked as art director;
moved to Paris in 1933 and then to
New York in 1941 where he became an
illustrator for *Fortune*, *Harper's Bazaar*
and *Vogue*; in 1952 he abandoned
commercial work and concentrated on
drawing, painting and teaching at the
Pratt Institute, Brooklyn; in later years,
spent increasing proportion of time
in Paris.

The Meeting was Richard Lindner's first major painting. Although it carries obvious parallels with the contemporary 'theatre of the absurd' of Ionesco and others (*The Bald Soprano*, 1953, could well have been the title of one of Lindner's paintings rather than an Ionesco play), it is an autobiographical group portrait of figures from his past and the present. As a young man in his native Germany, he had worked as an art director and illustrator, and continued to work in graphic design in Paris from 1933 to 1939 and then from 1941 in New York. In 1952, probably with the encouragement of his *émigré* friends, he decided to devote himself to painting and began sketches for *The Meeting* in August 1953.

The Meeting, originally entitled *Entr'acte,* is considered to be a 'rite of passage' work, celebrating Lindner's successful entrance into the New World from the Old. It also contains many of the figures and types that became the vocabulary of his art and dominated his mature work. They may be identified as follows. Of the contemporary people, at front left sits the trim figure of the photographer Evelyn Hofer, who became one of his closest friends in New York and with whom he had been on a trip to Europe the previous winter. Appearing slightly outside the 'frame' of the *mise-en-scène*, she is perhaps both spectator and critic. She took the photographs that Lindner used for the portraits of his friends, the artist and cartoonist Saul Steinberg (1914–99) and his then wife the painter Hedda Sterne, both seated on the right. The centre of the composition is dominated by three emblematic figures who would subsequently make frequent appearances in Lindner's work. The cartoon-like mad King Ludwig II of Bavaria seems to have represented the forces of the irrational and is an obvious referral back to his German origins. The geometrically corsetted figure, one of his most familiar motifs, has never been precisely explained. It must to some extent represent secret and forbidden aspects of female sexuality; Lindner's mother had run a corset business from their home in Nuremberg and he later stated that the woman was based on the family cook. The cat is variously said to have belonged to Saul Steinberg, and to be a reminder of the poverty Lindner suffered when he lived in Berlin in 1927–8 and could afford to feed his cat only in preference to himself.

In the background, clustered round the blank doorway (a transition to or from the past?) are members of Lindner's family from his youth. The wunderkind or child prodigy is another Lindner obsession. The artist

Oil on canvas
1524 × 1829mm (60 × 72″)
The Museum of Modern Art,
New York
Given anonymously, 1962

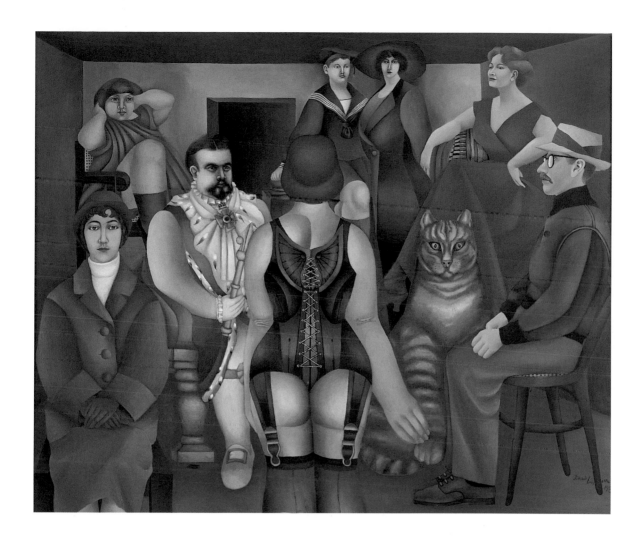

himself is portrayed as a child, while his older sister Lissy on the left displays her more obvious precociousness – a talented opera singer, she perished in a 'flu epidemic in 1915. Both she and the fashionably dressed aunt with Lindner, later described by him as the local beauty, clearly represent different aspects of female sexuality as perceived by a boy growing up in a family dominated by women. Lindner's use of imagery led him to be claimed as the father of American Pop Art, although he remained a totally individual figure. His obsession with the past and with the world of toys and childhood have something in common with the British artist Peter Blake (see p.168).

REFERENCES

D. Ashton, *Richard Lindner*, New York, 1969, pp.17–19

J. Zilczer et al., *Richard Lindner. Paintings and Watercolors 1948–1977*, Washington, 1996, pp.24–6, 53, 141

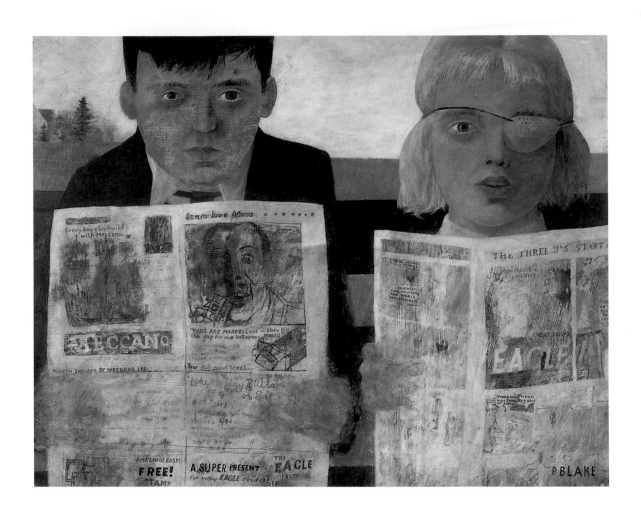

Peter Blake
Children Reading Comics, 1954

PETER BLAKE b.1932

Artist and designer, born in Kent, studied at the Royal College of Art and travelled in Europe on a Leverhulme research award, studying popular art; as a pioneer of Pop Art in Britain he created numerous collages and reliefs, including the album cover for the Beatles' *Sergeant Pepper's Lonely Hearts Club Band* in 1967; founder member of the Brotherhood of Ruralists, 1975; retrospective at the Tate Gallery, London, 1983.

The majority of Peter Blake's early paintings deal with the world of childhood, a theme to which his work has constantly returned and made reference. Growing up during the war and the 1940s, his education as an artist was interrupted by National Service in the RAF, and it is perhaps remarkable that as a 22-year-old student at the Royal College, he not only painted children but identified with them. But there is certainly no hint of insecurity in any of his portrayals, only an enormous pleasure in the recent past which is characteristic of all his work not obviously concerned with the joys of the present. This early series culminates in the remarkable *On the Balcony* (1955–7) with its hundreds of allusions, and in *Self-portrait with Badges* (1961; both Tate Gallery), which continues Blake's childlike vision of himself though seen at last as a fashionably dressed young man with a beard.

Probably the earliest painting of the group, *Children Reading Comics* already carries all the hallmarks of Blake's mature preoccupations. Although based on a family snapshot of himself and his sister Shirley, it is not a portrait of either of them. Aptly described by Michael Compton as possibly from a family snapshot 'of the kind that are an embarrassment to many young adults who can remember the agony of having to pose for them', the portrait contains an element of embarrassment as the brother and sister are interrupted by the photographer/artist in their attempts to read their comic. *The Eagle*, though slightly after Blake's own childhood, was considered to be the most responsible and respectable of the post-war publications aimed at children; it had a more grown-up format, like a tabloid newspaper. It could be read like one, though almost invariably it had to be split up and shared with others. The girl has had first choice of the coloured front and back pages with their exciting strip cartoons; the boy is having to make do with the less interesting inside bit with the advertisements, and looks slightly resentful about it. The girl is not old enough to be self-conscious about the eye-patch concealing one of childhood's myriad injuries. Painted in the slightly *faux naïf* yet realist style that Blake probably took from American painters such as Ben Shahn, it is both an affectionate salute to mid-century childhood and a foretaste of Blake's ephemera-based Pop Art, which lay ahead at the end of the 1950s.

Oil on hardboard
369 × 470mm (14½ × 18½″)
Tullie House Museum & Art Gallery, Carlisle

REFERENCE

Peter Blake, exh. cat., Tate Gallery, London, 1983, pp.23–5, 74

Larry Rivers
The Studio, 1956

LARRY RIVERS b.1923

Painter and sculptor, born in New York; initially trained as a professional musician at the Juilliard School before studying with Hans Hofmann, 1947–8; known for his works on historical and Jewish themes, he was a leading figure in the American Pop Art movement; he has also produced sculpture and taught widely.

Oil on canvas
2095 × 4915mm (82½ × 193½")
The Minneapolis Institute of Arts,
The John R. Van Derlip Fund

A trip to Paris in 1950 was a major factor in the comparatively late transformation of Larry Rivers from accomplished jazz saxophonist and part-time poet into full-time painter. The large canvases of the mid-nineteenth century realist schools made a profound impression on him; a tribute to Courbet's monumental *Burial at Ornans* in the form of the rather expressionist *The Burial* (1952; Fort Wayne Museum, Indiana) was one of the first important paintings he produced on his return. Over the next eight years, his art evolved with great rapidity through an enthusiasm for Bonnard, which resulted in figures and nudes in almost exquisite interiors; the important *Washington Crossing the Delaware* (1953; The Museum of Modern Art, New York), which demonstrated the strong sense of history that is a recurring motif throughout his career, to the fully fledged Pop artist of the Tate Gallery's *Parts of the Face: a French Vocabulary Lesson* (1961). The last is also a portrait – and it is portraiture, admittedly in a thousand guises, that

is the true constant at the heart of Rivers' work. Family and friends are the subjects of many of his early paintings, and most visitors to Rivers' studio found themselves being drawn as he talked to them.

The Studio is Rivers' masterpiece of these years, its inspiration Courbet's huge *The Artist's Studio* (1853; Musée du Louvre, Paris). Instead of Courbet's tastefully draped and attentive nude model at the centre of the composition, Rivers' totally naked dancer with the remains of a banner inscribed 'Liberty' freely proclaims the joys of nudity and sex and a more permissive era. Rivers' nudes of the mid-1950s, especially those of his mother-in-law Berdie, had the power to shock, especially given his reputation as a hard-living, drug-taking, bisexual jazz musician. Unlike Courbet's *Studio*, however, the remaining constituents of the 16-foot painting are confined to Rivers' personal life and the studio's everyday inhabitants. From left to right, they are his close friend, the poet Frank O'Hara; his stepson Joseph; his son Steven from his short-lived first marriage; his mother-in-law, with whom he lived at the time, and, pinned to the wall above her, a self-portrait. The repeated figures move contrapuntally in and out of focus and across the canvas like an extended jazz improvisation. Far more than in his earlier paintings, the background now appears dissolved and is at times little more than a basic grid of sketchy lines. The figures are moving elements in this grid, their changes of position during a sitting recorded spontaneously as they happened. Remarkably, a similar phenomenon can be observed in the work of the British painter John Bratby (p.176), who began a major series of freize-like works at almost exactly the same time. The only probable common source of inspiration for both artists seems likely to have been the increasing use of wide-screen cinemascope in contemporary films. Whereas Bratby continued to hold fast to a Sickertian tradition of technique and subject matter, Rivers, with the increasing dissolution of the painted surface in his work and what Sam Hunter calls 'the interplay of form and void', was halfway along the road to a truly modern art.

REFERENCE

S. Hunter, *Larry Rivers*, London, 1989, p.27

Karel Appel
Michel Tapié and Stéphane Lupasco, 1956

KAREL APPEL b.1921

Painter, born in Amsterdam, where he
studied at the Royal College of Art;
joined the influential group of Dutch,
Belgian and Danish Expressionists
known as CoBrA; moved to Paris, 1950;
exhibited with Art Informel exhibitions,
1952; did decorations for the UNESCO
building, Paris, 1955; settled in New
York in the 1960s when he began to do
sculptures and wall-reliefs.

Oil on canvas
1300 × 1950mm (51¼ × 76¾")
Stedelijk Museum, Amsterdam

REFERENCES

S. Vinkenoog, *Karel Appel: Malninger
1947–1965*, exh. cat., Moderna Museet,
Stockholm, 1966, pl.67 (ill.)

Karel Appel: Gemälde, exh. cat.,
Städtische Kunstgalerie, Bochum,
1965, p.7

The primitivist, often childlike, paintings and sculptures that Appel began
to produce in the late 1940s did not always find ready acceptance in his
native Netherlands. A mural, *Children Asking Questions,* painted for the
cafeteria of the former city hall in Amsterdam in 1949, had to be covered
with wallpaper for the next ten years, such was the public outcry. A founder
member with Asger Jorn, Corneille and Constant of the CoBrA group,
Appel moved to Paris in 1950 where he struck up an immediate accord
with Michel Tapié (1909–87), writer, critic and originator of the term 'Art
Informel'. With Tapié's financial support, Appel was able to afford better
painting materials and benefited from contact with a more sympathetic
intellectual milieu and a sophisticated public already used to Art Brut and
the scribbled assemblages of Dubuffet.

The brightly coloured and heavily impastoed canvases that began to
flow from Appel's hand in the 1950s had an expressionistic fervour: colour
and line were fused into a mass of agitated paint, which usually took
precedence over the motifs of animals and human beings. Herbert Read
described his pictures as leaving an impression of a 'spiritual tornado that
has left these images of its passage'. Like Dubuffet, he painted a number of
often large-scale portraits of friends and female nudes. In 1957, he went to
New York and painted jazz musicians including Count Basie and Miles Davis,
and began winning major international awards. Although in retrospect it is
easy to appreciate the post-war reaction against the pre-war neo-realist
movements and geometrical abstraction that gave rise to CoBrA and Art
Informel and the denial of all but the basics of image-making, the amount
of frankly outrageous portraiture that was thrown up in the process does
seem rather extraordinary. Such works were, to some extent, intended to
shock by their total indifference to the traditions of an ancient art form and
were in no sense intended to be recognisable likenesses. Insofar as Appel's
work always depended on a 'subject', his portraits are celebrations of
friendships made in the full flood of whatever creative preoccupation he
had at the time. As principal mentor, Tapié was the subject of a number of
paintings by both Appel and Dubuffet. Here he is seen with another leading
proponent of current artistic theory, Stéphane Lupasco, a Rumanian
mathematician and author of the seminal *Science et art abstrait* (1963).
Perhaps because of Appel's close relationship with and respect for the
sitters, the portrait is unexpectedly sober and has a monumental dignity
and vitality, which communicate directly with the viewer.

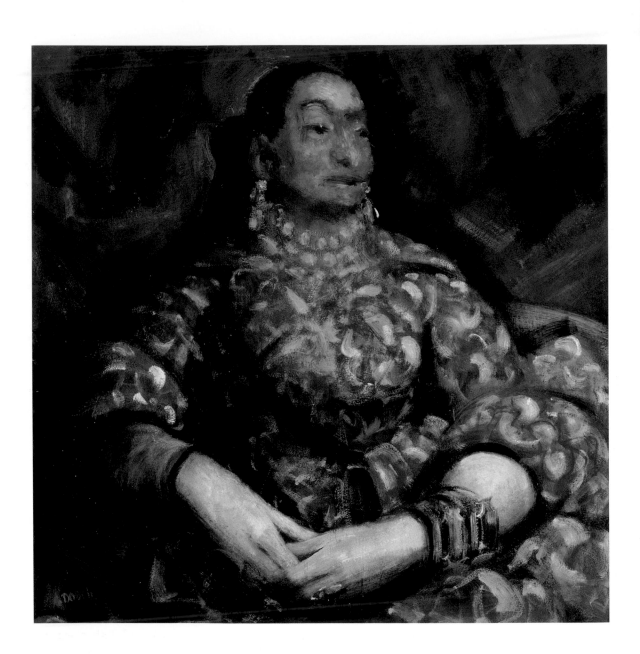

William Dobell
Helena Rubinstein, 1957

WILLIAM DOBELL 1899–1970

Born in Newcastle, New South Wales, Australia; studied at the Julian Ashton Art School in Sydney and won a travelling scholarship to study at the Slade School of Fine Art in London; worked during the Second World War painting camouflage; won the Archibald Prize in 1944 with a controversial portrait of Joshua Smith, which resulted in a court case; knighted in 1966; bequeathed his estate to establish the Sir William Dobell Art Foundation.

Oil on hardboard
954 × 956mm (37⅝ × 37¾")
National Gallery of Victoria, Melbourne. Felton Bequest 1964

REFERENCES

J. Faigan, *Uncommon Australians. Towards an Australian National Portrait Gallery*, Melbourne, 1992, p.96 (63)

B. Pearce, *William Dobell, 1899–1970: The Painter's Progress*, exh. cat., Art Gallery of New South Wales, Sydney, 1997, pp.18–19

Helena Rubinstein (1872–1965) was the first really big businesswoman of the twentieth century, perhaps the first ever. Born in Poland, she emigrated to Australia where she found a ready market among Australian women for a home-made face cream; she opened her first beauty salon in Melbourne in 1902. By 1908, she was thinking globally and opened a salon in London, followed by others in Paris (1912) and New York (1915). In 1917, she began distributing and marketing her products and after the Second World War she built cosmetics factories around the world. Her personal fortune was worth around $100 million and she took an active interest in running the company almost until her death.

After the restrictions and proprieties of the Victorian age, there was initially some resistance to the overt use of cosmetics among women, especially in Europe, but by the 1920s it had become commonplace. Helena Rubinstein's career coincided with a general emancipation of female attitudes; it was perhaps by a combination of good fortune and shrewd business acumen in encouraging women to make the most of themselves that she was so successful. By the end of the First World War she was already collecting African and Oceanic art, but her interest also spread to European and oriental decorative art and modern painting. Part of her patronage of modern artists consisted of commissioning portraits of herself, of which no fewer than twenty are still in the collection of the Foundation that she set up in 1953 to adminster charitable, medical and artistic projects and endowments. The most successful of the portraits include those by Savador Dalí, Marie Laurençin and Graham Sutherland. The last was a masterpiece from 1957, the same year as Dobell's portrait to which she consented at the artist's request when she was visiting Australia in March. Known for his rather expressionistic and mannered portraits, Dobell was one of Australia's most distinguished painters and had won both the Wynne and the Archibald portrait prizes. His painting of the 86-year-old Rubinstein makes her look even more like a little oriental empress than Sutherland's, but unlike Sutherland's it makes no attempt to compensate for her dumpiness, her over-upholstered clothes or her extravagantly large jewellery. She was only four feet and ten inches tall in her high heels, and heavily made up. Dobell remembered her 'as a very sad woman for all her millions'. His frank portrayal did not entirely please her; this painting, one of several he completed of her, was acquired several years later for the National Gallery of Victoria, Melbourne.

John Bratby
Nell and Jeremy Sandford, 1957

JOHN BRATBY 1928–92

Born in London; studied at the Kingston College of Art (1948–50) and the Royal College of Art, London (1951–4), where he was awarded a bursary to travel to Italy; with Jack Smith, Edward Middleditch and Derrick Greaves became one of the main exponents of the Kitchen Sink School; taught at Carlisle College of Art, 1956, and at the R.C.A., 1957–8; wrote three novels in the early 1960s; elected ARA, 1959, and full member of the Royal Academy, 1971; retrospective of his portraits, National Portrait Gallery, London 1991.

Oil on composition board
1977 × 2340mm (77⅞ × 92⅛″)
The Museum of Modern Art,
New York
Gift of Mr and Mrs Robert W.
Dowling, 1959

REFERENCE

R. Gibson, *John Bratby Portraits*, exh. cat., National Portrait Gallery, London, 1991, pp.13, 14, 55

In 1957 John Bratby was employed to produce the paintings for a film of *The Horse's Mouth*, Joyce Cary's story of a maverick painter, Gully Jimson; he shot to international fame when it was released the following year. The paintings that survived from the film (some mural-sized ones were bulldozed in pursuance of the plot) were whisked off with other recent work to an exhibition at French & Company, New York. They were well received and many were sold, including the one shown here.

Bratby's output was always phenomenal, but never so great as in 1957–8. As well as a substantial group of works for the film, he produced two series of 12-foot panoramic paintings, exhibited at the Beaux Arts Gallery, London in 1957 and 1959, and a number of large individual portraits, including *Lady Antonia Pakenham* (1957; Graves Art Gallery, Sheffield) and two of Nell and Jeremy Sandford. The writer Nell Dunn (b.1936) had purchased an early Bratby self-portrait in 1955 and, when she married fellow writer Jeremy Sandford in early 1957, she asked Bratby for a commemorative portrait. Both writers were on the brink of highly successful careers. Nell Dunn's novel *Up the Junction* (1963) was followed by the best-selling *Poor Cow* (1967); her much later play, *Steaming* (1981), met with great critical acclaim. Sandford's works include the television dramas *Cathy Come Home* (1967) and *Edna the Inebriate Woman* (1971).

Bratby's first double portrait (private collection), showing them standing together in a kitchen, appeared in May 1957. He then immediately embarked on this larger work, the dates 13 and 27 June inscribed along the top presumably documenting the days on which the bulk of the work was done. It is far more impressive than the first – the frantic patterning and detail demonstrate not only Bratby's *horror vacui* but an eye for decoration as content that is almost reminiscent of Klimt. In that sense, it already represents a move away from the Kitchen Sink ethos. The small child on the left is Bratby's oldest son, David, and his bricks and letters scattered along the top of the painting spell out the names JEREMY and NELL SANDFORD. The bizarre composition with its steep perspective and the strange, flattened figure of Sandford lying on the floor, the psychological gap between the two sitters who appear almost unaware of each other, the obsessive notation of objects and patterns of every variety – all these combine to make this one of Bratby's most remarkable paintings and a unique document of its time.

Raphael Soyer
Farewell to Lincoln Square, 1959

RAPHAEL SOYER 1899–1987

Born in Tombor, Russia; came from a family of painters who emigrated to New York in 1912; studied at Cooper Union (1914–17) and at the National Academy of Design (1918–22); a prominent member of the Fourteenth Street School which flourished in Greenwich Village during the 1920s; held his first show in 1929 at the Daniel Gallery, New York; taught at the Art Students League (1933–42); also worked as a writer, publishing his most famous book, *Diary of an Artist*, in 1977.

Oil and conté crayon on canvas
1524 × 1397mm (60¼ × 55″)
Hirshhorn Museum and Sculpture Garden, Smithsonian Institution, Washington, D.C.
Gift of the Joseph H. Hirshhorn Foundation, 1966

REFERENCES

A. Lerner, *Soyer Since 1960*, Washington, D.C., 1982, pp.1, 7

A. Lerner, ed. *The Hirshhorn Museum and Sculpture Garden*, New York, 1974, p.750

One of the most distinguished of American social-realist painters, Raphael Soyer was prominent, together with his brothers, in the Fourteenth Street School, which flourished in New York in the 1920s. He became known for his studies of the unemployed during the Depression, as well as for street scenes and paintings that depicted his family's middle-class Jewish life with quiet poignancy. His paintings of fellow artists, usually in various gatherings, are a unique record of the mid-century New York art world.

Farewell to Lincoln Square combines his interests in Manhattan street life and in its artists. He described the subject in his own words for the Hirshhorn catalogue: 'My subject matter has always been derived from the locale where I happen to be at a particular time. The earlier pictures were painted on the Lower East Side. In the 1930s I lived in the Union Square area where I painted the people I saw there . . . *Farewell to Lincoln Square* was painted in the Lincoln Arcade Building located in Lincoln Square, on the eve of it being demolished to make way for Lincoln Center. I loved that building. Many American painters from way back lived and worked there. The painting depicts the exodus of its denizens from that famous building, with myself in the group waving farewell.' Of all the other figures, only the artist's wife, Beatrice, whose profile is seen to the left of the girl in red, is identified. The girls were probably students and models, but the two men in spectacles are likely to be fellow artists in this symbolic eviction.

Soyer referred privately to this painting as 'The Dispossessed', but despite the element of social criticism in this scene of art having to make way for big business, it is primarily an ambitious figure painting on an auto-biographical theme. While its formal complexity and use of bright colours marked something of a departure in Soyer's work, it is thematically a close relative of Larry Rivers' *The Studio* (see p.170) though it is firmly rooted in the traditions of the past. Lerner draws attention to the similarity between Soyer's centrally placed young woman and the central figure in a more profoundly disconsolate group, Rodin's *Burghers of Calais* (1884–8).

1960s

The US finally achieved a manned space flight and, by the end of the decade, put the first men on the moon. Meanwhile, the CIA sponsored right-wing juntas in South America and the disastrous Bay of Pigs invasion of Cuba. A decade of protest by the black civil rights movement saw riots in over a hundred US cities and the assassination of Martin Luther King. Youth protest and peace movements were echoed by 'hippy' and 'flower power' culture; Europe enjoyed miraculous economic growth and exported the Beatles as Liverpool's answer to the Pop movement.

HISTORICAL EVENTS

1960	1961	1962	1963	1964
In the USSR, American U-2 spy plane shot down and pilot Gary Powers imprisoned.	US invasion of Cuba to overthrow Castro, planned by Eisenhower and approved by Kennedy, fails in the Bay of Pigs débâcle.	In the Caribbean, independence of Jamaica, Trinidad and Tobago.	In the US, Martin Luther King leads a black civil rights campaign in Birmingham, Alabama.	In East Germany, 1.25 million West Germans visit East Berlin for one day over Christmas. .
First test of French atomic bomb.	South Africa becomes a Republic; it is censured by the UN for its policy of apartheid and leaves the British Commonwealth.	In Africa, independence of Uganda, with Milton Obote as Prime Minister, and Tanganyika, with Julius Nyerere as President.	Assassination of President Kennedy by Lee Harvey Oswald.	In the USSR, Khrushchev is succeeded by Kosygin, then Brezhnev.
In South Africa, a peaceful protest by blacks results in the Sharpeville Massacre.	Construction of the Berlin Wall by East Germany.	US denounces Soviet missile bases on Cuba and establishes naval blockade.	Visit of Castro to the USSR; he is decorated as a Hero of the Soviet Union.	In Britain, election of Labour Party under Harold Wilson ends 13 years of Conservative government.
In Nigeria, independence.	Death of Dag Hammarskjöld in an air crash; he is post-humously awarded the Nobel Peace Prize.	Test of Soviet hydrogen bomb.	In Britain, resignation of minister John Profumo after a sex scandal involving Christine Keeler and Mandy Rice-Davies.	In the US, Civil Rights Act under President Lyndon Johnson bans racial and religious discrimination.
In the US, election of John F. Kennedy as President.	Invasion by Indian troops of Portuguese territories on India's west coast.	In Iran, earthquake leaves 10,000 dead.	Alec Douglas Home becomes Prime Minister.	In India, death of Prime Minister Nehru.
In the US, the contraceptive pill becomes commercially available.	Yuri Gagarin becomes the first man in space, on the Soviet satellite *Volstok I* .	John Glenn becomes the first American astronaut to orbit Earth.	In Nigeria, declaration of a republic, with Nnamdi Azikiwe as President.	In Africa, Zanzibar and Tanganyika unite to form new republic of Tanzania; Northern Rhodesia becomes independent republic of Zambia.
Heart pacemaker developed in Britain.		In Britain, the biggest ever public demonstration against nuclear weapons.	In Kenya, independence; Jomo Kenyatta is Prime Minister.	In Saudi Arabia, deposition of King Saud; succession of his brother Prince Faisal.
			Death of Pope John XXIII; succession of Pope Paul VI.	
			Valentina Tereshkova becomes the first woman in space.	

CULTURAL EVENTS

1960	1961	1962	1963	1964
Composition of Luciano Berio's *Circles*, written for Cathy Berberian.	Publication of Joseph Heller's *Catch-22*; John Updike's *Rabbit, Run*; Iris Murdoch's *A Severed Head*; Henri Michaux's *Connaissance par les gouffres*.	Appearance of Pop Art in New York.	Pop Art by Warhol, Oldenburg, Lichtenstein and others on show at the Guggenheim Museum, New York.	Posthumous publication of Ernest Hemingway's autobiography *A Moveable Feast*.
Release of Federico Fellini's controversial film *La Dolce Vita*; Alfred Hitchcock's *Psycho*.	Release of John Huston's film *The Misfits*.	First performance of Benjamin Britten's *War Requiem*; Dmitri Shostakovich's *13th Symphony* (*Babi Yar*).	Experimentation by Warhol with 'passive camera' film-making, including *Sleep*, an eight-hour observation of a man sleeping.	First performance of Joe Orton's play *Entertaining Mr Sloane*.
Frank Lloyd Wright's Solomon R. Guggenheim Museum opens in New York.	Release of Elvis Presley's 'Are You Lonesome Tonight'.	Release of David Lean's film *Lawrence of Arabia*.	US revival of folk music led by Bob Dylan and Joan Baez. Release of Dylan's protest song *Blowin' In The Wind*.	Huge success for The Beatles with *I Want To Hold Your Hand*; they appear on the Ed Sullivan Show.
	The Beatles make their début at the Cavern Club, Liverpool.	Death of Marilyn Monroe, aged thirty-six.	Release of *Love Me Do* marks the start of 'Beatlemania'; Dusty Springfield's first solo hit, *I Only Want To Be With You*.	Release of Stanley Kubrick's film *Dr Strangelove (How I Learned to Stop Worrying and Love the Bomb)*.
	The last journey of the Orient Express from Paris to Bucharest.	The Twist craze sweeps the US, with Chubby Checker's song *Let's Twist Again*.	Publication of Betty Friedan's *The Feminine Mystique*, landmark text in the women's liberation movement.	The Beach Boys have hits with *Fun, Fun, Fun* and *I Get Around*.
			Publication of Anna Akhmatova' s poem *Requiem*.	In the UK, Mods and Rockers clash at seaside resorts.
			Release of Federico Fellini's film *8¹/₂*	

In the US, Malcolm X, founder of the Black Nationalist movement, assassinated at a rally in New York.

In North Vietnam, first US bombing campaign.

In Algeria, deposition of President Ahmed Ben Bella; succession of Boumedienne.

India and Pakistan are at war.

In East Pakistan, two cyclones and accompanying tidal waves leave 45,000 dead.

In Rhodesia, declaration of independence under Ian Smith.

In Vietnam, the war gathers strength; parades and rallies held worldwide in protest.

In China, the beginning of the Cultural Revolution under Mao Tse-tung.

In India, Nehru's daughter Indira Gandhi elected leader of ruling Congress Party and becomes Prime Minister.

Discovery of the chemical make-up of DNA.

Soft landings on the moon made by both Russian and American spacecraft.

In the village of Aberfan, Wales, a landslide of coal waste destroys a school, claiming 144 lives.

In the Middle East, the Six-Day War between Israel and the Arab Nations takes place.

International Tribunal on War Crimes convened in Stockholm to hear charges of US atrocities in Vietnam.

In the US, race riots in Newark, New Jersey; federal forces used to quell civil disorders.

Cuban revolutionary Che Guevara injured in battle and later dies of his wounds.

In Greece, control seized by military junta; King Constantine forced into exile.

In Nigeria, outbreak of civil war.

The first heart transplant is performed in Cape Town, South Africa.

Invasion of Czechoslovakia by the USSR, which demands the removal of reforming leader Alexander Dubcek.

In the US, assassination of Martin Luther King Jr in Tennessee.

Assassination of Senator Robert F. Kennedy while campaigning for Democratic presidential nomination.

In Vietnam, the Mai Lai massacre: Lt William Calley and Staff Sgt David Mitchell will be tried for the murder of 300 civilians.

In France, resignation of President de Gaulle; succession of Georges Pompidou.

In Northern Ireland, civil unrest between Protestants and Catholics.

In Iraq, execution of 14 alleged Israeli spies, despite worldwide criticism.

In Israel, death of Levi Eshkol; succession of Golda Meir.

In Vietnam, the first withdrawal of US troops; death of Ho Chi Minh.

Neil Armstrong, Commander of the Apollo 11 mission, becomes the first man to set foot on the moon.

1965 1966 1967 1968 1969

Performance by Joseph Beuys of 'How To Explain Pictures to a Dead Hare' at the Schmela Gallery, Düsseldorf.

Publication of Norman Mailer's An American Dream.

Release of Robert Wise's film adaptation of the musical The Sound of Music, starring Julie Andrews.

The Beatles awarded MBEs.

The Rolling Stones spend twelve weeks at no. 1 with (I Can't Get No) Satisfaction.

The first mini skirts appear in Mary Quant's boutique in London.

Andy Warhol makes The Chelsea Girls.

The Metropolitan Opera House, New York, opens with Samuel Barber's opera Antony and Cleopatra.

Release of The Beach Boys' Pet Sounds.

Publication of Truman Capote's non-fiction thriller In Cold Blood.

Release of Sergio Leone's The Good, The Bad and The Ugly.

England wins the World Cup.

Birth of movements 'Arte Povera' and 'Land Art'.

Release of The Beatles' album Sgt Pepper's Lonely Hearts Club Band, with a Pop Art cover designed by Peter Blake.

Publication of Desmond Morris's The Naked Ape, which becomes an international best seller; Roland Barthes's seminal essay, 'The Death of the Author'.

Release of Arthur Penn's film Bonnie and Clyde, starring Warren Beatty and Faye Dunaway.

In the US, artists such as Richard Estes and Chuck Close are painting in a photo-realist style.

Publication of Norman Mailer's The Armies of the Night, an account of protest against the war in Vietnam.

Release of Stanley Kubrick's 2001: A Space Odyssey; Roman Polanski's Rosemary's Baby; Franklin J. Schaffner's Planet of the Apes.

In Bethel, New York, 450,000 gather for the three-day Woodstock Music and Arts Festival.

In Britain, a free open-air concert by the Rolling Stones attracts 250,000 fans to London's Hyde Park.

Desmond Dekker, the first international reggae star, has a huge hit with Israelites.

Publication of Philip Roth's Portnoy's Complaint.

Release of George Roy Hill's Butch Cassidy and the Sundance Kid; John Schlesinger's Midnight Cowboy.

Howard Hodgkin
Adrian and Corinne Heath, 1960–61

HOWARD HODGKIN b.1932

Born in London; studied at Camberwell
and Bath Academy of Art, Corsham
(1945–54); taught at Charterhouse
School, Bath Academy and Chelsea
School of Art, 1954–72; solo exhibitions
include Tate Gallery, 1982; *Venice
Biennale*, 1984 (and subsequent tour);
Turner Prize, 1985; knighted in 1992.

Oil on canvas
760 × 910mm (30 × 35¾")
Private collection

REFERENCE

M. Auping, J. Elderfield, S. Sontag and
M. Price, *Howard Hodgkin Paintings*,
London, 1995, p.141 (no.13)

The tranquil aestheticism of Hodgkin's mature work should not cause us to forget how good much of his early work is. The paintings made when he was teaching at Bath Academy of Art are among the liveliest and most inventive works of the early 1960s; they also contain the key to his development as a painter and to the interpretation of the late work we are more likely to know. There is a greater preponderance of named portraits and fewer evocations of times and places than later, but his often-quoted statement, 'As far as the subjects of my pictures go, they are about one moment of time involving particular people in relationship to each other and also to me' (in *Art News*, May 1967), holds true both for the works of the 1960s as it does for those of the 1980s.

Thirty to forty of the portraits painted up to the mid-1970s are of fellow artists and their wives: they have been described as a 'who's who' of the London art world of the time. Adrian Heath (1920–92) was one of the most distinguished abstract painters of the previous generation, and author of the authoritative study *Abstract Art, its Origin and Meaning* (1953). His wife Corinne (née Lloyd) was a stage designer. As in many of Hodgkin's double or group portraits, the woman is the dominant figure; here, her vivacity and startling red hair set the tone for the painting. The wobbly, unidentified hanging object echoes the light-hearted theme. The lattice-patterned screen establishes the intimacy of the space, and provides a foil for the more severe stripes of Adrian Heath's tie.

What Michael Auping described as a flirtation in Hodgkin's work with 'the decorative banality and painterly caricature of early pop painting' is certainly evident here; interestingly, however, a similar tendency is also visible in the work of Allen Jones, with whom Hodgkin shared the 1962 exhibition at the ICA in which the Heaths' portrait was first exhibited. Striped ties certainly became de rigueur in Jones's paintings around 1963 (such as *Man/Woman*, 1963; Tate Gallery, London and *Hermaphrodite*, 1963; Walker Art Gallery, Liverpool). The more solid common ground between them – a general preoccupation with the use of pattern, the bold exploration of colour, and a certain playful ambiguity between the sexes – serves only to emphasise how widely their paths were to diverge.

Ben Shahn
Dag Hammarskjöld, 1962

BEN SHAHN 1898–1969
American painter and graphic artist, born in Kovno, Lithuania; emigrated to the USA, 1906; apprenticed to a lithographer (1913–17); attended New York University (1919) and later National Academy of Design; Sacco-Vanzetti Trial series, 1931–2, set tone for much of his mature work, which deals with social protest and scenes from American life; produced murals for public buildings and posters for government departments.

Tempera on plywood
1520 × 1220mm (59¾ × 48″)
National Museum, Gripsholm, Stockholm

REFERENCE

C. Nordenfalk, 'Ben Shahn Portrait of Dag Hammarskjöld', *Statens Konstsamlingars tillväxt och förvaltning 1962*, Stockholm, 1962, pp.84–90

The Swedish civil servant Dag Hammarskjöld (1905–61) became Secretary-General of the United Nations in 1953 and held office for the rest of his life during a time of unprecedented international crises. Expanding the scope of his office by initiating practical moves for peace, he earned severe criticism from the British, French and Soviet governments but nevertheless helped resolve both the Suez (1956) and Lebanon (1958) crises. In 1959, the Swedish government decided to commission a portrait of their distinguished citizen under an 'Honorary Portraits' scheme for the Swedish National Portrait Gallery at Gripsholm Castle, south of Stockholm. The choice of artist fell on Ben Shahn, partly because he was American and would have better access to his sitter, but significantly because of Shahn's preoccupation with social and humanitarian issues.

Artist and sitter apparently got on well when they first met in 1960, but agreed to postpone sittings when the Congo crisis broke out. In September 1961 they met again and made an appointment for sittings on Hammarskjöld's return from his imminent visit to the Congo. During his efforts to negotiate an end to the conflict, Hammarskjöld was killed in an air crash. His death was generally seen as a major loss to world peace, and Shahn must have felt under considerable moral pressure to finish the portrait. Working from memory and from press photographs, he completed a more or less straightforward portrait drawing in his distinctive graphic style. The painting, however, is a deeply symbolic work. Hammarskjöld is sitting as if in the UN, with a view of what might be Brooklyn Bridge through the window. Above him hovers a blackish haze, representative of the prevalent threat of nuclear war as he listens to Khrushchev's call for his resignation in the General Assembly. Before him are spread, in Shahn's calligraphy, the words of his famous reply, concerning the role of the UN in relation to large and small nations. Shahn wrote: 'I wanted to express his loneliness and isolation, his need, actually, for such remoteness in space that he might be able to carry through, as he did, the powerful resolution to be just.' The painting was so openly a tribute to Hammarskjöld rather than a descriptive portrait that there was considerable opposition to it in Sweden, and Shahn was forced to defend himself in an article in a Stockholm newspaper. He concluded: 'I have sought to make a portrait about, rather than of, a man.'

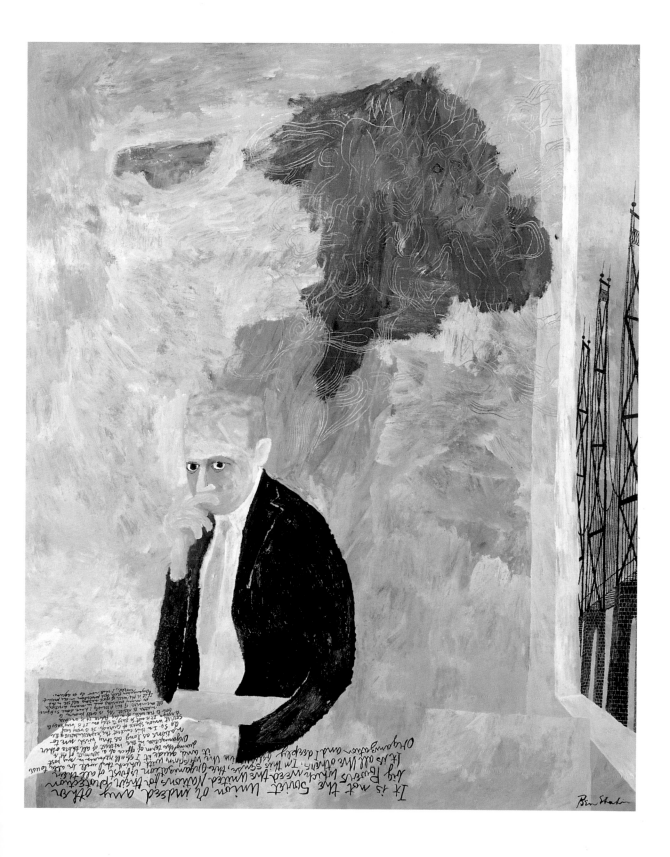

It is not the Soviet Union or indeed any other ... [text continues illegibly]

Ben Shahn

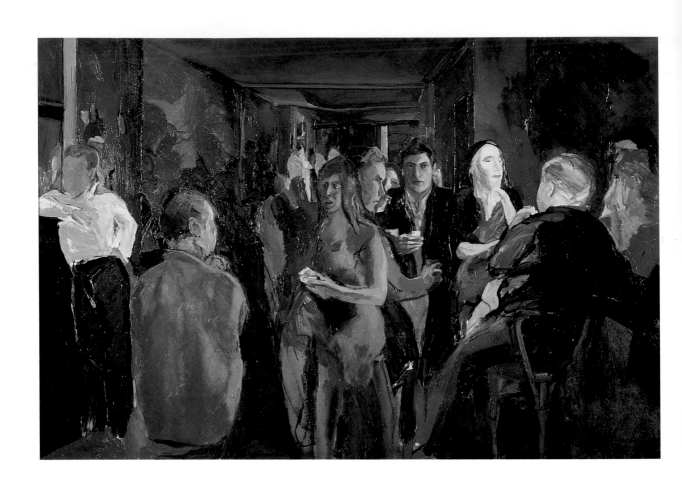

Michael Andrews
The Colony Room, 1962

MICHAEL ANDREWS 1928–95

Born in Norwich; studied at the Slade
School of Fine Art (1949–53); frequently
identified with his teacher Sir William
Coldstream and the Euston Road
School and later with the School of
London; his metaphorical use of the
physical world is characterised by
the series *Lights* (1968–74) and *Ayers
Rock* (1984–90); retrospectives at
the Hayward Gallery, London, 1980;
Whitechapel Art Gallery, London, 1991.

The Colony Room, a Soho drinking club run by the formidable Muriel
Belcher, was the hub of bohemian life in 1950s and 1960s London (and
indeed continues to this day). Increasingly familiar to the general public
from biographies, documentaries and films about its most famous *habitués*,
it occupies an ambivalent position at the centre of modern British art in the
second half of the twentieth century. An early friend of artists including
Lucian Freud and Francis Bacon (and a willing participant in drinking parties),
Andrews became part of this circle well before finding his artistic feet (in 1958
he decorated the Colony Room with a mural after a painting by Bonnard,
which can be seen in the background on the left). The characters in this
nocturnal drama are, from left to right: Jeffrey Bernard, the photographer
John Deakin, Henrietta Moraes, Bruce Bernard, Lucian Freud (prophetically
confronting the viewer with an unwavering gaze), Muriel Belcher's friend
Carmel, Francis Bacon (leaning on the bar) and Ian Board.

The Colony Room, despite its considerable achievement, is very much a
transitional painting in Andrews's development. Following the meticulously
planned and executed *The Family in the Garden* (1960–2; Calouste Gulbenkian
Foundation) it was the first in a series of four large 'party' pictures.
Lawrence Gowing, who described Andrews' purpose in painting *The
Family in the Garden* as 'to define and preserve his family background',
analysed the new subjects and their manner of execution as plunging
'more deeply than ever into the kind of life and subject matter that cut him
off most sharply from his parents, and from his artistic background too.'
Andrews blocked up the windows in his flat in Duncan Terrace, Islington,
and painted (quite rapidly in comparison with *The Family in the Garden*) his
first night-life scene by artificial light. A new subject does not automatically
carry with it new solutions for how to paint it, and *The Colony Room* was
very much an observation of a specific place, painted in the subdued
colours of Andrews' Euston Road heritage. Any trace of bright colour in
the sketches for the composition has been suppressed in the finished
painting. Andrews was also troubled by a perceived 'stodginess' in the
paint: 'the accretion had a certain punched-up definiteness which allowed
me to say that the work was done.' When he began on his next painting,
The Deer Park, (1962; Tate Gallery, London) he had a programme in mind
rather than a scene from life. *The Colony Room,* however, remains in its
authenticity and ambition a seminal work of art that allows us to place a
whole range of other work into context.

Oil on canvas
1210 × 1828mm (47⅝ × 72″)
St John Wilson Trust

REFERENCE

Michael Andrews exh. cat., Hayward
Gallery, London, 1981, pp.12–14, 30, 60

Andy Warhol
Double Elvis, 1963

Born in Pittsburgh and studied at the
Carnegie Institute (1945–9); worked as
a commercial artist in New York, 1949;
first solo exhibition at Hugo Gallery,
New York, 1952; pioneer of American
Pop movement and exhibited world
wide; made films from his studio,
The Factory, 1963; retrospectives at
Kunsthaus Zürich, 1978; New York
and Paris, 1989–90.

Silkscreen on aluminium paint
on canvas
1830 × 1370mm (72 × 54″)
Museum Ludwig, Cologne
(Ludwig Donation)

REFERENCES

D. Bourdon, *Warhol*, New York, 1989,
pp.147, pl.142

*Twentieth Century Art: Museum Ludwig
Cologne*, 1996, pp.744–7

Warhol's discovery of the power of the repeated image rocketed him to
fame in 1962–3 with much the same speed that *Heartbreak Hotel* had
pushed the previously unknown Tennessee truck driver, Elvis Presley
(1935–77), to the top of the charts in 1956. In 1962, Warhol produced his
series of *Campbell's Soup*, *Dollar Bill* and *Coca-Cola* paintings, mostly using
stencils and acrylic paint for the unrewarding task of constantly repeating
the same image. By the summer of that year, he had discovered that it was
possible to have black-and-white photographs converted into silkscreen
images. When Marilyn Monroe, the greatest female sex symbol of her
time, died on 5 August 1962, the press coverage was enormous; in a matter
of days, Warhol was experimenting with a publicity still photograph he
had found of her. The resulting silkscreen paintings, intentionally slightly
off-key and in a wide variety of colours and formats from single heads to
multiples, diptychs and even some on gold leaf, created an instant sensation
and have remained his most unforgettable image.

Although the Marilyns were intended as a memorial to the film star, the
notion of glamour inherent in the image Warhol had chosen quickly led
him to seek out its male equivalent. Presley was certainly the greatest of
the post-war male sex symbols, who caused scenes of hysteria among his
fans unseen since the days of Rudolph Valentino. The image that Warhol
finally settled on, however, is very different from both the Marilyns and
an earlier *Red Elvis*. Again a publicity still from a minor film, in this case
the western *Flaming Star* (1960), the full-length image conveyed both
the sexuality and element of danger that Warhol rightly divined would
epitomise the American ideal of male glamour. Had Presley been fully
dressed as a cowboy with hat and boots, the point would have been lost.
In jeans and freshly laundered shirt with fashionably raised collar, he was
contemporary and accessible. Pointing the gun at the viewer, he is also
both macho and a threat. The typical Presley open-legged stance and
form-hugging jeans and shirt proclaim his sex appeal. The perfect pyramidal
format lent itself to super-impositioning in a cumulative effect that is
visually disturbing in a different way from the square-formatted Marilyns.
Significantly, at the time Warhol was producing the Elvis series, he was
also working on his *Disaster, Car Crash* and *Race Riot* series, images of the
violence beneath the surface of American society of which the gun-toting
male is an integral part.

188 THE NINETEEN SIXTIES

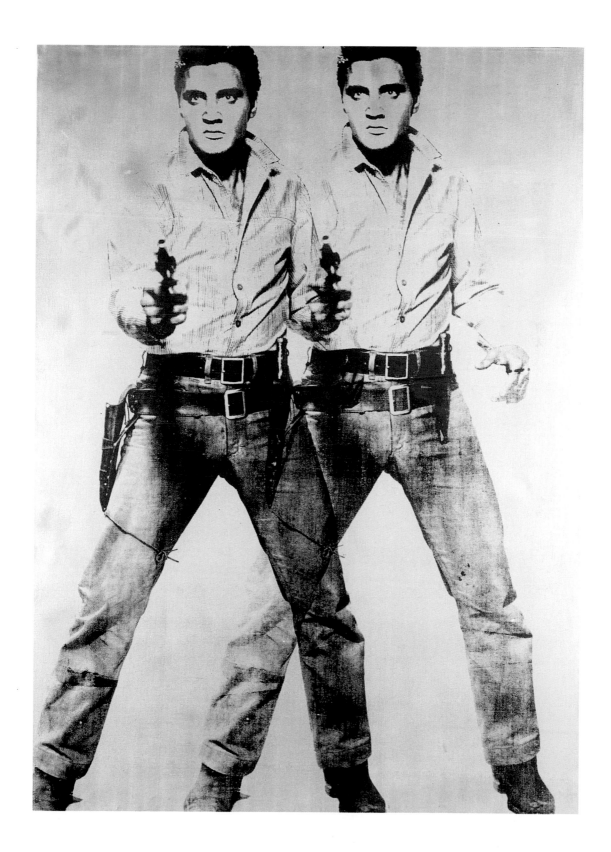

Alberto Giacometti
Head of a Man I (Diego), 1964

ALBERTO GIACOMETTI 1901–66

Swiss painter and sculptor; born in
Borgonova (Grisons), son of a
distinguished painter, Giovanni
Giacometti, nephew of another,
Augusto, and godson of Cuno Amiet
(see p.54); trained with his father in
Geneva, and with Bourdelle in Paris
(1922–5); early work influenced by
Cubism and later by Surrealism;
from 1937, evolved the elongated
and distinctive style for which he is
best known.

Oil on canvas
455 × 350mm (17⅞ × 13¾″)
Kunsthaus Zürich

REFERENCE

Alberto Giacometti, 1901–1966, exh. cat.,
Scottish National Gallery of Modern
Art, Edinburgh, 1996

Giacometti's brother Diego, thirteen months younger than him, was a gifted furniture designer who followed his brother to Paris in 1927 and initially shared a studio with him. Once Alberto's sculpture began to sell, he acted as Diego's business manager and technical adviser. In the early 1930s, they designed and fabricated bronze furniture together in order to make a living. By about 1935, when Alberto was becoming known as a Surrealist sculptor, he returned to life drawing and Diego posed for him every morning, but very little work survives from this period, which was interrupted by the war. The older brother returned to Switzerland in 1942, remaining in Geneva until 1945. The results of his renewed interest in working from the life did not really become visible until 1946–7, when the first of his drastically pared-down bronze figures and portrait paintings appeared, in what is universally recognised as his mature style. Diego began posing for his brother again in 1947, and bronzes and paintings of him continued to appear for the rest of Giacometti's life. This late, rather austere, portrait is one of a group that he presented to the Alberto Giacometti Foundation in Zurich to mark its creation at the end of 1965.

Giacometti had concentrated on drawing and sculpture during the war – partly because he still regarded himself primarily as a sculptor, but possibly also for personal reasons, associating the activity with his family life. With a newly settled existence in post-war Paris and his new-found enthusiasm for 'the living head', he discovered a new compulsion to paint. Working mostly with a sophisticated use of line, he could if he wanted dash off canvases remarkably quickly, but usually it was a far more laborious procedure of scraping back time after time and restarting. Sittings were rigorously controlled, and the distance of the model from the artist (about nine feet) carefully monitored by red paint marks on the floor. Even with the writer Jean Genet, who sat to him on several occasions in the mid-1950s, Giacometti insisted on absolute immobility and silence. From a wide variety of studio scenes, still lifes and landscapes in the early 1950s, his subject matter and working methods became gradually more restricted in his obsessive search for perfection. Despite using the same models, Giacometti saw them each time afresh. Of Diego he said: 'He has posed for me ten thousand times, but when he poses I don't recognise him. I'm eager to have him pose for me in order to see what I see.' On another occasion: 'The adventure, the great adventure is to see something unknown appear each day in the same face. That is greater than any journey round the world.'

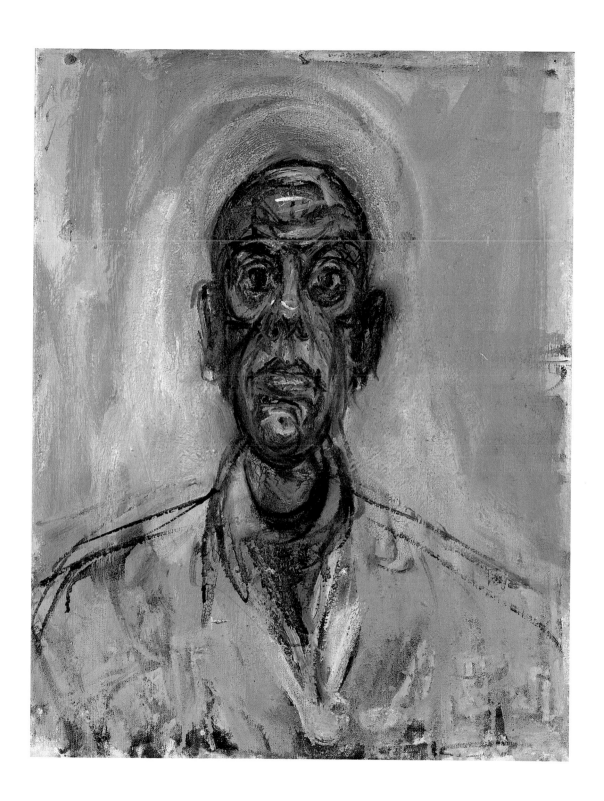

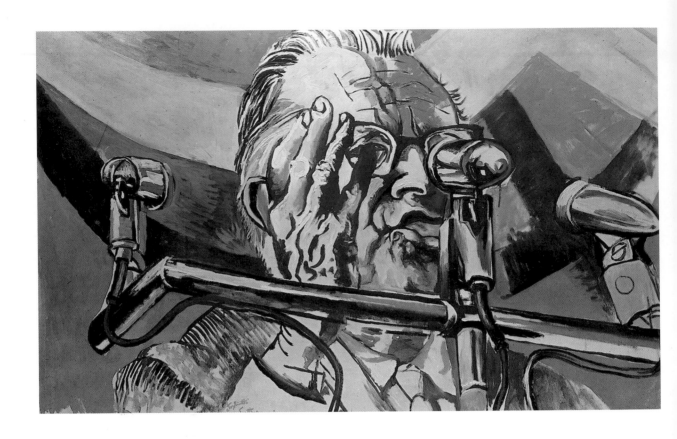

Renato Guttoso
Study for a Portrait of Togliatti as an Orator, 1965

RENATO GUTTOSO 1912–87

Born in Palermo, Sicily; self-taught artist who originally studied law; worked as a picture restorer and settled in Rome in 1937; associated with anti-Fascist groups between 1942 and 1945, including the Corrente Group, who opposed Fascist cultural policy; a committed Communist, he was co-founder of the Fronto Nuovo delle Arti in 1947; became city councillor of Palermo, 1975, and Senator of the Italian Republic, 1976.

Oil on canvas
950 × 1400mm (37⅜ × 55⅛")
Pushkin Museum, Moscow

REFERENCES

Guttoso: Opere dal 1931 al 1981, exh. cat., Palazzo Grassi, Venice, 1982

G. Cortenova, E. Macelloni and A. Mercadente, *Guttoso: 50 anni di pittura*, Palazzo Forti, Verona, 1987

Guttoso's willingness to tackle both the political issues of his times and scenes from everyday life (such as *The Spaghetti Eater*, 1956; Farinelli Collection, Rome) made him for many years the most popular Italian painter of his day, both at home and abroad. A certain distaste for politically motivated art probably reduced his acceptance in Britain compared with his more favourable reception in Germany and Italy, although his vivid and accessible figuration was popular here in the 1950s. Ironically perhaps, he is remembered best in Britain not for his paintings, but for his illustrations to Elizabeth David's ground-breaking cookery book, *Italian Food* (1954).

With *Execution in the Countryside* (1939; Galleria Nazionale d'Arte Moderna, Rome) depicting the murder of the Spanish poet Federico García Lorca in the Spanish Civil War, Guttoso announced himself as an artist of political principle; the following year he joined the Italian Communist Party, to which he remained loyal until 1983. Communism as such is seldom an issue in his work. As an artist who was always prepared to comment on contemporary events such as the conflicts in Algeria, Korea and Vietnam, however, it is not surprising that Guttoso wanted to mark the death of the founder of the Italian Communist Party, Palmiro Togliatti (1893–1964). Exiled in the USSR from 1926 to 1944 where, as a loyal Stalinist, he was a member of the Comintern Secretariat, Togliatti gained a reputation after the war as the most enlightened (and most powerful) Communist leader in the West. This status was enhanced after his death by a posthumously published political memorandum, in which he called for greater freedom in the Soviet Union and increased autonomy for national Communist parties.

The poster-like, over life-size format for this rather impersonal image of the professional politician, and the heavily edited reference to the hammer and sickle in the background, create an almost decorative effect. Guttoso's titling of the work as a study implies that this may be just one possible way of commemorating the orator, rather than the artist's last word on the subject.

James Fitton
Firebird I, 1966

Oil on board
1217 × 1017mm (47½ × 40″)
Private collection

REFERENCE

J. Sheeran, *James Fitton R.A. 1899–1982*, exh. cat., Dulwich Picture Gallery, London, 1986–7, pp.21, 56–7, 76 (no.36)

James Fitton's politically acute drawings for *Left Review*, his posters for London Transport and those produced for the Ministry of Information during the war are among the best of their kind. His eye for human frailties gives his paintings a Hogarthian quality that relates them to those of his friend Ruskin Spear, although they are distinguished by their graphic inventiveness and lightness of touch. Fitton had a lifelong love of music, though it was seldom touched on in his work except in a few paintings of his daughter Judith practising (she became a professional musician). Passionate about many things from politics to art education, he could become obsessed with a particular subject that had made an impression. Such was his reaction on seeing the great Russian-born composer Igor Stravinsky (1882–1971) conduct a concert of his own works in St Mark's, Venice, in about 1960.

His portrait of Stravinsky was named symbolically after one of the composer's best-known ballet scores. He wrote about its origins to the friend who purchased the painting when it was exhibited at the Royal Academy in 1966: 'The performance started about 10.30 in the evening and finished well after midnight – In order to familiarise the audience with a difficult and complicated work he conducted two of the movements through for a second time. I was hypnotised by the whole setting and performance but particularly by his own part in it. And the next few days I spent making notes and drawings from memory. I find this an ideal way of working – The more I drew – the clearer and more precise the image became . . . I've watched out for a chance to repeat this process and this came last year with the Stravinsky rehearsals [on television]. I did dozens of drawings until it became absolutely clear what I wanted to paint – I think I could now draw him standing on my head with my eyes closed, he's become so engrained on my mind.'

While a tendency to gentle caricature was always endemic in Fitton's work (he had a field day with Stravinsky's nose), this and a second version with a plain background, *Firebird II,* are remarkably accurate portraits of the 80-year-old composer, whose concentration while on the podium was absolute. The larger painting of the two, it vividly conveys Fitton's overwhelming excitement at seeing one of the great geniuses of the century at work.

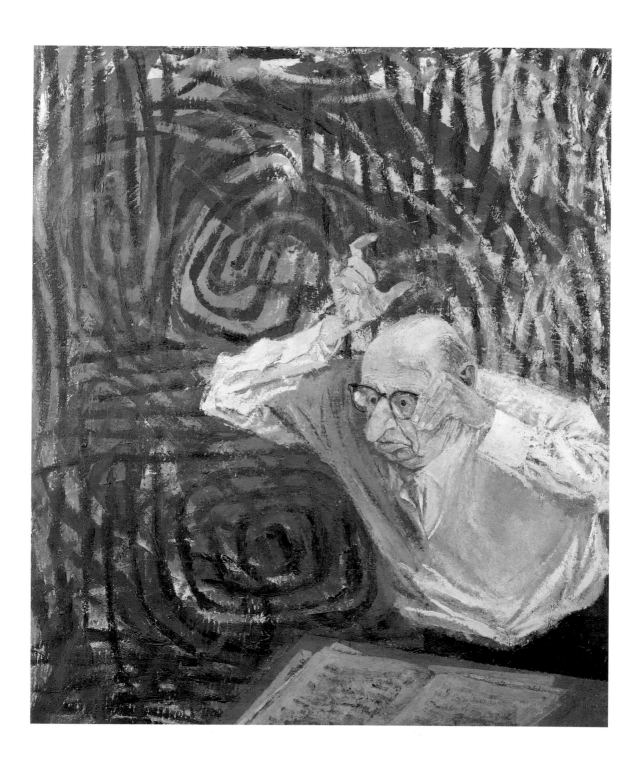

Francis Bacon
Three Studies of Isabel Rawsthorne, 1967

FRANCIS BACON 1909–92

Dublin-born painter; came via Berlin and Paris to London, 1925, and worked as an interior decorator. Painted sporadically throughout the 1930s, destroying most of his early work; made his name with *Three Studies for Figures at the Base of a Crucifixion* (1944; Tate Gallery) and paintings based on Velázquez's *Pope Innocent X*. Retrospectives at the Tate Gallery, 1962 and 1985; Paris and Düsseldorf, 1971; Washington, Los Angeles and New York, 1989–90.

Oil on canvas
1195 × 1525mm (47 × 60″)
Staatliche Museen zu Berlin, Nationalgalerie

REFERENCES

D. Sylvester, *Interviews with Francis Bacon 1962–1979*, London, 1981, pp.150–2

Francis Bacon, exh. cat., Museo d'Arte Moderna, Lugano, 1993, pp.78–80, 150 (no.36)

Herself a painter and a stage designer of some distinction, Isabel Rawsthorne (1912–92) was the catalyst for an extraordinarily wide range of works by other artists. She went to study in Paris in 1934, and married the *Daily Express*'s foreign correspondent, Sefton Delmer. From 1935 she modelled for Giacometti, Derain, and briefly for Picasso; she was Giacometti's most important model and a close friend from 1935 to 1940. During the war she worked with Delmer in London on propaganda, but returned to Giacometti and lived with him for several months in 1945. Back in London from about 1947, she married the composer Constant Lambert that year and, partly through his influence, designed four ballets and an opera for Covent Garden during the 1950s. In 1955 she married the composer Alan Rawsthorne. She later became a friend of Francis Bacon, and was the model for some of his most important works in the 1960s.

It is difficult to gauge from Bacon's paintings the nature of his relationships with the friends who were his subjects. A mutual admiration for Giacometti was obviously something Isabel Rawsthorne and Bacon had in common; as well as her intelligence and independence, he also clearly admired her sensuous looks, which she still retained in her fifties. This painting was done in the same year as the more famous *Portrait of Isabel Rawsthorne Standing in a Street in Soho* (also Nationalgalerie, Berlin), which seems to have been loosely inspired by one of John Deakin's photographs of her. Bacon uses a very similar head for the principal portrait here, which seems to be a more personal, though hardly intimate, image of her. It is unusual in Bacon's œuvre, both in its horizontal format and its tripled subject.

Interviewed by David Sylvester, in connection with the later *Painting 1978* the artist quoted from T. S. Eliot's *The Waste Land*: 'I have heard the key / Turn in the door once and turn once only'. Like that later work, this is an almost dream-like picture. Isabel may be unlocking the door to reveal some secret about herself, but it seems to be an involuntary gesture and she does not look to see what she is doing. The picture of herself pinned to the wall appears to scream in horror as she admits her *alter ego*; her shadow seeps slowly up the door. Compared to the works of Giacometti, it is a positive melodrama, although imbued with the same existentialist view of man alone and at the mercy of forces over which he has no control. But there is also something heroic about the way Bacon portrays his subject: it is an experience that we know she will survive.

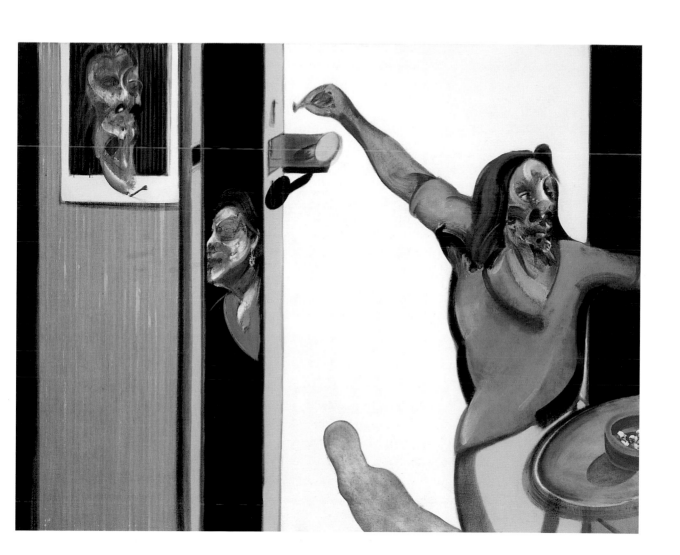

Richard Hamilton
Swingeing London 67, 1968

RICHARD HAMILTON b.1922

Born in London; founder member of
the Independent Group at the Institute
of Contemporary Arts, London, 1952;
contributor to *This is Tomorrow*
exhibition, Whitechapel Art Gallery,
London, 1956, and leading figure in
Pop Art movement; his paintings,
prints and multi-media works have
continued to provide a succinct
commentary on contemporary cultural
issues and styles; retrospectives at the
Tate Gallery, London, in 1970, 1992.

The enduring British obsession with 'immorality', either in terms of sex or drugs, underwent one of its more dramatic eruptions in the 1960s when two members of the Rolling Stones, Mick Jagger and Keith Richards, along with Marianne Faithfull, were at a party that was raided by the police on 12 February 1967. Richards was charged with allowing his house to be used for smoking cannabis, and Jagger and the art dealer Robert Fraser were charged with being in possession of different drugs. Jagger and Fraser were sentenced to imprisonment, Fraser to six months, and Jagger to a sentence commuted to twelve months' conditional discharge. His arrest and prosecution were front page news for weeks. Richard Hamilton, much of whose best work – from *Portrait of Hugh Gaitskell as a Famous Monster of Filmland* (1964; Arts Council) to his Northern Irish subjects of the 1980s – has been openly political or socio-critical, was this time more directly involved: Robert Fraser was his art dealer at the time.

With the aid of press cuttings collected by Fraser's secretary, Hamilton decided to make a work focusing on a press photograph by John Twine for the *Daily Mail* that showed Jagger (right) and Robert Fraser, hand-cuffed together, through the window of a police van arriving at court in Chichester to be charged. The strength of Hamilton's feelings about this example of socially inflicted suffering may be deduced from the fact that there are seven versions in all, of which this is the final one. The other six were, in effect, tests of differing effects of colour and technique; this one alone has the frame mocked up as the sliding window of the police van which, as well as providing an allusion to the event, also increases the sense of confinement. Common to all the versions is the different coloration of the windows behind the two figures: the brick colour behind Fraser, suggesting impending confinement, the sky and landscape behind Jagger, representing the freedom they were leaving behind. The title for the series was an ironic combination of *Time* magazine's memorable by-line in 1966 which gave rise to the concept of 'Swinging London', and a reported observation made by the judge at the trial on the possible effectiveness of a 'swingeing sentence' as a deterrent for the pair.

Relief, silkscreen and oil on
photograph on hardboard
584 × 787 × 76mm (23 × 31 × 3")
St John Wilson Trust

REFERENCE

R. Morphet and others, *Richard Hamilton*, exh. cat., Tate Gallery, London, 1992, pp.166–8

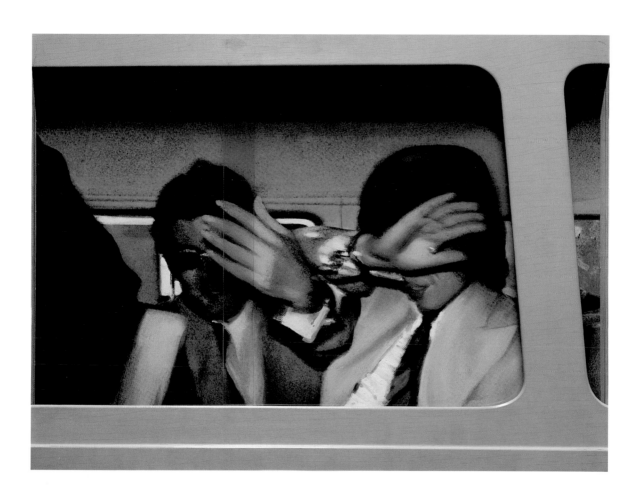

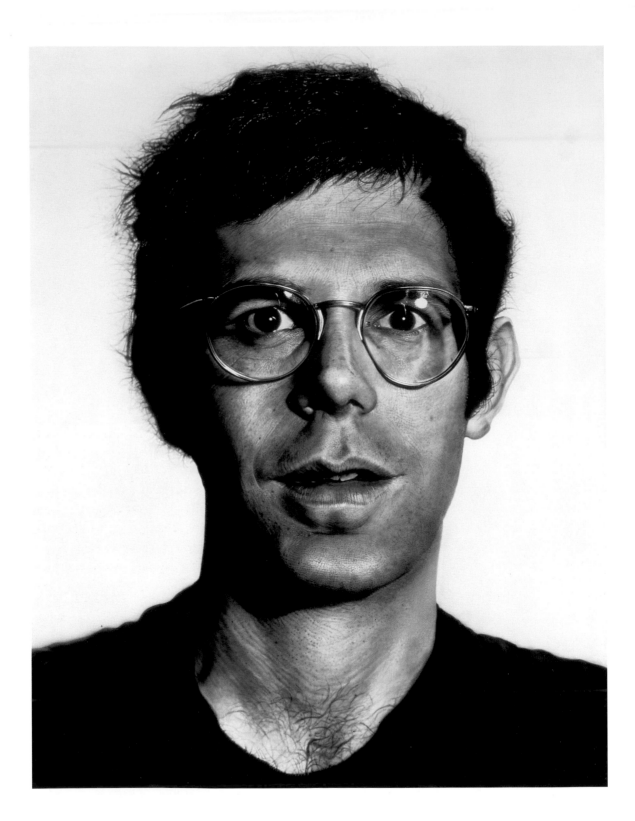

Chuck Close
Bob, 1969–70

CHUCK CLOSE b.1940

Born in Monroe, Washington; studied
at the University of Washington,
Seattle, and Yale Schools of Art;
Academy of Fine Art, Vienna (1962–5);
solo exhibitions include Museum of
Contemporary Art, Chicago, 1972;
Centre Georges Pompidou, Paris,
1979; Walker Art Center, Minneapolis,
1980–81; Yokohama Museum of Art,
Japan, 1989; The Museum of Modern
Art, New York, and tour, 1998–9.

Acrylic on canvas
2743 × 2133mm (108 × 84″)
National Gallery of Australia,
Canberra

REFERENCES

L. Lyons and R. Storr, *Chuck Close*,
New York, 1987, pp.28–9, 46–7, 52

D. Hickey, ed., *The portraits speak;
Chuck Close in conversation with 27 of his
subjects*, New York, 1997, pp.139–40

An abstract artist as a student, Close moved to mixed-media constructions while teaching at the University of Massachusetts, Amherst, before his breakthrough to the large-scale photo-based works that established his mature style. These began with a 22-foot painting derived from a photograph he had taken of a nude. 'I had the belief that the essential American image at that point, whether it was Pollock or Stella, had a consistent surface . . . and that every piece was essentially the same. I wanted to approach the nude with the same lack of hierarchy . . . in a deadpan, dumb kind of way.' After the failure of a freehand colour attempt in 1966, Close completed *Big Nude* in 1967–8 in the monochrome of the original photograph. Not entirely satisfied with his technique or scale, Close then took a close-up photograph of his own face and transformed it into a 9 × 7 foot painting (*Self-portrait*, 1997–8; Walker Art Center, Minneapolis); its success led to seven other large black-and-white portraits before he switched to colour in 1970.

Bob, a portrait of the stage designer Robert Israel, was the sixth in this series to be completed. The two had met in 1968 at the Walker Art Center, Minneapolis; Close had decided to use only friends as subjects, on the grounds that if he was going to spend several months working on a face, he wanted it to be someone he cared about. Other subjects in this early series included the artists Richard Serra and Nancy Graves, and the composer Philip Glass (photographed at the same time as Israel). Though almost all of the subjects have since become relatively well known, the deadpan frontal approach has, as Close intended, in a sense helped to preserve their anonymity. While the painting has a monumentality, fascination and aesthetic presence that establish it as a work of art, the physiognomy depicted remains strangely forgettable. The viewer is brought into far closer proximity with the subjects than would be possible or desirable in normal life. It is easier therefore to view them as 'types' rather than individuals – *Richard* (Serra) looks like a 'tough guy'; *Bob* looks like the nice, good-looking, 'preppy' young man one's mother would be pleased to meet. The interest lies less in who he is than in specific physical details – such as the intense eyes behind the spectacles, and the apparently just-washed hair. Only the portrait of Glass (1969; Whitney Museum, New York) conveys an interpretive view of the face (perhaps because it is not looking straight at the camera), which brings the image more directly into a relationship with a traditional photographic or painted portrait.

1970s

The final agonies of the Vietnam War, the Watergate scandal and terrorist movements and atrocities around the world ran hand-in-hand with increasing scepticism about orthodox science and progress; the decade saw the rise of both alternative and fundamentalist systems and beliefs. Against a background of increasing affluence and hedonism in the West, art became big business, exhibitions like *The Treasures of Tutankhamun* became blockbusters, and new art became conceptual and largely autobiographical.

HISTORICAL EVENTS

1970

In Britain, Edward Heath becomes Prime Minister of a Conservative government.

In Egypt, sudden death of President Nasser; succession of Anwar Sadat.

Three western airliners bound for New York hijacked by Arab guerillas and blown up in Jordan.

In Jordan, ten-day civil war between King Hussein's army and Palestinian guerillas.

In Chile, Salvador Allende elected President, heading a Marxist government.

In Nigeria, end of civil war leaves about 2 million dead and 5 million starving Biafran refugees.

In the US, four students killed by National Guard at an anti-Vietnam War protest at Kent State University in Ohio.

1971

In Uganda, deposition of President Obote; army officers headed by Major General Idi Amin take control.

In Pakistan, outbreak of civil war; Bangladesh secedes and India declares war on Pakistan.

In Cambodia, Red Commandos bomb Phnom-Penh.

China joins the UN.

In Switzerland, women get the vote.

In Britain, decimalisation of the currency.

Foundation of Greenpeace, international environmental organisation.

1972

In Uganda, Idi Amin gives members of the Asian community 90 days to leave the country.

China and Japan resume diplomatic relations.

In China, historic visit of President Nixon who agrees with Mao Tse-tung on a 'normalisation of relations' with the US.

In Northern Ireland, British troops fire on civilians: the day becomes known as 'Bloody Sunday'.

1973

US troops leave Vietnam; release of the last American prisoners of war.

In the US, senate committee hearings begin on the Watergate scandal, implicating President Nixon.

Britain, Eire and Denmark join the Common Market.

In Chile, President Allende overthrown by a military junta and, reportedly, commits suicide; Gen. Augusto Pinochet takes over as president.

In Argentina, Juan Perón re-elected president after 18 years in exile.

In the Middle East, outbreak of war between Arabs and Israelis on Yom Kippur, the Jewish holy day of atonement.

1974

Worldwide inflation and financial recession.

In Britain, Harold Wilson becomes Prime Minister.

In Israel, resignation of Golda Meir; succession of Itzhak Rabin.

In West Germany, resignation of Chancellor Willy Brandt when an aide is found to be an East German spy.

In France, death of President Pompidou.

In the US, President Nixon forced to resign over Watergate scandal; succession of Gerald Ford.

In Argentina, death of President Perón; succession of his vice-president and wife, Isabel Martinez de Perón.

CULTURAL EVENTS

1970

Site-specific Land- or Earth-works include Robert Smithson's 'Spiral Jetty' at Great Salt Lake, Utah.

Composition of Witold Lutoslawski's *Cello Concerto*.

First performance of Michael Tippett's *The Knot Garden*.

First performance of Rolf Hochhuth's play *Guerillas*.

The Beatles split up.

1971

Walter de Maria begins his arrangement of 'Lightening Field' in a New Mexico desert.

Publication of Norman Mailer's *Of a Fire on the Moon* and *The Prisoner of Sex*; Susan Sontag's *On Photography*.

Release of Stanley Kubrick's film of Anthony Burgess's novel *A Clockwork Orange*, which was quickly suppressed in the UK by Kubrick when it inspired copycat violence.

1972

Release of Bob Fosse's film of the Broadway musical *Cabaret*, starring Liza Minnelli; Francis Ford Coppola's *The Godfather*; Sidney Furie's biopic of jazz singer Billie Holiday, *Lady Sings The Blues*, starring Diana Ross.

Release of David Bowie's 'The Rise and Fall of Ziggy Stardust and The Spiders from Mars'.

Richard Branson and Nik Powell form Virgin records.

1973

Opening of the Sydney Opera House.

Publication of George Lucas's *American Graffiti*.

Release of Nicolas Roeg's film *Don't Look Now*.

The Who's *Quadrophenia* stars Phil Daniels as Jimmy.

Release of Elton John's *Goodbye Yellow Brick Road*.

1974

Nobel prize-winning author Alexander Solzhenitsyn deported from the USSR to West Germany.

Publication of Erica Jong's *Fear of Flying*.

Swedish pop group Abba win the Eurovision Song Contest (at their third attempt) with *Waterloo*.

Release of Andrei Tarkovsky's film *The Mirror*; Roman Polanski's *Chinatown*.

In Italy, kidnap of former Prime Minister Aldo Moro by Red Brigade terrorists; the government refuses to accede to their demands and he is murdered.

In Rhodesia, Ian Smith agrees to transfer power to the country's black majority by the end of the year.

In Vietnam, the final squad of US Marines are airlifted from the embassy roof in Nha Trang.

In South Vietnam, surrender of President Duong Van Minh to the Communists.

In Saudi Arabia, assassination of King Faisal by his nephew, who is executed.

In Mozambique, independence from Portugal, with Samora Machel as President.

In Cambodia, a campaign of genocide launched by the Khmer Rouge under Pol Pot.

In Vietnam, the country is officially reunited after nearly twenty years of warfare, with Hanoi as its capital.

In China, death of Chou En-lai; succession of Hua Kuo-feng as Prime Minister. Later, death of Mao Tse-tung; succession of Hua Kuo-feng as Chairman of the Communist Party.

In Britain, resignation of Harold Wilson; succession of James Callaghan as Prime Minister.

In South Africa, students protest over the Afrikaan Education Plan.

In the US, Jimmy Carter becomes President.

In Uganda, unexplained deaths expose brutality of Idi Amin regime.

UN embargoes arms to South Africa in protest against its repressive racial policies.

Egyptian President Sadat meets Israeli Prime Minister Begin for peace talks in Jerusalem.

Pioneer II reaches Saturn and *Voyager I* discovers that Jupiter has a ring.

In Britain, celebration of Queen Elizabeth II's silver jubilee.

In Vietnam, hundreds of ethnic Chinese flee persecution; over one year, an estimated 100,000 'boat' people die attempting to reach neighbouring countries.

At Camp David, peace talks between Egypt and Israel are mediated by US President Carter.

Polish Cardinal Karol Wojtyla becomes Pope John-Paul II, the first non-Italian pope for over 450 years.

In England, the first 'test-tube' baby is born.

Egypt and Israel peace treaty ends 31 years of conflict.

Expulsion of Idi Amin from Uganda.

In Tehran, US embassy seized by Iranian militants who take hostages.

Rhodesia agrees to short-term British administration, prior to general elections.

In Britain, Margaret Thatcher becomes Prime Minister.

Murder of Earl Mountbatten of Burma and three others in an IRA bomb attack.

1975

1976

1977

1978

1979

Rembrandt's *Night Watch* slashed by a vandal in Amsterdam; three Renaissance masterpieces stolen from the Ducal Palace in Italy.

Release of Milos Forman's film, *One Flew Over the Cuckoo's Nest*; Pier Paolo Pasolini's last film *Salò, or the 120 Days of Sodom*, before he is murdered

First performance of Michael Bennett's musical *A Chorus Line*.

Release of Queen's *Bohemian Rhapsody*, accompanied by the first major rock video.

International Women's Year.

Christo embarks on his project *Wrapped Reichstag, Berlin*; it is finally achieved in 1995.

First performance (in Amsterdam) of Viktor Ullmann and Peter Klein's opera *The Emperor of Atlantis*, based on their experiences in the Nazi concentration camp where they both died; (in Avignon) of Philip Glass's opera *Einstein on the Beach*, staged by Robert Wilson.

Publication of Gabriel García Marquez's *The Autumn of the Patriarch*.

Punk explodes in London, with The Sex Pistols, The Damned and The Buzzcocks.

Release of Steven Spielberg's *Close Encounters of the Third Kind*; George Lucas's *Star Wars*.

Television broadcast of Alex Haley's *Roots*.

John Travolta stars in *Saturday Night Fever*; the soundtrack is a huge hit for The Bee Gees.

Release of The Sex Pistols' *God Save The Queen*; The Clash's *White Riot*.

Death of Elvis Presley from a drug overdose.

Opening of the Centre Georges Pompidou, Paris, designed by Renzo Piano and Richard Rogers.

Release of Michael Cimino's film *The Deer Hunter*, the first major Hollywood treatment of the Vietnam War; the screen version of *Grease*, starring John Travolta, celebrating the years of rock 'n' roll.

Release of AC/DC's *If You Want Blood, You Got It*.

Retrospective of Salvador Dalí in Paris; exhibition of Judy Chicago's *The Dinner Party*.

Publication of Margaret Atwood's *Life Before Man*.

First performance of Peter Shaffer's *Amadeus*.

Release of Ridley Scott's science-fiction thriller *Alien*; Francis Ford Coppola's Vietnam War film *Apocalypse Now*.

Pink Floyd's *Another Brick In The Wall* is an international hit.

David Hockney
Le Parc des Sources, Vichy, 1970

DAVID HOCKNEY b.1937

Born in Bradford; studied at the Royal College of Art, London; etchings *A Rake's Progress* issued in 1963; moved to Los Angeles and began the swimming-pool paintings, 1964; designed for Glyndebourne, Metropolitan and Los Angeles operas from mid-1970s; developed photo-works from 1976; retrospective exhibitions at the Whitechapel Art Gallery, London, 1970; Los Angeles, New York and Tate Gallery, London, 1988–9.

Acrylic on canvas
2140 × 3050mm (84 × 120″)
Private collection

REFERENCES

M. Livingstone, *David Hockney*, London, 1981, pp.130, 133

Nikos Stangos, ed., *David Hockney by David Hockney*, London, 1976, pp.196, 202

Following three decades of naturalistic painting in all its various Pop, Photorealist and Postmodernist forms, it is difficult to recapture the impact that Hockney's paintings of the mid- to late 1960s and early 1970s made on the gallery-going public. After half a century of increasingly impenetrable 'isms', works like *Peter Getting out of Nick's Pool* (1966; Walker Art Gallery, Liverpool) and *Mr and Mrs Ossie Clark and Percy* (1970–71, Tate Gallery, London), with their factual, everyday titles and glimpses of glamour and a high life that was not only desirable but almost accessible, seemed to bring art back to the people. Most importantly, they attracted the young, who began then to raise the numbers of gallery-viewers to the high levels we witness today.

Le Parc des Sources, Vichy, begun just before his portrait of Mr and Mrs Clark, was Hockney's first painting after nearly a year spent doing etchings for Grimm's *Fairytales*. 'I'd first visited Vichy in, I think, 1968. I've been back almost every year since then. It's a very pretty town with a park in the middle, a kind of formal garden, and they use this false perspective of trees to make it look longer than it really is. And I thought, it's marvellous, the whole thing is like a sculpture . . . In 1969 I made a journey to Vichy specially to draw and photograph it all again. I took with me Peter Schlesinger [his American boyfriend, on the right] and Ossie Clark [fashion designer, in the centre], because I wanted to set the three chairs up for the three of us, me Peter and Ossie; then I'd get up to paint the scene. That's why the empty chair is there – the artist has to get up to do the painting. It's like a picture within a picture; I was going to call it "Painting within Painting" like *Play within a Play*. That gives it the strong surrealist overtones. It's actually a perfectly natural scene, there's no real oddness in it. It's just a mood created by this strong V in the perspective, slightly off-centre.'

Apart from the existing false perspective of the avenues of trees, it is of course the back views of his two friends that create the Surrealist element, and the atmosphere of unease and insecurity. Marco Livingstone has aptly described this work as almost a '"found" Magritte', and points out that the construction of triangles defining the composition could also be an echo of the romantic triangle in which the three men were involved at the time.

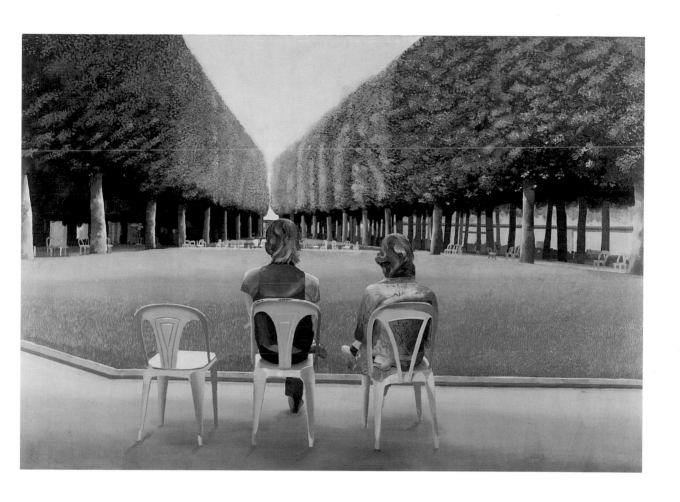

Francis Bacon
Study for Portrait, July, 1971

For biography, see p.196

The late 1950s and early 1960s were possibly the great age of the in-depth television interview. While interviewers such as Alan Freeman on his *Face to Face* series posed searching questions about subjects' lives and beliefs, the camera mercilessly recorded every movement of their face and hands, not sparing (in the case of the television personality Gilbert Harding) even their tears. While most of Bacon's portraits were painted away from the sitter, works like *Study for Portrait,* with their clinical, studio-like settings and suggestion of constant but repressed movement, are perhaps the nearest equivalent in painting to the episodes of self-revelation that were taking place in the BBC studios.

The most obvious points about *Study for Portrait* are its brilliant, upbeat colour and box-like structures that frame Bacon's portrait of an unidentified friend. He shows us enough of the man for us to deduce that he is young, quite good-looking and well-dressed. The first box, which is drawn in perspective with the image on the front (very like a television), frames him in close-up, and focuses our attention on the most significant aspect of any portrait – the head. A second structure pans out to reveal the rest of the seated figure. Like the semi-flayed head that turns to the right, the body is in awkward movement, shifting on the chair, the right leg thrown high over the left so that the subject can perhaps fiddle with his shoelaces or trouser cuff, the left arm moving up and down on the back of the chair and catching a shaft of light. The two structures suggest not so much the confinement of a studio but rather the personality of the sitter creating its own space.

The really Baconesque moment occurs at the bottom of the painting, where the legs of the chair appear to be teetering half on and half off a platform, suddenly bringing an element of instability into an otherwise fairly normal situation. The sitter's foot remains firmly planted on the ground, like a pedestal for the insecurity above it. Where it breaches the front line of the outer box, a large splash of white pigment catches the leg as if there has been a violation. Perhaps the barrier between artist and subject has been broken and some intimacy revealed – but by whom?

Oil on canvas
1980 × 1475 mm (78 × 58″)
Private collection

REFERENCES

M. Leiris, *Francis Bacon: Full Face and in Profile*, London, 1983, no.73

Francis Bacon, exh. cat., Centre Georges Pompidou, Paris, 1996, pp.186–7, no.62

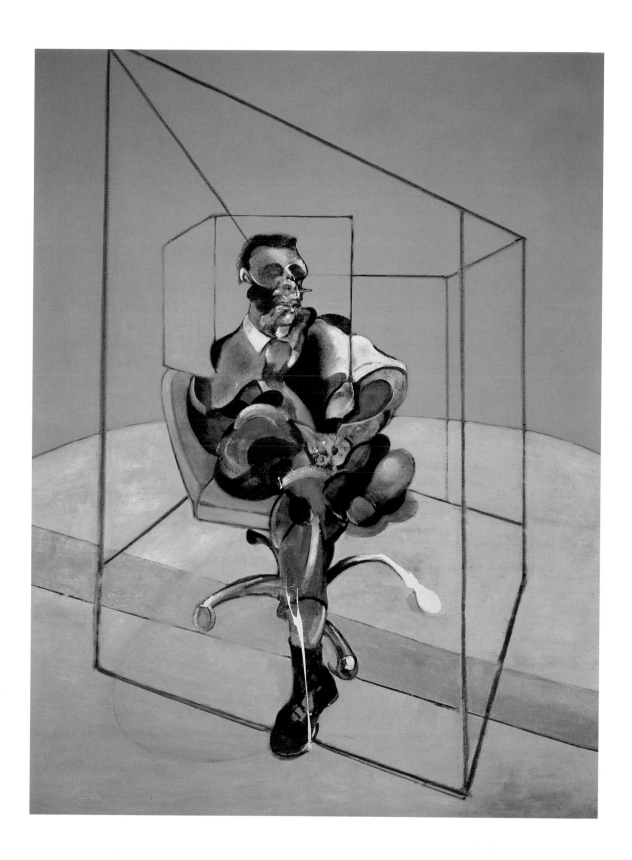

Werner Tübke
Group Picture, 1972

WERNER TÜBKE b.1929

Born in Schönbeck, Germany; studied art at the Hochschule für Graphik und Buchkunst, Leipzig, and art education and psychology at the Ernst-Moritz-Arndt-Universität, Greifswald (1948–53); by 1971 began working on a large scale creating murals and panoramic paintings; his later work was influenced by travels to Italy and became associated with Postmodernism.

Tempera on wood
1475 × 1475mm (58 × 58″)
Gemäldegalerie Neue Meister,
Staatliche Kunstsammlungen, Dresden

REFERENCES

I. Emmerich, *Werner Tübke. Schöpfertum und Erbe*, Berlin, 1976

E. Beaucamp, *Werner Tübke – Artbeiterklasse und Intelligenz. Eine zeitgenössische Erprobung der Geschichte*, Frankfurt am Main, 1985

G. Meissner, *Werner Tübke. Leben und Werk*, Leipzig, 1989

This 'hard hat altarpiece' is a rather unexpected attempt by an artist from communist eastern Europe to bring a personal note into the ailing genre of Soviet Socialist Realism. East Germany witnessed a revival of imaginative figure painting in the 1970s and 1980s, with artists such as Bernhard Heisig looking to the work of Kokoschka, Dix and the Expressionists, and others like Sighard Gille inspired by the more satirical aspects of the New Objectivity movement. Tübke is perhaps unique in that, on his own admission, he ignored the influence of any painting later than the eighteenth century. His works of the early 1960s take their cue from medieval and early Renaissance diptychs, and his battle and crowd scenes recall Netherlandish artists like Pieter Bruegel I. Following visits to Italy, Renaissance and Mediterranean influences begin to come into play. His *Sicilian Land-owner with Marionettes* (also 1972; Gemäldegalerie, Dresden) presents a bizarrely theatrical view of its dandified subject, surrounded by life-size but inert puppets strung around a baroque proscenium. By the end of the decade this work was being annexed as a key document of Postmodernism.

Tübke's ever-present sense of irony surfaces especially when he is attempting to reconcile the demands of an official party commission with his own interests. This portrait group of German builders repeats part of a mural begun in 1971 for the Karl-Marx University, Leipzig, on the theme of 'Working Class and Intelligentsia'. The subject, presumably equating manual labour with academic achievement, sets its own unavoidable agenda, which the Renaissance-minded Tübke has solved by basing his group of labourers on a work very close to Raphael's *St Cecilia* altarpiece (*c*.1515–18; Bologna). The disposition of the three figures on the right is identical to the Raphael, though it may be coincidence that the central figure (the foreman?) looks like the artist's self-portrait equating himself with the manual workers). Although tools are in evidence, the men hold documents like sixteenth- or seventeenth-century officials or clerics, presumably to draw attention to the often-overlooked need for qualifications and detailed paperwork in the construction industry. Whereas Michael Browne borrows directly from the Old Masters in *The Art of the Game* (see p.263), Tübke reinterprets the art of the past in an entirely personal manner: the result is simultaneously disconcerting and imposing, and underlines the artist's rather throwaway view that 'everything is history'.

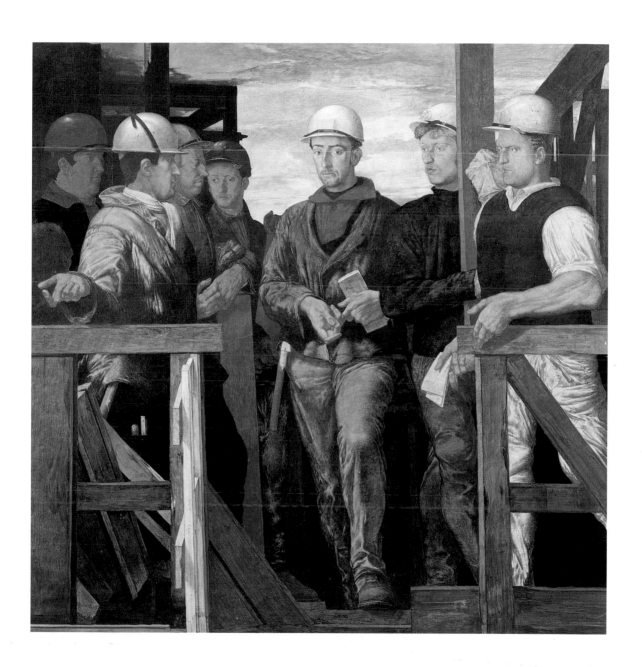

Gerald Scarfe

Richard Nixon – 'If I go, I'll take you all with me', 1973

GERALD SCARFE b.1936

Born in London; studied at St Martin's School of Art and the Royal College of Art; by 1961 was contibuting cartoons to *Punch*; work for *Private Eye* from late 1962 brought his name to a wider public and regularly caused outrage; contributor of political cartoons to the *Sunday Times* since 1965 and more recently to the *New Yorker*; much acclaimed for innovative contributions to theatre design and to animated films including Pink Floyd's *The Wall* (1981) and Walt Disney's *Hercules* (1987); retrospective exhibition at the Royal Festival Hall, 1983; *Scarfe at the National Portrait Gallery*, 1998.

While a number of American presidents in recent history have been the subject of vilification, Richard M. Nixon (1913–94) was the first to resign from office. The Watergate scandal – a break-in by members of his re-election committee into Democratic campaign headquarters – erupted in May 1973. One of Scarfe's most memorable cartoons, this was published in the *Sunday Times* on 28 October, by which time Nixon had made a prestigious rapprochement with President Brezhnev of the USSR and, in a delayed press conference, was trying to dismiss the Watergate allegations as an irrelevance. Despite his claim that he and Brezhnev were bringing peace to the world, he went on to order a nuclear alert over the USSR's involvement in the Middle East. The impression remained, as Scarfe's cartoon shows, that Nixon was playing nuclear games to save his own skin.

Nixon became one of Scarfe's most fertile creations in his representation of foreign politicians. As with his treatment of Britain's Prime Minister, Margaret Thatcher, the impact of his satire was such that it is now almost impossible to visualise Nixon untainted by Scarfe's imagery. Scarfe had followed Nixon on his presidential campaign in 1968 for the purpose of making a papier-mâché figure of him for a *Time* magazine cover (it was deemed too extreme). He wrote later: 'I suppose I was obsessed with Nixon. As I drew him time and time again, he began to transform himself. Slowly but surely his pendulant jowls began to detach themselves from the upper part of his face just below the cheekbones, and almost imperceptibly began to slide down and along his nose, releasing the rest of his face to balance at the top, and either side, of his big dipper nose. His shoulders bowed even more, and pulled his body backwards into a huge question mark.' Scarfe's gift for giving material form to our worst nightmares is realised here in a drawing of consummate skill; he is considered to be one of the greatest draughtsmen of the century. We accept without quibble the sheer anatomic impossibility of his vision because it conveys so precisely the message he wishes us to share. After the long drawn-out agony of Nixon's resignation just over nine months later, Scarfe pushed the dagger in and drew him as 'the old rogue Republican elephant, a sad sagging leather sack, hung on whitened bones, bleached in the heat of the Watergate sun.'

Ink and watercolour on paper
745 × 530mm (29⅜ × 20⅞")
Collection of the artist

REFERENCES

G. Scarfe, *Scarfe by Scarfe*, London, 1986

G. Scarfe, *Line of Attack*, London, 1988, pp.10, 96

Maggi Hambling
Portrait of Charlie Abrew, 1974

MAGGI HAMBLING b.1945

Born in Sudbury, Suffolk; early studies
with Lett Haines and Cedric Morris at
Hadleigh; began painting portraits,
1973; first artist in residence at
National Gallery, London, 1980–81;
Max Wall pictures at National Portrait
Gallery, 1983; solo exhibition
Serpentine Gallery, London, 1987;
more recent work includes series
of *Sunrises, Laughs,* prints, ceramic
and bronze sculpture; *Oscar Wilde*
sculpture for Adelaide Street,
London wc2, 1997.

Oil on canvas
1410 × 1136mm (55½ × 44¾")
Wakefield Museums and Arts

REFERENCES

E. Cayzer, *Changing Perceptions.
Milestones in Twentieth Century British
Portraiture*, London, 1999, pp.114–15

Max Wall. Pictures by Maggi Hambling,
exh. cat., National Portrait Gallery,
London, 1983, p.34

Like many young artists of her generation, Maggi Hambling stopped painting when she finally arrived at the London art college of her ambitions. In her case it was the Slade School of Fine Art in 1967, and for several years she became closely involved in conceptual projects and installations, sharing first prize in the Nottingham *John Player Biennale 2 – Conceptual Art* for *Blue Skies*. By 1970–71 she was experimenting with painting again, and by 1972 had not only made a conscious decision to return 'to her primary concern of painting people again' but had begun taking a weekly painting class at Morley College in Lambeth. Charlie Abrew was one of the many life models who have passed through this legendary class, which is still flourishing nearly thirty years later. Models, pupils, people in the street or in pubs – all were attractive to Hambling. Her constant succession of interests, whether an individual like Max Wall or a phenomenon like a sunrise or laughter, is always followed through to its limit in her paintings and has never ceased to be a source of amazement to her followers.

Immigration to Britain from the Caribbean began, almost accidentally, in the aftermath of the Second World War when the *Empire Windrush* docked at Tilbury with 492 mostly ex-servicemen. They stayed because, on the whole, they liked it in Britain, and were the advance guard of what has since become a more or less completely British community. Many, like Charlie Abrew, did not find it easy. In 1974, in the aftermath of Enoch Powell's prophecies, racial tension was an everyday reality and work not always easy to get. Abrew had been a boxer, but had lost his sight. The sense of barely controlled physical power and his enormous hands that could nevertheless perform the most delicate task fascinated the artist. Clearly, for Abrew, sitting for a portrait (as opposed to modelling) meant assuming a formal pose and sitting stock still, facing the artist as if he was in a photo-booth. This is a remarkably undemonstrative portrait for Hambling, in which only the hands take on the sort of supporting role more commonly reserved in her portraits for narrative or symbolic elements. Included in the John Moores exhibition the year it was painted, this is an image of simplicity and enormous dignity.

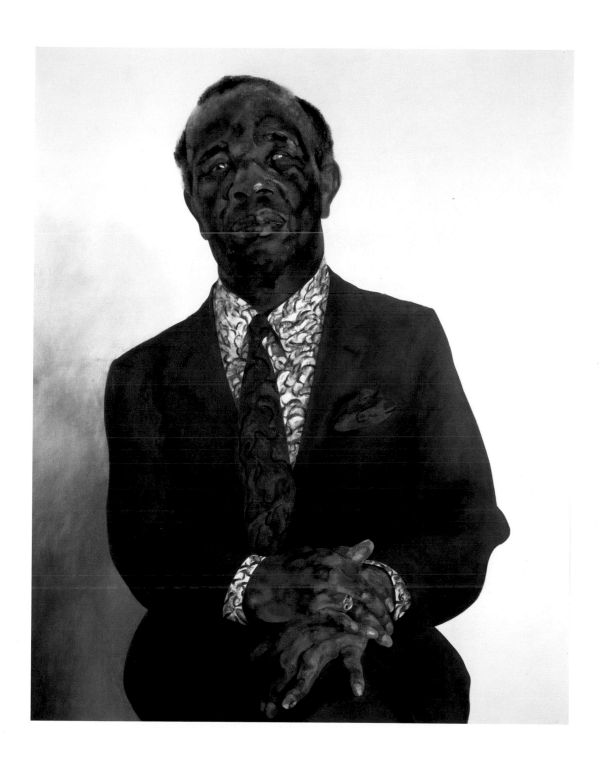

Franz Gertsch
Marina making up Luciano, 1975

FRANZ GERTSCH b.1930

Born in Moerigen, Switzerland; studied
painting at the Malschule Max von
Muehlenen, Berne (1947–50); received
DAAD fellowship in Berlin, 1947; first
solo exhibition, 1968, at Galerie Martin
Krebs, Berne; first solo travelling
exhibition, 1975; works in numerous
international galleries including
Museum Moderner Kunst, Vienna,
and Nationalgalerie, Berlin.

While his contemporary Andy Warhol (see p.189) was creating archetypal
icons of American culture, in 1970 Franz Gertsch was beginning to paint
huge transcriptions from life which focus hypnotically on very specific
people or situations to create a totally individual view of contemporary
society. In scale, his work is reminiscent of Chuck Close (see p.200), but
Gertsch's portraits are environmental whereas Close's are almost abstract.
The photographic origins of Gertsch's paintings (they are worked from a
slide projected on to cotton duck) have inevitably led to his being lumped
together with the American super-realists, but he has always insisted on the
humanity and spontaneity of his imagery, and the subjectivity conferred by
the act of painting with a brush rather than with a spray-gun. The creation
of a thin skin of paint is seen as conveying an almost erotic charge to the
illusion that is being created on the canvas. Covert eroticism does seem to
lie behind much of Gertsch's subject matter – from the series of paintings
of the androgynous Luciano with their issues of gender, to the huge head-
and-shoulders portraits of beautiful but ultimately inaccessible women of
the 1980s and 1990s (for example, *Johanna II*, 1985–6, Hess Collection,
Steinhölze, Berne).

Gertsch came to fame with the monumental and arbitrarily named
Medici (1971–2; Ludwig Museum, Aachen), a *tour de force* that showed a
group of five fashionably long-haired young swingers, apparently on a
building site; it was a sensation when exhibited in documenta V at Kassel.
In a very real sense, it was *the* portrait group that defined the era of the
Beatles. The *Luciano* series is based on Luciano Castelli, a Swiss performance
artist then working with a transvestite company called Transformer.
Luciano I (1971; Kunstmuseum, Lucerne) shows him staring, long-haired,
wide-eyed and enigmatic, out of the left of the painting as if unsure both
of himself and of his involvement with the viewer or the artist. In *Luciano II*
(Hess Collection), Gertsch returns to his subject five years later and fixes
him in exactly the same pose. Still wide-eyed and long-haired, he has in the
meantime experienced a significant shift. Luciano is older, and perhaps
wiser. His eyes swivel to confront the viewer, and a subtle and probably
knowing smile crosses his lips. The painting with his girlfriend Marina as
they make up for a performance was produced between the two single
portraits and acts as a sort of rite of passage. Sexual confusion reigns. The
viewer's first reaction is that Luciano must be the figure on the left and
Marina the one on the right, although the title denies this. Gertsch came in

Acrylic on unprimed cotton
2340 × 3465mm (92⅛ × 136⅜″)
Museum Ludwig, Cologne
(Ludwig Donation)

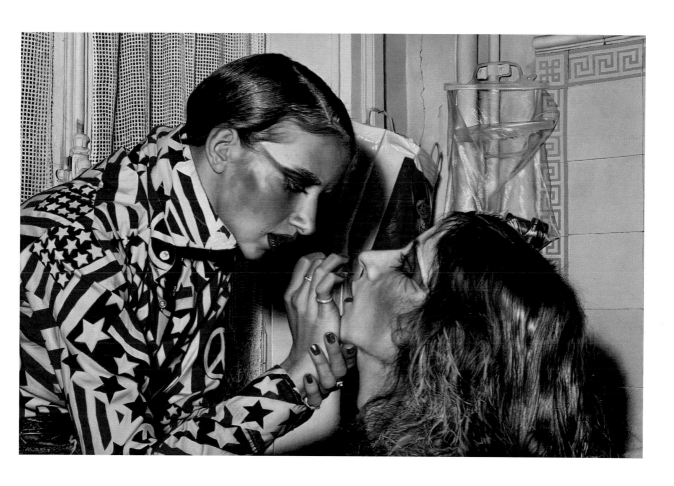

for heavy criticism from his fellow Swiss after his first major solo exhibition at the Kunsthaus Zürich in 1980 for his portrayal of decadent youth. The exotic nature of the scene unfolding before us is heightened by contrast with the banality of the background, with its plastic bags, coarse net curtains and old-fashioned tiles. On the one hand, the painting is simply a traditional view of performers behind the scenes; on the other, it is a tract for sexual and creative tolerance.

REFERENCES

E. Billeter, *Franz Gertsch*, exh. cat., Kunsthaus Zürich, 1980, pp.48–53 (ill.)

Franz Gertsch: Works from the Hess Collection, exh. cat., Vinopolis, London, 1999

Georg Baselitz
Elke, 1976

GEORG BASELITZ b.1938

Born Georg Kern in Deutschbaselitz, Germany; expelled from East Berlin Academy, 1956; studied at the Academy of Fine Art, West Berlin, 1957–64; *Die grosse Nacht im Eimer* confiscated by the Public Prosecutor's Office, 1963; from 1969 inverted the subjects of his paintings; began series of massive wooden sculptures, 1979; Professor of the Academy of Fine Art, (West) Berlin, 1983–92.

Oil on canvas
2500 × 2000mm (98½ × 78¾")
Modern Art Museum of Fort Worth, Museum Purchase, Gift of the Friends of Art Endowment Fund

REFERENCES

F. Dahlem and G. Baselitz, *Baselitz*, Cologne, 1990, pp.28–9, 92–105

A. Franzke, *Georg Baselitz*, Munich, 1989

'If you stop fabricating subjects but still want to carry on painting, then turning the subject upside down is the obvious thing to do. The hierarchy which has the sky at the top and the earth at the bottom is, in any case, only a convention. We have got used to it, but we don't have to believe in it. . . . What I wanted was quite simply to find a way of making pictures, perhaps with a new sense of detachment. That's all.' (Georg Baselitz in an interview with P. M. Pickhaus, 1990.)

Baselitz's decision around 1969 to distance his viewers from his work by painting the subject upside down followed a period in 1967–8 when he had painted a group of 'Fracture Pictures' in which parts of the subject (woodmen, trees, animals) were moved around the canvas and positioned at will. The first paintings to result from the inversion tactic were a group of semi-naturalistic portraits of friends, done in what looked like his old, broad style. As he said: 'I decided . . . to dispense with narrative and content and deal only with the things that painting normally uses: landscape, the nude, the portrait, the still life and so forth.' Over the next few years, these turned out to be a series of paintings of birch trees, another of eagles and, most powerfully, a number of large nude studies of himself and his wife Elke Kretschmar, whom he had met in Berlin in 1958 and married in 1962.

The first nudes, painted with considerable subtlety and realism, climax in the wonderful double portrait *Schlafzimmer* [Bedroom] (1975; Museum Ludwig, Cologne), one of Baselitz's biggest paintings to date. Details of the bedroom furniture are legible in some of the other nudes, and the paintings are worked from the centre outwards leaving white canvas around the edges of the composition, almost like a drawing. The large canvases may have had something to do with his move in 1975 to the château-like surroundings of his new home at Derneburg. It is possible to see in the more conventional figuration a desire to establish his mastery of the new inverted manner by producing representational paintings in as traditional a way as possible. A number of the nudes are also painted entirely in shades of black. In the one shown here, a broader approach is discernible; by 1977, in *Male Nude – Black* and *Elke 4*, the figures were reduced to greatly simplified black shapes. His move towards a more abstract use of paint, colour and motif was already in place.

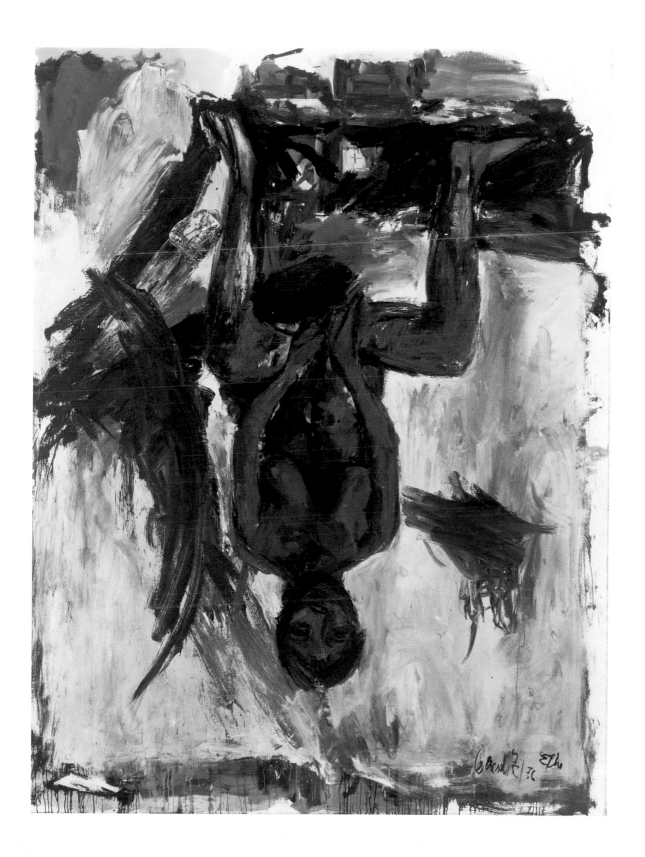

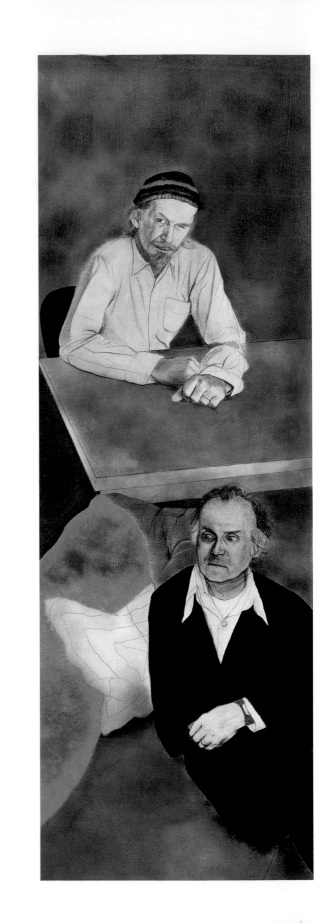

R. B. Kitaj
A Visit to London (Robert Creeley and Robert Duncan), 1977–9

R. B. KITAJ b.1932

Born in Cleveland, Ohio; served as a merchant seaman before studying in New York, Vienna, Oxford and finally at the Royal College of Art (1960–62); immediate success with first solo exhibition, Marlborough Fine Art, London, 1963; organised *The Human Clay*, Hayward Gallery, London, 1976; retrospective exhibition Washington, Cleveland and Düsseldorf, 1991–2; following mixed reviews of Tate Gallery retrospective in 1994 he returned to live in the USA.

Essentially an intellectual painter, Kitaj's portraits of artist and writer friends of the 1970s and 1980s are not only among his best work, but act as a memorial to the culture of a period that already seems amazingly remote. The apparent conflict in his work between the natural brilliance of his draughtsmanship and an almost overwhelming awareness of the inexorable onward thrust of modern art seems resolved here in a composition of great simplicity and sobriety, with no underlying programme beyond the fact of two friends sitting for their portraits. The writer Julián Ríos, interviewing Kitaj in the mid-1980s, and clearly hoping for some more profound *raison d'être* for this portrait, could elicit little from the artist except his enthusiasm for both men and the fact that they were staying with him at the time.

Kitaj had met Creeley and Duncan in California in 1967. Robert Creeley (above, b.1926) and Robert Duncan (below, 1919–88) were both associated with the Black Mountain School of poets and became two of the most influential literary figures of mid-century America. The elegant verticality of the *panneau*-like format is a common theme, particularly in a number of Kitaj's other major portraits of the 1970s (e.g. *The Orientalist*, 1976–7; Tate Gallery, London), but what singles the work out from most of his other paintings is the apparently arbitrary and near-monochrome colour scheme. Again, although Creeley and Duncan had been friends at least since the mid-1950s, there is no point of contact between them, and they remain strongly differentiated in character and separated by the hard diagonal of the table-top. The two halves of the painting have occasionally been reproduced as separate details, but they lose much of the complete work's impact; the two portraits are like verses from the same poem. The sombre colour scheme binds the portraits together and confers an overall reflective dignity both on the two men and on the occasion.

Oil on canvas
1829 × 610mm (72 × 24″)
Museo Thyssen-Bornemisza, Madrid

REFERENCES

R. Morphet, ed., *R. B. Kitaj: A Retrospective*, exh. cat., Tate Gallery, London, 1994, pp.218, 109

J. Ríos, *Kitaj: Pictures and Conversations*, London, 1994, pp.668

Philip Guston
Figure, 1978

PHILIP GUSTON 1913–80

Born in Montreal, Canada, but moved to Los Angeles, California, with his family in 1919; attended the Otis Art Institute (1930) before becoming involved with the mural movement and working for the Works Progress Administration's Federal Arts Project, 1941–5; appointed artist-in-residence at the State University of Iowa and later at the School of Fine Arts at Washington University, awarded Guggenheim Fellowship in 1947, but continued to teach at New York University and the Pratt Institute.

Oil on canvas
1524 × 1220mm (60 × 48″)
The Estate of Philip Guston.
Courtesy McKee Gallery, New York

REFERENCES

P. Schjeldahl, in *Art of Our Time*, exh.cat., The Saatchi Collection, London/Royal Scottish Academy, Edinburgh, [1987], pp.7, 8

Philip Guston: Paintings, 1969–1980, exh. cat., introduction by Norbert Lynton, Whitechapel Art Gallery, London, and tour, 1982

R. Storr, *Guston*, New York, 1986

Philip Guston's painting career with its changes of direction from successful figure painter to widely admired Abstract Expressionist and, in the last decade of his life, cult figurationist – seemed to follow shifts in the cultural psyche of the times. When, in 1968, he abruptly abandoned his abstract work for what seemed to many to be clumsy, cartoon-like and jokey figures and objects in interiors, the loyalty of many of his admirers was severely dented. Even the disciplined Renaissance-inspired structure of his early figurative paintings (for example, *Martial Memory*, 1941; St Louis Art Museum) went out of the window.

Like several other modern artists working in pure abstraction (Ben Nicholson is another who periodically felt the need to return to the landscape and still-life origins of his art), Guston seems to have abandoned the strain of working for an idealistic sense of art in order to be true to himself. It is possible to deduce from many of the late works such as this one that they are in essence self-portraits, explorations of his own psyche in which, as Peter Schjeldahl put it, 'affected by the world but unable to affect it in return, the artist is stuck with his visions, which assume ambivalent roles in the tragicomedy of his inner life.' Common to many of the paintings is a sense of helpless inertia in which the artist is either in bed or lying on his back, unable to act and only to observe, often with one huge eye. Other obsessions such as heaps of shoes, cigarettes and light bulbs also crop up with great frequency. Here, the 65-year-old artist seems to imagine himself at an earlier stage in his life (perhaps when he lived near Venice Beach, California), the old-fashioned cap possibly another allusion to smoking. Although he is upright, he is nevertheless rooted to the ground and immobilised. The light bulb and blind are common motifs in the art of the century, easily interpreted as metaphors for light and revelation, and used for instance by Beckmann and Picasso, and most significantly by Guston's contemporary Francis Bacon. Like Bacon, Guston's late work is riven with the insecurity of a life in which the ideals of modernity have fallen in on themselves. All that remained, as Peter Schjeldahl put it, was 'mortified humanity and, if one could manage it somehow, painting.'

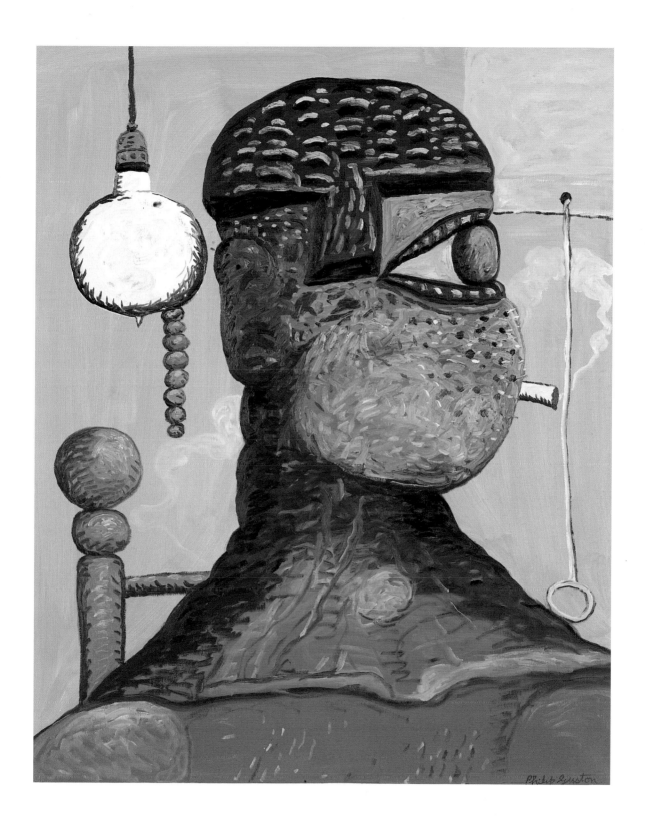

Frank Auerbach
J.Y.M. Seated IV, 1979

FRANK AUERBACH b.1931

Evacuated to Britain from Berlin as
a child in 1939; studied painting in
London under Bomberg at Borough
Polytechnic (1947–8) and continued
to attend his classes while at
St Martin's College of Art (1948–52)
and the Royal College (1952–5);
included in David Sylvester's *Critic's
Choice* at Tooth's, London, 1958, and
in Kitaj's *The Human Clay*, Hayward
Gallery, London, 1976; retrospective
at the Hayward Gallery, 1978.

Oil on board
550 × 450mm (21⅝ × 17¾")
Private collection

REFERENCES

*Frank Auerbach: Paintings and Drawings
1977–1985*, exh. cat., Venice Biennale,
1986, no.12

R. Hughes, *Frank Auerbach*, London,
1990, pp.178–80, 202–3, no.204

Like the later paintings of Giacometti, Auerbach's works are about painting – making paintings perhaps *with* rather than *of* the same person (or sometimes a city neighbourhood) day after day, year after year. Like the model (or friend, or co-worker), the paintings change imperceptibly with the passing of the years, though when making a direct comparison with a photograph of an older work the change can seem quite dramatic. Auerbach first painted J.Y.M. (Juliet Yardley Mills) in 1963 as *Seated Model*, a long-legged nude leaning back in the same chair, her hands above her head, her youthful figure outlined in powerful brush strokes against the framework of the chair. Now, approaching middle age, she sits sedately clothed, her hands folded, the broad strokes of paint that delineate her presence separated from those of the background only by their change of direction. Her head leans back, slightly askew, as it has done in more than seventy other paintings Auerbach has made of her (not counting drawings) – the pose she habitually assumes in the studio. Whereas Auerbach was initially known for the prodigal build-up of paint on his canvases – palimpsests of changed ideas and directions – his broad strokes now represent paint scraped away, the colour (as in the background here) occasionally marbled with the remaining paint beneath. This is one of the most aggressively 'blocky' of all Auerbach's paintings, both the execution and the bright colours of the yellow clothing and green foreground conveying a freshness and spontaneity that must reflect a buoyant mood. Over ten years later, in two paintings of *J.Y.M. Seated* (1992), the same woman in the same chair has become a calligraphic swirl of paint in a space defined with almost flat colour and light, a wall and a floor.

Painting is a time-based activity. Though we may sense the passing of time in the creation of individual works, with Auerbach it has over the years become a thread of continuity that we can follow through the cumulative density of his creative output. While much contemporary art is issue based and needs shock tactics to draw our attention, Auerbach turns the other cheek and asks us to observe and to ponder. Finding time for moments of quiet and for observing other people, wondering at the power of colour or the sheer beauty of paint – these are also necessary in contemporary life. Communication can be made with a whisper as well as with a shout.

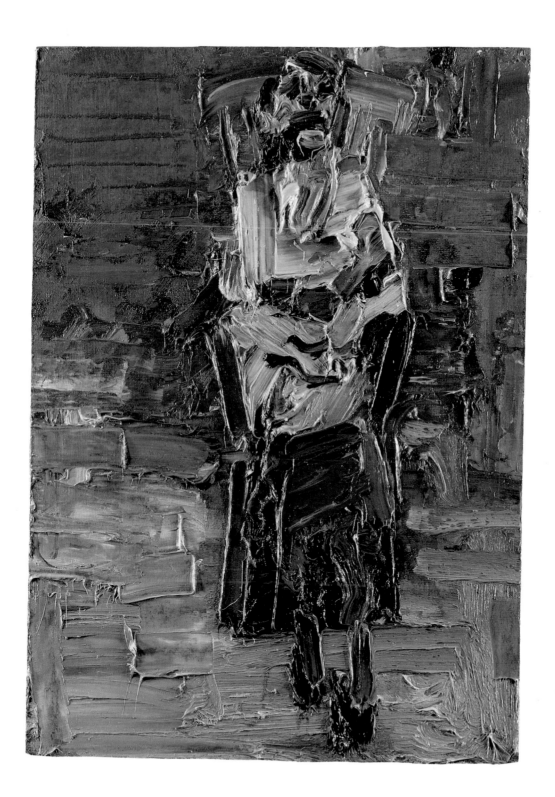

1980s

Under monetarism and the conservative governments of Ronald Reagan and Margaret Thatcher in the West, and with Mikhail Gorbachev's *glasnost* in the USSR, the last vestiges of old-style socialism and communism were effectively consigned to history. While computer technology rapidly took over many aspects of business, modernism, especially in architecture, was abandoned in favour of eclecticism and the recycling of old buildings. Several vigorous new figurative movements appeared in painting, at the same time as the acceptance of photography and video into the canons of orthodox art.

HISTORICAL EVENTS

1980	1981	1982	1983	1984
Death in a plane crash of Sanjay Gandhi, heir to Indira Gandhi of India.	Attempted assassinations of President Reagan and Pope John Paul II.	Invasion of the Falkland Islands by Argentina; Britain declares war.	In Northern Ireland, 134 prisoners escape from The Maze prison.	In India, assassination of Indira Gandhi.
In Iran, death of eight in a failed US attempt to rescue 53 Embassy hostages.	In Egypt, assassination of President Anwar Sadat by extremist Muslims.	Invasion of Lebanon by Israel.	In Britain, re-election of Margaret Thatcher for a second term.	In Brunei, independence.
In Yugoslavia, death of President Tito.	In Britain, formation of the Social Democrat Party.	In the USSR, death of Leonid Brezhnev; succession of Yuri Andropov.	A Korean commercial airliner shot down by the USSR; all 269 on board are killed.	In Ethiopia, famine.
In Poland, creation of independent trade union Solidarity under Lech Walesa.	Race riots in Brixton, London.	In Britain, the first Greenham Common protest against American military bases in the UK.	Exposure of the newly discovered 'Hitler Diaries' as a fake.	In Sri Lanka, violent clashes between Tamils and Sinhalese.
In the US, election of Ronald Reagan as President; influx of anti-Castro Cuban exiles.	In Northern Ireland, hunger strike in Belfast's Maze Prison; IRA gunman Bobby Sands and nine others die.	Unemployment figures exceed 3 million, the highest figure since the 1930s.	Introduction of the first cordless telephone by British Telecom.	China and the UK agree terms for the return of Hong Kong to China.
Zimbabwe (former Rhodesia) declared a republic, with Robert Mugabe as Prime Minister.	Marriage of the Prince of Wales to Lady Diana Spencer.	The Commodore 64 computer goes on sale to the public.		In Britain, explosion of an IRA bomb at the Grand Hotel, Brighton, during the Conservative Party Conference injures senior members of the Government.
Iraq and Iran declare war over the Shatt al-Arab waterway which divides them.	In France, François Mitterand becomes President.			National miners' strike.
Invasion of Afghanistan by the USSR; widespread boycott of Moscow Olympics in protest.	Official recognition of the AIDS epidemic.			British geneticist Dr Alec Jeffreys develops DNA finger-printing.

CULTURAL EVENTS

1980	1981	1982	1983	1984
Publication of Patrick White's *The Twyborn Affair*; William Golding's *Rites of Passage*; Umberto Eco's *The Name of the Rose*; William Styron's *Sophie's World*.	Composition of John Tavener's *Akhmatova Requiem*.	Jenny Holzer's series of 'Truisms' (such as 'Money Creates Taste') shown in Times Square, New York.	Graffiti artists such as Keith Haring and Jean-Michel Basquiat make the transition from street to Manhattan gallery.	Jean-Michel Basquiat's work shown at The Museum of Modern Art, New York.
	Publication of Salman Rushdie's *Midnight's Children*.	Release of Steven Spielberg's science fiction film, *E.T. The Extra Terrestrial*; Richard Attenborough's *Gandhi*.	First performance of Harrison Birtwistle's opera *The Mask of Orpheus*.	The first Turner Prize awarded to Malcolm Morley.
Release of Stanley Kubrick's film adaptation of Stephen King's *The Shining*.	Release of Steven Spielberg's *Raiders of the Lost Ark*.	Michael Jackson's *Thriller* becomes the biggest-selling album ever released.	Publication of Alice Walker's *The Color Purple*.	Publication of Martin Amis's novel *Money*.
Former Beatle John Lennon murdered in New York.			Release of Brian De Palma's *Scarface*, starring Al Pacino.	Release of Band Aid's charity single *Do They Know it's Christmas?* in aid of Ethiopian famine victims.
				Bruce Springsteen's *Born In The USA* becomes a worldwide hit.
				Release of Madonna's *Like A Virgin*.

In the USSR, succession of Mikhail Gorbachev.

In East Africa, AIDS epidemic.

In Middle East, withdrawal of Israel from Lebanon.

Selective economic sanctions against South Africa announced by the US.

The World Bank sets up a fund for Africa.

In Mexico City, an earthquake claims 2,000 lives.

European Cup in Brussels sparks crowd violence, killing 41; fire in Bradford City Stadium.

The wreck of the *Titanic* is discovered by means of underwater robots.

In the USSR, explosion at the Chernobyl nuclear plant.

In the US, Reagan government hit by the Iran–Contra arms scandal.

Desmond Tutu becomes first black archbishop of South Africa.

Terry Waite and John McCarthy taken hostage in Beirut.

Explosion of space shuttle *Challenger*, killing all seven on board.

Return of Halley's Comet.

On Black Monday (19 October), stock exchanges crash through-out the world.

In Britain, Margaret Thatcher re-elected for a third term.

In Mecca, massacre of Iranian pilgrims.

In France, former SS officer Klaus Barbie sentenced to life imprisonment.

Sinking of ferry *The Herald of Free Enterprise* off Zeebrugge claims 187 lives.

In Chile, end of Pinochet's dictatorship; Aylwin becomes President.

In the USSR, Gorbachev implements *glasnost* (openness) and *perestroika* (reconstruction).

In the US, election of George Bush as President.

In Pakistan, Benazir Bhutto, daughter of former leader Zulfikar Bhutto, becomes Prime Minister.

In Bangladesh, floods leave over 20 million people homeless.

A bomb on board Pan American flight 103 over Lockerbie, Scotland, kills 270 people.

In Europe, fall of the Berlin Wall.

In South Africa, De Klerk replaces Botha as President.

In Iran, death of Ayatollah Khomeini.

In China, student protests in Tiananmen Square brutally suppressed.

In Beirut, British pensioner Jackie Mann, aged 74, is taken hostage.

At Hillsborough, overcrowding at FA Cup Semi-Final causes death of 95 Liverpool fans.

1985 · 1986 · 1987 · 1988 · 1989

Release of Robert Zemeckis's film *Back to the Future*.

Live Aid benefit pop concert raises millions of pounds for charity.

Release of Dire Straits' 'Brothers In Arms'.

Richard Rodgers' Lloyds Building opens in City of London.

Opening of Broadway musical *A Chorus Line*.

Release of Paul Simons' *Graceland* sparks interest in African music.

Release of Oliver Stone's film *Platoon* rekindles public interest in the Vietnam War; Stephen Frears' *My Beautiful Laundrette*.

Van Gogh's *Field of Irises* achieves a world record price at auction in New York of $53.9 million.

First performance of John Adams's opera *Nixon in China*.

Release of Adrian Lyne's film *Fatal Attraction*; Bernardo Bertolucci's *The Last Emperor*.

First of the British 'Warehouse Shows' organised by Damien Hirst ('Freeze').

Publication of Salman Rushdie's *Satanic Verses* leads to a Muslim *fatwa* against him by Ayatollah Khomeini of Iran; he goes into hiding.

Publication of Stephen Hawking's *A Brief History of Time*.

Artists Against Apartheid stage first Nelson Mandela tribute show at Wembley Stadium, London.

Release of Martin Scorsese's film *The Last Tempation of Christ*.

First performance (in Houston) of Michael Tippett's last opera *New Year*.

Publication of Kazuo Ishiguro's *The Remains of the Day*.

Release of Steven Soderbergh's *sex, lies and videotape*.

Brett Whiteley
Portrait of Patrick White at Centennial Park, 1979–80

BRETT WHITELEY 1939–92

Australian painter and sculptor, born in Sydney; painted murals on sporting themes while at school (c.1955–6); came to London, 1961, where he achieved fame in the *Recent Australian Art* exhibition at the Whitechapel Art Gallery, London; returned to Sydney, 1965, and began incorporating items of detritus into his paintings in a manner close to Pop; increasingly alienated from Western culture, made abortive attempt to settle in Fiji; problems with drug addiction hastened his early death.

Patrick White (1912–80), perhaps Australia's most distinguished writer, began his career in London and wrote his first novel, *Happy Valley*, in 1939. His subject was always Australia, the loneliness and frustration of Australian life and the ingrained conformity of its society, and in 1948 he returned home 'to learn the language again'. *The Tree of Man* (1955) and *Voss* (1957) established his international reputation and in 1973 he won the Nobel Prize for literature. With the status conferred by the prize, White became a vocal advocate for nuclear disarmament, environmental conservation and racial and social justice. In 1970 his novel *The Vivisector*, dedicated to Sidney Nolan and his wife, revolved around the life and limitations of an artist incapable of loving anything except what he painted. As Australia's leading painter of the younger generation, Brett Whiteley's path was inevitably going to cross with that of the novelist; White agreed to sit to him at about the time of the publication of *The Twyborn Affair* (1980).

By mid-1979 White was working on his autobiography, *Flaws in the Glass* (1981), and something of his preoccupation seems to have communicated itself to the artist, who has filled the painting with biographical references. The setting is not White's writing-study, but the downstairs living room in Martin Road, Paddington, with a view of Centennial Park on Sydney Harbour bay beyond the garden outside the window. The view of the harbour with the opera house is artistic licence, as are the collaged memorabilia beside the writer and the books that presumably represent the writers and artists they discussed during sittings. White's handwritten list of 'loves' and 'hates' in the foreground was requested by Whiteley, though it apparently angered White to find it glued to the canvas. The most noticeable piece of collage, however, and one to which the eye is irresistibly drawn, is the photograph on the shelf of the writer's lifelong companion Manoly Lascas, a Greek officer he met while serving with the RAF in the Second World War. White discussed his homosexuality and his cantankerousness in *Flaws in the Glass*: 'I may be homosexual but I am certainly not gay!'

Whiteley seems to have been determined to make this painting as biographical as he could. The work is unusually controlled, and carries few of the Baconesque mannerisms or imaginative flights that characterise much of his best work. Constantly at war with his drug addiction, he could probably have identified with White's own self-doubt, and the portrait is a penetrating character study, its silent melancholy emphasised by the

Oil and collage on canvas on composition board
1770 × 2075mm (69¾ × 81¾")
The Parliament of New South Wales, Sydney

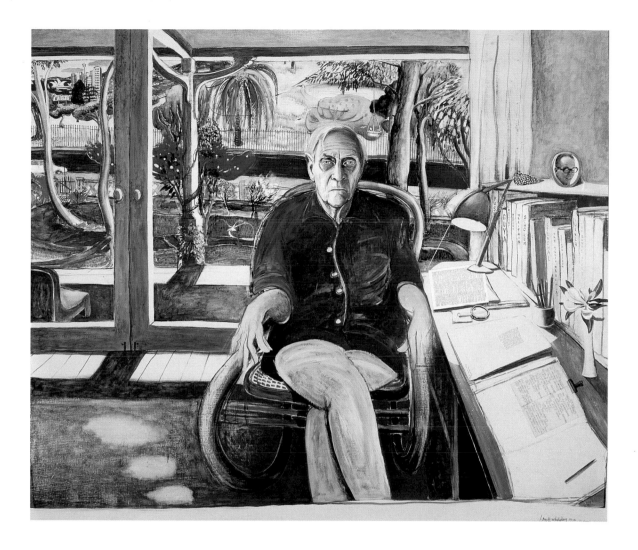

overriding blues of the composition. An extremely gifted and lyrical landscape painter, Whiteley painted *Patrick White as a Headland* (private collection) some time during or just after the completion of this large work – a head floating on its side, metamorphosed Dalí-style into a solitary outcrop marooned in a featureless sea. It is inscribed as being painted after a discussion with White about reincarnation. A disturbing and unhappy image, it represents perhaps what Whiteley could not say in the other portrait.

REFERENCES

J. Fagan, *Uncommon Australians. Towards an Australian Portrait Gallery*, Melbourne, 1992, pp.114–15 (no.80)

B. Pearce et al., *Brett Whiteley, Art & Life*, exh. cat., Art Gallery of New South Wales, Sydney, 1995, pl.134, p.234

Humphrey Ocean
Lord Volvo and his Estate, 1981

HUMPHREY OCEAN b.1951

Studied at Tunbridge Wells, Brighton
and Canterbury Schools of Art
(1967–73); began his career as an artist
in residence touring with Paul
McCartney's group Wings; a regular
exhibitor at the Royal Academy; has
done portrait commissions for the
National Portrait Gallery; first solo
exhibition, Ferens Art Gallery, Hull,
1986; *Double Portrait*, Dulwich Picture
Gallery (and tour), 1991–3.

Humphrey Ocean, a generation younger than the grand old men of British
Pop Art, was specifically concerned with popular culture in many of his
paintings of the 1980s. At Canterbury he was taught by the late Ian Dury,
became a bass player with Kilburn and the High Roads and made a record
which got to no. 187 in the pop charts. In 1976, Paul MacCartney made him
'artist in residence' for the Wings tour of the USA. A number of large-scale
works from these years, such as *Triumph* (1980), are concerned with street
culture; motorbikes continue to provide fertile subject matter for him.

Lord Volvo, which won the John Player Portrait Award in 1982, is the sort
of picture that makes one wonder why there are not more paintings of
council estates and battered Volvos. The central figure's dandyish clothes,
the old Greater London Council blocks of flats, the expanses of concrete,
the nearly dead trees and the obligatory bull terrier, mascot of the south
London macho man, are all redolent of a period of British life that is fast
disappearing. Ocean was no casual observer: meticulously constructed
from many drawings and sketches over eighteen months, the painting
is an elaborate group portrait of his own 1966 Volvo Estate and his own
friends, and the location is Peckham, where he lived at the time. The
pivotal central figure, cautioning the viewer to 'wotchit', is Jock Scot,
ex-forester, librarian and peripatetic poet; leaning against the car is a
former member of Ian Dury's group The Blockheads. The figures on the
right are not a gang of local roughs, but students of the artist who agreed
to pose for him. Cars have never been an entirely respectable subject for
painting, but the Volvo clearly shares the honours with Jock Scot for the
true subject of this portrait. However, this car is no symbol of liberation
and fast-living (compare Tamara de Lempicka, p.105). Parked and possibly
broken down in a place where there is nowhere to go, it is a symbol of
urban living from which there is only a remote possibility of escape.

Acrylic on canvas
1778 × 2876mm (70 × 113¼″)
Wolverhampton Art Gallery

REFERENCES

Y. Roberts, 'Quite a life on
Mr Ocean's wave!', *The Standard*,
London, 10 March 1983, p.23

Humphrey Ocean, exh. cat.,
Ferens Art Gallery, Hull, 1986

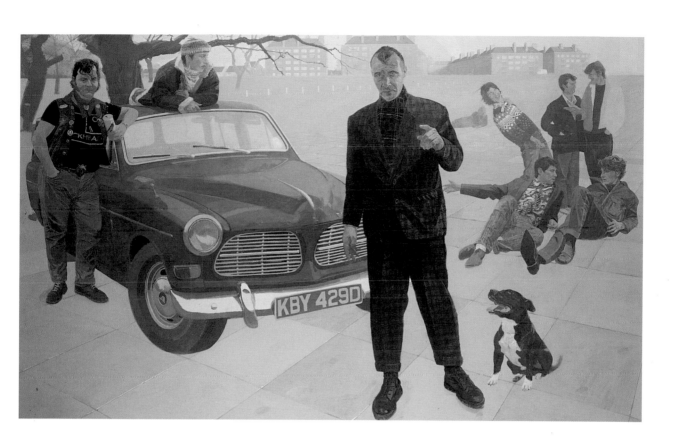

Cindy Sherman
Untitled #97, 1982

CINDY SHERMAN b.1954

Born in New Jersey; studied at New York State College, Buffalo (1972–6); first solo exhibition *Hallwalls*, Buffalo, 1979; rose to celebrity status internationally in the early 1980s with photographic self-portraits in various scenarios; has exhibited throughout Europe and the United States.

Cindy Sherman was one of the first artists to use straight photography as a medium for imagery that thirty years earlier might have been expressed in paint. Enormous technical advances enabled her to produce work of a subtlety, scale and durability comparable with painting; her work has mostly been 'about' photographic imagery. She has been followed by a number of other artists, including Thomas Struth, Nan Goldin and Jeff Wall (the last working on an increasingly large scale).

Sherman came to notice in the late 1970s with the large black-and-white series *Untitled Film Stills*, in which she posed in a variety of costumes and positions reminiscent of Hollywood B-movies. Impressive in their scale and seriousness, they offered an oblique attack on the role of women in later twentieth-century life and culture. The following series in colour, from which *Untitled #97* is taken, was produced over a period of three to four years; it is a more generalised critique of female stereotypes as portrayed in the media and advertising. Over the whole series, the range is wide – from pin-up to housewife, sex kitten to murder victim, girlish, boyish, worried or self-possessed. Those made in 1982, showing her confronting the camera semi-naked, deliberately express both provocation and vulnerability. She told the makers of the Channel 4 television series *State of the Art*: 'I was trying to make a content that would be alluring, but then as soon as you looked at it, it would kind of bite you back like something that would make you feel guilty for feeling that way . . .' Exhibited out of context from the rest of the series, *Untitled #97* remains a powerful piece of imagery and picture-making. It seems less like role-playing and more like self-examination. it may, in other words, be read as a self-portrait.

Colour photograph, edition of 10
1143 × 762mm (45 × 30″)
The Eli and Edythe L. Broad
Collection, Los Angeles

REFERENCES

A. Cruz et al, eds., *Cindy Sherman,* Los Angeles, 1997, pp.107, 108

S. Nairne et al., *State of the Art: Ideas and Images in the 1980s,* London, 1987, pp.128, 132–7

Hans Haacke
Taking Stock (unfinished), 1983–4

HANS HAACKE b.1936

Born in Cologne; educated at State
Art Academy, Kassel; exhibited with
the Zero Group (1960–65) and later
associated with Fluxus; turned from
water-based sculptures to creating
large-scale politically motivated works
in the 1970s; taught in Germany and in
the US; professor at the Cooper Union,
New York, from 1979.

Oil on canvas with gold leaf frame
2413 × 2057mm (95 × 81″)
Gilbert and Lila Silverman Collection,
Detroit, Michigan

REFERENCES

H. Haacke, *Hans Haacke: Artfairismes*,
Centre Georges Pompidou, Musée
national d'art moderne, Paris, 1989,
pp.58–61

Hans Haacke. Global Marketing, Victoria
Miro Gallery, London, 1987, pp.1–10

S. Nairne et al., *State of the Art: Ideas
and Images in the 1980s*, London, 1987,
pp.173–82

In a decade that saw the production of Richard Hamilton's Northern Ireland paintings *The Citizen* (1981–3) and *The Subject* (1988–90; both Tate Gallery, London), this remarkable indictment of the political and artistic status quo in Britain in the early 1980s remains one of the period's most cogent and memorable images. Originally painted for his solo exhibition at the Tate Gallery in 1984, it makes clear the artist's feelings about the relationship between museums and corporate culture, as personified by the Saatchi brothers who are depicted on the cracked plates on the top shelf.

As Sandy Nairne points out, the complex iconography of *Taking Stock* 'makes available information that is no secret but is otherwise scattered. The image becomes a concentrated network of the threads that connect the cultural, the political and the corporate.' With its obvious reference to the then Prime Minister Margaret Thatcher's exhortation to return to 'Victorian values', Haacke researched his background elements in the Tate's own collections. Taking the lid off Pandora's Box is a small marble figure from the collection by Harry Bates. The cracked portrait plates of Charles and Maurice Saatchi are a reference both to the brothers' controversial advertising for the Thatcher election campaigns in 1979 and 1983, and to the New York painter Julian Schnabel, nine out of ten of whose paintings with broken plates in his Tate show of two years earlier had belonged to the Saatchi collection. On the base of the white marble column is the fragmented inscription ES SAATCHI TRUS / ITECHAPEL GAL / TRONS OF NEW ART / COMMITTEE / HE TATE GALLER, referring to Charles Saatchi's Trusteeship of the Whitechapel Art Gallery, and his membership of the Tate's Patrons of New Art committee, which had organised the Schnabel exhibition and was responsible for purchases for the Tate's collection. The many inscribed titles on the books are the names of accounts held by the Saatchi and Saatchi advertising agency, while the pieces of paper on the table and floor refer to some of their recent art dealing activities.

The painting's main achievement is its satire on a political leader, implicit in the unflattering 'iron lady' expression of Margaret Thatcher and the ludicrous pomp and poor taste of the frame and background detail (although to a public used to the searing caricatures of Gerald Scarfe (p.210), the satire was perhaps fairly gentle). There are two final ironies: sixteen years later, Charles Saatchi is acknowledged to be now one of the strongest forces in the contemporary art market in Britain, and the painting looks increasingly like one of the most memorable images of Margaret Thatcher ever produced.

Jean-Michel Basquiat
Brown Spots (Portrait of Andy Warhol as a Banana), 1984

JEAN-MICHEL BASQUIAT 1960–88

Born in New York City; studied at the City-as-School, an alternative high school (1976–8); met and collaborated with graffiti artist Al Diaz; created T–shirts, postcards, drawings and collages that developed from graffiti and his interest in painting; exhibited publicly for the first time as part of *The Times Square Show*; first solo exhibition held in 1981–2 at the Annina Nosei Gallery, New York; from 1984 collaborated occasionally with Andy Warhol.

Despite Basquiat's reputation as a wild graffiti-kid rescued from the streets of New York, he was already a star on the New York art scene by the time he was introduced to Andy Warhol, largely through the agency of his dealer Bruno Bischofberger, in 1982–3. New York critics, such as Thomas Lawson, were quick to be cynical about the relationship: 'Warhol realised that Basquiat, as a wild child in an expensive suit, could provide a much more unsettling image of the uses of money and leisure than . . . the older artist's lost superstars'. Despite an inevitable element of basking in each other's reflected glory, this was a genuine friendship based on a real mutual understanding of motives, which allowed them to work together in 1984–5 producing a series of collaborative works. The results are neither typically subversive Basquiat, nor recognisably Warhol, but pit elements of white American popular culture against the diverse ethnic imagery of Basquiat's Puerto Rican and Haitian heritage.

Several portraits of Warhol date from this first year of their friendship. One of Basquiat's miraculous large drawings (1984; Mugrabi Collection) shows an engaging, bespectacled, apparently disembodied head of Warhol on top of a short column. Although a great many of Basquiat's more complex works include self-imagery, these portraits concentrate with bold simplicity on an appropriate metaphor for the older artist. The unpeeled banana with its trademark shock of whiteish-grey hair suggests an affectionate joke, possibly based on some private reference. The painted-out background is also reminiscent of their collaborations; as the critic Paul Taylor put it: 'Warhol begins with his choice corporate logos writ large. Enter Basquiat who blocks out the boss's images or scribbles all over them.' Here, just enough of a complex drawing remains, palimpsest-like, to suggest complexities beneath the bland face that Warhol customarily presented to the world. His death devastated Basquiat, who had become increasingly dependent on drugs; just eighteen months later, at the age of twenty-seven, he died alone in his Manhattan loft of an overdose.

Acrylic and oilstick on canvas
1930 × 2130mm (76 × 83⅘")
Private collection. Courtesy Galerie
Bruno Bischofberger, Zurich

REFERENCES

L. Marenzi et al., *Basquiat*, Milan, 1999, pp. XL, 94, 95, 201

S. Nairne, *State of the Art*, London, 1987, pp. 238–45 (for cited quotations)

John Wonnacott
Sir Adam Thomson, 1985–6

JOHN WONNACOTT b.1940

Born in London; studied at the Slade
School of Fine Art, 1958–63; work
included in *The Hard-Won Image*, Tate
Gallery, London, 1984 and *The Pursuit
of the Real*, Manchester, London and
Glasgow, 1990; commissions for the
Scottish National Portrait Gallery,
Imperial War Museum, National
Maritime Museum and National
Portrait Gallery (*Portrait of John Major*,
1998); solo exhibitions include The
Minories, Colchester, 1977; Agnew's,
London, 1992; Hirschl and Adler,
New York, 1999.

Sir Adam Thomson (1926–2000), founder and Chairman of British Caledonian Airways, was one of the great independent figures in post-war British aviation. As a pilot in the Fleet Air Arm 1944–7 and subsequently a commercial pilot and flying instructor until 1950, he retained a strong link with the basic elements of flying. He was duly impressed with this staggering depiction of Hangar 3 at Gatwick airport and its workforce. This *tour de force* of selective description was painstakingly compiled over an eighteen-month period, and painted in tandem with a similar night-time portrait. No photograph could convey either as much information or the atmosphere inside the hangar. The figure of Sir Adam, though likely to seem overwhelmed by the view of the activity in the hangar and its structure, is dominant in the composition and is a fine and thoughtful portrait.

Wonnacott wrote about the genesis of the painting (commissioned by the Scottish National Portrait Gallery) for its launch in December 1986: 'I have framed Sir Adam Thomson (he endured my regular presence in his office to draw and re-draw his features) in the open hangar doorway with the wings of the DC10 and Boeing 747, the mainstay of the present Caledonian long-haul fleet, crossed in salute over his head. Through the door, the 1-11, the 707 and the earlier carriers complete, with further small portraits of Sir Adam and of distinguished colleagues inside the hangar, a history of the airline he has built in less than thirty years. (Harry Whykes, who ran Hangar 3, also appears more than once as my layman's idea of what an aircraft engineer should be.)' Wonnacott's changing ideas for the perspective view of the hangar in relation to the figure, and the plotting of the different small figures on the shop floor, all had to be accommodated as he went along. Different tracings in ink on glass, in front of which Sir Adam would pose on various occasions, were used to establish his position as a coherent part of the perspective composition; most of the painting was done in a specially prepared studio space in the roof of the hangar.

There are few enough paintings that deal with the facts and achievements of modern life, but Wonnacott's unique eye, sense of involvement and almost obsessive will to succeed have created one of its most remarkable manifestations. Now that neither Sir Adam nor British Caledonian are with us any longer, it is a unique memorial to a man, to an industry and to the times in which they flourished.

Oil on canvas
2440 × 2440mm (96 × 96″)
Scottish National Portrait Gallery,
Edinburgh

REFERENCE

Sir Adam Thomson: John Wonnacott,
exh. cat., Scottish National Portrait
Gallery, Edinburgh, 1986

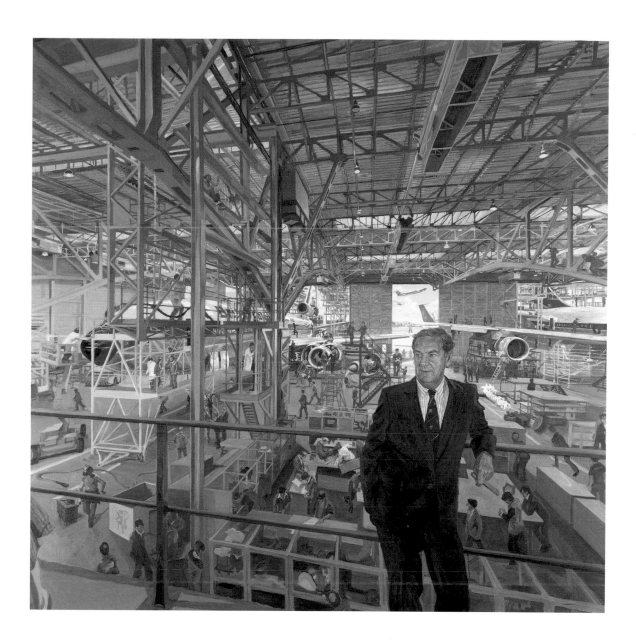

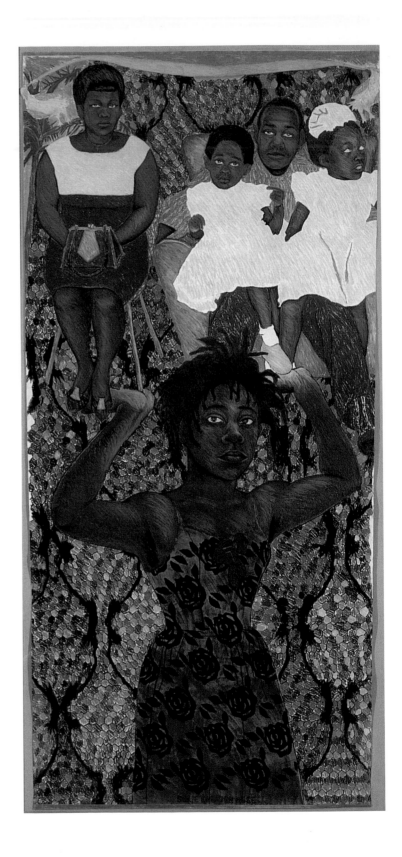

Sonia Boyce
She Ain't Holding Them Up, She's Holding On (Some English Rose), 1986

SONIA BOYCE b.1962

Born in London; studied at East Ham College of Art and Technology, and Stourbridge College of Art and Technology, Birmingham; first solo exhibition, *Conversations*, held at the Black Art Gallery, London, 1986; exhibited at Whitechapel Art Gallery, 1988; served on panels for both Arts Council and Greater London Arts.

Crayon, chalk, pastel and ink on paper
2180 × 990mm (85¾ × 39″)
Middlesbrough Museums and
Galleries

REFERENCES

S. Nairne, *State of the Art: Ideas and Images in the 1980s*, London, 1987, pp.233–6

Sonia Boyce: Recent Work, exh. cat., Whitechapel Art Gallery, London, 1988, p.1 (ill.)

This engaging self-portrait is one of the most enduring attempts by a black British artist to establish her own identity and yet 'hold on' to her Afro-Caribbean heritage. The work acquires even greater significance in the context of 1980s Britain – the words of Enoch Powell were still resounding around the country and Margaret Thatcher was exhorting the nation to return to the values not just of the Victorian era but of the 'Empire that ruled a quarter of the world'. Current experience suggests that it has taken at least three generations for the offspring of 1950s black immigrants to begin to feel a measure of integration into British society. Members of Boyce's generation had real doubts about their role in this still-alien environment, although her work of this period was never political or militantly feminist.

Shortly after completion of this picture, Boyce told the makers of the Channel 4 television series *State of the Art*: 'I started thinking about conversations my mother used to have . . . this was just like a second of it, rather than encapsulating a whole story. That whole time, that whole culture you don't see anywhere else. I felt I had to talk about it. . . . I'm talking about the stories and tales that our parents brought with them when they came from the Caribbean, that whole lifestyle; it's like cutting short a continuity. They left everything and they came here, and what that means for us here. . . . keeping hold of those tales is really important to me, it gives me a sense of knowing what I am about. I'm from here, but I'm also from there as well . . .' Boyce confronts the viewer with a slightly questioning gaze. Above her, a childhood family group of herself with her sister and parents, representing her heritage, poses more anxiously for the photographer's scrutiny. The elaborate patchwork hanging and the stencilled tissue paper dress are also part of her visual heritage although she has tended to play these down: 'Surfaces and colours, they were just a device for me.' Later, thinking perhaps that she had slightly let the side down by making work that was so accessible and attractive, Boyce produced more complex imagery. But *She Ain't Holding Them Up* proves that, wherever she was from, she could produce paintings that spoke to everybody.

Bernd Heinrich
Thomas Keneally, A.O., 1987

BERND HEINRICH b.1940

Born in Weimar, Germany; studied at Kunstakademie in Augsburg; moved to Australia 1970; exhibitor in the Archibald (portrait) Prize, 1978 and 1990; regular exhibitor in the annual *Grosse Kunstausstellung*, Munich since 1983.

Thomas Keneally is one of Australia's best-known contemporary novelists; in 1982 he won the UK Booker Prize for *Schindler's Ark* (later memorably filmed by Steven Spielberg as *Schindler's List*). A keen sportsman, he is a member of Australia's Irish Catholic community and one of the country's most articulate advocates of republicanism. He has a genius for story telling, and his enormously wide range encompasses three early novels about Catholicism, military adventures and travel books.

This portrait is illustrative of the highly skilled craftsmanship that has enabled many good artists to stay one step ahead of the portrait photographer, even though they work in a genre unlikely to find a place on the walls of cutting-edge modern art galleries. Assimilating lessons from a variety of the century's greatest masters, this up-front image takes something both from Art Nouveau and Francis Bacon; it provides a 'frame' for the figure that outlines the shadow and lower body in an abstract manner; it makes use of the written word (here, a passage from *Schindler's Ark*), a device that goes back to the Cubists (see also Ben Shahn's 1961 portrait of *Dag Hammarskjöld*, p.185); and features an ambiguous transition from brilliant blue sky to abstract space which is essentially a device of the Surrealists. Lit by the bright light of an Australian morning, this tracksuited figure is a man of the people – a far cry from the traditional 'literary' portait of the respectable middle-class author in a book-lined study.

Oil on canvas
1738 × 1377mm (68½ × 54⅛″)
Private collection
Courtesy of National Portrait
Gallery, Canberra
On loan from Gordon and
Marilyn Darling

REFERENCE

J. Fagan, *Uncommon Australians. Towards an Australian Portrait Gallery*, exh. cat., Melbourne, 1992, p.119 (84)

Larry Rivers
Primo Levi I (Periodic Table), 1988

For biography, see p.170

Always prepared to react to major issues and events – whether drug addiction (*Bad Witch*, 1971), questions of American identity (*Last Civil War Veteran*, 1959; The Museum of Modern Art, New York) or sex (*America's Number One Problem*, 1969) – Larry Rivers has also frequently returned to his Jewish heritage. This preoccupation culminated in 1982–3 with the monumental series *History of Matzoh: the Story of the Jews*, a three-part mural-sized compilation, from Moses to the mass immigrations to the USA in the twentieth century, shown at the Jewish Museum, New York, in 1984–5. In 1986, the *New York Times* commissioned a magazine cover about the Holocaust, *Erasing the Past*, which involved research into concentration camp imagery and led to an interest in the writings of Primo Levi (1918–87). When Levi committed suicide the following year, Rivers was inspired to produce three major paintings – a tribute to the man who had taken on heroic status for him, and also an attempt to tackle one of the blackest moments in Jewish and in twentieth-century history.

Primo Levi was a chemist by training; this first portrait makes a sinister play not only on his vocation and on the pseudo-science with which the Nazis justified their use of the gas ovens depicted in the painting, but also on the title of Levi's best-known book, *Il sistemo periodico* (*The Periodic Table*, 1984), a volume of memoirs and autobiographical reflections. Levi, a wartime resistance fighter, was arrested in December 1943; incarcerated in Auschwitz for ten months, he was one of very few to survive, partly because he contracted scarlet fever as the Germans were evacuating the camp. His graphic account of life in Auschwitz, *Si questo è un uomo*, was published in Italy in 1947, and eventually in English in 1959 (as *If This Is a Man*); it is rendered the more powerful by virtue of the detached sensibility of its scientist author. It is thought that the trauma of this experience, which haunted him for the rest of his life, finally prompted his suicide.

Rivers' three-dimensional relief projects the image of the writer in a confrontational manner, the sombre colours a frank acknowledgement of its photographic origin. Only the inscribed names of the chemicals qualify for an ironic touch of colour. In his other two portraits, *Primo Levi: Witness* and *Primo Levi II (Double Head)*, Rivers deals respectively with Levi as witness to the holocaust and as prophet, and the trauma and reality of being a survivor.

Oil on canvas mounted on sculpted foamcore
1854 × 1485 × 102mm (73 × 58½ × 4")
Collection: La Stampa, Turin

REFERENCE

S. Hunter, *Larry Rivers*, London, 1989, pp.43, 44, 53, 184, 185, 339

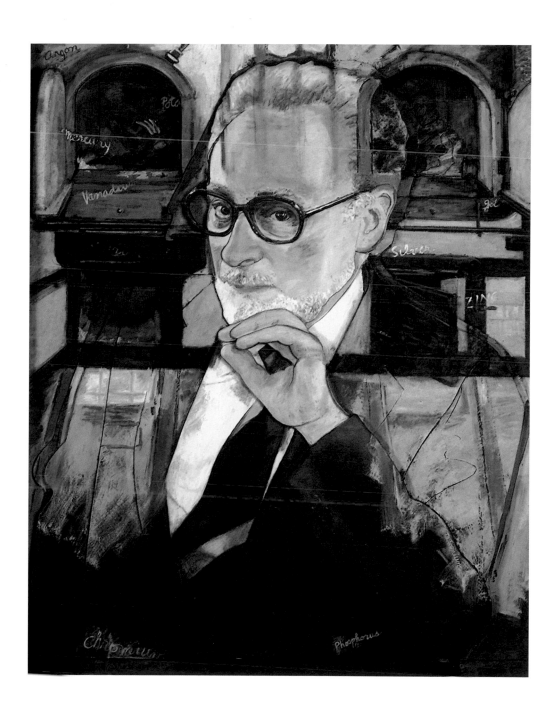

A. R. Penck
Me in Hamburg, 1989

A. R. PENCK b.1939

Born Ralf Winckler in Dresden; met
Michael Werner who championed his
work outside East Germany, 1965;
collaborated with Jorg Immendorff
following their meeting in Berlin, 1977;
moved to the West, 1980; lived for a
while in Britain; exhibition *Brown's
Hotel and other works* at Tate Gallery,
London, 1984; appointed professor at
Kunstakademie, Düsseldorf, 1989;
retrospectives in Bern, 1975; Cologne,
1981; Nationalgalerie, Berlin, 1988;
Dresden 1992.

Oil on canvas
1000 × 700mm (39⅜ × 27½″)
Galerie Michael Werner, Cologne
and New York

REFERENCES

A. R. Penck, Analyse einer Situation,
exh. cat., Staatliche Kunstsammlung,
Dresden, 1992

J. Yau, *A. R. Penck*, New York, 1993

It would be logical to see in many of Penck's figure paintings a continuation of the process begun by Dubuffet and Art Brut, the simplification and reduction of the human form to a basic repertoire of childlike symbols and gestures, which convey as little – or as much – as we need to know or can know about the subject. In his big compositions of the 1960s and 1970s, Penck, officially silenced and muzzled in East Germany, evolved a whole language of signs and symbols that tackle questions of communication head on. Sometimes they deal with universal issues, but often there is a strong autobiographical element in his world view, as in *Me in Germany (West)* (1984). Even *Large World Picture* (1965; both Museum Ludwig, Cologne) includes a small, frantically running stick figure at the bottom bearing a placard with Penck's first name, Ralf.

When Penck was finally allowed to move to the West in 1980, there seems to have been a shift in his work towards exploring his own identity, borne out by several series of self-portraits at the end of the decade. The problem of identity has been, for obvious reasons, a focus of attention for many German artists born during or just after the Second World War; for Penck, who was obliged by the disapproval of the East German authorities to work and exhibit under a pseudonym ('A. R. Penck' was one of several), it had a particular bearing on his work. The freedom of life in the West, but at the price of the loss of his homeland, must also have been a disorientating factor.

Penck, in his teens repeatedly denied entry to the art schools of Dresden and Berlin, began painting portraits of friends and acquaintances to support himself: notions of likeness and identity were therefore central to his work from a young age. *Me in Hamburg* is one of a series of self-portraits from 1989 in which he related himself to the western cities he had visited. A series painted in 1991 was classified with stylistic sub-titles ('conceptualist', 'classic', 'influenced by Immendorff') and relied perhaps more heavily on his 'ideogrammatic' approach; the city series are also explorations of different modes of painting and painterly effects. *Me in New York* glows with dark golden browns that provide background illumination for the artist's heavily blacked-in features (in appearance very short, rotund and bearded, Penck often seems to see himself as a subject for self-caricature). *Me in Düsseldorf* looks a bit like an exploded strawberry, with a wonderful deep pink background covered with green spots, from which Penck's soulful eyes and features emerge, outlined in vegetal green.

1990s

The reunification of Germany in 1990 led the way to independence for former East European states, while the election of Bill Clinton in the USA and the collapse of the Conservative government in Britain signalled a shift to the left in international politics. Black majority rule was at last achieved in South Africa. The rapid growth of the World Wide Web seemed set to revolutionize business, education and domestic life. Corporate patronage and the National Lottery largely took over state funding for culture, financing a rash of arts projects for the Millennium and promoting British artists to superstars.

HISTORICAL EVENTS

1990	1991	1992	1993	1994
Reunification of Germany.	US-led 'Operation Desert Storm' seeks to liberate Kuwait from Iraqi occupation: beginning of the Gulf War.	Yugoslavian civil war spreads to Bosnia.	In Europe, the EC's single market comes into force.	Jordan and Israel sign peace treaty.
In Yugoslavia, outbreak of civil war.	In the USSR, Mikhail Gorbachev resigns, and the USSR officially ceases to exist. Boris Yeltsin becomes President of the new Russian Federation.	In Sarajevo, violent clashes take place between Serbs, Croats and Muslims. Serb 'ethnic cleansing' denounced by the US as a war crime.	Czechoslovakia divides into the Czech Republic and Slovakia.	In South Africa, election won by the ANC; Nelson Mandela becomes President.
In Britain, John Major becomes Prime Minister.	In Latvia, Lithuania and Estonia, independence.	In the US, election of Democrat Bill Clinton as President.	In the Middle East, agreement signed between Palestinian leader Yasser Arafat and Israeli Prime Minister Yitzak Rabin for the mutual recognition of Israel and the PLO.	In Rwanda, massacre by the Hutu tribe of the Tutsis; outbreak of civil war.
In South Africa, Nelson Mandela freed after 27 years in prison.	Slovenia and Croatia declare independence; civil war in Yugoslavia continues.	Riots in Los Angeles.	In the US, the World Trade centre bombed by Muslim terrorists.	Opening of the Channel Tunnel between France and Britain.
Invasion of Kuwait by Iraq leads to the Gulf War.	In Somalia, civil war.	In Britain, admission of women priests to the Church of England.	Nobel Peace Prize won jointly by Nelson Mandela and President De Klerk of South Africa.	In Russia, rebellion in Chechnya, which is seeking independence.
In Eire, Mary Robinson becomes the first woman president.	Release of British hostage John McCarthy after 1,943 days as a hostage in Lebanon.			
In Britain, anti-poll tax demonstrations lead to riots and violence in London; in Manchester, 1,000 inmates riot in Strangeways Prison.	Collapse of the business empire of Robert Maxwell after his unexplained death reveals fraud and misappropriation of funds.			

CULTURAL EVENTS

1990	1991	1992	1993	1994
Opening of the Bastille Opera House, Paris, with Hector Berlioz's *The Trojans*.	Publication of Ben Okri's *The Famished Road*.	Exhibition of Damien Hirst's *The Physical Impossibility of Death in the Mind of Someone Living*.	Turner Prize awarded to Rachel Whiteread for *House*.	Publication of V. S. Naipaul's *A Way in the World*.
First performance of Harrison Birtwistle's opera *Gawain*.	Release of Zhang Yimou's *Raise the Red Lantern*; Quentin Tarantino's *Reservoir Dogs*; Jonathan Demme's *The Silence of the Lambs*; Ridley Scott's *Thelma and Louise*.	Publication of Paul Auster's *Leviathan*; Jung Chang's *Wild Swans*.	Release of Steven Spielberg's film *Schindler's List*, adapted from Thomas Keneally's prize-winning book *Schindler's Ark*; Chen Kaige's *Farewell My Concubine*.	Release of Quentin Tarantino's *Pulp Fiction*; Frank Darabont's *The Shawshank Redemption*; Oliver Stone's *Natural Born Killers*.
Publication of A. S. Byatt's *Possession*; Martin Amis's *London Fields*.		Release of Sally Potter's film of Virginia Woolf's *Orlando*.	Publication of Vikram Seth's *A Suitable Boy*.	
Production of Derek Walcott's *Remembrance*.			Nobel Prize for literature awarded to American novelist Toni Morrison.	
Release of Tim Burton's film *Edward Scissorhands*.				

UN War Crimes Tribunal indicts Bosnian Serb leaders for genocide and crimes against humanity.

In the US, terrorist bombing destroys Federal Building, Oklahoma City, killing 168 people.

In Israel, assassination of Prime Minister Yitzak Rabin.

In France, Jacques Chirac becomes President.

In Nigeria, execution of nine human rights activists leads to the country's expulsion from the British Commonwealth.

In Sri Lanka, rebellion by the Tamil Tigers.

In Israel, Benjamin Netanyahu becomes Prime Minister.

In Britain, the 'Stone of Destiny' is returned to Scotland from Westminster Abbey.

In Northern Ireland, resumption of campaign of violence by the IRA.

Controversy erupts over claims to property confiscated from Jews by Nazi Germany.

In Dunblane, Scotland, a gunman kills 16 young children and their teacher; handguns will later be banned in the UK.

In Zaire, overthrow of President Mobotu; succession of Laurent Kabila in the newly named Democratic Republic of Congo.

Britain hands Hong Kong back to China.

In Britain, the Labour Party under Tony Blair ends 18 years of Conservative government.

In Thailand, devaluation of the currency sets off Asian ecnomic crisis.

Death of the Princess of Wales in a car crash in Paris.

Death of Mother Teresa of Calcutta.

First successful cloning of animal tissue produces 'Dolly' the sheep.

In Kosovo, civil war between Serbs and ethnic Albanians. NATO forces take aggressive action, bombing Belgrade.

In Asia, recession brings a sudden end to the 'tiger economies' of the Pacific Rim; financial effects felt worldwide.

In India and Pakistan, nuclear devices tested.

In the US, impeachment and acquittal of President Clinton in the Monica Lewinsky scandal.

In London, arrest of former Chilean dictator Augusto Pinochet, pending extradition proceedings to face charges in Spain.

In Northern Ireland, a new power-sharing assembly set up by the Good Friday Agreement.

In Central America, Hurricane Mitch causes widespread devastation.

In Europe, limited launch of single currency unit, the Euro.

In Britain, devolution of power to Scotland and Wales.

In South Africa, resignation of Mandela; Thabo Mbeki becomes president.

In Kosovo, refugee crisis.

In Jordan, death of King Hussein.

In Mozambique and Zimbabwe, massive flooding causes devastation.

In Taiwan, an earthquake claims 1,500 lives.

The first round-the-world trip by hot air balloon completed by Bertrand Piccard and Brian Jones.

1995

Centenary of the Venice Biennale.

Release of Danny Boyle's film adaptation of Irvine Welch's *Trainspotting*.

In Britain, rivalry between Britpop bands Blur and Oasis.

1996

Exhibition of Sam Taylor-Wood's photo-piece *Wrecked*, based on Leonardo's *The Last Supper*.

'Girl Power' phenomenon The Spice Girls achieve worldwide success with *Wannabe*.

Release of the painter Julian Schnabel's film *Basquiat*, starring Jeffrey Wright as Basquiat and David Bowie as Warhol; Mike Leigh's *Secrets and Lies*.

1997

Opening of *Sensation* at the Royal Academy, London, featuring the 'Young British Artists'; it later travels to New York.

Exhibition of Gillian Wearing's lip-synched video-piece *10-16* at the Chisenhall Gallery.

Opening of Frank Gehry's Guggenheim Museum, Bilbao.

Fiftieth anniversary of the Cannes Film Festival.

1998

Chris Ofili paints *No Woman No Cry* in homage to murdered black London teenager Stephen Lawrence.

Release of Steven Spielberg's film *Saving Private Ryan* rekindles interest in the Second World War; John Maybury's *Love is the Devil*, about the life of Francis Bacon, starring Derek Jacobi as the artist.

Victory on home ground for France, who defeat Brazil in the World Cup Final.

1999

Re-opening of The Royal Opera House, Covent Garden after extensive re-building.

Community events staged around the world in celebration of the new millennium.

British architect Sir Norman Foster completes work on the restored Reichstag building, Berlin, Germany's new capital.

Lucian Freud
Leigh Bowery (Seated), 1990

For biography, see p.142

Australian-born performance artist, owner of the Taboo Club, clothes designer, transvestite and general exhibitionist, Leigh Bowery (1961–94) seems to have felt that his mission was to *épater les bourgeois*, to scandalise and to outrage. By the time Lucian Freud discovered him at a performance at the Anthony d'Offay Gallery in 1988 he was the grand old age of twenty-eight, but had already been a powerful catalyst – in the London art world generally, on the generation who would grow up to be the Young British Artists of the 1990s, on the dancer Michael Clark, who shook up the world of ballet, and on the designer Vivienne Westwood, who continues to do the same for fashion. The nude human body had become a significant and primal motive in Lucian Freud's painting; with Leigh Bowery as model, it suddenly became the ultimate subject, responsible for what are arguably the greatest paintings produced anywhere in the 1990s.

Leigh Bowery (Seated) is the first portrait Freud made of his model. Bowery's enormous bulk determined the size and shape of the canvas. His pose is both casual and aggressive, its frontality designed to show every fold and sag of flesh, the penis framed by the corner of the red velvet chair and destined to be seen at eye level. The upward sweep of the floorboards emphasises the sheer weight of the static figure on the scarcely adequate chair. The diagonals of the background walls that fail to meet behind the figure pick up directions in the asymmetrical tilt of the body. Not since Rubens had an excess of human flesh been painted with such respect. The photographer and writer Bruce Bernard considered that Bowery, who already knew that he was HIV-positive, felt that Freud's paintings would immortalise him, but he can scarcely have envisaged the over-whelming impact that they actually had. Four further large nudes and a number of smaller ones add up to one of the most astonishing portrait series ever made. In 1995, shortly after Bowery's death on New Year's Eve, the last small painting appeared – it was a study of his head, less than 12 inches high, showing him asleep.

Oil on canvas
2437 × 1830mm (96 × 72")
Private collection

REFERENCES

B. Bernard and D. Birdsall, *Lucian Freud*, London, 1996, pp.18–19

Lucian Freud: recent work, exh. cat., Whitechapel Art Gallery, London, 1993, no.66

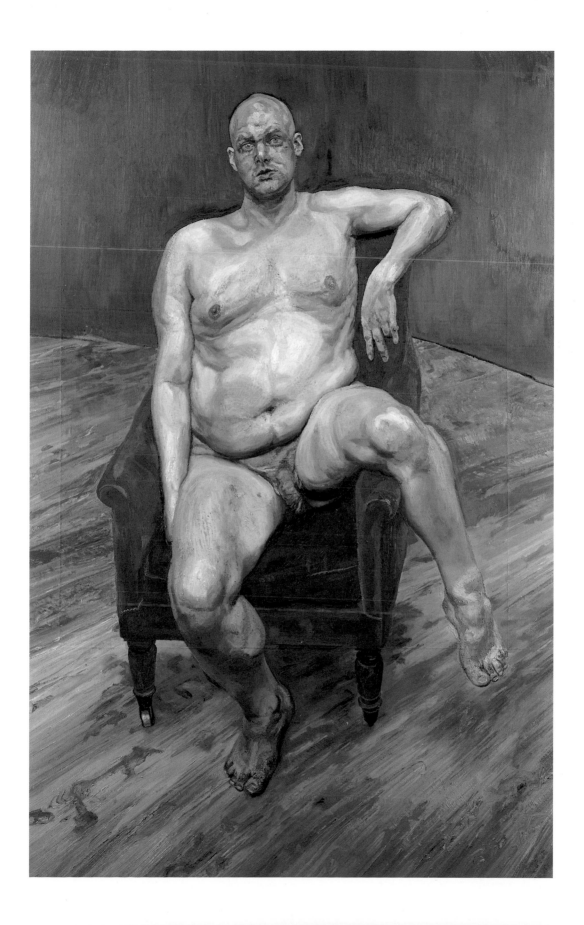

Jiri Georg Dokoupil
Portrait of Francesco, Julian and Bruno, 1991

JIRI GEORG DOKOUPIL b.1954

Born in Bruntál, Czechoslovakia; fled to Germany in 1968 after the Russian invasion; studied at the Fachhochschule für Kunst und Design in Cologne (1976–8) and later at the Cooper Union under Hans Haacke (see p.232); founded the group Mülheimer Freiheit in 1980; enhanced his reputation with exhibition at the Paul Maenz Galerie, Cologne (1982); appointed guest professor at the Kunstakademie in Düsseldorf and at the Circulo de Bellas Artes, Madrid (1989); retrospective at Museo Nacional Centro de Arte Reina Sofía, Madrid, 2000.

Dokoupil, sometimes described as the archetypal postmodern artist, has moved effortlessly from one style to another, following the principles of the Mülheimer Freiheit group which he founded. On the whole, he has adhered to painting, aiming to be provocative by taking imagery from a multitude of sources including art history and popular imagery such as the comic strip, and he is quoted as believing that 'the only real policy in art is not to have one'. Following a period of residence in Tenerife in 1988–9 (he still has a home in the Canaries) his paintings became more settled and serene, with an increasing focus on organic subjects done with their complementary materials, such as fruit juice and candle soot – these paintings still form a substantial part of his output (some of them were first exhibited in Britain at the Edward Totah Gallery, London in 1990).

Dokoupil's use of soot from a candle flame as a medium not only has obvious graphic qualities, it is also evocative of one of the oldest and most basic sources of light known to man. This substantial canvas is based on a photograph of the artist's Swiss dealer Bruno Bischofberger, who is seen here in his gallery flanked by two of his biggest international 'stars'. On the left, the Italian painter Francesco Clemente (b.1952), and on the right the American Julian Schnabel (b.1951). On one level, this painting has the fuzzy mysteriousness of an ancient snapshot of an anonymous group of friends assembled for some long-forgotten occasion, a faded but archetypal image of masculine camaraderie. Seen from closer, the erratic meanderings of the smeared soot deposits have all the random beauty of animal tracks in snow or the inexplicably interrupted trails left by snails. As with these natural phenomena, the quality of evanescence makes us stop and wonder. Who left these marks, and why?

Candle soot on canvas
1700 × 2000mm (67 × 78¾")
Galerie Bruno Bischofberger, Zurich

REFERENCES

Dokoupil: Candle-Paintings, 1990–1991, exh. cat., Galerie Krinzinger, Vienna, 1991

Dokoupil, Museo Nacional Centro de Arte Reina Sofía, Madrid, 2000

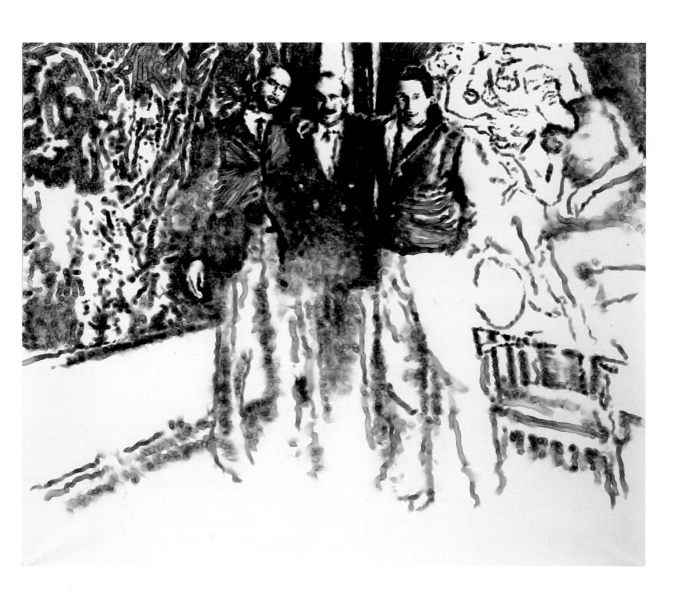

Jenny Saville
Branded, 1992

JENNY SAVILLE b.1970

Born in Cambridge; studied at Glasgow School of Art; exhibited in *Contemporary '90* at the Royal College of Art; work has appeared at the Saatchi Gallery, London, and the Yale Center for British Art, New Haven; included with the Young British Artists in the 1997 *Sensation* exhibition at the Royal Academy.

Preoccupation with the body in contemporary art is often autobiographical, and has been the province of a number of women artists since the 1980s. This may in part be a feminist phenomenon, a reaction against centuries of painting of the female nude by men for the delectation of other men. Saville's distressing mountains of flesh are issue-based self-portraits, possibly leading on from Cindy Sherman (see p.230). Obesity is the shock tactic she uses to force viewers into an examination of conventional notions of female beauty. Concepts relating to desired stereotypes of the female body are cruelly incised into the flesh, suggesting that women are indelibly marked by them from birth. Although it would be wrong to read Saville's series of paintings as autobiographical, the head remains a still, small constant throughout – the property of the artist, the signature on the image that makes the work a personal statement about a universal issue. But it is the body that makes the overwhelming impact – the personality of the woman beneath is totally submerged and ignored by us, the viewers.

Oil on canvas
2134 × 1829mm (84 × 72″)
The Saatchi Gallery, London

REFERENCES

S. Kent, *Young British Art: The Saatchi Decade*, London, 1999, p.129

F. Borzello, *Seeing Ourselves: Women's self-portraits*, London, 1998, pp.177–9

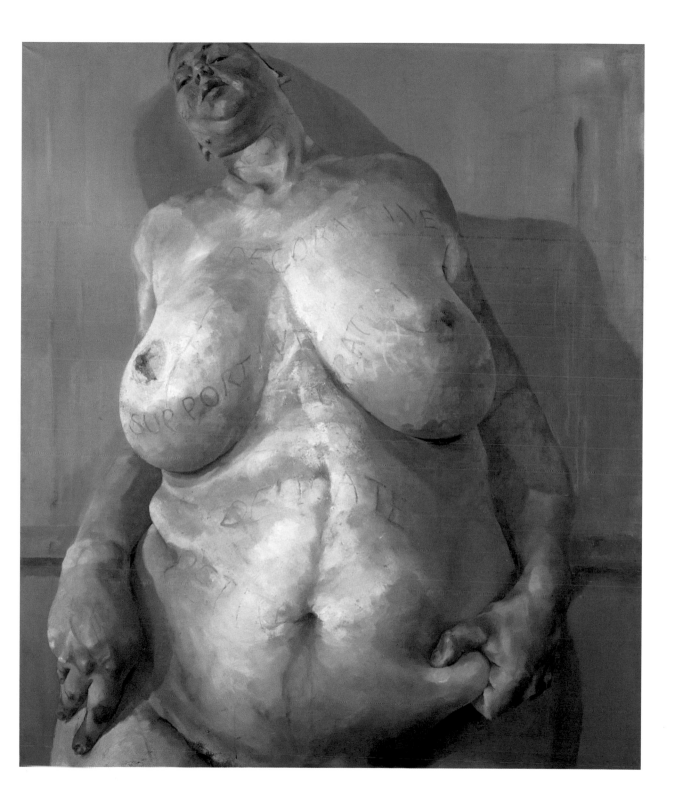

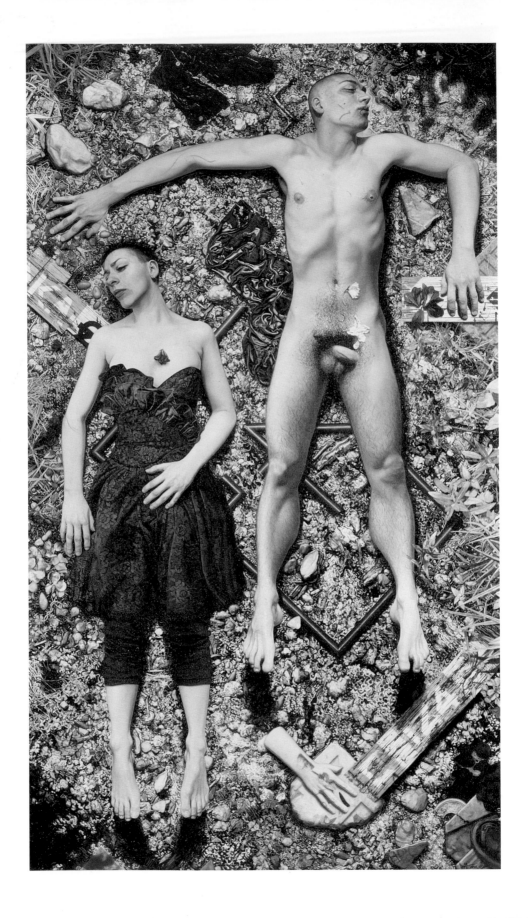

Philip Harris
Two Figures Lying in a Shallow Stream, 1993

Born in Doncaster; studied at
Mansfield and Bradford; awarded
Third Prize, *BP Portrait Award*, 1990;
first solo shows at Tricycle Gallery and
Merz Gallery, London; work purchased
by Metropolitan Museum, New York,
1992; First Prize, *BP Portrait Award*,
1993; solo show Beaux Arts Gallery,
London, 1996

Philip Harris embodies the continuing small miracle that compels a young
artist to paint in oil on canvas against the prevailing fashion of the last
years of the century. If *Two Figures Lying in a Shallow Stream* were a blurry
black-and-white video with private parts waving in slow motion, would it
not qualify as a major feature in the displays of a number of contemporary
art museums? This highly original and miraculously executed work of
contemporary youth culture is about role-playing, the search for identity
and the rubbish strewn underbelly of contemporary culture – but rather
than limit himself to promoting the concept for the work or suggesting a
means for its creation, he has carried it through to completion in a manner
redolent of the great practitioners of the past. Indeed, Harris's microscopic
technique and obsessive observation seem to take us way beyond the
furthest limits of imagination.

If 'the world, the flesh and woman' might be an appropriate way to
characterise Jenny Saville's paintings (see p.253), 'the world, the flesh and
the devil' might be even more appropriate for Philip Harris's. But this is
not Surrealism. The situations found in Harris's paintings are nightmarish,
but they are fully realistic: 'radical realism' was one of the better descriptions
thought up (by *Time Out* magazine) to describe his work at the time of
his first solo shows in the early 1990s ('neurotic realism' would have been
just as good). Although some of Harris's recent paintings have included
moving depictions of an older man, the self-image is pivotal to his art, with
his girlfriend Louise usually playing a more-or-less passive observer to his
narcissistic agonising. Sex is present here, as in his other paintings, possibly
represented by the flowers strewn strategically over the two bodies, but its
significance among so much complex imagery remains unclear. The artist
throws himself and his dreams into the rubbish beneath our feet, in this
extraordinary work of self-exposure and undeniable power.

Oil on canvas
1825 × 1070mm (71¾ × 42⅛″)
Collection: Harold Wong

J. Russell Taylor, in *Philip Harris*, exh.
cat., Beaux Arts Gallery, London, 1996

B. Sewell, 'Opening a window on a
naked talent', in *The Standard*, London,
21 May 1992, p.30

255 THE NINETEEN NINETIES

Mai Jinyao (K. S. Mak)
The Mask, 1994

MAI JINYAO (K. S. MAK) b.1940

Born in Singapore; studied at
St Martin's School of Art (1961–4)
and Royal College (1964–7) taught in
various colleges in UK, 1966–88;
painted geometric abstractions until
c.1989; solo exhibitions Arnolfini
Gallery, Bristol, 1967; Schoeni Art
Gallery, Hong Kong, and Kuala Lumpur,
1995; has lived in Ireland since 1999.

The exhibition in which this satirical portrait of the then Governor and
Commander-in-Chief of Hong Kong, Chris Patten (b.1944), was first
shown was called *Talking Pictures*. After more than twenty years of teaching
and painting the purest of geometrical abstractions, Mak (as he calls
himself in Europe) was becoming conscious of 'the increasingly formulaic
and tendentious nature of the modernist works I then habitually produced.
I slowly became aware of the traps of the dogma and self-importance
inherent in so much of that work, and I began to look beyond the self-
referential world of the avant-garde. I wanted to connect the word "art"
with my personal beliefs and with the physical realities of the human
condition.' Mak's earlier work was not without external references or
humour, however: a painting from 1976 with repeated vertical stripes was
called *Buddhist Television* (British Council collection). But the *Talking
Pictures* are nearly all concerned with political, social or environmental
issues; the paintings are reproduced in the catalogue with bubble captions
to underline the point the artist wants us to understand. Chris Patten,
in the run-up to the handover of Hong Kong to China, removes his affable
public and political mask to reveal either that he is wearing an identical
one beneath, or that there was nothing there in the first place.

The toy panda is a frequently recurring metaphor for the artist
himself and for China. In *Prosperity* (1994–5), a satire on creeping Western
materialism, two pandas sit munching carrots while watching television.
In *We have no bamboo today* (1994–5), a 'theme park' performing panda
juggles a Disneyesque ball in a plea for humane conservation. Metaphor
is one weapon in this artist's armoury, and humour another. Chris Patten
faces up to Jiang Zemin in a sumo wrestling bout; John Major in clown's
costume wrestles with the chimpanzees of his political opponents. Ever
present are the toys and masks of oriental life, serving as metaphors for
human activity and displacement. Mak's large recent series (exhibited in
8 + 8 + 1: Selected paintings by 15 Contemporary Artists, Schoeni Art Gallery,
Hong Kong and tour, 1997–8) is totally devoted to the mask; like the work
of several leading contemporary Chinese artists, it is conceptual in intent
and concerned with issues of identity. Mak's own new-found identity as
an artist may seem populist and didactic, but his elegance and wit never
obscure the profound humanity beneath.

Oil on canvas
608 × 762mm (24 × 30")
Timothy Prager and Berthe Latreille

REFERENCE

Talking Pictures. Paintings by Mai Jinyao,
Schoeni Art Gallery, Hong Kong, 1995

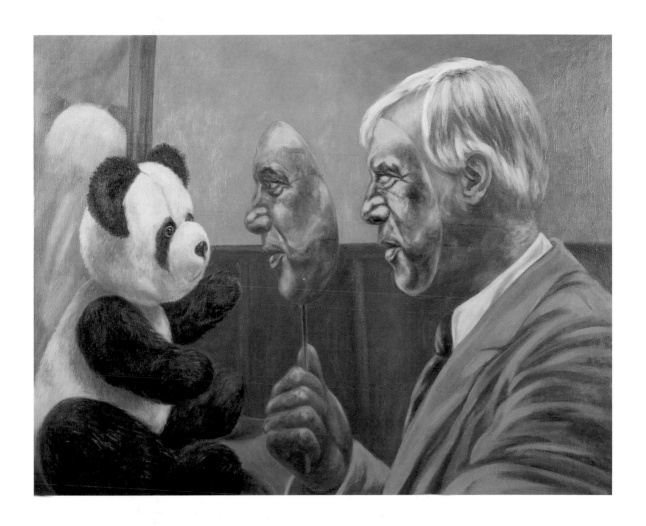

Life is so complex
We make up
We put on masks
We lose ourselves in disguise
Irrational actions
Until we're caught in surprise

[Artist's text]

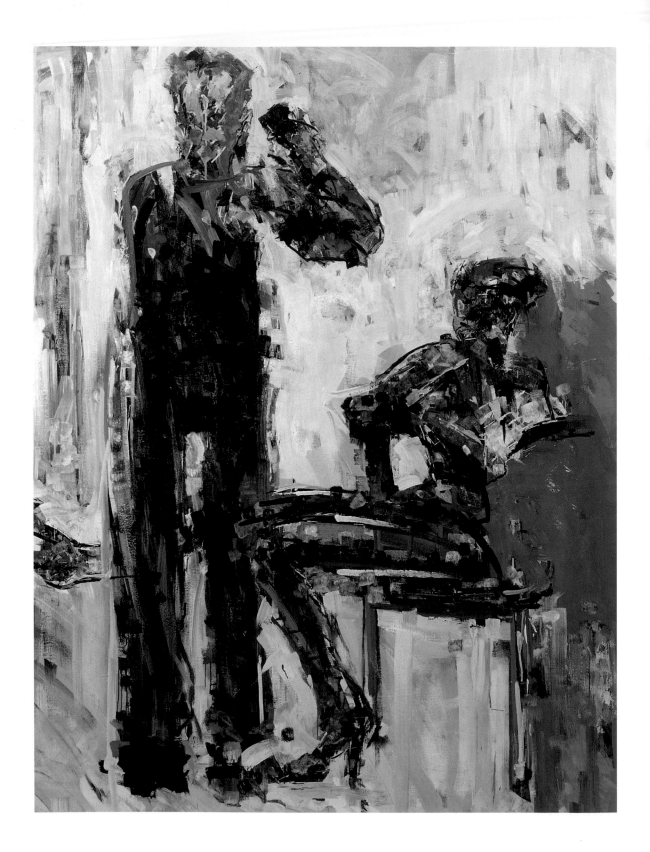

Stephen Finer
David Bowie and Iman, 1995

STEPHEN FINER b.1949

Born in London; studied at
Ravensbourne College of Art, 1966–70;
developed distinctive painterly
treatment of heads and figures; began
organising his own solo shows from
1981; subsequent exhibitions include
Anthony Reynolds Gallery, 1986, 1988;
Berkeley Square Gallery, 1989; Bernard
Jacobson Gallery, 1992; Woodlands
Art Gallery, 1994; Agnew's, 1998.

The conjunction of superstar David Bowie (b.1947) and his wife Iman
with the visual complexities of Stephen Finer's paintings was a matter
of enlightened artistic patronage rather than a conventional portrait
commission. It is a tribute to Bowie, himself an artist and a keen collector,
that he was prepared to expose himself to the totally unknown outcome
of such a confrontation. But it was a shrewd move: of the resulting three
portraits, the lively half-length one is now among the most popular
items in the National Portrait Gallery's contemporary collection. Ten
or fifteen years ago, such a nearly abstract image might have provoked
incomprehension from most of Bowie's fans and visitors to the Gallery.
Increasing exposure to contemporary art in all its variety has since created
more sophisticated viewers, who are prepared to accept work at face
value and take an intelligent interest in a multitude of different art forms.

Unlike some of Finer's small paintings of heads, this is a very readable
image. Two figures in a room: the man standing with his arm raised,
perhaps drinking, perhaps making a point; the woman leaning back
elegantly in a chair, smartly dressed and wearing very high-heeled shoes,
the striking gesture of her right leg outstretched behind the man both
drawing him towards her and linking the two in a gesture of intimacy.
The white paint suggests a light-filled room behind the couple, but is also
an abstraction evoking their presence. The intrusive grey paint on the
right might be a shadow cast by Iman, or it might be a third person
(perhaps the artist), or it might be the place in the composition where
weight was needed to stop the imagery implicit in the rest of the painting
from drifting away. Is this an 'impression' of the two people, or is it an
'expression' of their presence in front of the artist? Would we look at the
painting in a different way if we did not know who they were? The fact
that these questions cannot be answered confers a kind of privacy on the
subjects, allowing them to remain hermetic, to preserve their identities
both as individuals and as a couple, while at the same time giving the artist
unlimited licence to work wonders with his paint.

Oil on canvas
1981 × 1524mm (78 × 60″)
Ultrastar, New York

REFERENCES

N. Lynton, introduction, *Stephen Finer*,
exh. cat., Bernard Jacobson Gallery,
London, 1995

M. Golding, 'Stephen Finer: Presence
and Identity', in *Modern Painters*,
Spring 2000, pp.112–14

Robert Silvers
Bill Gates, 1995–6

ROBERT SILVERS b.1968

A graduate student in the MIT Media Lab, he began developing the software to create mosaic images from a large digital picture bank built up by Robert Hawley, 1995; first pictures published in 1997, followed by another book based on Disney images; founded Runaway Technology, Inc., 1996.

Visual ambiguities, the 'man in the moon' – a shadow that looks like a rabbit, a rock that looks like a face – are an eternal source of fascination, and a number of artists have delighted in creating visual puns to intrigue their viewers. Arcimboldo (1537–93), working at the Habsburg court in Prague, painted head-and-shoulder symbolic 'portraits' of the seasons and of the elements from fruit and vegetables; Salvador Dalí rediscovered his work and combined his anthropomorphic imagery with other forms of optical illusion. Pavel Tchelitchew followed Dalí's example, creating landscapes and trees from the human body. Artists have been slow to follow up the almost unlimited scope offered by computer manipulation; many developments in computer graphics have been led instead by the technology and by those who create it.

Robert Silvers' photomosaics resemble the work of his artistic forbear Arcimboldo in that he employs components appropriate to his finished image. A flower-seller is made up of photographs of flowers. A portrait of Abraham Lincoln is compiled from American Civil War photographs. Silvers has designed posters and corporate imagery for various institutions, including the Library of Congress and Mastercard. Few of his photomosaics, however, seem to have hit the spot in the same way as his portrait of the founder of the giant Microsoft Corporation, Bill Gates (b.1955) – reputedly the world's richest man, his portrait was compiled from photographs of thousands of banknotes. The *Bill Gates* portrait was commissioned as a present for Gates's 40th birthday, and the composite image based is on one of Silvers' own photographs. It is an intriguing and memorable image of one of the most powerful men of our times.

Digital photomosaic
1521 × 1218mm (59⅞ × 48″)
Collection of the artist. Courtesy
Fabien Fryns Gallery, Marbella

REFERENCE

R. Silvers, ed., M. Hawley, *Photomosaics*, New York, 1997, pp.48–9 (82)

Michael J. Browne
The Art of the Game, 1997

MICHAEL J. BROWNE b.1963

Studied at the Chelsea School of Art
and Manchester Metropolitan
University; exhibited works in the *BP
Portrait Award* show, National Portrait
Gallery, 1987 and 1993; works locally in
Manchester and executes commissions
for frescos and portraits.

Oil on canvas
3048 × 2435mm (120 × 95¾")
Collection: Eric Cantona

REFERENCES

C. Garner, 'Divine Cantona rises again'
in *the Independent*, 15 April 1997

J. Huntington-Whiteley, *The Book of
British Sporting Heroes*, National
Portrait Gallery, London, 1999,
p.24 (ill.)

The use (or misuse) of a famous painting to evoke a reaction in a totally
unrelated context is a stratagem long known to caricaturists, but it has
seldom been carried out on such an ambitious scale or to such remarkable
effect. In an accurate transcription of Piero della Francesca's famous
Resurrection (c.1472; Borgo Sansepolcro), the French-born football star Eric
Cantona (b.1966), affectionately known to loyal Manchester United fans
as 'God', stars as the risen Christ, his semi-nudity sanctioned by several
published series of pin-up photographs. As well as Cantona's perceived
divinity, the allegory relates more specifically to his triumphant return to
redeem the misfortunes of Manchester United in 1995–6 after a fate worse
(in football terms) than death – a year's suspension for kicking a jeering fan
at Selhurst Park. Piero's sleeping sentries who should have been guarding
the tomb are replaced by the slightly more watchful figures of Cantona's
team-mates: from left to right, Phil Neville, David Beckham, Nicky Butt
and Gary Neville. The symbolic spring landscape in the background of
Piero's painting is replaced by a scene from another early Renaissance
masterpiece, Mantegna's *Triumph of Caesar* (c.1486; Hampton Court, Royal
Collection); with its complex classical yet basically barbaric pageantry, it is
a suitable metaphor for modern football. Browne transforms Julius Caesar
into the team's manager Sir Alex Ferguson.

On one level, this painting is an elaborate satire on the excessive adulation
afforded to modern football players. Whereas twenty or thirty years earlier
it would probably have given rise to accusations of blasphemy, its appearance
in the late 1990s provoked hardly a whisper of protest. This is not merely
the result of a decline in religious observation: no mere satire would be
worth the hundreds of hours of work that Browne clearly put into this
painting, and his genuine admiration both for Cantona and for two great
masterpieces of art shines through with touching transparency. Even
given its obviously specific origins, the work can still be easily related in
its elaborate classical pastiche to the Postmodernism of the 1980s, and
the work of Carlo Maria Mariani and Sandro Chia in Italy, and Werner
Tübke (see p.208) in former East Germany. As with much of the period's
architecture, the high camp and jokiness of many Postmodernist painters
now often seems discredited and frankly vulgar. But the memory of
Cantona's sporting brilliance and Gallic charm, combined with Browne's
meticulous workmanship and conviction, should secure a niche for this
extraordinary document of its times.

1997

John Beard
Wanganui Heads, 1998

JOHN BEARD b.1943

Born in Aberdare, Glamorgan; studied at Swansea College of Art (1962–5), University of London (1965–6), and the Royal College of Art (1979–81, Masters); first solo exhibition at the Welsh Arts Council in Cardiff, 1966; from 1968 taught in various schools and universities in England; also a freelance design consultant and producer for the BBC; co-founded the firm of Artigiani (1981–2) before taking a teaching post in Perth, Australia; became full-time painter, 1989; residencies at Wanganui, New Zealand, 1996; University of New South Wales, 1997, and Tate Gallery, St Ives, 1998.

Oil on linen
760 × 760mm (30 × 30″) each,
and video monitor
Private collection of the artist

REFERENCES

John Beard: Wanganui Heads, exh. cat., Sarjeant Art Gallery, Wanganui, 1998

John Beard: Heads Phase III, exh. cat., Art Gallery of New South Wales, Sydney, 1998

This installation is the third part of an ongoing project described as *Heads*. It developed directly from John Beard's previous *Adraga* series – a visual exploration of a wave-beaten rock off the Atlantic coast of Portugal. In the artist's words: 'The work is a result of a kind of struggle, a precarious equilibrium that must remain suspended so as to sustain its intensity. The *Adraga* project gave me clues as to how to deal with the head and the face as subject matter. . . . I find myself literally washing in and washing away the most familiar features of reference in the face, arresting it would seem the anticipated need for confirmation of certain aspects of subject . . . another body of knowledge existing behind, and perhaps beyond, the similarly complex layering of what we know.' Most of the heads from Phase I and II of this series are large self-portraits painted, or drawn, in layers of the palest colour with some underlying darker areas of paint suggesting modelling of the features. 'I am responding to what is before me, from myself as mirror image, and from an internalised sense of what I am. I am working from within and without.'

The idea of using video as an integral part of the work came to him during a residency in 1997 at the Sarjeant Art Gallery, Wanganui, New Zealand. The 'virtual reality' of the video shown in juxtaposition with the paintings raises questions about portraiture and the nature of current art practice; the viewer is left to decide which one ultimately tells us more about the sitter, or whether one medium enhances the other. Having obtained the friendship and cooperation of the staff of the Sarjeant Art Gallery, nine of whom were the original subjects of these heads, Beard scripted an eight-minute audio tape which each person responded to whilst being filmed. Their reactions to the same series of propositions range from the profound to the humorous to the disconcerting, so that a portrait is also constructed in words as well as in images. The paintings themselves were done both from memory and from the video, and in their varying degrees of definition and implied movement themselves chart the artist's reactions to his sitters. He wrote: 'It was a deliberate choice to use subjects who were familiar enough with me to willingly "collaborate", but whose images were not so familiar as to be "fixed". The impressions I now have of them are, in the most positive sense, fleeting and fragmentary.' Beard's exploration of 'the possibilities of portraiture' in the age of video led to the exhibition of some of this work at the new Australian National Portrait Gallery in Canberra in 1999.

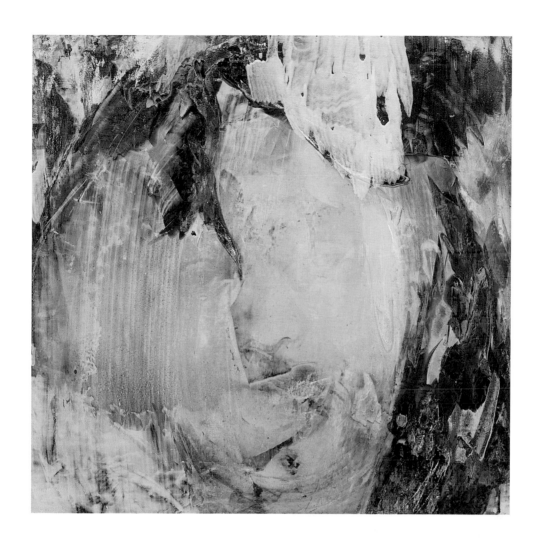

Gary Hume
Pauline K., 1999

GARY HUME b.1962

Born in Kent; studied at Goldsmiths College, graduating 1988; first solo exhibition at Karsten Schubert Ltd, London, 1989; shortlisted for the Turner Prize, Tate Gallery, 1996; awarded Jerwood Painting Prize, 1997; included in *Sensation*, Royal Academy, London 1997; other solo exhibitions include Kunsthalle Bern and ICA London, 1995, XXIII Bienal de São Paolo, 1996, Venice Biennale, Scottish National Gallery of Modern Art, Edinburgh and Whitechapel Art Gallery, London, 1999.

Gary Hume is inextricably associated with the Young British Artists through his inclusion in Damien Hirst's epoch-making *Freeze* exhibition in 1988 and his friendships with many of the group, but he has forged his own career, finding equal success in the US and never attracting tabloid attention in the 'Sensation' manner. Postmodern irony is plentiful in his work. The series of *Door* paintings with which he made his name in the early part of the 1990s were a stringent comment not only on 'minimalist' painting of the previous decades, but also on one of the least attractive and banal features of public architecture.

Significantly, Hume is recorded as saying that one of the reasons he painted the doors was because they 'looked like a face', and faces have been among his preoccupations ever since. It is difficult not to be reminded of Warhol's graphic reductions of faces, though both the intent and the result are very different. Whereas Warhol relies on multiple repetition of imagery that is almost universally recognisable, Hume's paintings are unique and mysterious, only occasionally striking a subtle chord of recognition to engage our apprehension of the work. Even where, like Warhol, he uses a well-known Old Master portrait, such as in *After Vermeer* (1995), the effect is neither satirical nor celebratory, more a gentle jogging of the memory. Celebrities such as Patsy Kensit, Tony Blackburn and Francis Bacon, on the whole unrecognisable without their titles, provide motifs from popular culture and a resonance that is aesthetic rather than, with Warhol, historical.

Hume also applies his techniques of selection and simplification with enormous effect in portraits of his friends. Here, Pauline seems totally recognisable in a manner that reminds us of what Matisse could do with a similar reduction of inessentials eighty years before (*The Feather Hat*, 1919; The Museum of Modern Art, New York). The enigma of the portrait is preserved behind reflective flat surfaces which take the place of volume and space, but there is a similar fascination with the emotional power of colour and with feminine mystery. The technique and the presentation are new, but Hume's paintings stand firmly in a long artistic tradition.

Gloss paint on aluminium panel,
1185 × 910mm (44 × 35½")
Private collection

REFERENCES

Gary Hume, exh. cat., Whitechapel Art Gallery, London, 1999, pp.67, 85

N. Rosenthal et al., *Sensation: Young British Artists from the Saatchi Collection*, London, 1997, pp.100–7

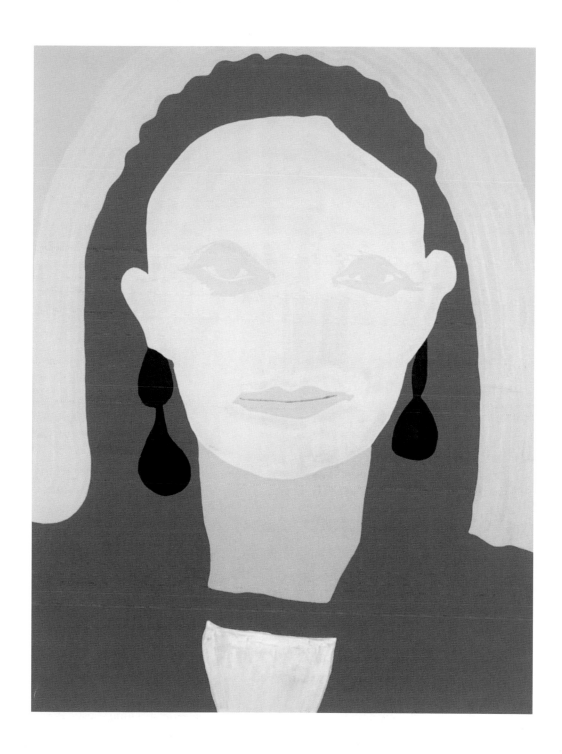

Marty St. James
boy/girl diptych, 2000

MARTY ST. JAMES b.1954

Born in Birmingham; studied at
Bourneville School of Art and Cardiff
College of Art; concentrated on video,
performance and installation art from
1982; collaborated with Anne Wilson
1981–96, especially on video portraits
including the 14-monitor *The Swimmer*
(Duncan Goodhew) and two others
commissioned for the National
Portrait Gallery, 1990; residency at
Kunstakademiet, Trondheim, Norway,
1993; Arts and Humanities Research
Board award for research in North
America, Far East and Australia,
1999–2000; *Picture Yourself*
video/print installation at the
Scottish National Portrait Gallery,
Edinburgh, 1999–2001.

Dual channel video projection
Courtesy of the artist
[Mounted with a contribution from
Cadbury Schweppes]

REFERENCES

S. Cubitt, *Videography*, London, 1995,
pp.66–7

Electronically Yours, exh. cat., Tokyo
Metropolitan Museum of
Photography, 1998, pp.38, 121–8,
nos.45–52

'Time, like an ever-rolling stream/ bears all its sons away,' goes the line from Isaac Watts's well-known hymn. The passing of time has over the ages been the subject of many works of art – from H. G. Wells's *Time Machine* to Salvador Dalí's soft watches – though only with the advent of film and video has it been technically possible to record the phenomenon. For the last ten years or so, Marty St. James has specialised in video portraits that present an individual engaged in some activity, often including speech, over a specific, though until now, short, period of time. Unlike a television interview that relies on the cameraman's observation and the cooperation of the interviewee, St. James's pieces depend almost entirely on direction by the artist. In that sense, they are far more like a traditional painted portrait, and indeed have intentionally been presented as such, often with the ornate picture frames associated with an art gallery setting.

boy/girl diptych represents, in the artist's words, 'memory, time passing and change', and was partially inspired by a seventeenth-century portrait by the Swiss painter Conrad Meyer of a group of children with *memento mori* skulls, which St. James saw in *The Story of Time* exhibition at the National Maritime Museum. St. James had been filming his own children at intervals from babyhood since the early 1990s: his daughter, shown in the projection on the left, is now ten and his son is seven. The forlorn group of Swiss children with grim reminders of their mortality gave the artist the impetus for the final concept: of growth and regression, constancy and mutability, life and death. Using morph and dissolve techniques and occasionally slowing down the tape with the resultant distortion of the sound, the work also 'questions the transition of genetic materials from father to son and daughter and the changes that occurr within childhood growth as they develop.'

With recent discoveries about the human genome in mind, there seems little now that we cannot at least account for, even if we do not fully understand it. For most of us, time, life and growth are likely to remain as mysterious as the will and ability to create works of art about them. The language and imagery used may change over the century from Amiet's diptych *Hope* (p. 54) to St. James's *boy/girl*, but the aspirations and message remain the same.

Acknowledgements

Our greatest thanks are due to all the lenders, both private and institutional, who have so generously agreed to make their pictures available for the exhibition.

For all sorts of information and for help in organising the loans, my particular thanks go to the following: Wendy Baron, John Beard, Mary Boone, Irene Bradbury, Michael J.Browne, Richard Calvocoressi, Carolyn Carr, Catherine Clement, Di Condell, Beverly J. Cox, Arne Eggum, John Erle-Drax, Marla Goldwasser, Peter Grosz, Maggi Hambling, Brigitte Hedel-Samson, Jane Holmes, Ralph Jentsch, Allen Jones, Peter Killer, Dr. Erica Költzsch, Karen S.Kuhlman, Stephen Lacey, Frederic Leris, K. S. Mak, Sandra Martin, James Mayor, David McKee, Dany McNutt, Tobias Mueller, Sandy Nairne, Dr Tobias Natter, Humphrey Ocean, Antony Penrose, Cora Rosevear, Andrew Sayers, Dr. Angela Schneider, Robert Silvers, Marty St. James, Peter Tunney, Robin Vousden, Angela Weight, Helen White, Frank Whitford.

Very few of my colleagues in the National Portrat Gallery have escaped involvement in the exhibition one way or another. Apart from Jennifer Cozens who did much of the looking up and chasing up for me, Hallie Rubenhold wrote a number of the artists' biographical notes. I am particularly grateful for useful discussions and help from the Director, Charles Saumarez Smith, and from Honor Clerk and Kathleen Soriano who were at all times supportive when I needed it most. Beatrice Hosegood in the Exhibitions Office suffered a baptism of fire with some of the most complex arrangements and negotiations for an exhibition yet experienced by the Gallery, and I am very much indebted to her and her assistant Claire Everitt. In the Public Relations and Development Department, I owe thanks to Pim Baxter, Kate Crane, Hazel Sutherland and Emma Marlow for all their hard work in connection with publicising and financing the exhibition, and not forgetting Imogen Lock for her efforts on behalf of the Gallery. In the Education Department, my colleagues John Cooper and Liz Rideal have been very helpful in planning associated activities. I am grateful to Calum Storrie and my colleagues Jude Simmons and Anne Sorensen for undertaking the complex task of designing the installation and graphics for the exhibition.

Finally, due to the extremely complex administrative arrangements for the loans, work on the production of this catalogue has been far more last-minute and fraught than I would have wished. I am therefore especially grateful to our editor Anjali Bulley, the project manager Jane Havell, and the designer Philip Lewis, not to mention Jacky Colliss Harvey and other colleagues in Publications and the Picture Library, for working so hard and uncomplainingly on what promises to be a well-designed and worthwhile book.

ROBIN GIBSON
August 2000

Index

References in *italic* are to illustrations in the essay.

Published in Great Britain by National Portrait Gallery Publications,
National Portrait Gallery, St Martin's Place, London WC2H OHE
to accompany the exhibition

Painting the Century
101 Portrait Masterpieces 1900–2000

Supported by PROVIDENT FINANCIAL

For a complete catalogue of current publications,
please write to the address above, or visit our website at
www.npg.org.uk/pubs.htm

Chronology compiled by Jennifer Cozens

ISBN hb 1 85514 289 9
ISBN pb 1 85514 313 5

A catalogue record for this book is available from the British Library.

Publishing Manager: Jacky Colliss Harvey
Senior Editor: Anjali Bulley
Project Manager and Editor: Jane Havell
Additional Picture Research: Carrie Haines
Production: Ruth Müller-Wirth
Design: Philip Lewis of LewisHallam, London
Printed by Conti Tipocolor, Italy